3000 800058 99359
St. Louis Community College

W9-CZT-806

Florissant Valley Library
St. Louis Community College
3400 Pershall Road
Ferguson, MO 63135-1499
314-595-4514

WITHDRAWN

Calder

Portrait of Calder, ca. 1930 / Photo: Man Ray

CALDER: GRAVITY AND GRACE

Editors

Carmen Giménez

Alexander S. C. Rower

Essay by

Francisco Calvo Serraller

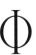

Phaidon Press Limited
Regent's Wharf
All Saints Street
London N1 9PA

Phaidon Press Inc.
180 Varick Street
New York. NY 10014

www.phaidon.com

This edition first published 2004
© 2004 Phaidon Press Limited
First published by Tf. Editores © 2003
Images and texts © Alexander Calder/VEGAP.
 Madrid. 2003
Other texts © their authors
Photographs © VEGAP. Madrid. 2003

ISBN 0 7148 4410 1

A CIP catalogue record for this book is available
from the Bristish Library

All rights reserved. No part of this work may be
reproduced. stored in a retrieval system. or
transmitted in any form or by any means.
electronic. mechanical. photocopying. recording or
otherwise without the written permission of
Phaidon Press Limited.

Designed by Juan Ariño and Marta Elorriaga
Translated by Alfred MacAdam and Isabel
Saavedra

Printed in Spain
Paper distributed by Coydis

CONTENTS

Carmen Giménez 1 INTRODUCTION

Francisco Calvo Serraller 5 CALDER: GRAVITY AND GRACE

Carmen Giménez 41 SELECTED TEXTS BY AND ABOUT CALDER

47 I. CALDER'S WRITINGS
AND QUOTATIONS

57 II. SELECTIONS FROM CALDER'S
AUTOBIOGRAPHY

65 III. TEXTS BY OTHER AUTHORS

83 IV. INTERVIEWS WITH CALDER

105 PLATES

178 LIST OF PLATES

Alexander S. C. Rower 187 CHRONOLOGY

Alexander S. C. Rower 217 BIBLIOGRAPHY

Alexander S. C. Rower 237 EXHIBITION HISTORY

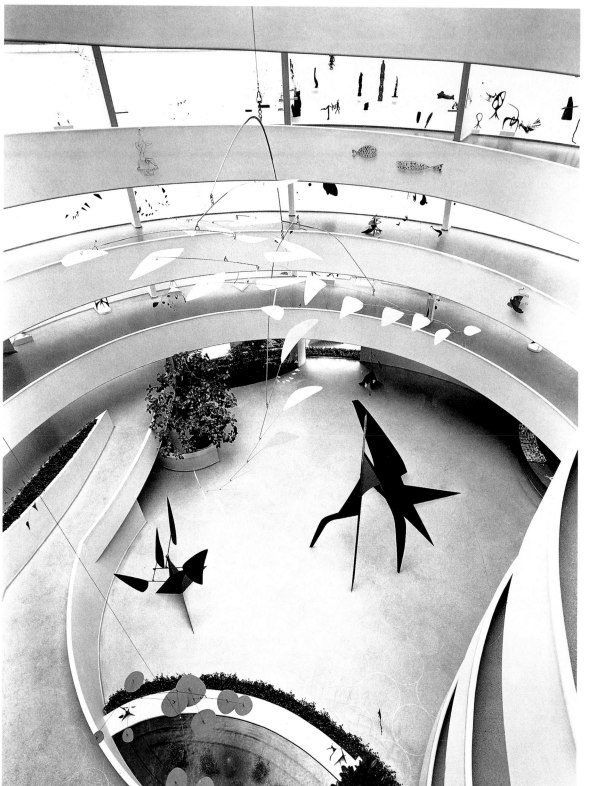

Alexander Calder: A Retrospective Exhibition, 1964.
Solomon R. Guggenheim Museum, New York.
Courtesy Calder Foundation

INTRODUCTION

Carmen Giménez

For me, it all began in 1993 with the exciting *Picasso and the Age of Iron* show at the Guggenheim Museum New York. I later found myself involved in solo exhibitions of sculpture by one or another of the five great artists in that show. I had a double experience with the work of David Smith, first when I curated a commemorative exhibition in Italy marking his historic participation in the 1962 Spoleto Festival, and then when I curated the ambitious retrospective *David Smith 1906–1965*, which was shown in 1996 at the IVAM in Valencia before traveling to the Museo Nacional Centro de Arte Reina Sofía in Madrid. And now, exactly ten years after that first experience, I find myself confronting the challenge of showing in Spain the work of another of the artists whose sculpture appeared in that memorable 1993 exhibition: Alexander Calder.

Except for Alberto Giacometti, who spent his life in his native Switzerland and in Paris, it seems that the "Age of Iron"—the focus of the New York exhibition—was dominated by two Spaniards, Pablo Picasso and Julio González, and two Americans, Smith and Calder: two pairs, who all had close and productive relationships. Smith, for example, was the first artist to take inspiration from and to honor the memory of González, while Calder not only had a fruitful, direct relationship with Picasso, González, Joan Miró, and other Spanish artists in the School of Paris, such as Pablo Gargallo and José de Creeft, but had exhibitions in both Madrid and Barcelona in 1933. Later, in a unique and moving way, Calder contributed to the Spanish Pavilion at the 1937 International Fair in Paris, where he showed his celebrated *Mercury Fountain*. And the story doesn't end there: When metal sculpture became more widespread after World War II, thanks to the work of these pioneers, two of the sculptors who led this new international movement, the Basques Eduardo Chillida and Jorge Oteiza, revitalized in their own way the earlier happy and ironclad artistic entanglement between Spain and North America.

In any case, whatever the background for that cordial artistic and moral fusion, the personality of each of those four great artists, Picasso, González, Smith, and Calder—the sculptors who forged that transcendent episode in twentieth-century iron sculpture—was so revealing and singular that it demands their being considered individually.

If I've evoked here at the outset the experience of *Picasso and the Age of Iron*, it's because there in the beautiful building created by Frank Lloyd Wright, the marvelous, captivating spiral of light that radiated within that space served as the unexpected frame for emphasizing the abrupt qualities, the expressive cuts, and the ductile subtleties of the sculptures created by these avant-garde blacksmiths. All of them simultaneously established a personal dialogue with that dynamic space sheltering their works, but I will always remember the elegant, almost magical delicacy with which Calder's mobiles floated above it, filling space without filling it, being there without being there, with a presence that spontaneously seemed to embody the "infinite lightness of being" made famous by Milan Kundera.

Painter, printmaker, and in many ways a kind of architect-engineer, but, above all, a sculptor: a sculptor, let us never forget, able to work with many kinds of materials besides metal: capable of working on any scale and, of course, in both static and dynamic idioms, the massive and the weightless. All of Calder's diversity and versatility is, seen from the position of someone making a selection of his work, an exciting and, at the same time, dangerous challenge. We need to remember, when choosing from among them, those that will represent the trajectory of his production in a permanent record, that there are not only aesthetic factors to consider but functional, historic, and cultural ones. We have to take into account both the demands of the book format and the public for which it is intended. While all this certainly influences the comprehensive presentation of any artist's work, we must recognize that it weighs (the word is exactly right) heavily on Calder, about

whom it is possible to postulate infinite interpretations because of the myriad facets of his work.

In this sense, the book we are now presenting, while it does attempt to include almost all the most significant and outstanding aspects of Calder's extensive production, has not shrunk from formulating a specific vision of this protean artist. That vision is contained in the book's title— *Calder: Gravity and Grace*—which appropriates the title of a famous, posthumously published anthology of the work of the French thinker Simone Weil, who was herself obsessed by the physical sense in which the law of gravity is negated during a mystical "transport" or state of levitation. Long before Weil analyzed the unique quality and meaning of the different elements that make up nature, philosophers from the pre-Socratics to Saint Augustine of Hippo made similar inquiries. "Bodies tend, by their own weight, to move toward the place proper to them," wrote Saint Augustine in his *Confessions*. "But a weight does not necessarily move downward: It moves toward the place proper to it. Fire ascends, stones descend. . . . My weight is my love. Wherever it moves, it takes me with it."

For different reasons and by very different means—though not in ways entirely unrelated to this Christian tradition—Calder brought twentieth-century sculpture to a state of transparency and weightlessness similar to the magic of levitation, inaugurating a way of conceiving space from a cosmic, aero-spatial, cosmonautic perspective.

Using levers and motors, Calder sometimes infused movement into his sculpture, but his most marvelous contribution was, without a doubt, what I regard as the "motorless flight" of bodies in space, which transformed the weight of sculpture, its mass and volume, into an authentic mobile. For this reason, although the present book is not devoted exclusively to the mobiles, a limitation that would deprive us of other, essential aspects of Calder's work, we can affirm that it is dominated by the

celebration of weightlessness and how it has shaped the horizon for the sculpture that followed. Our way of formulating and measuring Calder's contribution, in terms of weight, has been influenced by a desire to show the tension that he produced between heaviness and lightness, gravity and grace: all that has brought sculpture from the classical statue to this almost miraculous idea of a gesture in space.

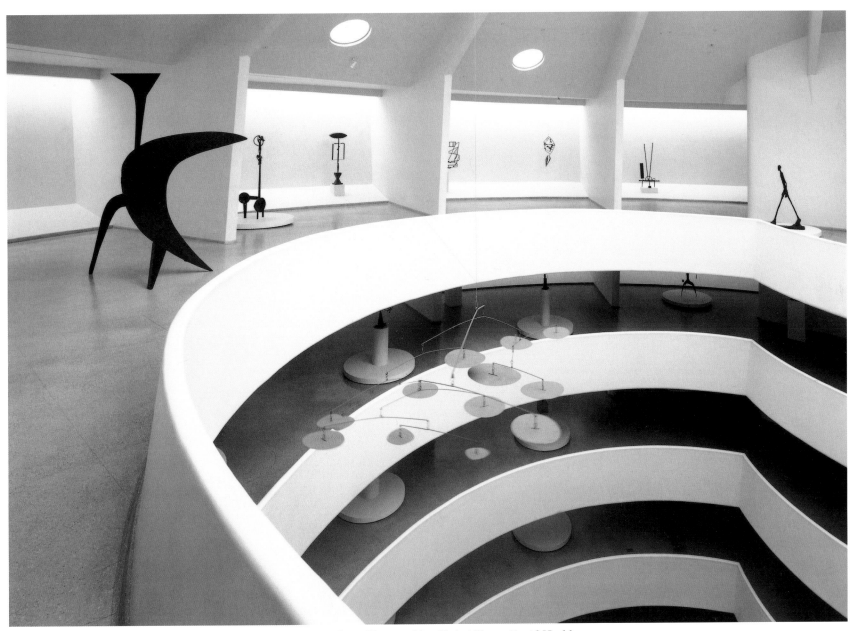

Exhibition *Picasso and the Age of Iron*, 1993. Solomon R. Guggenheim Museum, New York / Photo: David Heald

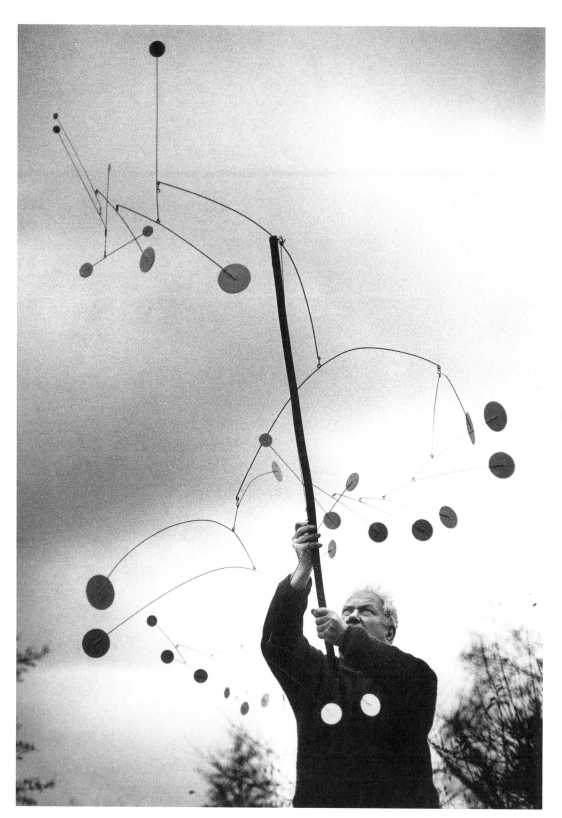

Calder in his Saché Studio, 1961 / Photo: Ugo Mulas

CALDER: GRAVITY AND GRACE

Francisco Calvo Serraller

Why not begin with a fundamental statement of aesthetics, especially since it was formulated by the hero of this story, Alexander Calder himself? "People think monuments should come out of the ground, never out of the ceiling, but mobiles too can be monumental."[1] To my way of thinking, it's hard not to be fascinated by this apparently innocuous remark, even if it seems to contradict the law of gravity. Perhaps that idea no longer shocks us, when every day we see gigantic commercial airliners and military supertransports of even greater size and weight flying above our heads, and there is an enormous space station placidly orbiting our planet. The issue is weight, which is always relative. Long before the age of flight, there were kites and lighter-than-air balloons coursing across the skies, and, of course, since time immemorial humans have admiringly stared at the dizzying swoops of birds. However, the impact of Calder's statement does not derive from our astonishment at the idea of flight, and not even at the size of the flying body in question, but from the notion that such a body might be a monument—a word that, when spoken by a sculptor, alludes not only to something big but to a work of art. For instance, could you imagine a flying Parthenon?

It's also the case that Calder is an artist who came of age during a revolutionary era in the twentieth century, the century of the greatest artistic and technological revolutions. All revolutions turn the world upside down, and perhaps the greatest and most radical revolutionary of the modern era, Karl Marx, conceived his system by (we should never forget) totally inverting that of his predecessor Hegel. And if, in effect, we've seen traditions, ancestral forms of life, social, political, and economic regimes, even physical landscapes take wing without being shocked, why shouldn't monuments also start flying?

* "The Hanging Monument."
[1] Calder, in interview with Robert Osborn, "Calder's International Monuments," *Art in America* 57, no. 2, March–April 1969, p. 36.

Picasso, *Drawing from a sketchbook*, Juan-les-Pins, 1924. Musée Picasso, Paris

One of the art forms that in recent times has flown most through the air to the point of completely disappearing from view has been traditional sculpture, whose requiem had already been intoned at the beginning of the nineteenth century. This dramatic sacrifice, both physical and symbolic, of figural sculpture was so complete and unstoppable that we shouldn't be shocked that the salvation of its remains was taken on principally by painters such as Géricault, Daumier, Degas, or Rodin—this last the only one who was professionally considered a sculptor, but

who was also perhaps the most pictorial of all of them. In this sense, isn't it curious that at the beginning of his career Calder believed himself to be a painter?

But let's not get ahead of ourselves. Before Calder began his artistic career or even thought of himself as a painter, Rodin had already pushed freestanding figural sculpture beyond its old limits, as has been explained so many times, not only by pulling the pedestal out from under it and tossing it onto the ground, but by literally smashing it into a thousand expressive fragments. Born in 1898, Calder began his artistic career during the Roaring Twenties, when the classic concept of sculpture—was there ever any other?—was in ruins. For those of his generation, to be or to become a sculptor meant starting from zero, evolving in a void, dancing in midair.

In the summer of 1926, Calder, thinking he was nothing if not an artist, though still imagining he was a painter, reached Paris, the city that marked his creative destiny, which was then the indisputable world capital of the avant-garde. After that exciting first visit, which barely allowed him time to breathe in the city's air, Calder returned again and again to Paris, where he began living for longer and longer periods. It was during this second half of the Twenties that Calder committed himself totally to the militant avant-garde. It was a time of enormous artistic unrest, dominated especially by the windstorm of Surrealism that swept onto the scene. They wanted to turn all art, including the avant-garde, upside down, but their wish eventually landed them in a crisis, which marks the division between the Surrealism of the Twenties and that of the Thirties. In this atmosphere of critical tumult the early Calder developed, and out of that crucible emerged the pattern of his future personality as a sculptor.

But to return to the image of the hanging monument, what we must remember is that the crucial theme of sculpture in the Paris of the

Twenties was the idea of "drawing in space." As always, but even more so then, the artist most responsible for that motto was Pablo Picasso. According to his friend, secretary, and confidante Jaime Sabartés, Picasso in 1926 said the following: "Some followers of the Surrealist school discovered that my sketches and ink drawings are made up of points and lines. The fact is, I'm a great admirer of celestial maps. They seem beautiful to me irrespective of their meaning. So one fine day I started drawing a huge number of points linked by lines and blots that seemed suspended in the sky. I had the idea of using them in my compositions, introducing them as purely graphic elements."[2] Picasso was referring to some drawings he'd made in 1926 that had those characteristics and later formed part of the celebrated *Vollard Suite*, but he was also alluding to something that, during the late Twenties, constituted his most characteristic mode of creation, namely his experiments with using iron to make sculpture. He first became interested in iron in order to create a monument in honor of his friend the poet Guillaume Apollinaire. It was also during this period that the decisive artistic meeting took place between Picasso and Julio González, which went from being an incidental consultation about technique to constituting an authentic aesthetic revolution, leading to what might call the "Age of Iron" in twentieth-century sculpture.

Scrap Iron

Picasso's meeting with González in 1928 concerned González's knowledge—not merely about metal working, which González had learned as a member of a Catalan family who made wrought-iron window

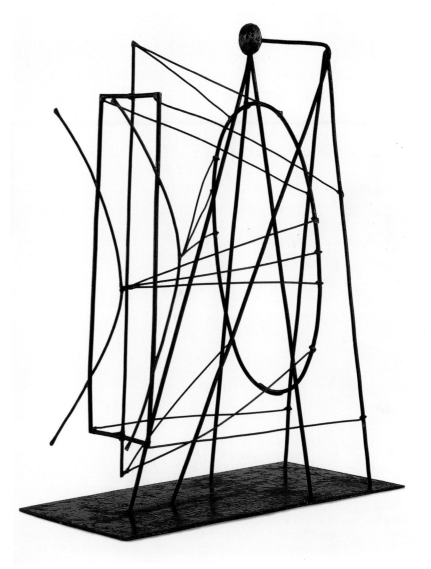

Picasso. *Figure*, Autumn 1928, offered as a maquette for a monument to Guillaume Apollinaire. Musée Picasso, Paris

[2] Pablo Picasso, "Letter on Art," originally published in the magazine *Ogonek 20* (Moscow, May 16, 1926). It was also published in *Deutsche Kunst und Dekoration*, vol. 58 (Darmstadt, 1926). See *Picasso: pintura y realidad: textos, declaraciones, entrevistas*, edited by Juan Fló (Montevideo, 1973), pp. 57–58.

gratings, but specifically about how acetylene torches were used in the industrial welding of iron. This was a technique in which González was an expert, having been employed in a Renault auto factory in 1918. During those years, the automobile industry was expanding widely, especially in the United States, where—significantly—as a young engineering graduate,

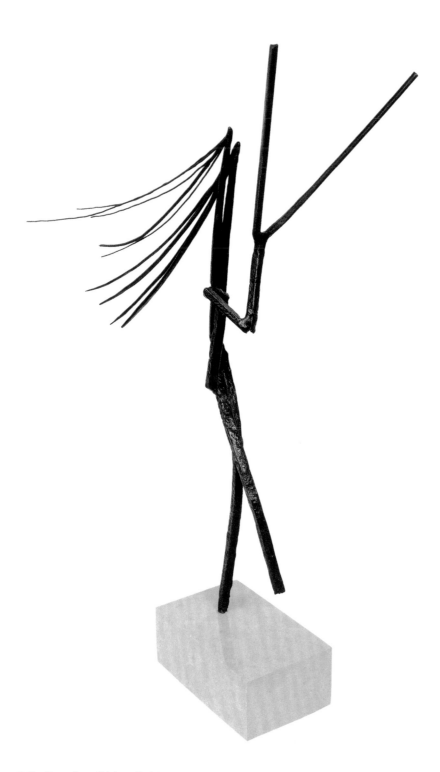

Julio González. *Disheveled Dancer*. ca. 1935. Musée de Beaux-Arts. Nantes

Calder had worked in an auto factory in 1919 and David Smith, after a year at the University of Ohio, worked in a Studebaker factory in Indiana in 1925. Thus, three of the most conspicuous representatives of avant-garde iron sculpture all had this particular kind of work experience before deciding to be artists, or, at least, before finding what would be the medium and the language that would characterize their mature work. Before all of them, including Picasso, did their pioneering work using iron during the period between the two world wars, there were some isolated precedents, such as earlier iron sculptures by Pablo Gargallo and Jacques Lipchitz and by some of the Russian Constructivists, but the aesthetic nucleus of this issue is what could be called the "scrap iron revolution"—that is, the artistic use of old pieces of iron via the recycling of scrap.

Scrap iron entered twentieth-century avant-garde art thanks to the aesthetic principle of appropriation, or, as it would be defined by one of its first and most effective promoters, Marcel Duchamp, the readymade. In effect, the readymade only functions in situations where the principle of "take it and use it as it is" prevails. In this sense, the Dadaist Duchamp was unconcerned about the source, the material, or the function of the occasionally used found object, be it a urinal—the absolute readymade exhibited without any alterations—or a simple bicycle wheel. Now, this same Dadaist indiscriminate use of objects should make us skeptical about the need to distinguish and rank materials that, in avant-garde hands, are available to be appropriated as art, because, even if the basic principle doesn't change, it is not the same thing to use a porcelain bathroom fixture as it is to use scrap iron.

Properly speaking, scrap iron is only old iron, worn out by use, and therefore, it must be directly related to the waste generated by industrial society, whose original material symbol was iron. Unless we keep in mind the rich mythological background of early iron cultures and the important role that iron played in the industrial revolution, I don't think we can understand

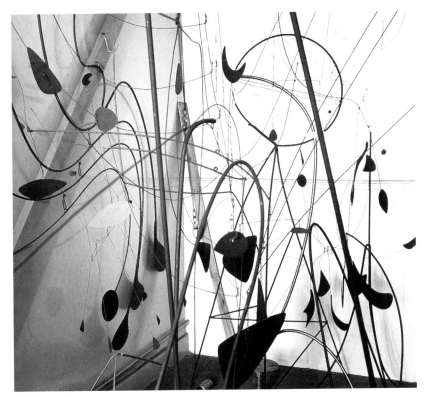

Calder's studio. New York City. 1940 / Photo: Herbert Matter

the explosive aesthetic meaning. both powerful and subversive. that scrap iron had for the twentieth-century avant-garde. And were it not for the legion of critics who disparaged the machine-made products of the industrial revolution. who shrieked with horror both at locomotives and at the Eiffel Tower. there might not have been the aesthetic rebellion against such thinking initiated by the fanatical lovers of machine symbolism. the Futurists. which was followed by a whole-hearted embrace of the liberating and egalitarian power of engineering by the Russian Constructivists. However. an even more radical insurrection—hilarious. nihilistic. and extremely caustic— was staged by the Dadaists and Surrealists. who laughed. perversely. at any liberating mechanical invention. For these artists. who were simultaneously iconoclasts and predators of illusionism. the most extraordinary mechanical device was ultimately nothing more than pure junk capable of playing havoc with anyone not aware of its hidden dangers.

The insolent mania for seizing any object to make a work of art originated with Picasso and Braque. the inventors of Cubism. who. once they'd rejected the traditional system of plastic representation. synthetically reconstructed the image with bits and pieces taken directly from reality—a newspaper page. a bit of linoleum. a fragment of sheet music. a piece of oilcloth printed with a chair-caning motif. and so on. After that liberating lack of discrimination in the synthetic construction of the object. there were no more material restraints on making artistic junk heaps out of anything at all. Among the avant-garde artists who used scrap iron. aesthetic preeminence belongs to Picasso. but with regard to technique. we would have to emphasize the role of González. Picasso's instructor in the art of the forge. González. descendant of an ancient race of Catalan ironworkers whose craftsmanship may be attested to by Gothic ironwork and by the ironwork they produced for Gaudí. had learned oxyacetylene welding techniques at the Renault plant where he had worked in 1918. According to the testimony of those close to him. González would wander the outskirts of Paris looking for scrap iron. which he would bring back to his studio and transform into strange sculptural creatures. Along with Jacques Lipchitz and Pablo Gargallo (though these two in a more tangential way). Picasso and González were the initiators of the Age of Iron in sculpture. succeeded immediately by Calder. Smith. and Giacometti.

Even before Calder moved to Paris for the first time. he had taken an interest not only in industrial scrap iron but also in other unconventional materials. as evidenced by his first wire sculpture. the lost "rooster sundial." of 1925. It was also around that time that he became entangled in line drawings. so to speak. which undoubtedly predisposed him to a clear understanding of the idea of "drawing in space" that had stimulated the talents of Picasso and González. with whom Calder maintained frequent contact.

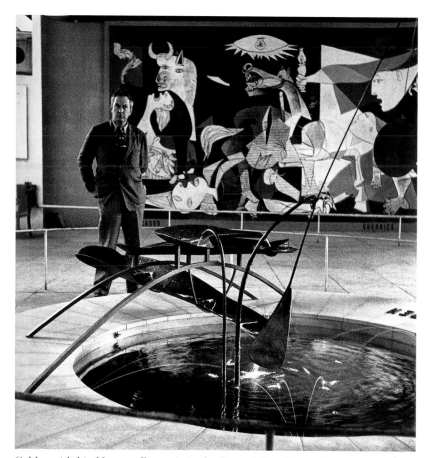

Calder with his *Mercury Fountain* in the Spanish Pavilion at the Paris World's Fair, July 1937, Paris / Photo: Hugo Herdeg

There is also a political meaning entailed in the use of iron, especially during the Thirties, marked as they were by the most extreme ideological confrontation between opposed totalitarian positions equally eager to reach "final solutions." If we focus our attention on the artistic avant-garde, we find there as well the hardest kind of confrontations. In this sense, iron, which served both to construct a new form of civilization and to destroy much of the old, represents "a metaphor for the crisis that arose in both society and the avant-garde itself between the two world wars."[3] Only two or so years after Calder moved to Paris, there came about the

first great crisis within the Surrealist movement, which had been highly politicized since its birth, but which now divided its forces according to how political commitment and militancy were to be interpreted.

This generalized political anxiety, exacerbated by the devastating world economic crisis after the collapse of the New York Stock Market in 1929 and the rise to power of the National Socialist Party in Germany in 1933, transformed the Marxist-Fascist dichotomy into a choice between the most urgent intellectual options. The boiling point was reached with the outbreak of the Spanish Civil War, in which nearly all the writers and artists in the movement took part. How could we describe such a context without using the metaphor of the Age of Iron, especially since sculpture in that material coincided with the growing ideological radicalization we've just mentioned? Despite the fact that Calder never allowed himself to get carried away by any political fanaticism, he offered to create a sculpture for the Spanish Pavilion, sponsored by the besieged Spanish Republic, at the Paris International Exposition of 1937, held in the second year of the Spanish Civil War. Although his best Spanish friends, Picasso, González, and Miró, had a major role in the pavilion, and because of Miró, Calder had shown his work in Spain during 1933, it is impossible to regard the exceptional event of a U.S. sculptor exhibiting his work in a Spanish pavilion—the only foreign-born artist invited to do so—as a simple matter of friendship and sympathy. Besides, the celebrated *Mercury Fountain* contained all the symbolic connotations, aesthetic and political, necessary to minimize Calder's gesture of solidarity and his personal immersion in that steely era.

Linearity

In his autobiography, Calder says the first artistic commission he ever had was in 1924, when the *National Police Gazette* had him make line drawings to represent boxers as they trained. The drawings, each composed of a single continuous line, were a success, and Calder got

[3] Carmen Giménez, Introduction, *Picasso and the Age of Iron*, exh. cat. (New York: Solomon R. Guggenheim Museum, 1993), p. 15.

more commissions of that kind, on a variety of subjects, including the circus, sporting events, and animals. The greatest significance of these line drawings was that they led directly to his first wire sculptures in 1926. While this spontaneous shift by Calder from line drawing to wire sculpture can be explained using many biographical examples, I don't think this "facility" or natural predisposition can be separated from contemporaneous developments in the artistic avant-garde. And I'm not referring only to the specific connection with the idea of "drawing in space" that kept the creative minds of Picasso and González so busy during the second half of the Twenties, but also to that passion for linear purity that came about toward the end of World War I with the return to classical order by some of the most conspicuous representatives of the artistic avant-garde, first and foremost Picasso. It also seems to me that this sudden return to the cult of the line can be disconnected from other, earlier avant-garde precedents, like the one known through the formula "romanticism of the line," whose aesthetic meaning is worth a digression.

The return to classicism embarked on by Picasso around 1917 coincided with a trip through Italy, when he made a series of line portraits in such a pure style and in such a synthetic conception that they deserve to be called "in the style of Ingres." Although at that particular time the connection between Picasso and Ingres was perhaps at its most explicit, his artistic fascination with Ingres is evident throughout the period (as well as in the numerous homages that Picasso made to him in his later years, such as the well-known series based on Ingres's *Turkish Bath*). The first signs of Ingres's influence on Picasso can be seen during the preliminary phases in the development of Cubism, notably in the idea of integrating the three dimensions in a single flattened image, defined by simple lines. In this sense, even if, to my way of thinking, it has not been sufficiently emphasized, the influence of Ingres on Cubism is undeniable, and not incompatible with those other frequently mentioned sources of

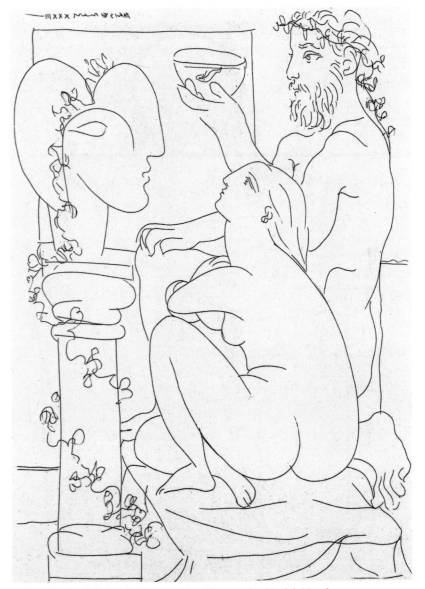

Picasso, *Vollard Suite: Sculptor with a Bust and a Model*, March 21, 1933. Private collection

Cubism, the late works of Cézanne and African sculpture. In addition, during that same period, the avant-garde interest in the line and its synthetic meaning, clearly derived from Ingres, also affected other artists, including Matisse, Modigliani, Brancusi, and Mondrian.

Ingres was unjustly discredited in avant-garde circles, even during the nineteenth century. However, during the latter part of his long life

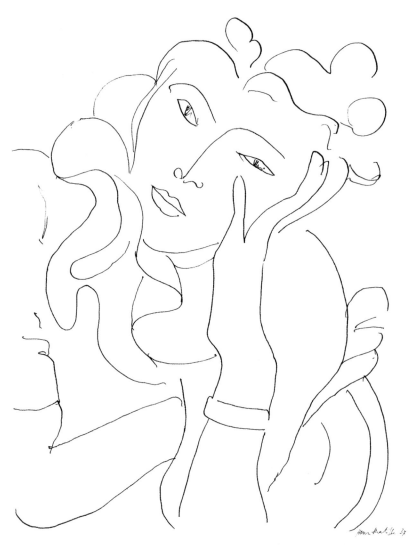

Henri Matisse, *The Flower*, 1937. Pushkin Museum of Fine Arts, Moscow

(1780–1867), prejudice against Ingres was always more a matter for critics and art historians rather than artists, who were less perturbed by the fact that official taste systematically ranked him higher than Delacroix. Degas professed an impassioned admiration for Ingres, which was later continued by Toulouse-Lautrec, and to some degree by Gauguin, whose example enables us to understand better the reason behind the cult of Ingres by Picasso and some of his contemporaries.

This same line—the appropriate term—could widen even further the horizon of our historic wandering in search of the web or net that caught (on the one hand) and made more elastic (on the other) Calder's flying sculpture. It would bring us as far back as 1799, to the emergence of the first avant-garde current in what is thought of as the modern era: an embrace of certain elements of archaic art, a tendency that in France is called "Etruscanism." This was the first leap backward over history toward the prehistory of originality, and represented the first, most primitive steps in an attack on the very foundations of classicism. That was the year of a public milestone: the official presentation of the monumental painting *The Sabine Women*, by Jacques-Louis David, an obvious political symbol celebrating the contemporaneous reconciliation of the French after the fratricidal upheaval of the Revolution, and an aesthetic manifesto in favor of Etruscanism, holding up as a model the synthetic, linear, simplicity of Greek and Etruscan vase painting, with its the heroic purity of line and its capacity, also "modern," to synthesize the most profound, elevated, and complex thoughts. Beginning with this Etruscan thesis, which also made use of Winckelmann's ideas and, above all, John Flaxman's neoclassical engravings, a polemical schism occurred among the disciples of the already crowded international workshop of David, one of whose factions, the most radical, opened the way to so-called ultra-classicism—or Romanticism of the line—in which Ingres was trained.

While going that far back in time may seem excessive, I'm convinced that it is absolutely necessary to make clear the source of so-called "drawing in space," which marked the beginnings of Calder's artistic career. This "Romanticism of the line," whose most complete incarnation we see in the work of Ingres, consisted of, on the one hand, the synthetic reduction of art to pure form by means of drawing, while, on the other, it supposed its complete intellectualization, or, one might say, its abstract conception. Starting from these presuppositions, Ingres succeeded in delineating the

female nude by making it revolve on its own axis in such a way that, with a convincing naturalist sense, the viewer successively sees three-quarters of the model's face in profile, all of her back, her breasts, hips, and intertwined legs, as he does in his *Grand Odalisque*. In his nude depictions of Venus, of bathers, or in any of his portraits, he bestows contour on the line with a rhythm of infinite, curvilinear development that begins with the model's hair and terminates in the soles of her feet, only to begin its progress again from there. This cannot be judged only as a prodigious display of the ability of this most admittedly virtuoso artist but also as an expression of the absolute potential inherent in the faculty of drawing as line. We therefore understand the prestige accorded to the "academic" Ingres among the early avant-garde artists of the twentieth century, themselves bent on breaking with the traditional conventions of naturalistic illusionism, classical perspective, and "literary" subjects—in sum, bent on breaking with the artistic presuppositions of classicism.

But Calder's early line drawings also had their source in mechanical drawing—which also utilizes a line of pure contour—and were nourished by at least two other currents: one being Chinese shadow or silhouette theaters, magic lanterns, and pantographs (tracing devices used to trace the outline of a figure by delineating its projected shadows), and the other being cartoons (caricaturists having been the only artists who did not see their future compromised by photography), and the antecedents of late-nineteenth-century comic strips. One could say that a new, complex world arose from the stroke of a pen, derived from pure, endless lines.

The reduction of reality to a linear structure that not only occupies space but literally "moves" through it, animates it, can explain the fundamental role played by drawing in the contemporary world, but, together with its conceptual contribution, we would also have to count its

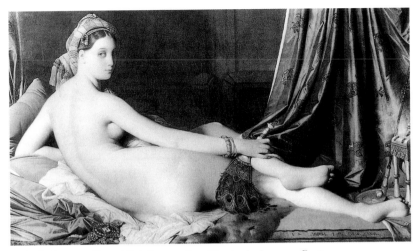

J.-A.-D. Ingres, *Grand Odalisque*, 1814. Musée du Louvre, Paris

"lightness," its "mobile weightlessness," which allows us to conceive of the "flotation" of bodies in space. The physical realization of this spatial mobility of bodies reveals itself through its constant mutation, change of place, its extreme sensitivity in responding to any force in the environment and coming alive with it, moving constantly, though without losing its fundamental identity. All these suggestions are behind Calder's mobiles, along with a modern sense of irony. Manlio Brusatin's observation relating the aesthetic basis of mechanical drawing to the way Dadaist and Surrealist artists imagined things might also apply to Calder:

The twentieth-century engineer's graph paper, replete with details and densely covered by descriptive notes about something that isn't reproduced but is yet to be made, wins the prize of modernity. In our opinion, it retains many aestheticizing aspects: the mechanization of a new, creative imagination that only the "insolent" Surrealism of Francis Picabia or Max Ernst knew how to restore by using fantastic and not unconscious resources.[4]

We live in a world that is constantly shifting, in which we seek a balance—a stability—in an attempt to counteract physical and moral disequilibrium, what Brusatin aptly calls a "modern struggle between

4 Manlio Brusatin, *Histoire de la ligne* (Paris: Flammarion, 2002), pp. 145–46.

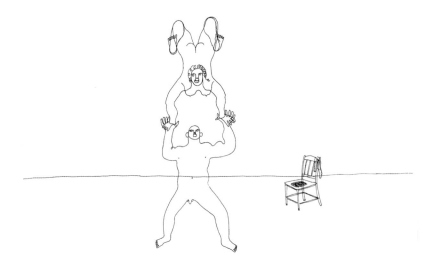

Calder. *The Handstand*, 1931. Courtesy Calder Foundation

Frankenstein and the Golem in which one of these is monstrous because of an excess of technology, and the other because of an excess of deformed humanity."[5]

These darker currents in the development of contemporary art cannot be ignored. even in a case like Calder's. whose vitality and pragmatic sense seemed to distance him from the abstruse whims of intellectualism. Although we must recognize the jovial naturalness. the humor. the carefree spontaneity. and even the childlike spirit of Calder. the error in this regard is to confuse that genial temperament and "naive" attitude with what he accomplished as an artist. works completely immersed in all the complex problems of revolutionary culture and art in this period. What we see as ostensibly childlike in these works, and thus closer to nature, is inseparable from the ideology of Rousseau and of much eighteenth-century thought.

James Johnson Sweeney once described Calder as the product of the "marriage of an internationally educated sensibility with a native American

ingenuity."[6] To this. Dore Ashton replied—and I agree completely—"I. for my part. think that Calder's American identity is less attributable to his power of invention than to his life as a nomad and to his empirical points of view. . . . Calder's spirited character and great vitality—he was a *bon rivant*. both in words and deeds—constituted essential features of his personality. What is odd is that he could translate those traits into works of art. But precisely because of that he was highly appreciated by those representatives of the Parisian art world who were capable of understanding him."[7] Although by 1929 Calder's works were already sufficiently appreciated in avant-garde circles in Paris to merit a one-man exhibition in Paris. it is clear that he did not make the qualitative "leap" in the mature conception of his work until the following decade. and only after his visit to the studio of Piet Mondrian. whose work is the antithesis of childlike ingenuousness.

Ludopathia

While I understand that my use (though ironic) of the term— "ludopathia"—may contradict my intention that Calder's work be taken seriously. I will not allow myself to be carried away by his joking personality. "Ludopathia"—meaning. "play" or. more specifically. "gambling-sickness"—is a neologism used by contemporary psychologists and psychiatrists bent on turning any human weakness into a symptom. According to them, this symptom has been caused by our consumer society. in which play becomes gambling and. therefore, a matter of money. What these psychologists try to study and correct is the mania for gambling away everything—whatever people have. and sometimes what they don't have—in what are euphemistically called "games of chance."

[5] Ibid.. p. 146.

[6] James Johnson Sweeney. *Alexander Calder* (New York: Museum of Modern Art. 1951). p. 7.

[7] Dore Ashton. "Calder." in *Calder* (Barcelona: Fundació Joan Miró. 1997). p. 149.

even though what matters in these games is not the complexity or diversion involved in games as such, but what is bet in them and what people win or lose in financial terms. In this way, even though ludopaths usually end up poorer than church mice, what they are attempting isn't to gamble but to become rich in the twinkling of an eye due to a quirk of fortune, luck now transformed into mere money.

The problem of ludopathia is tangential to the subject of Calder as well as to the ideas of play and chance, despite the connection between the current industry of games of chance and today's volatile world economy, based on international financial speculation and the ever-more abstract nature of global wealth. Nor is it possible to consider gambling in general or games of chance as an invention of our age, whose only innovation in this area is to have turned gambling into an industry. So, although play and gambling may be as old as mankind—and their historical development supplies us with a fascinating anthropological observation point, as we clearly see in Huizinga's marvelous essay *Homo Ludens*—[8] the notion of play has had a significant role in the development of modern art and aesthetics.

How can we forget, for example, what Schiller wrote in his *Letters on the Aesthetic Education of Man* (1794–95) about the "game instinct" whose primordial objective is "living form," the incarnation of beauty? For Schiller, this beauty could not be the product of the application of

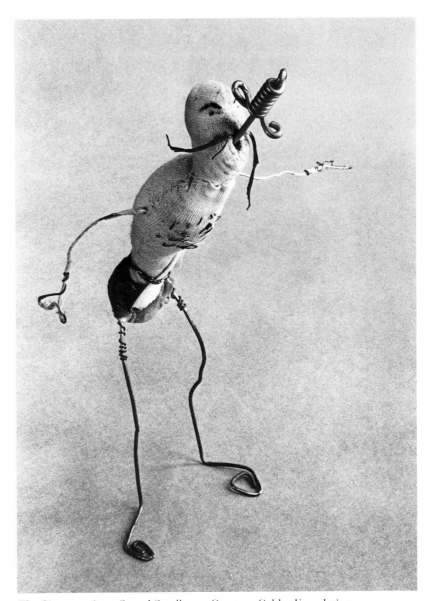

The Circus 1926–31: *Sword Swallower*. Courtesy Calder Foundation, on extended loan to the Whitney Museum of American Art, New York

a preestablished canon as it was in the Western classical tradition. Instead, he reaffirmed the ideal of "giving freedom by means of freedom."[9] In the ludic state, man achieves complete autonomy, even if only in play; that is, by not submitting himself to impulses other than those he himself, of necessity, willingly imposes on himself, he gains

[8] Johan Huizinga, *Homo Ludens: A Study of the Play-Element in Culture* (1944), trans. Huizinga (Boston: Beacon Press, 1966).

[9] J. C. Friedrich von Schiller, *On the Aesthetic Education of Man, in a Series of Letters*. Letter 15: "We know that man is neither exclusively matter nor exclusively spirit. . . . Beauty is the common objective of both impulses, that is of the play instinct. This name is fully justified by language, which usually designates with the word 'play' what is neither objectively nor subjectively accidental, and yet does not impose necessity either externally or internally. . . . Therefore, man shall *only play* with beauty, and he shall play *only with beauty*. Because—to say it once and for all—man only plays when in the fullest sense of the word he is a man, and he *is only fully a man when he plays*."

access to freedom, the foundation that took the place of beauty in the development of the art of the modern era, an art that is "playful," based on the pleasure of experimentation, on difference, on the unusual, on the surprising.

Play, irony, and humor, even though they are not inventions of the contemporary era, are perhaps the most determining modern traits of its literature and its art because all three are substantially related to freedom and to the corresponding erosion of all established, fixed norms. They are devices for setting in motion things that stagnate and don't change, that have remained too fixed, regulated, immobilized, that resist the flow of time through their inertia, which is the true poison of the modern—a term that means "made in today's style," contemporary, susceptible to modification, change, fashion. Temporal modern art is, therefore very dynamic and uses as its most powerful agents these vertiginous points of flight, which are play, irony, and humor, its "mobiles."

Calder's art between 1926 and 1930 (and even before that, in his work as an illustrator) was marked by just this kind of play. He began by making illustrations for newspapers and magazines, line drawings of scenes from boxing and other sports as well as games, but he quickly gave himself over to his favorite hobby, the circus, which he reproduced with subtle wire figures that did not remain static, but were frequently (thanks to ingenious mechanical devices) dynamic, mobile. This is what occupied his mind during his early years in Paris, and it is how he first made a name for himself in the most culturally sophisticated circles, including, of course, the Parisian avant-garde. That was perhaps inevitable, since all kinds of games, especially sports and circus games, had fascinated the artistic avant-garde of the first quarter of the twentieth century, continuing a tradition that ran through the entire nineteenth century, beginning with the Romantics, Géricault and Delacroix, and including realists such

as Daumier, Impressionists such as Degas, and Post-Impressionists such as Toulouse-Lautrec, whose work contains a huge number of examples of this theme.

But within Calder's circus there lived other games, like those made popular by the passion for automata that grew in a spectacular way beginning in the eighteenth century, and, especially, during the pre-Romantic and Romantic eras. Thus, in Calder there came together a "double play" or double animation: that of a fascination with the theme—or themes—of play, and that of the engineering practice of mechanization, which turned toys into mobile automata, fantastic creatures that, through human ingenuity, could seem as if imbued with a life of their own, like Frankenstein's monster.

Within this tension between the organic and the mechanical lies the grotesque, which has taken on particular importance in the contemporary world because of the sublime, whose effect is, according to Kant to "move" us, unlike the more static effect of "charming" us, which is characteristic of beauty. The boundlessness of the sublime, animated by fantasy, tends toward fantasy, toward the "grotesque" and the "extravagant," while inanimate beauty can degenerate into mere "frivolity."[10] Through the sublime, canonical restraints on contemporary art were relaxed in favor of an infinite beyond beauty, generating a new dialectic between the organic and the mechanical in a grotesque key. Organic forms proliferated after the Industrial Revolution and the urbanization that accompanied it, creating nostalgia for the growing loss of the savage character of nature. This nostalgia was manifested, in part, in simultaneous feelings of fear and attraction to dangerous wild animals, in the same way that people came to fear and be enticed by their own instincts, whose spontaneous expression became more and more dan-

[10] Immanuel Kant, *Observations on the Feeling of the Beautiful and the Sublime*, trans. John T. Goldthwait (Berkeley: University of California Press, 1960), pp. 46–49.

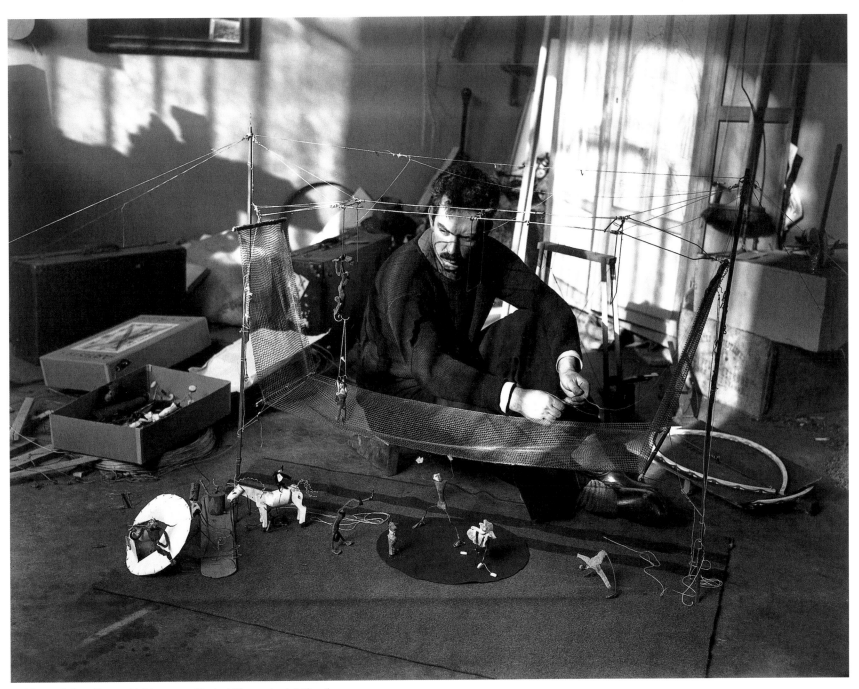

Calder with his *Cirque Calder*, 1927, Paris / Photo: André Kertész

gerous. In this sense, the popularity of the circus, with its acrobatic displays, its fearsome beasts, and its grotesque clowns, was a consequence of this ambivalent feeling about lost nature. That explains the enormous success achieved by animal trainer Henri Martin, when he presented his show of trained animals in Paris, in 1829, five years after Géricault died as a result of several riding accidents. Balzac, who attended the show and was deeply impressed, mentioned it at the beginning of his short story "A Passion in the Desert" (1830), about the fatal love between a French soldier, lost in the desert during Napoleon's Egyptian campaigns, and a panther.

Modern Paris was transformed by Baron Haussman as prefect of the Seine from 1850 to 1873, not only by constructing the Grands Boulevards—which facilitated the movement of artillery, in a city where barricades were put up during the uprisings of 1830, 1848 and 1871—but through the obligatory numbering of houses by the police. That is perhaps why Parisians had a special fascination for many kinds of shows that in some way defied their increasing domestication, including cabarets and the circus, exemplified by the mythical figure of the clown, which has a long tradition as a subject in art. Recall, for example, Jacques Callot's early-seventeenth-century engravings of characters from the commedia dell'arte, that irreverent troupe of Italian actors whose triumphant popularity made successive French governments try to stop its expansion by prohibiting the actors from speaking on stage— a move that paradoxically guaranteed their later fortune and also resulted in the art of pantomime. Their grotesque characters found their way into the theatrical and often voluptuous painting of the eighteenth century, which turned them into one of its constant themes, but which, above all, through Watteau's genius with his chilling *Gilles* (ca. 1719), made them into profound figures by pointing out the melancholy tone of those who made others laugh.

The subject of the commedia dell'arte is treated at length by Allardyce Nicoll in his book *The World of Harlequin: A Critical Study of the Commedia dell'Arte*. In a final note, Nicoll points out how the "Comédie Italienne" was suppressed in 1780, seeming to fall into definitive oblivion until Maurice Sand revived it in 1860 in a classic work, *Masques et Bouffons*. Nicoll points out that one of the two crucial stages in the revival of that world was the period between 1920 and 1930, when, significantly, Jacques Copeau transformed those traditional pantomimes into a method of theatrical teaching based on improvisation and gymnastics, a fashion that took root in both pre- and post-revolutionary Russia.

The disquiet usually aroused by this unconventional form of theater was due perhaps most of all to the fact that it was based on a very ancient form of folk-expression, which Mikhail Bakhtin accurately identifies as "grotesque realism."[11] Its essential principle is *degradation*, "that is, the lowering of all that is high, spiritual, ideal, abstract. . . . a transfer to the material level, to the sphere of earth and body in their indissoluble unity." In grotesque realism, the degradation of the sublime is not metaphorical or relative: "high" and "low" possess there an absolute and strictly *topographical* meaning. "High" is heaven; "low" is earth; the earth is the principle of absorption (the grave and the womb) and, at the same time, the principle of *corporeal* birth and renascence (the maternal breast). This is the meaning of "high" and "low" in their cosmic aspect; while, in their bodily aspect, the high is represented by the face or the head, and the low by the genital organs, the belly, and the buttocks. Grotesque realism and medieval parody are based on these absolute topographical connotations.[12]

[11] Mikhail Bakhtin, *François Rabelais and the Folk Culture of the Middle Ages and Renaissance*, excerpted in *The Bakhtin Reader*, ed. Pam Morris (London and New York: Eduard Arnold, 1994), pp. 194–244, esp. p. 205.
[12] Ibid., pp. 205–06.

In the scatological laughter of the clowns, we find echoes of that rebellion of repressed organic life, just as we find other forms of liberating parody that challenge the forced domestication of the people. The world of the clowns is a subterranean realm that runs parallel to the world of established order, a self-contained world that reveals the other face of reality, the repressed, hidden face. In this can be found the common thread between the success of Calder's circus and the huge success enjoyed then by the most outstanding figures of comic cinema, especially Charlie Chaplin. Chaplin was extremely popular among the avant-garde of the period between the wars, with a figure and gait much like a wire figure and his use of mimicry to deflate any and all authority.

With regard to the theme of liberating laughter, two fundamental essays on the subject were published at the beginning of the twentieth century: in 1900, *Laughter* by Henri Bergson, a work that had a huge influence, and, in 1905, Sigmund Freud's *Jokes and Their Relation to the Unconscious*. Laughter and the comic had aroused considerable interest since the start of the contemporary era, especially in the area of art, as exemplified in the modern importance given to this subject by one of its principle theoreticians, poet and critic Charles Baudelaire, in an early, illuminating essay, "On the Essence of Laughter and the Comic in General in the Plastic Arts."

Although during the nineteenth century, many books were written on this subject from various points of view, including the psychological, with special attention paid to the notion of caricature, the ideas of Bergson and Freud changed the way the subject was approached. They were especially influential during the first third of the twentieth century, the era of the first avant-garde movements and of Calder's arrival in Paris shortly after the publication of the first Surrealist Manifesto (1924), when the Surreal-

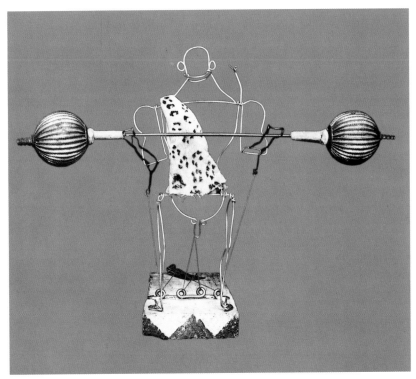

The Circus 1926–31: *Rigoulot: the Weight Lifter*. Courtesy Calder Foundation, on extended loan to the Whitney Museum of American Art, New York

ists banded together as a coherent group. Their championing of childhood, dreams, and madness as states and vehicles for an artistic inspiration based on the unconscious, as André Breton proclaimed in that first manifesto, was heading quite clearly in that direction; and in an earlier phase, when Dadaism burst onto the Parisian scene, Breton had led the movement for the vindication of figures like Alfred Jarry and Jacques Vaché, who epitomized the promotion of the comic and the grotesque.[13] All of which makes us understand very well both the context in which Calder modeled his festive circus jokes as well as the enthusiastic reception he had in Parisian avant-garde circles during the Twenties. Besides, to jump-start modernity by using irreverent humor and the expressive potential of machines is precisely what Vaché proposed to Breton in a letter dated August 18, 1917: "So, Modernity too, constantly and killed every night — We turn our backs on MALLARMÉ, without hatred — but he's dead

13 André Breton, *Les Pas perdus* (Paris: Editions de la Nouvelle revue française, 1924).

— But we no longer know either Apollinaire or Cocteau — Because — We suspect that they make art too consciously, that all they do is trick out romantic stuff with telephone wire while knowing nothing of dynamos. THE stars unhooked from the sky again! — how tedious — and besides don't they sometimes talk seriously? A man who believes is curious. . . . Humor should not be a result — But what should we do? — I'll allow a touch of HUMOR to Gide's LAFCADIO — because he doesn't read and doesn't produce except through amusing experiments — like murder — and murder without satanic lyricism — my dear old rotten Baudelaire!!! What we need is a bit of our dry art; machinery — rotary presses with smelly oils — buzz — buzz. . . hiss! — Reverdy — an amusing po-het, and boring in prose. Max Jacob, my dear practical joker — PUPPETS — PUPPETS — PUPPETS — would you like some cute puppets made of brightly painted wood? — Two eyes — dead flame and the crystal disk of a monocle — with an octopus typewriter — I like that better."[14] Prose of similar hilarious incoherence came to dominate among the Dadaists, although for Vaché the impulse was less a conscious one. And in the same unpremeditated way, Calder explored the comic and expressive possibilities of certain ideas and materials, when he first came to Paris. Even so, Calder wasn't a writer but an artist, one who, with his wire circus figures, was already involved in creating a new kind of sculpture, that of metallic "drawing in space."

This leads us to another matter related to the subject of play, that of toys, which in that era had also begun to attract the attention of avant-garde intellectuals—above all, Walter Benjamin, who, during the late 1920s, published several articles on the subject. In "Old Toys," a brief text on the exhibition of toys in the Märkisches Museum (1928), he informs us about current toys, precursors and the artisans who made toys from iron, wood, and paper, and how they were marketed by peddlers; he emphasizes the importance of mechanical marionette theaters.

peep shows, dioramas, myrioramas and panoramas; he also defends the liberating nature of play and toys: "To be sure, play is always liberating. Surrounded by a world of giants, children use play to create a world appropriate to their size. But the adult, who finds himself threatened by the real world and can find no escape, removes its sting by playing with its image in reduced form. The desire to make light of an unbearable life has been a major factor in the growing interest in children's games and children's books since the end of the war."[15] In a piece reviewing a book on the history of toys, Benjamin also comments on something certainly related to the world elaborated by Calder: "As long as the realm of toys was dominated by a dour naturalism, there were no prospects of drawing attention to the true face of the child at play. Today we may perhaps hope that it will be possible to overcome the basic error—namely, the assumption that the imaginative content of a child's toys is what determines his playing; whereas in reality the opposite is true. A child wants to pull something, and so he becomes a horse; he wants to play with sand, and so he turns into a baker; he wants to hide, and so he turns into a robber or a policeman. . . . Imitation (we may conclude) is at home in the playing, not in the play thing."[16] On this same issue, Benjamin insists in "Toys and Play: Marginal Notes on a Monumental Work" (1928), another review of this same book: "'Simplicity' became the fashionable slogan of the industry. In reality, however, in the case of toys, simplicity is to be found not in their shapes but in the transparent nature of the manufacturing process. . . . For a characteristic feature of all folk art—the way in which primitive technology combined with

[14] Jacques Vaché, *Lettres de Guerre* (1919), ed. Georges Sebbag (Paris: Editions Jean-Michel Place, 1989), n.p.

[15] Walter Benjamin, "Old Toys," trans. Rodney Livingstone, in Walter Benjamin, *Selected Writings*, vol. 2, 1927–34 (Cambridge, Mass.: Harvard University Press, 1999), pp. 99–100.

[16] "The Cultural History of Toys," book review by Benjamin, trans. Rodney Livingstone, in ibid., pp. 115–16.

cruder materials imitates sophisticated technology comined with expensive materials—can be seen with particular clarity in the world of toys."[17]

The commedia dell'arte, the circus, folk art, toys, play—these were among the ideas in the air when Calder began making his way in the intellectual center of the Parisian avant-garde, ideas being explored by many of the best artists and writers. Though enthusiastic about the Le Douanier Rousseau, Cheval the Mailman, or any of the other creative fanatics who populated the artistic world of that moment, Calder the American engineer, son and grandson of artists, did not need to saturate himself with information to know very well what he was doing or, in more than one sense, what he was playing with, in the same way that his compatriot Arthur Cravan, the poet-boxer, knew what he was doing or those already mentioned—Vaché, Jarry, Jacob, Satie, etc.— knew what they were doing. Responding to the era's lesson of risking— gambling—one's life that young people learned during World War I, Dada proposed risking—gambling—with art, with culture, with all order, all institutionalized forms. The old historic order was flying through the air, so it was up to art to become unstable as well: mobile. Exceptional in this regard was the innovating power of avant-garde ballet during the first third of the twentieth century, such as Serge Diaghilev's revolutionary modern ballets (1909–29), which Fernand Léger's film *Les Ballets Mécaniques* (1924) paid tribute to. Even the early circus Calder, with his subtle little figures endowed with animation, while gently parodying the genuine popular art of children's games, was evolving on the high wire of avant-garde experimentation. As Dore Ashton has so cogently observed: "Calder's innovations, especially with regard to the free play of forms moving in space, were the

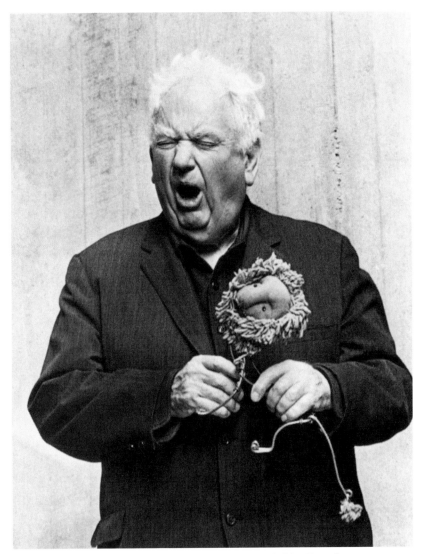

Calder. Roaring with his *Circus* lion, 1971. Courtesy Calder Foundation

best illustrations of his theory, which began with children's toys and ended in works of art."[18]

Therefore, let us recognize in Calder's first, ludic step in the late 1920s— his animated *Circus*—not just a phase but the authentic ludopathia of a person who from start to finish chose, aesthetically and morally, to play, to play for keeps at playing the game, because art at the time was a game or it was nothing. That's how Calder understood it, and that's how the best minds in that Paris which was a "movable feast" understood it as well.

[17] "Toys and Play," trans. Rodney Livingstone, in ibid., p. 119.

[18] Ashton, "Calder," p. 151.

Abstraction

In October 1930, a year after his first solo show in Paris, for which Jules Pascin wrote an introduction, Calder made his first visit to the studio of Piet Mondrian. This visit genuinely disturbed him, as we see in an early, oft-cited, personal statement: "It was a very exciting room. Light came in from the left and from the right, and on the solid wall between the windows there were experimental stunts with colored rectangles of cardboard tacked on. Even the victrola, which had been some muddy color, was painted red.

I suggested to Mondrian that perhaps it would be fun to make these rectangles oscillate. And he, with a very serious countenance, said:

"No, it is not necessary, my painting is already very fast."

This visit gave me a shock."[19]

But what was Calder, a "laughing" character, doing in the studio of Mondrian, who was famously serious and with a sense of orthodoxy bordering on fanaticism? After all, Calder's first show had given him a reputation as a playful, jovial iconoclast, an artist about whom people might wonder "Where will he end up, in or outside of art?" Moreover, as he himself confessed, he was still doubting if his vocation was that of a painter who amused himself making fantastic little figures—which were widely appreciated both by cognoscenti and by less sophisticated people—and who knows what else. Besides, when he met Mondrian, Calder was already thirty-two years old, a relatively late age for someone to be finding his own artistic path, but also, for that very reason, an age when any decision he might take would be more personal and mature. Although Calder's change of artistic direction was in no way capricious or accidental, there is something surprising about this sudden fascination by a more "naive," spontaneous, exuberant artist for an already established, rather austere master who was fifty-eight years old when the two met, and thus nearly twice Calder's age. Besides, Calder had to have

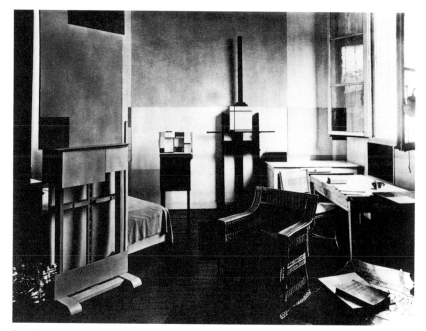

Piet Mondrian's studio, 1926. Private collection

been aware that Mondrian was not only one of the pioneers of abstract art in its most radical and purest version, but that, despite his affable manner and his amusing interest in ballroom dancing and American jazz, he was a dogmatic convert to the rigid principles of Neoplasticism who condemned any deviation from strictly horizontal/vertical right angles and flat colors.

However, our surprise at Calder's attraction to the ideas of Mondrian stems less from the apparent contrast between the former's charming circus figures and the latter's severe abstractions than from a more important contrast: between Mondrian's rectilinear geometry and the kind of forms Calder had been experimenting with since his arrival in Paris, which tended toward the organic abstraction of Miró and Jean Arp. His encounter with Mondrian and its effect on him are the first evidence of a duality within Calder's attitude toward abstraction, shaped as much by

[19] Alexander Calder, *Calder, an Autobiography with Pictures*, Jean Davidson ed. (New York: Pantheon Books, 1966), p. 113.

his experience as a mechanical engineer as by critical developments among the Parisian avant-garde during the transition from the Twenties to the Thirties, a period marked by a general hardening of positions (political and aesthetic) and a growing radicalism. Clearly, one of Mondrian's principal dogmas, the reduction of artistic representation to the line, was of interest to Calder, though not to the exclusion of curved lines, as Mondrian advocated.

In 1911, Mondrian, already living in Paris, experienced the impact of Cubism and began a rapid personal evolution that did not stop, not even when, in 1914, he had to return to his own country because his father was gravely ill and was forced to remain there because of the outbreak of World War I. In Holland in 1916, he became friends with and formed a close artistic association with Theo van Doesburg and Bart van der Leck, and in 1917 they founded the Neo-Plastic group De Stijl, and a periodical with the same name. Mondrian had begun writing about his ideas on art and aesthetics in 1914, and he became a theoretician and spokesman for Neo-Plasticism, whose origins in Cubism he explained in the following way: "Cubism also realized that perspective representation clouds and weakens the appearance of things, whereas projective representation represents them more purely. Precisely because it wanted to represent things as completely as possible, Cubism arrived at projective representation. By using various projections simultaneously juxtaposed or superimposed, the Cubists tried to achieve not only a purer representation but also a purer plastic expression—or volume expression as the Cubists called it."[20]

The following is one of the first theoretical declarations made by the De Stijl group: "The really modern, i.e., conscious artist has a twofold mission. In the first place, he must create the purely visual work of art; in the second place he should make the general public susceptible to the beauty of such purely visual art."[21] The new plastic language was to be characterized by its irreducible will to universality: "As man has matured to oppose the domination by the individual and its caprice, the artist has ripened to oppose the individual in artistic expression: natural form and color, emotion, etc."[22] This initial opposition, universal/individual, generates a series of oppositions (interior/exterior, matter/mind) that lead to a unity based on an awareness of man's duality—the source of all tragedy—and its corresponding play of equivalencies. A dynamic consciousness tries to resolve this opposition of extremes by means of a search for equilibrium, which is the mission of new art. According to Mondrian, the expressive power of the elements in a composition is directly related to its ability to establish relationships, among which there is one that predominates: the perpendicular. This is because the right angle contains the two cardinal elements of tension, the maximum point of balance between the vertical and the horizontal, which Mondrian also defines symbolically as masculine and feminine. He alludes to the possibility of using the curve, but declares that "the straight line is an intensification of the curve, which is more 'natural,'"[23] and thus less purely universal. Mondrian's disagreements with other members of De Stijl over widening the field of visual elements to include diagonal lines (Van Doesburg) and curves (Georges Vantongerloo) led him to break with the group in 1925.

Rather than making a composition dynamic through actual movement, as Calder had suggested to him at their first meeting, Mondrian proposed the idea of rhythm, which he explained would be achieved when "rectangular planes (formed by the naturalness of straight lines in rec-

[20] Piet Mondrian, "Natural Reality and Abstract Reality" (1919–20) in *The New Art—The New Life: The Collected Writings of Piet Mondrian*, ed. and trans. Harry Holtzman and Martin S. James (Boston: G. K. Hall, 1986), p. 98.

[21] Van Doesburg, introduction to *De Stijl*, no. 1 (1917), quoted in Hans L. C. Jaffé, *De Stijl, 1917–1931* (Cambridge, Mass.: Harvard University Press, 1986), p. 11.

[22] Van Doesburg, introduction to *De Stijl*, no. 2 (1918), in ibid., p. 93.

[23] Piet Mondrian, "Natural Reality," p. 91.

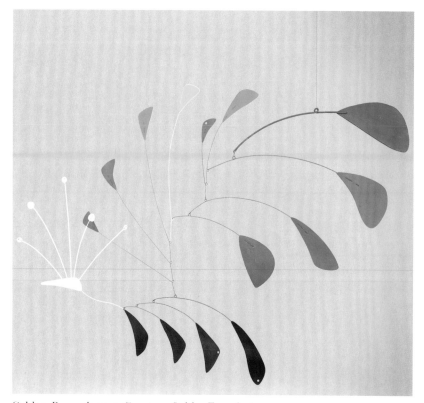

Calder. *Peacock*, 1941. Courtesy Calder Foundation

was widespread fascination among the avant-garde for the revolutionary idea of Cubism and the scientific-technological developments that seemed to completely change the traditional role of the artist. During that period, there occurred a series of radical aesthetic upheavals, whose protagonists included not only Mondrian, with his exalted abstract mysticism, and post-Expressionist Kandinsky, with his revelations about the "spirituality" of abstract art, but the Futurists and—after the war—the Constructivists. These two groups opted for a new, autonomous artistic idiom that harmonized perfectly with the emancipating world of machines, which were to produce the miracle of a rapid transformation of reality. They were fanatical believers in the new religion of progress, which is expressed in the slogan used by Tarabukin for the title of his manifesto "From the Easel to the Machine."[25] In one way or another, the generation of avant-gardists of the second decade of the twentieth century all came out in favor of a new art completely emancipated from fidelity to reality, the art that came to be known generally as "abstraction." However, for the younger generation who lived through the butchery of mechanized warfare, and felt inundated by official rhetoric that was reactionary and hypocritical, such naïve faith in artistic formalism was no longer possible, in the same way that faith in the emancipating power of simple technological-industrial development was no longer tenable. Their rebellion took contrary forms, including an embrace of anarchy by the Dadaists and to a lesser degree, the Surrealists, and a neoclassical "return to order" by Picasso and other members of the old avant-garde, thus interrupting that obligatory path which identified what was modern with non-figurative, self-referential art. By 1920, these developments brought about a profound crisis in the avant-garde, which

tangular opposition and which are necessary for determining color) are dissolved because of their uniform quality, and only rhythm emerges, leaving the planes as nothing."[24] Mondrian's art developed in a direction in which this rhythm became more evident, as in his two paintings *Broadway Boogie-Woogie* and *Victory Boogie Woogie*, from 1942–43, just before his death.

Unlike Mondrian, Calder came of age after World War I, a cataclysmic event that represented a decisive break with the past. Indeed, many historians of the twentieth century do not accept the simple chronological fact of 1901 as the start of the century and instead move its beginning to the onset of the Great War, which ended the old nineteenth-century world. Although this is not a universally accepted conclusion, the war clearly demarcated a "before" and an "after" in avant-garde art. Initially, there

[24] Piet Mondrian, "Plastic Art and Pure Plastic Art," in *The New Art—The New Life.*
[25] Nikolai Tarabukin, "From the Easel to the Machine" (1923), in Francis Frascina and Charles Harrison, eds., *Modern Art and Modernism: A Critical Anthology* (New York: Harper and Row, 1982), pp. 135–42.

had been identified with the reductive formalist criterion of constructing an autonomous artistic language, and which was now itself regarded by many as a new academy.

While we're not concerned here with reconstructing the complete story of avant-garde development during those first decades of the twentieth century, it seems essential that it be taken into account. It helps explain the dialectic between organic abstraction and geometric abstraction that shaped the aesthetic evolution of the young Calder and that, during the late Twenties and early Thirties, affected so many other non-militant avant-garde artists in the organized groups of that era. This dialectic between the organic and the abstract had been taking place from practically the beginning of the modern era, although it reached its decisive critical point during the period between the wars. In 1908, Wilhelm Worringer published the first German edition of *Abstraction and Empathy*, where he contrasted the tendency to abstraction with the tendency toward empathy (which, in his analysis, leads to the naturalistic depiction of space), as if they were two central categories in the history of art. Citing the pioneers of formalist art history, Adolf von Hildebrand and Alois Riegl, as well as pioneers of psychological aesthetics, such as Theodor Lipps, Worringer identified the taste for the abstract and geometric (which he referred to as "crystalline") as characteristic of primitive peoples in a first stage of artistic development, while naturalism was deemed to be the result of a later, more refined human evolution. This did not mean that Worringer assigned superior value to either of these tendencies, especially when the "primitivism" of the early twentieth-century avant-garde was in full swing, but that he recognized their existence, their polarization over the course of history and, finally, their contemporary relevance.[26]

[26] Wilhelm Worringer, *Abstraction and Empathy* (1908; and ed. 1910), trans. Michael Bullock (New York: International Universities Press, 1963), pp. XIII–XV, 4–24.

Piet Mondrian, *Broadway Boogie-Woogie*, 1942–43. Museum of Modern Art, New York

The problem of abstraction, though apprehended less directly, had already vexed the most lucid minds since the Romantic period as a passion for the absolute. This is how it was presented in Balzac's celebrated novella *The Unknown Masterpiece* (1831), which profoundly touched the imagination of many artists during the nineteenth century and even influenced Picasso, who made a series of etchings based on it. The tragedy of the highly gifted artist Frenhofer, the ill-fated protagonist of Balzac's novella, consisted in allowing himself to be carried away by what was in effect a sick passion for absolute perfection, a passion that made him lose all sense of reality, transforming a female nude into a delirious mass of undecipherable lines, of which—in the story's culminating moment, when

the artist is visited by two colleagues—the only remaining figurative trace is a foot. That is, Frenhofer's masterpiece becomes almost the first abstract painting in history.[27] That this fictional character should obsess Cézanne, one of the Cubists' sources of inspiration, and that his conundrum should take on special meaning during the first decades of the twentieth century, when avant-garde formalism had taken charge has a perfect historical logic.[28] In a certain sense, Mondrian transformed into something positive the failure that Frenhofer had suffered a century earlier.

How does all this relate to Calder? It is all part of the context for Calder's aesthetic evolution during the late Twenties after the turning point represented by his peculiar wire circus, and after making contact with several Spanish artists such as José de Creeft, Gargallo, Picasso and, probably, González, with whom in all likelihood he shared his predilection for the use of metal as an expressive material. It was during this period that Calder observed the development of the strongly polemical first wave of Surrealists, especially Miró. Despite these and other connections, Calder did not adhere to any one formal approach until the early Thirties and, according to his own statements, only did so then because of the profound impression made on him by Mondrian, whom, nevertheless, he never tried to imitate and whose influence never manifested itself in any specific way. The lightning bolt that struck Calder came when the avant-garde in general, including the Surrealists, went through a profound aesthetic and political crisis, involving both the rebellion against the pure abstraction of non-objective art and the relationship between art and political commitment. Thus, the contradictory notions of art as a self-involved, self-enclosed realm and art as directly engaged in social transformation were brought into confrontation. Out of this struggle emerged at least three simultaneous currents: the naturalistic approach of the various realisms, the figurative Surrealism of the Thirties, and the pure abstraction of the movement significantly named Abstraction-Création, the one Calder joined. Although the difficult years of

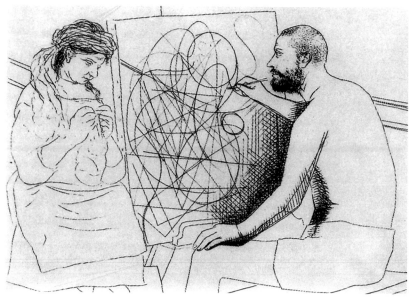

Picasso. *Painter with Model Knitting*. Paris, 1927. Private collection. Illustration for Balzac's novella *The Unknown Masterpiece*

the Thirties invited polarization in all senses, many avant-garde artists survived the dilemma by combining the two artistic languages in a more or less schizophrenic way. That was, for example, what González did, when he created and exhibited in the conflict-filled year 1937 both *Montserrat* and *Woman with a Mirror*. In fact, during that moment of so many doubts, this kind of ambivalence was relatively common—so much so that it should not be considered either opportunistic or eclectic. Just think of Picasso's work during this period, when he was making welded-metal sculpture and at the same time returned to modeling in plaster and clay in his Boisgeloup studio in 1931–33[29] In this sense, the step Calder took toward abstraction at

[27] Francisco Calvo Serraller, "¿Una inocente ilusión?" introduction to Balzac, *La obra maestra desconocida*, Spanish trans. Igalil Rudin and Ana Iribas (Madrid: Visor, 2001), pp. 9–27. See also Calvo Serraller, *La novela del artista: Imágenes de ficción y realidad social en la formación de la identidad artística contemporánea: 1830–1850* (Madrid, 1990).

[28] See Dore Ashton, *A Fable of Modern Art* (Berkeley: University of California Press, 1991).

[29] See F. Calvo Serraller, "La parábola del escultor," in *La senda extraviada del arte: Ensayos sobre lo excéntrico en las vanguardias* (Madrid: Mondadori, 1992), pp. 208–26.

that point implied neither a doctrinaire embrace of organic forms nor the deliberate suppression of any figurative trace in his work, which by then was decidedly oriented toward the world of sculpture.

Mobility

Although by character and attitude Calder was never given to making pompous statements, much less manifestos, he had strong opinions and frequently made them known. We see this in his oft-repeated account of his first encounter with Mondrian in 1930, during which he articulated a vision of what Mondrian's work might be like in motion, an idea that undoutedly stemmed from his experience with animating the wire figures in his own *Circus*. Even so, it is apparent that no matter what his former inclinations were, Calder, beginning in the Thirties, had a radically new intention and orientation.

In 1931, after marrying Louisa James in Concord, Massachusetts, Calder returned to Paris and, that spring, had what is regarded as his first show of abstract work. The exhibition, which also contained portraits and drawings in wire, was titled *Alexander Calder/Volumes—Vectors—Densities/Drawings—Portraits* and included a preface by Fernand Léger, an artist quite different from the one who introduced his previous show, Jules Pascin. Calder himself recalled that experience: "Due to the efforts of some friends in Abstraction-Création, I arranged for a show in the Galerie Percier and Léger wrote the preface. I still had some planks from Villa Brune; we put these on champagne boxes and painted everything white. The objects all ranged around the gallery, one or two were located in the middle, and on the walls overhead were wire portraits. In the window, we had two drawings of the circus."[30] Léger, in his preface, mentioned how this new work by Calder evoked for him the examples of Satie, Mondrian,

Duchamp, Brancusi, and Arp. Perhaps, seen from today's perspective, such a wide-ranging group may seem rather disparate, but in fact it makes sense, considering how involved Calder was in the problems of avant-garde artistic language and in avant-garde cultural life. The most interesting works in the show were constructions consisting of two or three wire elements capped by small wooden spheres of an unmistakably geometric design. The kinetic potentiality of these ductile and extremely fine wire pieces is evident, although they did not cause the same sensation as the works he presented in Paris a year later at the Galerie Vignon, which were motorized and were his first authentic mobiles.

As we know, the term "mobile" was suggested to Calder by Duchamp, who used it (aptly) as an optional name for his *Bicycle Wheel* (1913), and there are suggestions of various connections and influences between other avant-garde sculptures and objects created during the 1910s and 1920s and the dazzling series of works that Calder made during the 1930s. One can see particular connections with several unusual Dada and Surrealist objects, such as Man Ray's installation *Obstruction* (1920), with its suspended wooden clothes hangers, as well as more conventional avant-garde sculpture such as those made between approximately 1915 and 1920 by Constructivists Vladimir Tatlin, Naum Gabo, Antoine Pevsner, Lazlo Moholy-Nagy, and others, some of which conform in style very particularly with Calder—for example, Aleksandr Rodchenko's *Oval Hanging Spatial Construction* (ca. 1920). One can also clearly see the influence of Miró's paintings during the Twenties—composed of increasingly synthetic, simple, biomorphic forms that float against an airy spatial background, leaning on one another or connected to one another by fine lines—and of the sculpture of Jean (Hans) Arp. Nevertheless, Calder's sculptures during the Thirties display a highly powerful originality, even before he created his first prototypes for hanging mobiles. The key element resides in the lightness of these filamented structures dotted with small wooden

[30] Alexander Calder, *Calder, an Autobiography with Pictures* (New York: Pantheon Books, 1966), p. 118.

Aleksandr Rodchenko, *Oval Hanging Spatial Construction*, ca. 1920,
in Rodchenko's family house. Private collection

spheres, whose mass and roundness accentuate the magical effect of weightlessness, the volatility of bodies which, even when motionless, seem like motion sensors, not so much because they contain a mechanical motor but because they gather into themselves invisible spatial energies.

In this sense, the impulse toward the emptying of space, toward the transparency of the void—which Picasso's "drawing in space" brought into play, inaugurating what Apollinaire termed "a sculpture made of

nothing"—found its best interpreter in Calder. Especially curious is the photograph of Calder in his Paris studio on the Rue de la Colonie taken after his 1931 exhibition at the Galerie Percier, which shows him standing at a table in front of an armoire crowned by a formidable jumble of wires, and surrounded by sculptures hung on the wall and in other places, creating an environment that is an animated spectacle of floating lines.

The idea of representing motion was certainly a concern of avant-garde artists, especially the Futurists, who, at the same time they exalted speed and their new mechanical devices, had taken notice of photographer Eadweard Muybridge's experiments with the zoöpraxisscope in breaking down the locomotion of moving figures into its component parts. Even so, it is one thing to represent motion by dynamically deconstructing the outline of a static figure and quite another to make a mobile, something that really moves. Motorized or not, the contemporary world was full of machines with moving parts, challenging the limits of "natural" movement and traction, but it still remained to be seen what possibilities mobility offered in the experimental field of new art.

Through the infinite possibilities for movement embodied by the line and its mechanical translation into wire, a process by which he took advantage of his knowledge of physics and kinetics, Calder always worked using motion as a starting point, a means to an end. He became aware of these possibilities through his discovery of non-objective art via Mondrian, but he may also have appropriated the principles championed by Pevsner and Gabo in their *Realistic Manifesto* (1920), where they criticize Futurism for its simplistic interpretation of speed in terms of noisy machines and the din of the street: "The widely broadcast slogan of speed was the major trump-card in the futurist hand. . . . But ask any futurist how he imagines speed and out comes the whole arsenal of frenzied automobiles, roaring railway stations, tangled wires, clanging, clattering, noise, din, whirling streets—is there no convincing them that none of this

Calder's studio on the Rue de la Colonie, Paris, Autumn 1931 / Photo: Marc Vaux

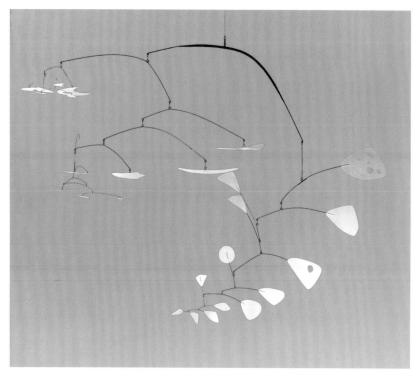

Calder, *International Mobile*, 1949. Museum of Fine Arts, Houston

is necessary for speed and its rhythms? Look at a sun beam: this most silent of silent forces travels at a speed of 300,000 kilometres per second. Our starry sky. Can anyone hear it? And yet what are our railway stations to this cosmic railway station, or our trains to these super-fast cosmic trains!"[31] And later: "Space and Time are the only forms on which life is built and on which therefore art must be built. . . . The realization of our perceptions of the world in the forms of space and time—this is the sole aim of our creative work in the visual arts. And in it we do not measure our works in yards of beauty, we do not weigh them in pounds of tenderness and mood. With a plumb line in the hand, with eyes as precise as a ruler, with a spirit as taut as a compass, we build them in the same way as the world builds its own creations, as the engineer his bridges, as the mathematician his formulae of the orbits. . . . This is why, when we represent objects, we tear from them the labels of their owners, everything

incidental and local, leaving them only their real and constant qualities, revealing the rhythm of forces hidden within them."[32] And finally, with regard to sculpture: "We reject volume as a visual form of space. It is impossible to measure space with volumes, just as it is impossible to measure liquid in yards. Look at our real space: what is it if not one continous depth? . . . We reject in sculpture mass as a sculptural element. Every engineer has known for a long time that the static force of bodies, their material strength, does not depend on the amount of their mass. . . . In this way we are bringing line as direction back to sculpture, of which it had been robbed by age-old prejudice. In this way we assert DEPTH as the only form of space in sculpture. We reject the thousand-year-old Egyptian delusion in art which held that static rhythms are the only elements of visual creativity. We assert that new element in creative art, KINETIC RHYTHMS, as the basic forms of our perceptions of real time."[33]

It requires no stretch of the imagination to recognize Calder's affinity with these doctrinal principles of Constructivism, above all from a practical perspective. In reality, more than clarifying his creative action, the contacts Calder established with Neo-Plasticists, Constructivists, and members and associates of Abstraction-Création clarified his ideas. Calder was never inclined to formal theories or doctrines, forged as he was in the American spirit of pragmatic vitalism, somewhere between Emerson and Dewey. In a certain sense, we may assert that his encounter with Mondrian and the abstract artists of the Thirties enabled him to understand the potential of what he was already doing, stripping it of its anecdotal aspects and focusing it on artistic syntax. This explains not only the "naturalness" and the rapidity of his transition but also his prolific inventiveness that began to

[31] Naum Gabo and Antoine Pevsner, "Realistic Manifesto" (1920), quoted in Martin Hammer and Christina Lodder, eds. and trans. *Gabo on Gabo: Texts and Interviews* (East Sussex, Eng.: Artists Bookworks, 2000), pp. 30–31.

[32] Ibid., p. 32.

[33] Ibid., p. 33.

emerge in the early Thirties, when he defined his personal poetics and language in definitive form. It is evident that no matter how much any formal precedents and manifestos might have prepared his path, Calder was doing what no one else had accomplished.

The sense of mobility and weightlessness Calder gave to his sculpture cannot be explained simply by his powerful intuition or the physical and mechanical knowledge he derived from his engineering education. At a time of profound crisis and confusion, when the majority of intellectuals and artists had become polarized over the aesthetic and political issues of the day and had adopted extreme postures, Calder exemplified dialectical mobility and ductility. Thus, in the standoff between figuration and abstraction, between the organic and the crystalline, between the subjective and the objective, Calder straddled the traditional and the avant-garde, using elements from both tendencies in an original and very fluid way. Geometry and biomorphism both merged in a spontaneous way in the language of his mobiles and stabiles, in which it is possible to recognize traces of Mondrian, Arp, Miró, Tanguy, etc., but forming a syntax of his own that transcends them. In this sense, Calder's position recalls the final evolution of Paul Klee, who had a similar, unusually profound capacity for a synthesis of seemingly disparate elements, one in which humor was present right down to the end.[34]

In Calder's work during the Thirties, there is also a decided Eastern presence, which is not due simply to some superficial similarity between his mobiles and the graceful beauty of Chinese kites and chimes, which are also activated by air currents. Whether he was conscious of it or not, Calder's mobiles illustrate many of the precepts that have inspired the traditional Chinese artistic spirit, even though they go beyond the con-

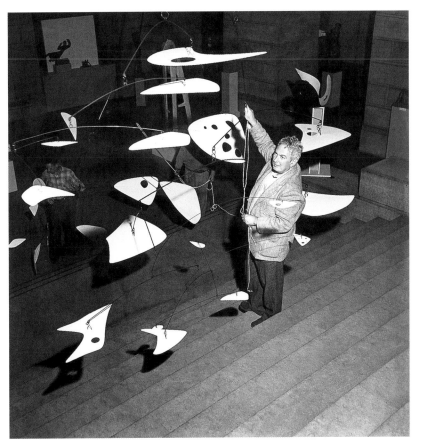

Calder installing *International Mobile*, Philadelphia Museum of Art in collaboration with the Fairmount Park Art Association, 3rd International Exhibition of Sculpture, 1949. Courtesy Calder Foundation

ventional channels through which contact had been made between West and East. For example, there is much in common between Calder's aesthetic evolution and the aesthetic evolution of the fictional Chinese painter imagined by writer and essayist François Cheng in his recent novel *The River Below*. From an artistic point of view, it reflects both an ancient sensibility and a way of dealing with the overwhelming process of a sudden and violent modernization. It's impossible not to think of Calder, when the protagonist of Cheng's novel, Tianyi, talks about his youthful fascination with the theater in the following terms: "I, seeing a drama for the first time, observed how freely the actor defied time and space! Leg lifted,

[34] See F. Calvo Serraller, "Notas sobre el pensamiento artístico de Paul Klee," in *Imágenes de lo insignificante: El destino histórico de las vanguardias en el arte contemporáneo* (Madrid: Taurus, 1987), pp. 234–55.

he crossed the threshold of his house. A crack of the whip and he rode his horse. Back bent, there he was, twenty years later. In short, neither space nor time, just a living creature moving about, space-time originating with him. So it took no more than a bare surface, a few square feet, to portray all human dreams and passions."[35] It's not difficult to see the connection between this joyful scenic representation, dominated by the movement of a subtle gesture, and Calder's little circus figures, set up in their arena. All they need is a movement, a position, a gesture to take on a complete existence. But it goes further, as we see in the cosmic explanation Tianyi gives of the work of ordinary potters: "Artisans like these, repeating the same actions time and time again, perpetuate a circular movement that matches faithfully the rotation of the Universe. Movement seemingly always the same, but renewed each time, subtly different. That is the way the Universe must have begun, stirred by a necessity born of itself; that is probably how it will end."[36] Finally, and above all, there is the artistic advice given by the hermit-master to Tianyi: "The great ancient tradition is what I can teach you. You are young, you live in a time open to all kinds of influences, some of them coming from afar. But it would be regrettable for you to remain ignorant of the living treasures of the past, which have proved their worth. So, to begin with, master the best of our tradition. How? Through the path you have already followed: start with calligraphy; go on to drawing, which teaches mastery of line. Then take up working in ink, the end being the creation of an organic composition in which the full embodies the substance of things and the empty ensures the circulation of the vital forces, thereby joining the finite to the infinite, as in Creation itself. . . . Chinese painting is based on an apparent paradox: however it expresses visible or invisible life, it is always humbly obedient to the laws of the real; at the same time, it aims straight for the Vision. But there is no contradiction here. For true reality is more than the shimmering appearance of the exterior, it is vision. In no way does vision

derive from the dream or the fantasy of the painter: it results from the great universal transformation set in motion by the breath-spirit. Being set in motion by the breath-spirit, vision can be captured by man only through the eyes of the spirit, what the Ancients called the third eye or the eye of Wisdom. How does one make that eye his own? Only through the way of the Chan masters, namely, the four stages of seeing: seeing; no longer seeing; profound non-seeing; re-seeing. When we finally re-see, we no longer see objects as outside ourselves. They are now an integral part of us ourselves, and the work of art that comes from re-seeing is an exact projection of an enriched and transfigured interiority. So, it is essential to attain the Vision. You still hold things too tight. You cling to them. But living things are never fixed or isolated. They are caught up in the universal organic transformation. In the time it takes to paint them, they go on living, just as you yourself go on living. While you are painting, enter into your time and enter into their time, until your time and their time merge. Be patient and work slowly, deliberately."[37]

Could there be any greater harmony than that between this description of art "set in motion by the breath-spirit" and the "weightlessness" achieved and given shape by Calder?

Weightlessness

Almost up until the modern era, sailing the seas constituted mankind's frontier for adventure and discovery. Once the globe was circumnavigated, we looked upward for a new frontier to conquer, and no other exploration than that of the heavens could satisfy us. In that way,

35 François Cheng, *The River Below* [orig. *Le dit de Tianyi*], trans. Julia Shirek Smith (New York: Welcome Press, 2000), p. 12.

36 Ibid., p. 101.

37 Ibid., pp. 108–09.

we entered the era of space travel, moving vertically into the inscrutable and infinite ether that leads us to the stars. That impulse first became noticeable during the nineteenth century, attaining popular interest through science articles and novels during the final third of the century. As Albert Boime explained in his monograph on Vincent van Gogh's *Starry Night* (1889),[38] this interest in the astral universe had been popularized through the work of French astronomer Camille Flammarion, which also had an effect on such other fin-de-siècle artists as Gauguin and Cézanne, and, translated into several languages, on artists outside France as well.

During the twentieth century, even before the first voyages into outer space took place, the theme of exploring the universe had begun to grow in importance and arouse greater attention, becoming one of the favorite topics of the avant-garde by the Twenties. Because the heavens interested Surrealists and abstract artists equally, the constellations became a common subject of many of the best artists of the period—Picasso, Miró, Klee, Kandinsky, David Smith, and, of course, Calder (a topic that I explored in my essay "Vulcan's Constellation," in the catalogue for the exhibition *Picasso and the Age of Iron* in 1993).[39] Nevertheless, it was Calder who took this cosmic vision the furthest and found the way to take maximum artistic advantage of it.

Calder's passion for astronomy and the heavens goes back to his adolescence, but with time it becomes a primary element in his artistic poetics, as is clear from one of his most important and most frequently quoted autobiographical texts. Recalling his situation at the outset of the Thirties, Calder wrote: "I think that at that time and practically ever since, the underlying sense of form in my work has been the system of the uni-

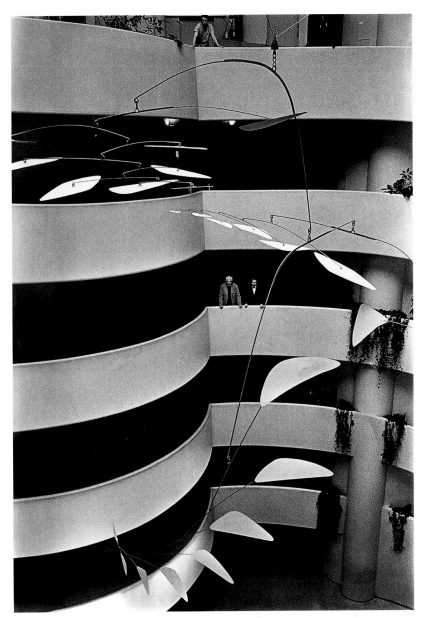

Calder overseeing the installation of *The Ghost*, 1964, for *Alexander Calder: A Retrospective Exhibition*, at the Solomon R. Guggenheim Museum, New York. Courtesy Calder Foundation

verse, or part thereof. For that is a rather large model to work from. What I mean is that the idea of detached bodies floating in space of different sizes and densities, perhaps of different colors and temperatures, and surrounded and interlarded with wisps of gaseous condition, and some at

[38] Albert Boime, *La nuit étoilée: L'histoire de la matière et la matière de l'histoire* (Paris: Adam Biro, 1990).

[39] See pp. 79–83 of *Picasso and the Age of Iron*.

rest, while others move in peculiar manners, seems to me the ideal source of form."[40]

One can see a certain resonance with the ideas of philosopher Henri Bergson (1859–1941), especially his notions of an *élan vital* (life force) animating all existence, the mobile fluidity of reality, and the vivifying power of intuition over dry intellectual analysis. In 1922 Bergson took up the problems posited by contemporary physics in his book *Duration and Simultaneity, a propos of Einstein's Theory*; and in 1934 he published a collection of essays and reviews entitled *Thought and Motion*. It has been pointed out that, late in his life, Bergson came to hold positions close to the mystic tradition of Christianity, in which the experience of ecstasy— illumination—is at times accompanied by the supernatural phenomenon of levitation, a weightless state of motionless aerial suspension. However, any parallels between Bergson and Calder are indirect and metaphorical. Even though, as is well known, Bergson's texts on intuition and our perception of reality were read and quoted in Cubist circles, it is very unlikely that Calder was one of those readers, as he did not have a highly intellectual attitude to art. Nevertheless, by the time Calder arrived in Paris, such ideas about the cognitive power of intuition as a primary element of the creative process were prevalent.

During the Thirties, despite the hostile and threatening circumstances, Calder's inventive power exploded in an extraordinary way, and he began to gain a wider stage for his work, both in Europe and the United States. In addition to the solo exhibitions he had in Paris and New York in 1931 and 1932, Calder's work continued to be shown in solo exhibitions in Paris (at Galerie Pierre Colle in 1933), New York (at Pierre Matisse Gallery from 1934 on), other U.S. cities (Chicago, Poughkeepsie, Hartford, Springfield, Los Angeles), Madrid and Barcelona (in 1933), and London (at The Mayor Gallery in 1937), and in group exhibitions in Paris, New York, Berlin, Chicago, London, Basel, Amsterdam, and else-

where. The exhibitions in Spain were an unequivocal demonstration of his very good relationship with Spanish avant-garde artists, especially with Miró. His friendship with Miró led to Calder's singular participation in the Spanish Pavilion at the Paris World's Fair of 1937, which took place at a critical point in the Spanish Civil War. In the United States, he also created mobile sets for dance works by Martha Graham and for a performance of Erik Satie's symphonic drama *Socrate* in Hartford, Connecticut. This was something for which Calder seemed destined, not only because dance is an art of movement, but also because of his growing identification with music and the subtle vibrations of sound unfolding in space-time.[41]

Calder's development, which I have analyzed in the context of the evolution of sculpture during the first third of the twentieth century, reached its highest point, during the war-torn Forties, in the series of sculptures called *Constellations*, 1942–43. Having started out from the new foundations that, beginning with Cubism, gave another definition to sculpture, Calder, in these mobiles, succeeded not only in making mass nearly transparent but also in transforming it into something weightless, floating.

"Stars and blossoming fruit-trees: utter permanence and extreme fragility give an equal sense of eternity."[42] This statement, which metaphorically applies so well to what Calder was doing, is one of the philosophical observations that French thinker Simone Weil recorded in her *Notebooks* between 1933 and 1943, the year of her premature death. A portion of those notebooks was published posthumously as *La Pesanteur et la Grâce*

[40] Calder's statement in *What Abstract Art Means to Me*, in *Bulletin of the Museum of Modern Art* (New York) 18, no. 3 (Spring 1951), reprinted in Herschel Chipp, *Theories of Modern Art* (Berkeley and Los Angeles: University of California Press, 1968), p. 561.

[41] See Manuela Barrero, "Intuiciones dinámicas y pensamientos 'in stabiles' de una escultura en movimiento. Alexander Calder," in *Anales de historia del arte*, vol. 2 (Madrid: Universidad Complutense de Madrid, 2001), pp. 313–27.

[42] Simone Weil, *Gravity and Grace*, trans. Emma Craufurd (London and New York: Routledge, 1952, ARK Edition, 1989), p. 97.

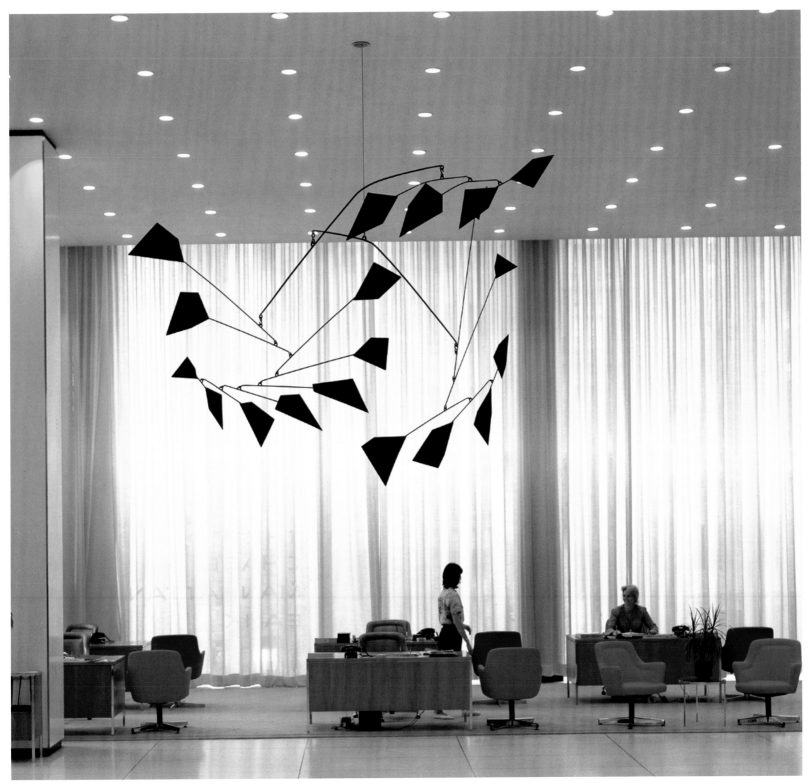

Calder, *Untitled* (*Mobile*), 1959. The JPMorgan Chase Art Collection

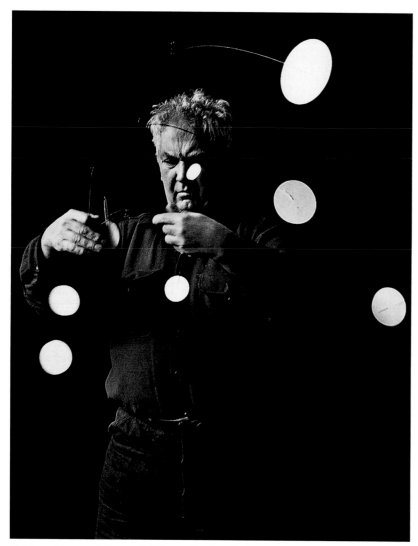

Calder with a mobile, 1948 / Photo: Gordon Parks

moral laws, where there is a clear affinity with the effects produced by Calder's mobiles: "To come down by a movement in which gravity plays no part. . . . Gravity makes things come down, wings make them rise: what wings raised to the second power can make things come down without weight? Creation is composed of the descending movement of gravity, from the ascending movement of grace and the descending movement of the second degree of grace. Grace is the law of the descending movement. To lower oneself is to rise in the domain of moral gravity. Moral gravity makes us fall toward the heights."[43]

"To fall toward the heights." Could there be a better definition of the subtle weightless floating of Calder's sculptures, that we described at the outset as a *monument pendu*? There are further parallels in what Weil says about emptiness: "Not to exercise all the power at one's disposal is to endure the void. This is contrary to all the laws of nature. Grace alone can do it. Grace fills empty spaces, but it can only enter where there is a void to receive it, and it is grace itself which makes this void. . . . Man only escapes from the laws of this world in lightning flashes. Instants when everything stands still, instants of contemplation, of pure intuition, of mental void of acceptance of the moral void. It is through such instants that he is capable of the supernatural."[44] In other words, the instant of being weightless, whose form is that of pure light, energy. Finally, note the analogies between Weil and Calder in what she says about the beautiful: "Distance is the soul of the beautiful. . . . Beauty: a fruit which we look at without trying to seize it . . . double movement of descent: to do again, out of love, what gravity does. Is not the double movement of descent the key to all art? This movement of descent, the mirror of grace, is the essence of all music. All the rest only serves to enshrine it."[45]

(1947)—"gravity and grace"—because many of her mystical reflections revolved around those ideas, where the physical and the metaphysical come so close to each other. Despite the very different sensibilities of this intense, rather strange Christian philosopher and mystic and the "Rabelaisian" vitalist Calder, I believe it is worthwhile to note some parallels between them, especially in relation to the idea of being free of gravity, a concept that they explored from very different perspectives. Here is Weil on the analogy between the laws of physical gravity and

[43] Ibid., pp. 3–4.
[44] Ibid., pp. 10–11.
[45] Ibid., p. 137.

The ethical and metaphysical connotations that Weil found in the physical notions of gravity and weightlessness seem to apply to Calder's mobiles as well. Both Weil's texts and Calder's most inventive work were produced during the same period, the Thirties and the early Forties. Weil, though, was a philospher educated in mathematics and physics, and her deep sense of political commitment led her to participate directly in the Spanish Civil War. Despite their different backgrounds and their divergent paths in life, they shared a similar vision of a weightless state attained, paradoxically, without leaving the world of gravity. To Weil, grace is a dynamic element whose energy can raise a body—a Christian concept that implies the supernatural intervention of an illuminating force. Derived from the Latin word *gratus* (which originally meant "pleasing" or "grateful"), *gracia* in Spanish has a rich variety of usages which, aside from what its etymology suggests, refers not only to its religious meaning (as divine favor) but also to expressing oneself with ease, having wit or a sense of humor, and, finally, to being "in a state of grace," favored by fortune, as if able to soar over one's difficulties. As we can all appreciate, some of these uses of the term "grace" are related, even when not referred to directly—as in art, where, significantly, the term *grazia* was already included in Renaissance treatises, as we can see from Vasari's use of it. It is not strange, therefore, that the terms *gravità* and *grazia* appear as entries in the *Vocabolario Toscano dell'Arte del Disegno* (1681) by Filippo Baldinucci, where "grace" is associated with motion and movement,[46] which leads the author to comment on several rules about knowing how to move and how to represent movement properly. So, be it through aesthetic affirmation of a subjective expressiveness or through grace in movement, art preserved the term, one that Calder made synonymous with his work, transforming his mobiles into one of its embodiments.

[46] Filippo Baldinucci, *Vocabolario Toscano dell'Arte del Disegno* (Florence 1681), p. 70.

Grace is the experience of a luminous, instantaneous flash of meaning, according to Weil, who seeks that state of lightness, a levitation that dematerializes her without eliminating the gravity of dead weight, the weight of death. For Calder, who envisioned Mondrian's rectangles "in flight"—or at least moving through the air—transparency became a state of weightlessness, but not only as a mere system of weights and balances but as that which floats, lightened, moved by ethereal, invisible impulses, just as his mobiles are sensors alert to environmental energy, fields of action for grace, energy, light.

Before deciding to return to the United States in 1938 because of increasing hostilities that presaged an immediate war in Europe, Calder continued without letup to create new art, participate in exhibitions, and engage in social activity. Until now, I have referred almost exclusively to his mobiles, though with no intention of slighting his other sculpture or his important work as a painter and maker of drawings. Indeed, forming an equally significant part of Calder's œuvre are his standing sculptures, which Arp dubbed "stabiles," a term so felicitous that it pleased Calder, becoming a category for all of that "gravity-bound" work that would lead to the large commissioned monuments he made after World War II, mostly in the United States. Unlike the mobiles, these steel monuments may give a better idea of the pictorial aspect of Calder's art, in part because of their decidedly gestural accent, which nevertheless does not diminish the expressivity he bestows on forms, for which Calder has been regarded, correctly, in my opinion, as one of the precursors of Pop art.

Except during the war years, Calder's comings and goings between Europe and the United States were continuous. He remained in the U.S. after World War II broke out, when there was a flood of European intellectuals and artists in exile all over the Americas, most of them in New York, and he was constantly in contact with many of them, especially because almost all were old friends. Thus, he participated in what turned

out to be the seminal period for the explosion of art in the United States in the postwar era. Once World War II was over, Calder went on working intensively for another thirty years, until the moment of his death in New York on November 11, 1976. This huge second phase of his career, that of his maturity, during which he received widespread international recognition, brought him commissions from all over the United States and Europe, although it did not change the orientation of his work.

If we consider 1926 the point at which Calder's artistic career began, we see that his creative period lasted exactly half a century. Today, when slightly more than a quarter of a century has passed since his death, we can state without fear of contradiction that Calder was one of the most important sculptors of the twentieth century, the century when sculpture completely reinvented itself. What helps us to make this declaration is not only the benefit of passed time—the best critic—but the fact that the past twenty-five years have been those during which our culture has reflected most and best on the legacy of the twentieth-century avant-garde, especially if we focus that reflection primarily on the modern destiny of sculpture, about which there have been myriad publications and exhibitions.

Thanks to this historical perspective and to the information we have today at our disposal, we can recognize something beyond the fame achieved by Calder, who is undoubtedly one of the most popular avant-garde artists of the twentieth century. By this I mean his fundamental contribution to the evolution of the classical monument, traditionally dominated by heavy, inert mass, which the true sculptor, according to fifteenth-century art theorist and architect Leone Battista Alberti's treatise *Della Statua*, should carve into something transparent, graceful, mobile, and gravity-free. Although Calder made that contribution by means of a rich and complex modern tradition, some of whose syntactic and semantic matrices I've tried to evoke over the course of this essay, no one can diminish the enormous merit and originality of his achievement. The influence of his most immediate antecedents, such as Picasso's and González's "drawing in space" and use of iron, as well as the theoretical contributions of the Constructivists, takes nothing away from the unique nature of Calder's work from the Thirties on. Except for a few works, such as Rodchenko's hanging sculptures or some of Tatlin's corner reliefs, which may have helped reveal the path that Calder slowly found for himself, the truth is that the Constructivists did not create, qualitatively or quantitatively, what he created. At most they came close, as in the flying machine *Letatlin*, constructed by Vladimir Tatlin in 1932 (reconstructed in 1991). As for the complex Constructivist machines, such as Laszlo Moholy-Nagy's *Modulator of Light and Space* (1930, reconstructed forty years later), it has nothing to do with the sense of weightlessness, of spatial flotation characteristic of Calder's first mobiles. Alone, he reached that new zero degree of sculpture, which at the outset I referred to as *le monument pendu*, the sculpture of the new space age in which we find ourselves.

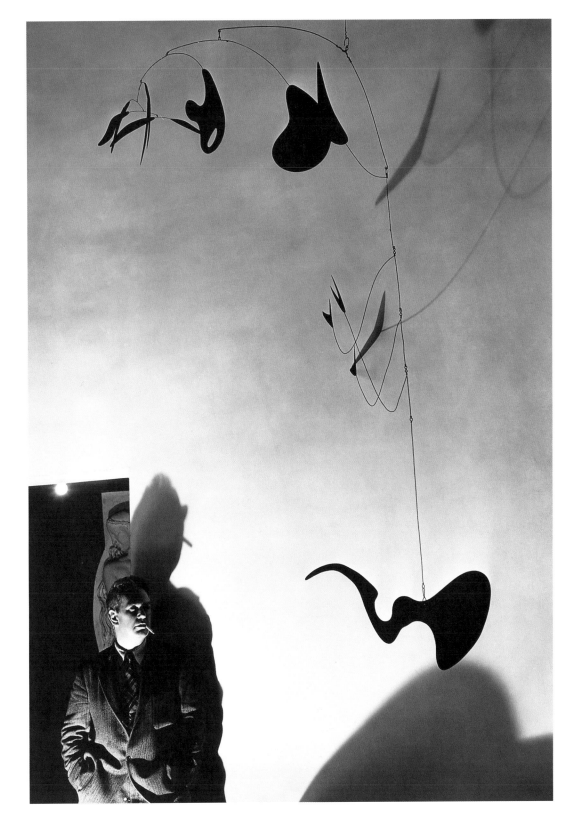

Calder with *Eucalyptus* (1940) in 1943 / Photo: André Kertész

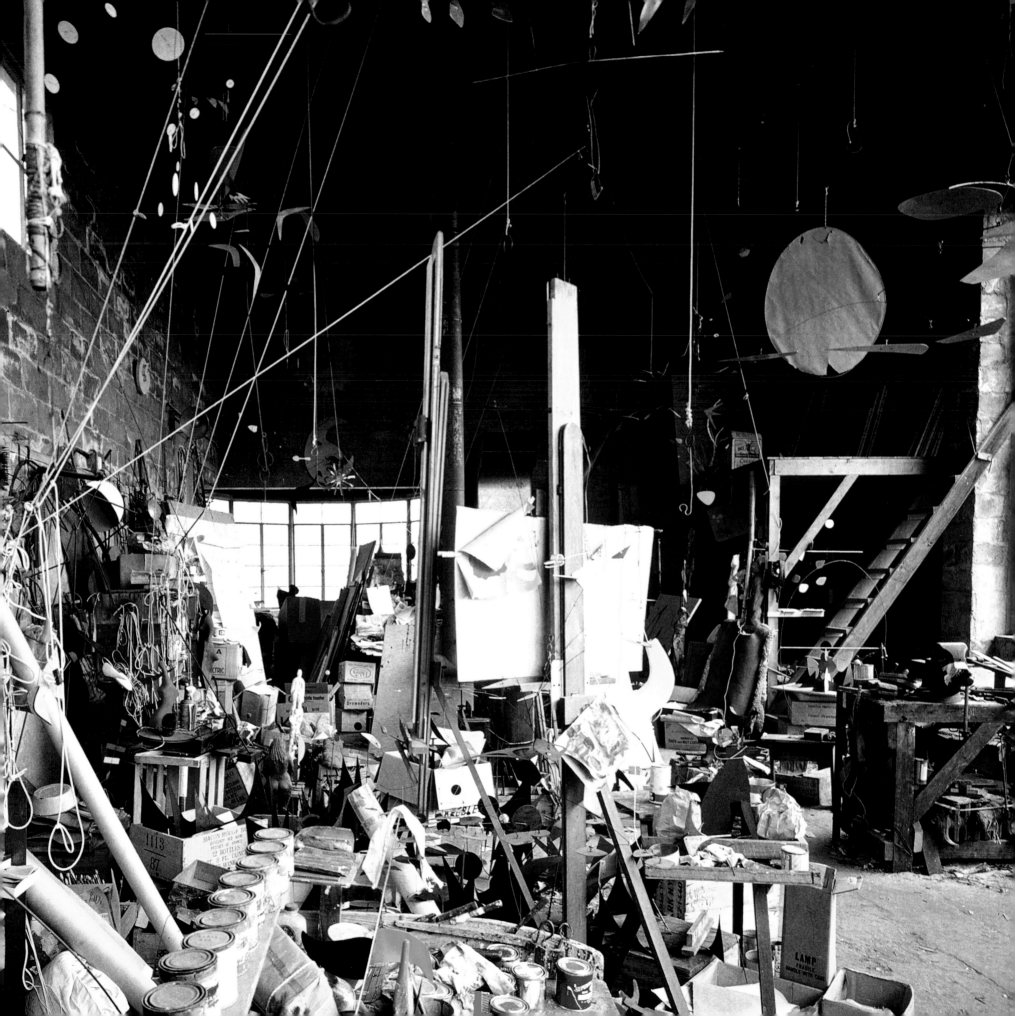

◄ Calder's Roxbury Studio, 1963 / Photo: Pedro E. Guerrero

SELECTED TEXTS BY AND ABOUT CALDER

Carmen Giménez

The texts reproduced here were culled from the huge bibliography that exists on Alexander Calder and his unique creative universe. The selection was made using the same criteria we used in choosing the pieces in the exhibition they accompany. As I pointed out in my introduction to this catalogue, it is possible to formulate as many different interpretations of Calder's work as its myriad facets allow. Therefore, I must declare from the outset that the reader will not find here texts about his early phase, whose major theme was *The Circus*, or about any of his first wire sculptures; or later documentation related to his activities as a painter, printmaker, scenography painter for ballets, or creator of jewels, toys, rugs, or utensils.

The texts gathered here are fragments and extracts that have no pretensions beyond their documentary character and their use in facilitating access to Calder's sensibility and intimate thoughts. They are words that illuminate the sculptures in the show, at least to the point that mere words can shed light on a mystery. They are written testimonies that try to bring us closer to understanding the physical and aesthetic concerns posed by the innovative mobile and stabile sculptures created by Alexander "Sandy" Calder. As Calder himself put it in a 1943 statement: "There is of course a close alliance between physics and aesthetics."

The documents are presented in four categories and arranged in chronological order within those categories:

I. **Calder's writings and quotations.** Twelve brief texts, featuring nine artist's statements, two that were originally handwritten by Calder.

II. **Selections from Calder's Autobiography.** Six extracts from *An Autobiography with Pictures*, published in 1966 with the assistance of Calder's son-in-law Jean Davidson. I sincerely recommend the complete text of this book to anyone interested in delving deeply into Calder's life.

III. **Texts by other authors.** Sixteen texts, including poems, personal notes, and reflections by Fernand Léger, Gabrielle Buffet-Picabia, André Masson, Marcel Duchamp, Jean Paul Sartre, Alejo Carpentier, and James Johnson Sweeney, among others.

IV. **Interviews with Calder.** Six interviews carried out between 1957 and 1969. Among these, we would stress the importance of Katharine Kuh's interview summarizing Calder's artistic and biographical development, as well as Robert Osborn's interview about "Calder's International Monuments," in which Calder himself reveals the problems resulting from the increase in the scale of his sculptures and the difficult technical processes such a change required, his particular way of working, and the relationships he had with foundations, mostly French and American.

The earliest text in which Calder reveals his concerns about movement, nature, the laws of the universe, and the beauty of spaces, masses, volumes, forms, and colors dates from 1932. The most recent text dates from 1989, a statement made on Belgian television by fellow artist Jean Tinguely: "With his mobiles, Calder had found a strong direct means of expression. . . . Let's just say that Alexander Calder opened a door through which I could enter." When we consider that Calder died in New York in 1976, this quotation is evidence of his stature and his international influence.

Between that text and the one that follows, all the others show us a Calder who was a corpulent, jolly, amiable man, imbued with an inexhaustible joie de vivre, a man whose special way of understanding life and sculpture distanced him from traditional academicism. While taking an active part in the most avant-garde and radical innovations of his age, he shied away from overly intellectual or manifesto-style declarations. He was a man whose humor and fertile imagination imbued everything he touched, brushing aside and mocking the "serious questions" of aesthetic theory. As he said in 1937: "When an artist explains what he is doing he usually has to do one of two things: either scrap what he has explained or make his work fit in with the explanation. Theories may be all very well for the artist himself, but they shouldn't be broadcast to other people. All that I shall say here will be about what I have already done, not about what I am going to do."

This admonition recalls what Henri Matisse said in the first paragraph of his "Notes of a Painter" (1908) included in his *Writings on Art*: "A painter who addresses the public not just in order to present his works but to reveal some of his ideas on the art of painting exposes himself to several dangers. . . . I'm fully aware that a painter's best spokesman is his work."[1]

Despite Calder's reticence with regard to theory, we should not overlook his high regard for some of the writers who'd dedicated themselves to him. In this regard, he said in 1957: "When my inspiration gets lost, I think about what Sweeney or Sartre or perhaps one or two others have written about my work, and that makes me feel very fortunate, and I start working with renewed enthusiasm."

And in 1960, he added: "My only theory of art is the disparity that exists between form, masses, and movement."

We have also attempted to call attention to certain events in Calder's life. To that end we have intentionally included accounts of these events in several texts both by Calder and by other authors. For example, Sandy's first visit in the fall of 1930, to Mondrian's studio—a visit that would be of supreme importance for the development of his new idiom—is described in the text where Calder first explains how he arrived at abstraction and then recalled in other texts by Calder many years later—*17 Mobiles by Alexander Calder, 1943*; *What Abstract Art Means to Me, 1953*; *Mondrian, 1965*; and Commentaries on the *Universes, 1971*—as well as in various statements and interviews. The same applies to the texts in which Marcel Duchamp

[1] Jack Flam, ed., *Matisse on Art* (Berkeley and Los Angeles: University of California Press, rev. ed., 1995), p. 37.

invents the term "mobiles," and Jean Arp coins the term "stabiles," which they did because Calder's creations were so wildly new that there was a need to invent names for them: *Calder, His Mobiles, 1965; Stabiles, 1965; Sandy Calder, Forger of the Moon, 1945.* Duchamp himself wrote about this in 1950: "Among the artistic 'innovations' that came about after the Great War, Calder's line was so distant from any established formula that it was necessary to invent a new name for his forms in motion: *mobiles.*"

The matters that interest Calder are related to his activity and his daily concerns, and, as I said at the outset, are related to movement, nature, the constellations, materials, balance, the primary colors often reduced to black, white, and red—to the way in which the branches of a tree hang at the tree's highest point or how his new mobile will capture the wind as if it were a "dog-catcher."

I would like to open this section by quoting from Maurice Bruzeau's brief text introducing Calder's words in his article:

Calder's conversational style has nothing to do with a majestic speech of a theorist of plastic art. He cuts, divides, welds, rolls and forges: his work speaks for him. These are therefore the rough words and thoughts that we have reported, like a precious harvest exclusive: without doubt this puzzle gives a better knowledge of Calder than any exegesis.

The Spanish and French texts have been translated into English for this edition by Isabel Saavedra and Alfred MacAdam. At the end of each text, its original source is given in a bibliographic reference, and the original language in which it was published is indicated, marked with an asterisk (*).

Abbreviations:

A. C.:	Alexander Calder
exh. cat.:	exhibition catalogue
p./pp.:	page/pages
ed.:	editor/edition

SELECTED TEXTS

CONTENTS

I. CALDER'S WRITINGS AND QUOTATIONS

47 **How to Make Art?**

47 **Objects to Art Being Static, So He Keeps It in Motion**

48 **Artist's statement in *Modern Painting and Sculpture***

49 **Mobiles**

50 **17 Mobiles by Alexander Calder**

50 **A Propos of Measuring a Mobile**

52 **What Abstract Art Means to Me**

52 **Artist's statement in *Exposición Calder***

53 **Artist's statement in *4 Masters Exhibition***

53 **How to Do It**

53 **Commentaries on the *Universes* and the *Constellations***

53 **Alexander Calder, a Blacksmith in the Town**
 Maurice Bruzeau

II. SELECTIONS FROM CALDER'S AUTOBIOGRAPHY

57 **Mondrian**

57 **"Calder, His Mobiles"**

58 **Stabiles**

59 **The Spanish Pavilion**

60 **Constellations**

60 **Pas Nobles Mobiles**

III. TEXTS BY OTHER AUTHORS

65 **Eric Satie Ilustrated by Calder**

 Fernand Léger

66 **Alexander Calder, or the King of Wire**

 Gabrielle Buffet-Picabia

66 **The American Sculptor Calder**

 Sebastián Gasch

67 **Sandy Calder, Forger of the Moon**

 Gabrielle Buffet-Picabia

69 **The Studio of Alexander Calder**

 André Masson

69 **The Mobiles of Calder**

 Jean-Paul Sartre

71 **Calder**

 Fernand Léger

71 **Alexander Calder: Introduction**

 James Johnson Sweeney

73 **Calder, Prodigious Smith**

 Alejo Carpentier

75 **Sandy Calder**

 Willem Sandberg

75 **The Trapper of Iron**

 Jacques Prévert

76 **Memories 1886–1962**

 Amédée Ozenfant

76 **How I Came Across Calder**

 Gabrielle Buffet-Picabia

77 **Alexander Calder. Sculptor, Painter, Illustrator**

 Marcel Duchamp

77 **Alexander Calder: 1898–1976**

 Josep Lluís Sert

79 **Tinguely on Tinguely**

 Jean Tinguely

IV. INTERVIEWS WITH CALDER

83 **Conversations with Artists: Alexander Calder**

 Selden Rodman

86 **I Am a Tinkerer**

 Ustinov

87 **Calder: No One Calls on Me When There Is a Horse to Be Done**

 Yvon Taillandier

88 **Talks with Seventeen Artists: Calder**

 Katharine Kuh

90 **Calder's International Monuments**

 Robert Osborn

100 **A Conversation with Alexander Calder**

 Robert Osborn

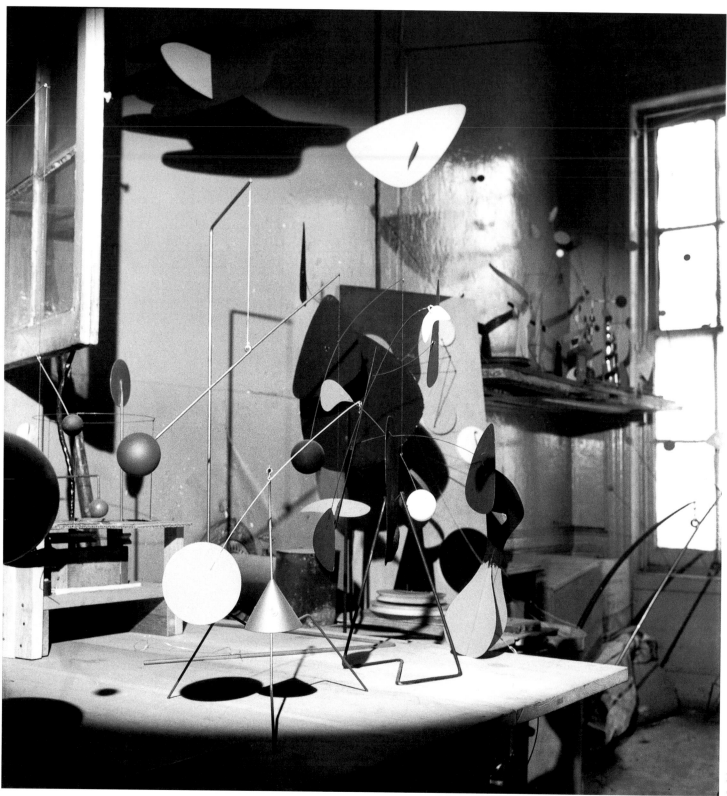

Calder's New York studio, ca. 1938 / Photo: Herbert Matter

How to Make Art?

How does art come into being?

Out of volumes, motion, spaces carved out within the surrounding space, the universe.

Out of different masses, tight, heavy, middling — achieved by variations of size or color.

Out of directional line — vectors representing motion, velocity, acceleration, energy, etc. — lines which form significant angles and directions, making up one, or several, totalities.

Spaces and volumes, created by the slightest opposition to their mass, or penetrated by vectors, traversed by momentum.

None of this is fixed. Each element can move, shift, or sway back and forth in a changing relation to each of the other elements in this universe.

Thus they reveal not only isolated moments, but a physical law of variation among the events of life.

Not extractions, but abstractions:

Abstractions which resemble no living thing, except by their manner of reacting.

A. C., "Comment réaliser l'art?," *Abstraction-Création, Art Non-Figuratif,* no. 1 (1932), p. 6.
* French

New York World-Telegram

Objects to Art Being Static, So He Keeps It in Motion

Sculptor Presses Button and Motor Does Its Duty—Hatpin Is Part of Exhibit—Works Have No Titles

Why must art be static?" demanded Alexander Calder calmly as he closed his exhibition at the Julien Levy Gallery today. "You look at an abstraction, sculptured or painted, an intensely exciting arrangement of planes, spheres, nuclei, entirely without meaning. It would be perfect, but it is always still."

"The next step in sculpture is motion." At this point Mr. Calder pushed a button.

Two white balls went into motion against the background of a black packing box. One ball went up and down like a yo-yo top, the other revolved counter-clockwise at the end of a piece of string. The entire sculpture was mounted on a White Rock case, painted white, and a small flywheel, operated by electric power, controlled the strings.

No Utility, No Meaning

"Quite a handsome motion," Mr. Calder observed complacently. He parried a suggestion that the vertically moving ball resembled those in a shooting gallery.

"The balls in a shooting gallery move for a utilitarian purpose," he said. "This has no utility and no meaning. It is simply beautiful. It has a great emotional effect if you understand it. Of course if it meant anything it would be easier to understand, but it would not be worth while."

Other examples of Mr. Calder's latest creations adorned the severely modern exhibition room. One consisted of a sickle shaped wire and something like a hatpin topped by a billiard ball. The sickle rotated slowly, the hatpin vibrated fast. The engine sputtered.

"The motors are not so good," said the sculptor. "I had my choice between perfecting a motor for one or two things or going on to new creations. I preferred to go on creating."

The sculptor, ex-engineer, painter and artificer of simplified portraits in wire and wood, is a middle-aged man, who wears shapeless tweeds and sandals. His hair is graying and his mouth is usually half-open in a guileless, sleepy smile. The lashes of the right eye are black, the left gray.

To the catalog of his works—a series of diagrams, for the items have no titles and he finds it easier to draw than describe them—is a quotation from the Parisian authority, F. Léger.

Not Sculpture, Some Say

"Before his recent works, which are transparent, objective and exact, I think of Satie, Mondrian, Marcel Duchamp, Brancusi, Arp—those incontestable masters of an inexpressive and silent beauty. Calder belongs to this line."

"The pigeon is rather a dumb animal," said the incontestable master. "Yet it has a handsome motion. To enjoy that motion, why must I tolerate an unpotted squab?"

"Some critics say that this is not sculpture, because in order to appreciate its beauties you have to turn on an electric switch."

"Well, that is true of any sort of plastic art at night. You have to turn on an electric switch to see it."

"Objects to Art Being Static, So He Keeps It in Motion." *New York World-Telegram*, June 11, 1932. * English

Artist's statement in *Modern Painting and Sculpture*

The sense of motion in painting and sculpture has long been considered one of the primary elements of the composition.

The Futurists prescribed for its rendition.

Marcel Duchamp's "Nude descending the stairs" is the result of the desire for motion. Here he has also eliminated representative form. This avoids the connotation of ideas which would interfere with the success of the main issue—the sense of movement.

Fernand Léger's film, "Ballet Mécanique," is the result of the desire for picture[s] in motion.

Therefore, why not plastic forms in motion? Not a simple translatory or rotary motion, but several motions of different types, speeds and amplitudes composing to make a resultant whole. Just as one can compose colors, or forms, so one can compose motions.

The two motor driven "mobiles" which I am exhibiting are from among the most successful of my earliest attempts at plastic objects in

motion. The orbits are all circular arcs or circles. The supports have been painted to disappear against a white background to leave nothing but the moving elements, their forms and colors, and their orbits, speeds and accelerations.

Wherever there is a main issue, the elimination of other things which are not essential will make for a stronger result. In the earlier static abstract sculptures I was most interested in space, vectoral quantities, and centers of differing densities.

The esthetic value of these objects cannot be arrived at by reasoning. Familiarization is necessary.

A. C., artist's statement in *Modern Painting and Sculpture*, exh. cat. (Pittsfield, Mass.: Berkshire Museum, 1933). * English

Mobiles

When an artist explains what he is doing he usually has to do one of two things: either scrap what he has explained, or make his subsequent work fit in with the explanation. Theories may be all very well for the artist himself, but they shouldn't be broadcast to other people. All that I shall say here will be about what I have already done, not about what I am going to do. . . .

I did a setting for Satie's *Socrate* in Hartford, U.S.A., which I will describe, as it serves as an indication of a good deal of my subsequent work.

There is no dancing in it. It is sung by two people—a man and a woman. The singing is the main thing in it. The proscenium opening was 12 feet by 30 feet. There were three elements in the setting. As seen from the audience, there was a red disc about 30 inches across, left center. Near the left edge there was a vertical rectangle, 3 feet by 10 feet, standing on the floor. Towards the right, there were two 7-foot steel hoops at right angles on a horizontal spindle, with a hook one end and a pulley the

other, so that it could be rotated in either direction, and raised and lowered. The whole dialogue was divided into three parts: 9, 9, and 18 minutes long. During the first part the red disc moved continuously to the extreme right, then to the extreme left (on cords) and then returned to its original position, the whole operation taking 9 minutes. In the second section there was a minute at the beginning with no movement at all, then the steel hoops started to rotate toward the audience, and after about three more minutes they were lowered towards the floor. Then they stopped, and started to rotate again in the opposite direction. Then in the original direction. Then they moved upwards again. That completed the second section. In the third, the vertical white rectangle tilted gently over to the right until it rested on the ground, on its long edge. Then there was a pause. Then it fell over slowly away from the audience, face on the floor. Then it came up again with the other face towards the audience; and that face was black. Then it rose into a vertical position again, still black, and moved away towards the right. Then, just at the end, the red disc moved off to the left. The whole thing was very gentle, and subservient to the music and the words.

For a couple of years in Paris I had a small ballet-object, built on a table with pulleys at the top of a frame. It was possible to move colored discs across the rectangle, or fluttering pennants, or cones; to make them dance, or even have battles between them. Some of them had large, simple, majestic movements; others were small and agitated. I tried it also in the open air, swung between trees on ropes, and later Martha Graham and I projected a ballet on these lines. For me, increase in size—working full-scale in this way—is very interesting. I once saw a movie made in a marble quarry, and the delicacy of movement of the great masses of marble, imposed of necessity by their great weight, was very handsome. My idea with the mechanical ballet was to do it independently of dancers, or without them altogether, and I devised a graphic method of registering

the ballet movements, with the trajectories marked with different colored chalks or crayons.

I have made a number of things for the open air: all of them react to the wind, and are like a sailing vessel in that they react best to one kind of breeze. It is impossible to make a thing work with every kind of wind. I also used to drive some of my mobiles with small electric motors, and though I have abandoned this to some extent now, I still like the idea, because you can produce a *positive* instead of a fitful movement—though on occasions I like that too. With a mechanical drive, you can control the thing like the choreography in a ballet and superimpose various movements: a great number, even, by means of cams and other mechanical devices. To combine one or two simple movements with different periods, however, really gives the finest effect, because while simple, they are capable of infinite combinations.

A. C., "Mobiles," *The Painter's Object*, ed. Myfanwy Evans (London: Gerald Howe, 1937), pp. 62–67. * English

17 mobiles by Alexander Calder

It is natural to ask for an explanation of these mobiles made by Alexander Calder, as natural as it is to ask about the wind and the swaying shapes of trees. An explanation will not be found in words but in listening, watching and feeling. The mobiles are man made yet they create themselves and obey in some unfathomable way impellent laws of balance, force, and tension as they slowly carve patterns in the space around them. It is this unpredictable yet ordered action, a sort of abstract dance, which intrigues the fancy and makes other explanations superfluous.

To tell how the mobiles came into being, however, the artist recounts the logical history of his own work: "My first abstract things grew out of meeting Mondrian, Léger, Miró. At first I began to paint, but this lasted only a few weeks as I soon began to work with wire (with which I had long been conversant) and detached objects. At first the objects were static ("stabiles"), seeking to give a sense of cosmic relationship. Then I felt that these relations were possibly not the most important and I introduced flexibility, so that the relationships would be more general. From that I went to the use of motion for its contrapuntal value, as in good choreography."

17 Mobiles by Alexander Calder, exh. cat. (Andover, Mass.: 1943), Addison Gallery of American Art, p. 6. * English

A Propos of Measuring a Mobile

It was more or less directly as a result of my visit to Piet Mondrian's studio in 1930, and the sight of all his rectangles of color deployed on the wall, that my first work in the abstract was based on the concept of stellar relationships. Since then there have been variations from this theme, but I always seem to come back to it, in some form or other. For though the lightness of a pierced or serrated solid or surface is extremely interesting the still greater lack of weight of deployed nuclei is much more so.

I say nuclei, for to me whatever sphere, or other form, I use in these constructions does not necessarily mean a body of that size, shape or color, but may mean a more minute system of bodies, an almost spheric condition, or even a void. I.E. the idea that one can compose *any things* of which he can conceive.

To me the most important thing in composition is *disparity*. Thus black and white are the strong colors, with a spot of red to mark the other corner of a triangle which is by no means equilateral, isosceles, or right. To vary this still further use yellow, then, later, blue. Anything suggestive of symmetry is decidedly undesirable, except possibly where an approximate symmetry is used in a detail to enhance the inequality with the general scheme.

The admission of approximation is necessary, for one cannot hope to be absolute in his precision. He cannot see, or even conceive of a thing from all possible points of view, simultaneously. While he perfects the front, the side, or rear may be weak; then while he strengthens the other facade he may be weakening that originally the best. There is no end to this. To finish the work he must approximate.

In a way it is even desirable that one face be of finer quality than the others, for this gives a head and a tail to the object and makes it more alive.

A knowledge of, and sympathy with, the qualities of the materials used are essential to proper treatment.

Stone, the most ancient, should be kept massive, not cut into ribbons. The strength must be retained.

Bronze, cast, serves well for slender, attenuated shapes. It is strong even when very slender.

Wood has a grain which must be reckoned with. It can be slender in one direction only.

Wire, rods, sheet metal have strength, even in very attenuated forms, and respond quickly to whatever sort of work one may subject them to. Contrasts in mass or weight are feasible, too, according to the gauge, or to the kind of metal used, so that physical laws, as well as aesthetic concepts, can be held to. There is of course a close alliance between physics and aesthetics.

Strength and durability in sculpture are highly desirable. However, fineness and delicacy may be even more essential to the general concept, and it will then be necessary to decide which is to control the design.

Also there is the possibility of using motion in an object as part of the design and composition. The sculpture then becomes in one sense a machine, and as such it will be necessary to design it *as* a machine, so that the moving parts shall leave a reasonable ruggedness. Even those sculptures designed to be propelled by the wind are still machines, and should be considered thus, as well as aesthetically.

However the mechanical element must never control the aesthetic. Much better a poor machine and a good sculpture.

So-called Industrial Design is not a fine art. Its motive is to instill "style," i.e. a yearly trend, be it up or be it down, to our daily commodities. There are certain makes of automobiles, whose body designs of a few years ago were simpler and much better than those of 1941–42. And after accustoming ourselves to the hardy simplicity of Army trucks and Jeeps for a few years we are threatened with being subjected to cars after the war whose design will be essentially that of the 1941–4[2] vintage.

As mobiles are so particularly my product I feel a word of two about their measuring and handling to be fitting.

A mobile in motion leaves an invisible wake behind it, or rather, each element leaves an individual wake behind its individual self. Sometimes these wakes are contracted within each other, and sometimes they are deployed. In this latter position the mobile occupies more space, and it is the diameter of this maximum trajectory that should be considered in measuring a mobile.

In their handling, i.e. setting them in motion by a touch of the hand, consideration should be had for the direction in which the object is designed to move, and for the inertia of the mass involved. Perhaps it is necessary to be fairly familiar with at least the *type* of mobile in order to decide upon the direction in which it will best move, but a simple glance should be sufficient to estimate the inertia of the various masses. A slow gentle impulse, as though one were moving a barge is almost infallible. In any case, gentle is the word.

A. C., "A Propos of Measuring a Mobile," essay written in 1943, quoted in James Johnson Sweeney, *Alexander Calder* (New York: Museum of Modern Art, 1951), p. 70. * English

What Abstract Art Means to Me

My entrance into the field of abstract art came about as the result of a visit to the studio of Piet Mondrian in Paris in 1930.

I was particularly impressed by some rectangles of color he had tacked on his wall in a pattern after his nature.

I told him I would like to make them oscillate—he objected. I went home and tried to paint abstractly—but in two weeks I was back again among plastic materials.

I think that at that time and practically ever since, the underlying sense of form in my work has been the system of the Universe, or part thereof. For that is a rather large model to work from.

What I mean is that the idea of detached bodies floating in space, of different sizes and densities, perhaps of different colors and temperatures, and surrounded and interlarded with wisps of gaseous condition, and some at rest, while others move in peculiar manners, seems to me the ideal source of form.

I would have them deployed, some nearer together and some at immense distances.

And great disparity among all the qualities of these bodies, and their motions as well.

A very exciting moment for me was at the planetarium—when the machine was run fast for the purpose of explaining its operation: a planet moved along a straight line, then suddenly made a complete loop of 360° off to one side, and then went off in a straight line in its original direction.

I have chiefly limited myself to the use of black and white as being the most disparate colors. Red is the color most opposed to both of these—and then, finally, the other primaries. The secondary colors and intermediate shades serve only to confuse and muddle the distinctness and clarity.

When I have used spheres and discs, I have intended that they should represent more than what they just are. More or less as the earth is a sphere, but also has some miles of gas about it, volcanoes upon it, and the moon making circles around it, and as the sun is a sphere—but also is a source of intense heat, the effect of which is felt at great distances. A ball of wood or a disc of metal is rather a dull object without this sense of something emanating from it.

When I use two circles of wire intersecting at right angles, this to me is a sphere—and when I use two or more sheets of metal cut into shapes and mounted at angles to each other, I feel that there is a solid form, perhaps concave, perhaps convex, filling in the dihedral angles between them. I do not have a definite idea of what this would be like, I merely sense it and occupy myself with the shapes one actually sees.

Then there is the idea of an object floating—not supported—the use of a very long thread, or a long arm in cantilever as a means of support seems to best approximate this freedom from the earth.

Thus what I produce is not precisely what I have in mind—but a sort of sketch, a man-made approximation.

That others grasp what I have in mind seems unessential, at least as long as they have something else in theirs.

A. C., "What Abstract Art Means to Me," *Museum of Modern Art Bulletin* 18, no. 3, Spring 1951, pp. 8–9. * English

Artist's statement in *Exposición Calder*

Since the beginning of my work in abstract art, and even though it was not obvious at that time, I felt that there was no better model *for me* to work from than the Universe. . . . Spheres of different sizes, densities, colors and volumes, floating in space, surrounded by vivid clouds and tides, currents of air, viscosities and fragrances—in their utmost variety and disparity.

A. C., handwritten statement in *Exposición Calder*, exh. cat. (Caracas: Museo de Bellas Artes, 1955). * Spanish

Artist's statement in *4 Masters Exhibition*

A long time ago I decided, indeed, I was told that primitive art is better than decadent art. So I decided to remain as primitive as possible, and thus I have avoided mechanization of tools, etc. (in spite of having been trained as an engineer).

This, too, permits of a more variable attack on problems, for when one has an elegant set of tools one feels it a shame, or a loss, not to use them.

When I am at a loss for inspiration I think of what Sweeney, or Sartre, or perhaps one or two others, have written on my work and this makes me feel very happy, and I go to work with renewed enthusiasm.

A. C., artist's statement in *4 Masters Exhibition: Rodin, Brancusi, Gauguin, Calder*, exh. cat. (New York: World House Galleries, 1957), p. 12. * English

How to Do It

I start with a small aluminium model, some 50 cm tall, to which I can freely add bits and pieces or holes. As soon as I am happy with the result, I take the model to my friends the Biemonts (there are three of them, and even more!), and they enlarge it as much as I want. When the enlargement is finished provisionally, I add to it nervures and gussets, and anything else I hadn't thought of earlier. Then, they apply my ideas to the reinforced model. And that's it.

A. C., "Comment Faire," handwritten statement in *Calder*, exh. cat. (Paris: Fondation Maeght, 1969), p. 44. * French

Commentary on the *Universes*

The *Universes* were in my 1931 show at the Galerie Percier and were the indirect result of my visit to Mondrian's studio in the Fall of 1930. They weren't intended to move, although they were so light in construction that they might have swayed a little in the breeze. Although I was affected by Mondrian's rectangular paintings, I couldn't do anything

similar. After seeing him, I tried to paint for a couple of weeks, but then I came back to construction in wire. The circular forms, particularly interacting, seem to me to have some kind of cosmic or universal feeling. Hence the general title *Universe*. What I would like to have done would have been to suspend a sphere without any means of support, but I couldn't do it.

A. C., commentary for *Universe*, 1931, cat. no. 18 in H. H. Arnason and Ugo Mulas, *Calder* (New York: Viking Press, 1971), p. 202. * English

Commentary on the *Constellations*

There wasn't much metal around during the war years, so I tried my hand at wood carving in the so-called constellations. I have always liked wood carving, but these were now completely abstract shapes. The shapes, as well as titles, came from Miró, who has been a friend of mine since 1929, but they had for me a specific relationship to the *Universes* I had done in the early 1930s. They had a suggestion of some kind of cosmic nuclear gases—which I won't try to explain. I was interested in the extremely delicate, open composition. I experimented once with Plexiglas to see what effects I could get, and even won a competition. But I didn't like the stuff and so I gave it up. I think it stinks.

A. C., commentary for *Constellations*, 1943, cat. no. 24 in ibid. * English

Alexander Calder, a Blacksmith in the Town
Maurice Bruzeau

We met Alexander Calder near Tours. He has been living for about twenty years in a village on the banks of the Indre, close to the castle where Balzac wrote "Le lys dans la vallée." We spent a long time in his workshops, the rooms where the models of the mobile and static statues in aluminium and iron are born, the largest of which is reserved for sculptures executed to 1/5 scale in the final metal. Let us also mention

that he has a workshop in his house at Roxbury, Connecticut, U.S.A., where he set himself up in 1933. Calder is very stocky, and his extraordinarily expressive face is crowned with hair: the hair of a man used to work, to the resistance of the materials that he has chosen to work, and who will not listen to rubbish. Taciturn therefore, at first glance almost secret, but warm, open, happy as soon as confidence is gained, as soon as a friendship forms.

Calder's conversational style has nothing to do with a majestic speech of a theorist of plastic art. He cuts, divides, welds, rolls and forges: his work speaks for him. These are therefore the rough words and thoughts that we have reported, like a precious harvest, exclusive: without doubt this puzzle gives a better knowledge of Calder than any exegesis.

A sculpture in the town should be used like a sea or river navigation marker with its red discs, its squares and its black triangles. It should be designed as a real urban signal.

Even in aluminium and very small, at the model stage, the object must please completely, whether it is intended to be made in large dimensions, or not.

I studied to become an engineer, then worked and looked for my way as a sculptor, without rushing, accepting little jobs here and there, to live. I always said to myself: "one needs a little technique, sufficient for these small jobs, but there is no need to run! It won't last very long." It was true. One day, I happened to be in the State of Washington, working as a lumberjack. I wrote to my mother for her to send me colors: my mother was a painter herself. Around the forest, there were three mountains. I put them on my first canvas. That was how everything began. Then I went to study painting in New Yok. And in Paris I became a sculptor. Without any rush.

I have executed very large mobile statues, and others adapted to interior dimensions, a landing for example. But things should not always be moved. Not necessarily. Also, some mobile statues are fixed on high polygons: most of the time they are calm, but when the wind blows, and one doesn't really know from where, then they turn and rock, they become more beautiful. But as they are very high, no one is bothered.

The excess of movement in the town? My business is to create sculptures, static or mobile, life or not, and not to think about the noise and movement of the underground and the cars. This poses in priority the problem of the space reserved for these sculptures. Not the reverse problem. Concerning static sculptures, look at the one in the town of Grand Rapids, Michigan. It is painted red, standing in front of modern buildings, in the middle of a place reserved for pedestrians, a large and beautiful place. People walk and stroll around the sculpture, they meet there to discuss, to demonstrate. This "thing" is very well integrated into the town scene. Grand Rapids is a good example of the integration of work into urbanism. And that could change, be mobile rather than static, no trouble at all.

Another example. At Montreal, my static statue in stainless steel is near the river, and there is a lot of space around it. That is very well designed also, and the sculpture has found a good place.

I am often called a blacksmith. It is very difficult and noble to be a blacksmith.

For me, the two essential, fundamental colors are black and white. On one side, I put red, and on the other, blue. Close to blue, a little yellow and orange. Not very much. Other colors don't interest me.

I am not trying to make people happier by my work. But it happens that all those who have something of mine, painting, mobile or static statue, say that it makes them very happy. For example, children adore mobile statues and understand their meaning immediately. I have seen children, here in France, in America or in Great Britain, run and shout with joy in my exhibitions. They like it instinctively.

I am not trying to create a "technological poetry" either! I don't even possess a machine. A sculpture cannot be made mechanically. Obviously, the largest subjects are executed to their final scale, in the factory, as I no longer have the time to do them myself. But their attachments, concerning the mobile statues, are then too mechanical. I prefer my own work, but there is no other solution to the problem of large dimensions.

Atmospheric chemicals and pollution? Metal rusts . . . well, each year it has to be repainted. The ideal, is stainless steel, but only my Montreal sculpture is entirely made in this metal. In mobile statues, certain elements "bars or plates" are sometimes in stainless. I think that this is the best answer to corrosion.

My static statues are no trouble. Maybe they are sometimes worried, but this is by themselves, because of their own personality.

My static statues do not complement the mobile ones. These are able to appear more gay because of aerial character and their movement. My static and mobile statues are like salt and pepper. They can be put together, or separately.

I don't believe any of my sculptures to be unhappy. Firstly, because I am happy in executing them. And then, they take their own size: some ask to remain small, others to grow. But it is true that certain "things" are unhappy . . . to be where they are: in fact, the architect alone decides on their positioning, whether it be in Europe or in America. My opinion is never asked before the integration of a sculpture into its urban environ-ment. The architects build, then they choose the work afterwards. They work backwards.

Should art be intended for the community, or for rich art lovers? Me, I work, that's all. In France, there is a law of 1% for educational building, but sometimes the required works cost two or three times more than the funds reserved by the 1%.

I like to work alone. My wife never comes into the workshop, except in the evening to see what I have done during the day. I have always refused to work collectively, for example with young people, although I have often been asked.

When I work, even when commissioned for the community, I do not necessarily think of all humanity. I mostly think of what those whom I love and those in whom I have confidence, will say about my work: my wife, my friends, and especially an American like me, James Johnson Sweeney, a great art critic . . . I do not think either, that an artist can represent; in sculpture, tragedies such as Pearl Harbor, the atomic bomb or war in general. Certainly, the world is horrible and war must be stopped. And no others started. Because war, for the environment . . . but how can all that be translated into plastic? I forget such things a little bit while working, and working very much.

Metal for me, is neither a friend nor an enemy. I have been studying it for a long time: then I came to an agreement with it!

Maurice Bruzeau, "Alexander Calder, a Blacksmith in the Town," *Revue Française des Télé-comunications* (December 1973), pp. 47–49. * English

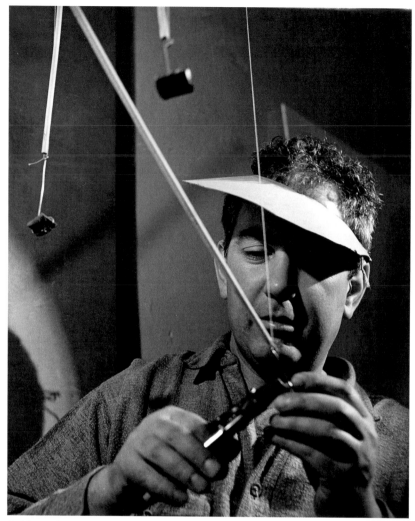 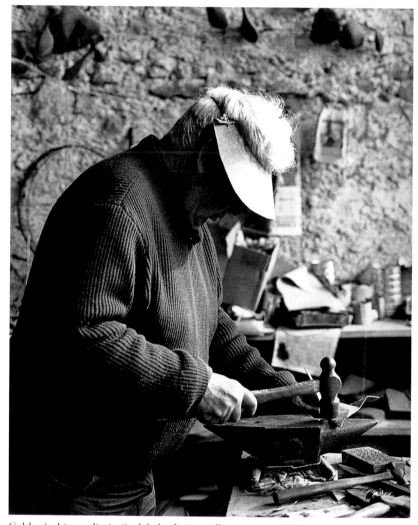

Calder in his New York storefront studio, winter 1936 / Photo: Herbert Matter

Calder in his studio in Saché the Loire valley, ca. 1969 / Photo: Ugo Mulas

Mondrian

Mondrian lived at 26 rue de Départ. (That building has been demolished since, to make more room for the Gare Montparnasse.) It was a very exciting room. Light came in from the left and from the right, and on the solid wall between the windows there were experimental stunts with colored rectangles of cardboard tacked on. Even the victrola, which had been some muddy color, was painted red.

I suggested to Mondrian that perhaps it would be fun to make these rectangles oscillate. And he, with a very serious countenance, said:

"No, it is not necessary, my painting is already very fast."

This visit gave me a shock. A bigger shock, even, than eight years earlier, when off Guatemala I saw the beginning of a fiery red sunrise on one side and the moon looking like a silver coin on the other.

This one visit gave me a shock that started things.

Though I had heard the word "modern" before, I did not consciously know or feel the term "abstract." So now, at thirty-two, I wanted to paint and work in the abstract. And for two weeks or so, I painted very modest abstractions. At the end of this, I reverted to plastic work which was still abstract.

Alexander Calder, *Calder, an Autobiography with Pictures*, Jean Davidson ed. (New York: Pantheon Books, 1966), p. 113. * English

"Calder, His Mobiles"

I had met Mary Reynolds when I went to pick up some photographs, rue de Montessuy, and again in Villefranche when I came off Fordham's boat. We had gotten to be very good friends—as a matter of fact, she got one of the best stars off Marc-Antoine's Christmas tree. One evening, she brought Marcel Duchamp to the rue de la Colonie, to see us and my work.

II. SELECTIONS FROM CALDER'S AUTOBIOGRAPHY

There was one motor-driven thing, with three elements. The thing had just been painted and was not quite dry yet. Marcel said:

"Do you mind?"

When he put his hands on it, the object seemed to please him, so he arranged for me to show in Marie Cuttoli's Galerie Vignon, close to the Madeleine.

I asked him what sort of a name I could give these things and he at once produced "Mobile." In addition to something that moves, in French it also means motive.

Duchamp also suggested that on my invitation card I make a drawing of the motor-driven object and print:

CALDER

SES MOBILES

The show opened around April and there were fifteen objects with motors and some fifteen others, all of which had moving elements. As I used to run a string as a belt around numerous corners—nostalgia for the whistle-punk days—these strings had to be tightened up every so often. And as I made most of the reduction gears myself, there was a good deal of greasing necessary. I spent most of the day of the opening leaning over my gearing, greasing and adjusting my babies. Louisa went home and got a clean shirt for me, but I had quite a beard by the end of the afternoon. . . .

I guess all the members of Abstraction-Création came to see my show. Moreover, their publication came out about this time. They kept it going for several years—one issue a year. At the end, they were hard up for funds and it was suggested they invite some successful artists to have their pictures printed alongside our own—they'd pay a bit more than we to carry the publication along. Somebody suggested inviting Picasso, and Delaunay became furious.

They did invite Brancusi. He sent a photograph, but no funds.

Ibid., pp. 126–27, 130. * English

Stabiles

It was about this time that Jean Arp said to me, "Well, what were those things you did last year [for Percier's]—stabiles?"

Whereupon, I seized the term and applied it first of all to the things previously shown at Percier's and later to the large steel objects I am involved in now—such as "The Guillotine for Eight," shown at the Guggenheim in 1964. . . .

The journalists did not seem to understand anything I was driving at. There were notes about *"l'art automobile,"* and a photograph of one object, likening it to a gear shift. They just did not, or would not, understand.

My fellow members seemed to understand. However, some of the lesser lights asked me, "What formula do you use?"

All this while, Louisa and I were enjoying the house at the rue de la Colonie very much. We saw Campigli, whom we had met at Villa Brune. Campigli was a very good cook. When buying a chicken, he would sniff it—you know where.

Sometimes, we almost had a full reunion of Abstraction-Création at the house. Mondrian used to listen to records and say very seriously, with a shake of the head:

"Ça, c'est bon."

"Ça, c'est pas bon."

One day, I had gone to see him and he surprised me greatly by saying, "At Le Boeuf sur le Toit, they painted the walls blue—like Miró."

I was amazed to hear that he frequented such cabarets or acknowledged Miró. . . .

[A year earlier] the St. Louis Einstein had just somehow joined the group of artists called "Abstraction-Création," which included Arp, Mondrian, Robert Delaunay, Pevsner, and Jean Hélion, among about thirty in all. The invitation to join was extended to me after an investigation by

several members. They came to the studio at Villa Brune and saw what I was doing. So. I became a member too.

During the "Abstraction-Création" days, I also came forth with this statement:

"Disparity in form, color, size, weight, motion, is what makes a composition... It is the apparent accident to regularity which the artist actually controls by which he makes or mars a work."

Ibid., pp. 130, 114. * English

The Spanish Pavilion

In the hallway of the house [we had borrowed in Paris], we improvised a banquet hall [and] entertained all sorts of people: Alvar Aalto, the Finnish architect, and his wife Aino: Alberto, the Spanish sculptor, who had done a large thing at the Spanish pavilion of the Paris World's Fair of 1937 and who sang to us beautifully in Spanish; and many other people.

It had been four years since we had left Paris, and we saw many old friends and I gave my circus. Possibly due to the Paris 1937 World's Fair, one day I went with my friend Miró to see the proposed Spanish pavilion where he was to do a large painting. I met José Luis Sert, the architect of the pavilion.

When I saw what was going on in general in this pavilion, which included "Guernica" by Picasso, I promptly volunteered my services to do something or other for it.

Sert was against this, for obviously I was no Spaniard, but later on, when he had received a fountain displaying mercury from Almaden, which looked like a plain drinking fountain, he called me in to get him out of the dilemma.

I was told that mercury was chemically very active and that the only things it would not corrode were glass and pitch. Whereupon I decided to make my object of iron covered with pitch. I had been to

Lalique's to see what was available in the way of glass, and decided that "glass is not for me"—that is, the glass of Lalique. (I have made things, such as mobiles and several fish, with pendent pieces of broken glass selected by me—some eroded by sea and sand, which I picked up on beaches.) . . .

Finally the Spanish pavilion was ready and it was opened with special ceremonies. The part I liked best was a little old man who beat a tattoo with a mortar and pestle.

Léger was there and said to me:

"Dans le temps tu étais le Roi du Fil de Fer, mais maintenant tu es le Père Mercure." (In the old days you were Wire King, now you are Father Mercury.)

To make the mercury circulate it was necessary to put a little water in with it so that it would wet the pipes and the pump; it would not work otherwise. The pump and a reservoir four feet across were located in a closet under a stairway. The reservoir was eighteen inches deep and full of mercury to maintain a steady pressure. The mercury was led to my fountain, underground, through a half-inch tube and then up thirty inches where it spewed onto an irregularly shaped dish of iron, lined with pitch. This dish was very nearly horizontal; otherwise the mercury would have rushed off. It trickled in turn onto another plate, differently shaped, and then from that onto a chute which delivered it rather rapidly against a sort of bat, attached to the lower end of a rod, which held at the upper end another rod—with a red disc at the bottom and in hammered brass wire the word A L M A D E N on top.

The impact of mercury against the bat made the combination of the two rods, the red disc, and the word "Almadén" weave in the air in a sort of figure eight.

The basin was seven feet and three inches across, but nonetheless we soon discovered that there were little particles of mercury being splattered

on the cement floor all around. As the mercury was very expensive, we tried to conserve it by making slowing-up dams in the chute. This was easy because all we had to do was to warm the pitch and stick in a piece of iron. I also made a labyrinthine spiral for the end of the bat to avoid lateral splatter.

But the most astute conservation stunt was not mine. Somebody took a folded-up fly screen and placed it just where the mercury dripped from one plate to another and this incarcerated the dripping mercury. Finally all worked beautifully, and there was no need to add any mercury to the fountain during the whole show.

It became the favorite pastime of onlookers to throw coins at the surface of the mercury and see them float. This did not gum up the functioning, as the mercury was drawn off from the bottom of the basin.

Some American journalist came through and dubbed me: "Calderón de la Fuente." But Lacasa, an architect and public relations man for the pavilion, claimed it was I who had thought it up.

Ibid., pp. 157–59, 162. * English

Constellations

In 1943, aluminum was being all used up in airplanes and becoming scarce. I cut up my aluminum boat, which I had made for the Roxbury pond, and I used it for several objects. I also devised a new form of art consisting of small bits of hardwood carved into shapes and sometimes painted, between which a definite relation was established and maintained by fixing them on the ends of steel wires. After some consultation with Sweeney and Duchamp, who were living in New York, I decided these objects were to be called "constellations."

Pierre Matisse must have thought Yves Tanguy and I were not doing so well, because he showed us together. I was mostly in the first room and Tanguy in the second room. In the constellations nothing moved, and it was a very weird sensation I experienced, looking at a show of mine where nothing moved.

The first constellation I had made was a small thing to stand on a table, with at one end a small carved thing looking like a bone and painted red. At the Matisse Gallery, this was standing on the floor and Jacqueline Breton, who was separated from André and affected an enormous Great Dane, came to the show with her mutt, and when he saw this bone-shaped object he menaced it and made as though to take a snap at it.

Ibid., pp. 179–80. * English

Pas Nobles Mobiles

Some architect appealed to me to make one or two very small mobiles to go with the model of a proposed building. I made these, took them to New York, and stopped at the Sweeneys', where I met the Serts. Everybody shouted:

"He's not such a good architect!"

And Laura Sweeney grabbed one little object and Moncha Sert grabbed another one. The architect never saw any of them.

These two little objects are the forebears of a line of very small mobiles I occasionally make. I got rather excited making them as small as my so-called clumsy fingers could do them.

Then in the fall of 1945, Marcel Duchamp said, "Yes, let's mail these little objects to Carré, in Paris, and have a show."

So a whole race of objects that were collapsible and could be taken to pieces was born.

I discovered at that time that a package eighteen inches long and twenty-four inches in circumference was [the maximum size] permissible [for mailing]. Well, I could squeeze an object into a package two inches thick, ten inches wide, and eighteen inches long. Using the diagonal, I

could even squeeze in a nineteen-inch element. Some of my plates bolted together and the rods unhooked and collapsed, and I kept mailing these to Carré, who had replied in the affirmative to a cable of Marcel Duchamp. So by June 1946, I had quite a stock of objects in Carré's larder and I took a plane over. There were even some quite large objects, such as the "Lily of Force." We set about photographing these things with Carré's photographer. The photographic material was very poor that year.

It was in the middle of the summer and I still don't understand why the show was put off—probably because the middle of the summer is a dead season in Paris. So I decided to go home again, via England where I got a plane.

I came back to Paris in October 1946. Jean-Paul Sartre had been in Mexico the previous year and on his way back, during a stay in New York, he had visited a few French artists. André Masson brought him to see us in Roxbury and I saw him again in New York, where he came to my little shop. I gave him a mobile bird made out of Connecticut license plates —there is nothing tougher than these; they look like aluminum, but they hang on forever.

During my first visit to Carré, we decided to ask Sartre for a preface, and he agreed. When I came back to Paris the second time, the catalogue was about ready.

One day, Carré said, "You go to Mourlot, the lithographer, and see what I have been doing for you." I went, and discovered a beautiful catalogue, in which the indifferent photography was replaced by a sort of line drawing—the contour of my objects—with color fillings.

Unfortunately, I found the thing a bit monotonous, as all the backgrounds were gray, and I suggested a few blue and yellow backgrounds as well.

However, the lithographic printing process is quite inexorable; you can't go back on what you did yesterday.

The following day, I got a *petit bleu*—telegram—from Louis-Gabriel Clayeux, the right hand of Carré at the gallery then, saying, "*Catastrophe!*"

Carré was furious with me and threw out the yellow backgrounds.

Finally Sartre's preface arrived and it all made a fine little book, with some of Herbert Matter's photographs, as well, of objects in motion.

In the show, there were several objects composed of a heavy metal plate, hanging horizontally close to the floor from a davit that came up from the floor through a hole in the plate; above this were some foliage and berries.

Carré wanted to put these on some pedestals and I said, "No, my wife insists these must be right on the floor."

And Carré said, "*Ce n'est pas noble.*" (It is not dignified.)

There were two mobiles of the epoch of the constellations—the war period—made of bits of hardwood, carved, painted, and hanging on strings at the end of dowel sticks. Carré had previously deleted these from what he wanted to show, so I gave them to Mary Reynolds, who was back in Paris. And she always refers to them, ever since, as the "*Pas Nobles Mobiles*" (the undignified mobiles).

These now belong to the Guggenheim Museum.

The show at Carré's opened on October 25, 1946; there were a lot of visitors and even Henri Matisse. The gallery was in the *huitième arrondissement*—there are a lot of electric-power users in this section, and from five to six in the afternoon they would turn off the electricity to save coal, as a postwar economy measure.

So, we put a candle on the floor under an object with a multitude of small leaves and made it rotate. It was very fine with the shadow going around the candle on the ceiling. This object is now in the Basel Museum.

Ibid., pp. 188–89, 194. * English

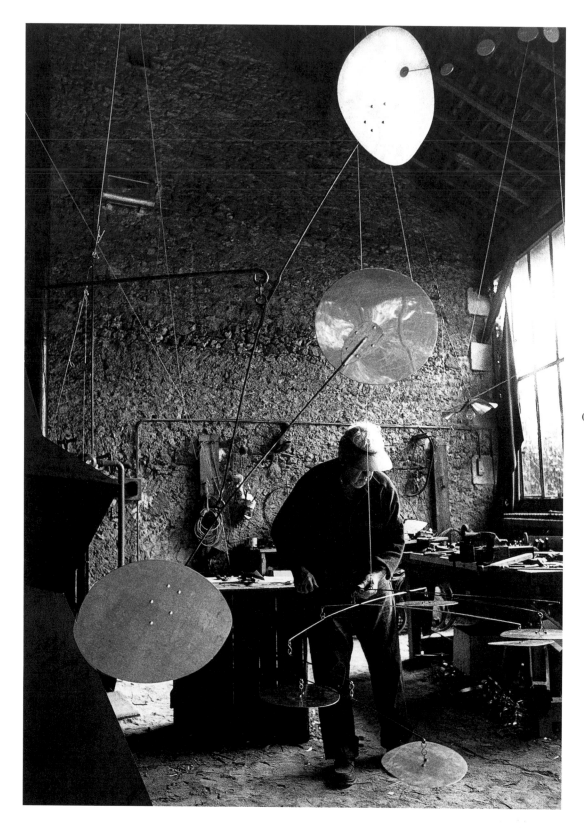

Calder in his studio in Saché, ca. 1969 / Photo: Ugo Mulas

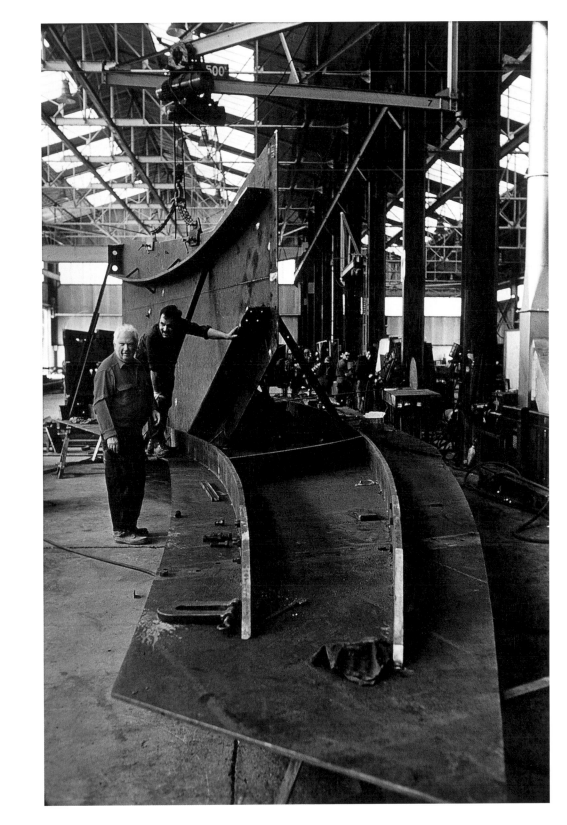

Calder with *Crossed Blades*, at the Biémont Ironworks,
Tours, 1967. Courtesy Calder Foundation

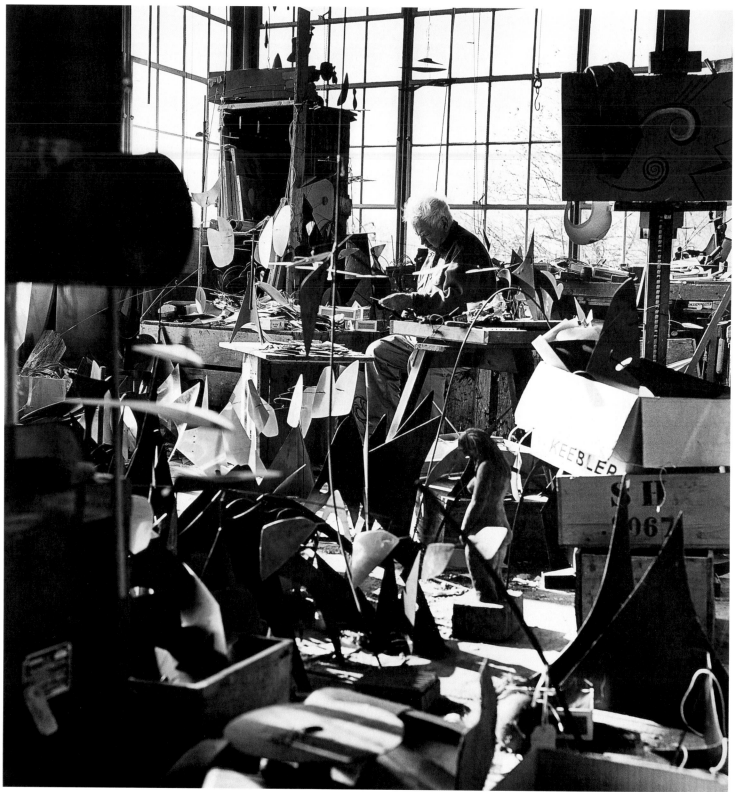

Calder in his studio in Roxbury, Connecticut, ca. 1964 / Photo: Herb Weitman

Fernand Léger

Why not?

"It's serious without seeming to be."

Neoplastician from the start, he believed in the absolute

of two colored rectangles. . . .

His need for fantasy broke the connection;

he started to "play" with his materials: wood, plaster,

iron wire, especially iron wire . . . a time both picturesque and witty. . . .

A reaction; the wire stretches, becomes rigid,

geometric—pure plastic—it is the present era—

an anti-Romantic impulse dominated by a concern for balance.

III. TEXTS BY OTHER AUTHORS

Looking at these new works—transparent,

objective, exact—I think of Satie, Mondrian,

Marcel Duchamp, Brancusi, Arp—these unchallenged masters

of unexpressed and silent beauty.

Calder is in the same family.

He is 100-percent American.

Satie and Duchamp are 100-percent French.

Where do they meet?

Fernand Léger, "Eric Satie Ilustrated by Calder," preface of *Alexander Calder: Volumes – Vecteurs – Densités – Dessins – Portraits*, exh. cat. (Paris: Galerie Percier, 1931). * French

Alexander Calder, or the King of Wire
Gabrielle Buffet-Picabia

The laws of contrast are probably to blame for the fact that Alexander Calder, American sculptor fit to work marble and granite, likes to use one material only: wire!

The word "material" is in fact not very appropriate here: concern for "material" properties is totally excluded from his work, and its real element is . . . motion.

Calder has a gift for the sense of motion, just as others have a gift for Poetry or Music.

He was first famous for his skillful and humoristic works, silhouettes, masks and above all for an animated circus that attracted all of Paris. He then exhibited in the Galerie Vignon a series of ingenious and strange machines to which it is difficult to assign a logical name and a specific place in the domains of the Nine Muses.

Calder calls them "Mobiles," suggesting that they are neither objects nor machines. It is these pieces that interest us most.

In the "Room of Useless Machines," 5, 8, 10 Mobiles buzz, driven by small motors and transmission belts.

Each of them follows a different aesthetic course, precise and complete. The value of each movement is complemented by optically intense, contrasting colors: red, black, white.

Over here, the arabesque performed by a wire in a swinging motion seems destined to cut across the agitated course of a pendulum: will they meet? No, they avoid each other with infinitesimal precision.

Over there, two small spheres, one red and one black, race each other along different trajectories and reach their starting point together.

The construction of these mobiles entails exceptional instinct or knowledge of the laws of mechanics: but finer still is the ethical identity they draw from the different arts in time and in space!

It borrows from music the succession of elements and the interplay of counterpoint, and while projecting itself in time, it also comes close to architecture in the modeling of lines in space.

These works have aroused great interest (perhaps because of the mysterious action of their motion); they touch us particularly because they remind us of the explorations undertaken so long ago by the Futurists, which in their own time were considered decadent fantasies destined to leave no trace; Calder's works achieve an "aesthetics of movement" that the Futurists had formulated in their theories, a direction suggested by the works of a few isolated individuals such as Picabia and Marcel Duchamp.

Despite the negative predictions of bourgeois minds, this heroic period of "abstraction" is proving to be one of the most enlightened intellectual phases and, as the most symptomatic artistic formula of our time, the only one likely to survive and evolve.

Gabrielle Buffet-Picabia, "Alexander Calder, ou le roi du Fil de Fer," *Vertigral* 1, no. 1, July 15, 1932, p. 1. * French

The American Sculptor Calder
Sebastián Gasch

This recent visitor to Barcelona belongs to the group *Abstraction–Création*, which counts among its members artists as important as Arp, Baumeister, Hélion, Mondrian, and others. This group is dedicated to creating pure plastic art, enlivened with illustrative and anecdotal elements, but not figurative.

Calder's sculptures are creations, as opposed to copies, imitations, transcriptions, or interpretations of nature. What he means by creation is the invention of objects that will have a beauty as unprecedented and unique as a natural creation; they will look like no other existing thing. Calder's works are beautiful in themselves and not merely in comparison to something; their beauty is autonomous. They are pure creation.

like the creation of a fruit or a flower. Pure invention of forms. Creation, not imitation.

Calder belongs to the same artistic family as Arp and Brancusi, but takes their reduction of plastic form a step further. They create corporeal objects that have bodies, whereas Calder creates skeletons. These metallic skeletons impress us most, because of their absolute nudity and simplicity, and the beauty of their aesthetics.

Sebastián Gasch, "El escultor americano Calder," *AC*, no. 7 (1932), p. 43. * Spanish

Sandy Calder, Forger of the Moon
Gabrielle Buffet-Picabia

From the Eiffel Tower, that irreverent long shot, to Calder, Sculptor of the wind, Forger of the moon, such a long distance has been covered!

The works he brings to us from across the Atlantic provide clear evidence of the new position adopted by plastic arts; and the testimony they convey is all the more precise that Calder seems not to have suffered the anguish and uncertainties over the "disintegration" of objects and subjects that tormented the generation preceding his, or the somewhat childish quarrels over the terms "abstract" and "concrete," which is still not settled. He set out from the previous phase with the confidence of a generation already firmly established on its conquests. We must add a few comments on his Yankee origins and point out that, far from denying them, he used them to the extreme, thus escaping from the rigid and obsolete classicism that has dominated the tastes of American artists even to this day and suppressed all attempts at originality from them. This is all the more remarkable because his father and mother were official artists and were well-regarded locally. Calder belongs to the generation of new American intellectuals known to us through their native literary works. They reveal to us temperaments and interests very different to the European frame of mind and resolutely set on the future and on the contributions of science,

which does not keep them from evoking latent memories of pioneer ancestors and a certain nostalgia for their first interactions and struggles with the wilderness.

Calder is gifted with surprising manual dexterity. It is rather exciting to watch his big powerful hands, real elephant paws, touch, grind, manipulate with his pliers (his favorite instrument) thin wires that he transforms into silhouettes or jewelry, real or imaginary objects, all bearing the seal of his particular genius.

I first visited his house in Paris, on the rue de la Colonie, in 1932 and was amazed at the gadgets he had invented to ease the inconveniences of daily domestic life. In the stairwell, long strings hung from the ceiling all the way to the ground allowing the front door to be opened from the top floor or taking the mail all the way up. The bathroom and the kitchen were favorite spots for his ingenious devices. In the bathroom, a little red flag would appear mysteriously to signal that the heater was on. Drawers and faucets were embellished with ornaments of wire or copper, making these utilitarian devices easy to handle and giving them a subtle sculptural form.

Calder arrived in Europe in 1926, which is when his great adventure began. . . . In Paris, he felt trapped, confined [in a tiny hotel room, but] he didn't travel in artistic circles, he went dancing at the Dôme and crafted animated toys activated by strings, like marionettes, which were early heralds of his later works. These little figures, schematic but quite realistic, and articulated to present a humorous exaggeration of their characters, displayed their dynamic quality when he set them in motion. The conception of these figures and the skill with which they were made lie little short of a masterpiece. . . . The performances of the miniature *Circus* designed and operated by Calder, accompanied by his amusing commentary, made him unexpectedly famous in a variety of circles. People called him the king of wire and string. But this celebrity did not satisfy him; he wanted something else. Calder returned to the United States,

where he spent a year carving wood. In the meantime, he met Léger, Miró, and Mondrian; the latter deeply impressed him. These encounters probably kindled the aspirations he harbored, which were still rather confused, and would help liberate his personality, with his skill and craftsmanship serving as the vehicle.

In 1932, Calder's house on the rue de la Colonie was surprising not only because of the strings filling the entrance hall, but also because in most rooms you would find things he'd made that were even more puzzling: various medium-size devices with many parts, each one different from the next and all of them really working, capable of activity and movement. These pieces were unclassifiable, and you would not know what they were designed for until they actually functioned, activated by little independent engines, each producing at a different rhythm. . . . We could say at the sight of these surprising works that *Calder sculpted Motion rather than Matter.*

Marcel Duchamp christened them "mobiles," the most suitable name for them. Arp, in turn, gave the name "stabiles" to those of Calder's works which were not destined to move.

Calder soon tired of the automatism of motors, as it invariably implied stability. He abandoned this concept of restricted motion in favor of a new type of mobiles composed of different pieces of metal, wood, and even glass suspended from the ends of thin supple wires, which would float in space in configurations that would change according to their various weights and positions. The rudimentary appearance of these mobiles concealed the fact that their balance, angles, and points of support had been carefully measured and calculated to allow a random breath of air to generate motion, setting each piece on a different course.

After eight years of absence, Calder returned to Paris with his latest pieces. In his new works, he seems to have achieved an extraordinary command of the interaction between weight and motion.

Here they are, carefully assembled and displayed. When you enter the room where the mobiles are on view, their long branches moving and rustling, you walk into an unknown world, where the welter of wires, iron stems, and pieces of steel gives you the hallucinating impression of a habitat and vegetation from the moon or Mars, where human values, appreciations, and aesthetic judgments lose all meaning (Calder himself said that his primary sources of inspiration were the Universe and Cosmography). Materials, ends, and means are completely disoriented, and yet together they constitute an authentic, deliberate, organized creation. Some mobiles recline under the caress of the breeze like water plants in a stream. Others do quite the opposite, challenging the current with their long metal tentacles. In this disturbing atmosphere, weight also seems to have lost its meaning. Heavy pieces of copper are scattered on the ground, representing different parts of a human body. But as soon as they are placed on their pivots, they are extremely responsive to the moving air.

Other, more recent, works have an entirely different intention. Although they are not mobile, they too are made up of multiple components, a cluster of forms that seems to have resulted from some cosmographical cataclysm. Splinters, debris, fragments of iron and wood are arranged at a certain distance from each other, set in space on rigid stems that connect them to a base, whether a wall or the ground. One almost wishes that a giant magnet could eliminate the constraints imposed by the wire stems and let these *Constellations* (another term invented by Marcel Duchamp) float in space freely, magically held up there by an invisible magnetic force.

Calder was criticized for making art for the Paris World's Fair [in 1937] rather than for art galleries. But this reproach does not hold up when we consider the difficulty of understanding and interpreting such complex works for a public unfamiliar with the new ideas about form and movement that had been subject to debate since 1908 or 1909, especially

among the Futurists. During this period, motion was represented in the plastic arts only by the static depiction of the successive phases of movement. . . . Calder and his mechanical skills brought real mobility to this evolution. Therefore, it is only natural that his work should be seen as the outcome of almost fifty years of research by the pioneers of a form of Art that, today, best represents the concerns and interests of our time.

Gabrielle Buffet-Picabia, from "Sandy Calder, Forgeron lunaire," *Cahiers d'Art*, nos. 20–21 (Paris 1945–46), pp. 324–33. * French

The Studio of Alexander Calder

André Masson

Newcomer from Europe, as they say,
 It is true that over there iron and copper are
 instruments only of evil
adding death to death and to degraded life
I fled, a fortunate fugitive,
The day and the night opened before
Wings —algae— mobile leaves.
I salute you forger of giant dragon-flies
Mercury-diviner your spring disclosed
A water heavy as tears.
But a merry-go-round of little scarlet moons
 fills me with joy
I think of a transparent circus
It is a leaf traversed by the sun.
One green day you saw a red bird
Pursuing a yellow bird:
You know that we are bound to nature
That we belong to the earth.
Hung from the studio's rafters,

in the striped light a gong sensitive to
 the whims of the air
is struck with extreme caution
Its note is the footfall of a dove: what hour does is strike?
This is the hour of the child with the cherries.
Here the seconds have not the weight of the clock
nor do they lie quiet in the grass
for they cannot conceive of immobility
they love the rustling of reeds
and the cry of the tree-toad so expert at musical breathing
and they play between your fingers, Calder, my friend.

André Masson, "L'Atelier d'Alexander Calder," handwritten poem, 1943, trans. Ralph Manheim, reproduced in *Alexander Calder*, exh. cat. (New York: Buchholtz Gallery/Curt Valentin, 1949). * French

The Mobiles of Calder

Jean-Paul Sartre

If sculpture is the art of carving movement in a motionless mass, it would be wrong to call Calder's art sculpture. He does not aim to suggest movement by imprisoning it in noble but inert substances like bronze or gold, where it would be doomed forever to immobility; he lures it into being by the use of incongruous and base materials, taking bits of bone, tin, or zinc and building strange constructions of stems and palm fronds, of disks, feathers, and petals. They are sometimes resonators, often booby traps; they hang on the end of a thread like spiders, or perhaps squat stolidly on a pedestal, crumpled up and seemingly asleep. But let a passing draft of cool air strike them, they absorb it, give it form, spring to life: a "mobile" is born!

 A "mobile," one might say, is a little private celebration, an object defined by its movement and having no other existence. It is a flower that fades when it ceases to move, a "pure play of movement" in the sense that

we speak of a pure play of light. Sometimes Calder amuses himself by imitating a natural form: he has given me a gift of a bird of paradise with iron wings. It needs only to be touched by a breath of warm air: the bird ruffles up with a jingling sound, rises, spreads its tail, shakes its crested head, executes a dance step, and then, as if obeying a command, makes a complete about-turn with wings outspread.

But most of Calder's constructions are not imitative of nature; I know no less deceptive art than his. Sculpture suggests movement, painting suggestes depth or light. A "mobile" does not "suggest" anything: it captures genuine living movements and shapes them. "Mobiles" have no meaning, make you think of nothing but themselves. They are, that is all; they are absolutes. There is more of the unpredictable about them than in any other human creation. No human brain, not even their creator's, could possibly foresee all the complex combinations of which they are capable. A general destiny of movement is sketched for them, and then they are left to work it out for themselves. What they may do at a given moment will be determined by the time of day, the sun, the temperature or the wind. The object is thus always halfway between the servility of a statue and the independence of natural events; each of its evolutions is the inspiration of a moment. It may be possible to discern the composer's theme, but the mechanism itself introduces a thousand personal variations. It is a fleeting snatch of swing music, evanescent as the sky or the morning: if you miss it, you have lost it forever. Valéry said of the sea that it is a perpetual recommencement. A "mobile" is in this way like the sea, and is equally enchanting: forever re-beginning, forever new. No use throwing it a passing glance, you must live with it and be fascinated by it. Then and only then will you feel the beauty of its pure and changing forms, at once so free and so disciplined.

It may seem that these movements are made only for the delight of our eyes, but they have a profound metaphysical sense. "Mobiles" have to draw their mobility from some source. At first they were equipped with electric motors, but now it suffices to place them in the midst of nature, in a garden, for example, or an open window, and let the breezes play with them as with an Aeolian harp. They feed on air, they breathe, they borrow life from the vague life of the atmosphere. Thus their mobility is of a particular kind.

Though made with human hands, they never have the precision and efficiency of Vaucanson's automaton. But the charm of the automaton is that it waves a fan or strums a guitar like a man, though with the inflexible jerkiness of a machine. The "mobile," however, weaves uncertainly, hesitates, and at times appears to begin its movement anew, as if it had caught itself in a mistake. In his studio I have seen a hammer and gong hung very high in the air; at the faintest breath the hammer went after the gong, which was revolving; and, taking its time in hitting its target, the hammer launched itself and passed to one side clumsily, then when least expected came straight up on the center of the gong and struck with a frightful noise. Yet the motions are too artfully composed to be compared to those of a marble rolling on a rough board, when each change of direction is determined, by the asperities of the surface. They have their own life.

I was talking with Calder one day in his studio when suddenly a "mobile" beside me, which until then had been quiet, became violently agitated. I stepped quickly back, thinking to be out of its reach. But then, when the agitation had ceased and it appeared to have relapsed into quiescence, its long, majestic tail, which until then had not budged, began mournfully to wave, and, sweeping through the air, brushed across my face. These hesitations, resumptions, gropings, clumsinesses, the sudden decisions and above all that swanlike grace make of certain "mobiles" very strange creatures indeed, something midway between matter and life. At moments they seem endowed with an intention: a moment later they appear to have forgotten what they intended to do, and finish by

merely swaying inanely. My bird, for instance, can fly, swim, float like a swan or a frigate. It is one bird, single and whole. Then all of a sudden it goes to pieces and is nothing but a bunch of metal rods shaken by meaningless quiverings.

The "mobiles," which are neither wholly alive nor wholly mechanical, and which always eventually return to their original form, may be likened to water grasses in the changing currents, or to the petals of the sensitive plant, or to gossamer caught in an updraft. In short, although Calder does not seek to imitate anything—because he does not want anything except to create scales and chords of hitherto unknown movements—they are nevertheless at once lyrical inventions, technical combinations of an almost mathematical quality, and sensitive symbols of Nature, of that profligate Nature which squanders pollen while unloosing a flight of a thousand butterflies; of that inscrutable Nature which refuses to reveal to us whether it is a blind succession of causes and effects, or the timid, hesitant, groping development of an idea.

Jean-Paul Sartre, "The Mobilers of Calder," in *Alexander Calder*, exh. cat. (New York: Buchholz Gallery/Curt Valentin, 1947), originally published in *Alexander Calder: Mobiles, Stabiles, Constellations*, exh. cat. (Paris: Galerie Louis Carré, 1946), pp. 9–19. * French

Calder

Fernand Léger

It would be difficult to find greater contrast between two things than between Calder, who weighs 220 pounds, and his slender, gossamer mobiles. Calder is something like a walking tree trunk, displacing a lot of air as he moves, and blocking the wind. One cannot help noticing him. He is an element of nature, swaying, smiling, and curious. Let loose in an apartment, he is a real danger to fragile things; he is better off outdoors, in the wind, in the sunshine.

Although it is not immediately obvious, his eye is sharp, he doesn't miss a thing, he sees everything. We have often explored the streets of New York together looking for picturesque elements: this is where the American jumble of things starts. You can see the crude reality of abandoned objects, junk, sculptural pieces of old garbage cans adorned with wire and intertwined with vegetables . . . And looking up to the roofs, you will find geometrical shapes and the outline of a thousand transparent, metallic structures against the sky, playing with the light. Calder's eye catches all of it. I already wrote somewhere that Calder is a realist. [His works] are based on all these scattered elements of daily modern life, and it seems appropriate that it is this big, hundred-percent American guy who integrates all of this and turns it into sculptural objects, making them move graciously at the touch of a magic button. Mobile sculpture was invented some time ago . . . Will Calder bring something new to it?

Calder's works should remain popular.

Extract from Fernand Léger, "Calder," *Derrière le miroir*, no. 31 (Paris: Fondation Maeght, 1950). * French

Alexander Calder: Introduction

James Johnson Sweeney

Exuberance, buoyancy, vigor are characteristics of a young art. Humor, when it is a vitalizing force not a surface distraction, adds a dimension to dignity. Dignity is the product of an artist's whole-hearted abandon to his work. All these are features of Alexander Calder's work, together with a sensibility to materials that induces new forms and an insatiable interest in fresh patterns of order.

Calder is an American. The most conspicuous characteristics of his art are those which have been attributed to America's frontier heritage—"that coarseness and strength combined with acuteness and inquisitiveness; that practical, inventive turn of mind, quick to find expedients; that masterful grasp of material things." . . . "that restless, nervous energy," . . .

"that buoyancy and exuberance which come with freedom."* But Calder is a child of his own time. His vernacular is the vernacular of his age in America—an age in which the frontiers of science, engineering and mechanics have dominated the popular imagination in the same way that the national frontier dominated it a century ago.

On the side of tradition, two generations of sculptors—father and grandfather—gave him an intimate familiarity with the grammar and conventions of art. In Paris he came to know the researches of some of the most venturesome contemporary pioneers at a time when he himself was seeking a more radical departure. The result in Calder's mature work is the marriage of an internationally educated sensibility with a native American ingenuity. Through the individuality of his work he has an established place in contemporary art both here and abroad.

The last fifty years have seen a profound reaction against the deliquescence of form which had marked Occidental sculpture since the Renaissance. Calder's art embodies this reaction.

From the time of Michelangelo until the opening of the twentieth century, nobility of style and simplicity of technique seemed usually incompatible. The sculptor as often sought to disguise his materials as to demonstrate them. The artist developed a facile virtuosity, which during the Baroque period became a prime quality. Modeling in clay for reproduction in bronze or marble tended generally to replace direct carving. Fluidity of sculptural form reached its highest level with Bernini in the seventeenth century. But, in general, the relaxation of material disciplines led to a decay of sculptural unity and force.

With the twentieth century a desire for simplicity of form and of expression began to reappear. In sculpture the most direct route to both these ends lay through a re-establishment of the discipline of materials.

The peculiarities of a raw material—the grain of the wood, the texture and hardness of a stone, the surface qualities of a metal—if respected, would exert a tonic restraint on the sculptor and his forms. African Negro sculpture was a clear illustration of the advantages of this discipline. It accepted and exploited the cylindrical shape of the tree trunk as well as the incidental suggestions of its grain and knots.

With Brancusi, virtuosity of handling gave way to the barest simplicity and directness. The orthodox materials of sculpture—metal, wood and stone—were employed once again to display their individual properties, not to simulate those of one another. The lightness and apparent insubstantiality of a polished metal surface were exploited to suggest a *Bird in Flight* or the shimmer of a *Fish*. Among the younger men who followed Brancusi we find Calder, like Henry Moore, "always ready to share credit for his work with his material."**

Calder's characteristic material is metal. He has always avoided modeling in favor of direct handling—cutting, shaping with a hammer, or assembling piece by piece. Such an approach has fostered a simplicity of form and clarity of contour in his work. It allies him with Brancusi, Arp, Moore and Giacometti in their repudiation of virtuosity.

At the same time Calder's concern as an artist with mechanical forms and mechanical organizations, and his use of new or unconventional materials link him with the Russian constructivists of the early twenties. Open composition was their interest, as opposed to the compressed unity of Brancusi. Their aim was to expand the conception of sculptural form, so long tied to nature and to conventional materials. Instead of advocating merely a reform in the use of the ortodox materials of sculpture, the constructivists explored new materials—steel, glass, celluloid, rhodoid and the like.

* Frederick Jackson Turner, *The Frontier in American History*, p. 37.

** Philip Hendy, "Henry Moore," *Horizon*, September 1941, vol. 4, no. 21, pp. 200–26.

The Paris cubist painters had felt that a volume could be more truthfully rendered by making its form, or a section of it, transparent. In this way features on the other side, which would normally be masked, could be seen. The constructivist sculptors carried the theory a step further, employing such transparent materials as glass and celluloid for the same purpose. Transparent surfaces led to surfaces actually nonexistent, but indicated by lines—wires, strips of wood—or merely implied by other planes. These surfaces defined "empty," or more precisely, virtual volumes. Certain constructions organized enclosed volumes; others, by means of the implied projections of their lines and planes, were designed to organize the surrounding space; or the space within a volume was employed as a foil to a solid in a sculptural composition. Even movement was tentatively introduced by Gabo in 1920 to add a time element and to trace virtual forms in space.

This last problem is the one which Calder has explored more fully than any other artist, after coming to it quite independently of constructivism. But Calder's most original contribution is his unique enlivening of abstract art by humor. Through humor he satisfies the observer's appetite for feeling or emotion without recourse to direct representation. The appeal of representation had evidently been the culprit in upsetting the balance between form and subject in art. In the effort to readjust this balance the temptation had been to limit representational appeal drastically, even to expunge it. As a result the art produced by the extremists was often chilly to the point of torpor. Every living experience owes its richness to what Santayana calls "hushed reverberations." Even without direct representation, natural materials—wood and stone—all have their funded associations for us. The "machine age" emphasis in the constructivists' materials was a limitation. Where associations existed they were usually of an impersonal, scientific or industrial character. For their esthetic effects the constructivists could look only to formal relations of a geometrical, architectural character. Calder, however, with similar materials found a means to give a new vitality to his structures, without compromising the nonrepresentational approach. Toys pointed the way. If one can enjoy certain qualities that predominate in a toy, such as unfamiliar rhythms and provocative surprise, why should these features not be embodied in more ambitious esthetic expressions—provided, of course, they are held in proper balance with form and material?

The result in Calder's work is the replacement of representational interests by a humor that stirs up no specific associations and no emotional recollections to distract the observer's attention from the work of art itself. Through this conscious infusion of a playful element, Calder has maintained an independence of the doctrinaire school of abstract art as well as of orthodox surrealism. At the same time the humor in his work is a protest against false seriousness in art and the self-importance of the advance-guard painter, as well as of the academician.

James Johnson Sweeney, *Alexander Calder* (New York: Museum of Modern Art, 1951), pp. 7–9.
* English

Calder, Prodigious Smith

Alejo Carpentier

This is my chisel," says Calder, brandishing his pliers. And in this metaphorical truth lies the key to an unprecedented type of art, in which mobility has been instilled after centuries of tradition had kept it completely immobile. Ancient makers of allegories used their chisel to create quadrigas high on elevated cornices, their hoofs eternally frozen in empty space; Calder's pliers, in contrast, give birth to imaginary horses, creatures from outer space hovering over our heads, unconstrained by the normal weight imposed by celestial mechanics, or by the heavenly cadences of the "music of the spheres," or by Galileo's pendulum. It is the poetry of trees subservient to a breeze that caresses and dishevels them, the poetry produced by an art that makes metals fly.

In Calder's powerful hands, iron becomes docile, light, insubstantial, akin to the feather and the leaf, to everything that turns, that murmurs, that dances in the wind. As soon as it is set, each form ceases to be inert and re-creates itself in its real element; it is always different, always new, it lives in the passage of time, independent from its creator, as free as its bonds and the laws of physics will allow; in its active nature and in its capacity for change, it is similar to a living creature.

Whoever thinks of a sculptor's workshop imagines remains of wax, unfinished torsos, frozen smiles, abandoned heads, and eyes that were never fully chiseled out of the stone. But whoever remembers Calder's workshop will think of metal, acetylene torches, and flames, and of the imposing smith working in the glow of his furnace. Like the man in the fairy tale who threw a stone so high in the air that it would never fall back to earth, he gives wings to flightless creatures. Out of the humblest and hardest materials on earth, he creates harmonies of forms, swarms, flowerings, gravitations, mirages, of shadow games. Whereas we usually say "hard as iron," we would sooner say "light as iron," about Calder's mobiles, floating in the air above terra firma, from the smallest birdlike ones to the biggest, hardiest ones featuring disks, bolts, shafts, and links.

On the bell tower of old cathedrals, at the stroke of noon, we can usually witness the twelve Apostles emerging through one little door and disappearing through another one, after briefly looking out at the lights of the city. Local inhabitants ceased to notice this little parade centuries ago: habituated to the never-changing daily ritual, they ended up forgetting it, until one day, a lizard or a bat caught in the clock's mechanism broke it. Scandal! The Apostles marched out at twenty past eleven, while the cock crowed Saint Peter's denial at twelve. People noticed the bell tower again, and complained about the problem. . . . The simple difference of appearing earlier was all it took for the figures to come back into people's lives and not to be forgotten for years like the quadrigas immobilized on their high cornices. We know that Calder at one time activated his mobiles with little motors, but he soon abandoned this project: his mobiles were too alive, too devoted to the wind to be restricted to the monotony of regular movements. Leaving a certain amount to chance or fortune was necessary for them, as for all living things, in order to assert their personality. Once he has assembled them, Calder blows his mobiles into life, into their own life! . . .

They consist of forms that move, turn one way and then another, stand apart, bump their way into a new trajectory, up, down, or toward the observer of their unpredictable impulses. Are they abstract? It would be difficult to characterize them as abstract when they call for the very things that keep them from conforming to abstraction: air, depth, tempo, the possibility of backward motion, of running after their own shadows. They are, more accurately, poetic forms: poetry in complete freedom. "Sky goats," like the creatures Sancho Panza would say he saw when dismounting from the imaginary horse Clavileño: "There are two green ones, two rose-colored ones, two blue ones, and one multicolored one." "That is apparently a new breed of goat," Don Quixote said to him, "one that has never before been seen in this land." "Obviously," replied Sancho, "since land goats are different from sky goats."

Calder, the prodigious smith, fills our space with little goats, bears, ships, tamed stars, suspended comets—new sky goats—just as Sancho Panza, the knight's squire did while carrying hard, heavy iron gear, when he discovered poetry and his imagination suddenly filled the skies with flocks, swarms, hends, clouds, flights. "This is my chisel," says Calder, brandishing his pliers, which, extending the metaphor, we could also call baton, wand, ruler, hammer—or a creator's breath instilling life into dormant matter.

Alejo Carpentier, "Calder, Calderero prodigioso," in *Calder*, exh. cat. (Caracas: Museo de Bellas Artes, 1955). * Spanish

Sandy Calder

Willem Sandberg

Sandy Calder
a man resembling a bear
hair white red shirt bright pants
everything round nose mouth body
his warmhearted wit not excepted
out of the corner of his mouth
fall
short
jaggy
sentences
from coarse fingers
flows gentle movement
the elements steel wire
tin and balance
delicate branches
with large autumn leaves
yellow
black red
white blue
driven by a breath of air
describing above
cheerfully colorfully
twisting forms
without beginning
or end
but
at once

we witness
the growth of
dark gigantic and
strong stable figures
"signals" "coal merchant" "dog"
"long nose" "black widow" "black beast"
"spider" "shoe" "cactus" "guillotine for eight"
alexander calder as the first american contributed
in the early 30's to the development of the visual arts :
balance and movement without a machine
his life work belongs to history as well as to the present

Willem Sandberg. "Sandy Calder." introduction to the catalogue of the 1959 exhibition at the Stedelijk Museum. Amsterdam. revised as a poem in *Alexander Calder*, exh. cat. (Berlin: Akademie der Künste. 1967). * English

The Trapper of Iron

Jacques Prévert

With a mobile on top
And a stabile below
Such is the Eiffel Tower
And such is also Calder

Trapper of iron
Catcher of the wind
Tamer of black beasts
Laughing engineer
Startling architect
Sculptor of time
Such a man is Calder.

Jacques Prévert. "Oiseleur du fer." in *Derrière le miroir*, no. 156 (Paris: Fondation Maeght. 1966). * French

Memories 1886-1962

Amédée Ozenfant

It took all kinds of artists to create the School of the New World—including passionate crafty, naive, and levelheaded ones, as well as originals such as Pollock, and ingenious craftsmen such as Calder.

He studied mechanical engineering and later became a painter, moving to Paris in 1926, where he created amusing wire figures for his miniature *Circus*. Calder was the ringmaster, and he used to perform with a hearty, playful spirit that greatly amused us. In 1930, he twisted wire into portraits, including mine.

In fact, he had probably already seen Jean Crotti's wire *Portrait of Marcel Duchamp* made in 1915.

Calder's true originality revealed itself in 1932 when the idea came to him to make his sculptures *mobile*. Sculpture, like architecture, is not as unavoidably "immobile" as painting, because we can walk around it and our own motion changes the angle we see just as much as if the sculpture itself had moved. But Calder makes the pieces of his compositions mobile with respect to each other; in the balanced ensembles he creates, a breath of air can set off a symphony of momentary permutations, with the figures swinging, pivoting, hiding and then reappearing, ad infinitum, but always differently.

During a time when many artists considered chance to be the supreme artist, I am grateful to this American man for having put some order in the infinity of possible options: nature itself rarely offers the combinations of branches, leaves, flowers, fruits, bits of sky, which we deeply long for. . . . This skillful engineer-artist sets a limit to incoherence through the well-thought-out disposition of articulations and pivots, the carefully calculated length of the branches, the balance of weights; elements can seemingly evolve in total freedom, but they are never allowed to collide with one another. It is like a piece of music in which different melodies occur in different registers and at different speeds, and, after coming close enough to salute each other, retire with the grace that their well-oiled gears allow, with no cacophony whatsoever.

There is something astronomical, heavenly, and therefore very natural in these pleasant calderian mechanics, where everything is ruled by the same natural laws that govern the serene, immutable orbits of the planets and their satellites—so can we really speak of CHANCE?

Amédée Ozenfant, extract from "Mémoires 1886–1962." (Paris: Seghers, 1968), pp. 549–50. * French

How I Came Across Calder

Gabrielle Buffet-Picabia

It was a long time ago, in 1932:

At that time, Mme Cuttoli managed a Modern Art Gallery in the rue Vignon. One day, I was not far from the gallery and decided to go see what she was exhibiting: it was an American sculptor, Alexander Calder. I did not know that name, and I had no idea that he already represented the avant-garde of the Arts. Sculptor—but where were his sculptures? I could only see about fifteen boxes lined up on a table, bearing strange constructions made out of wire, string, and wood, all different from one another. Other objects, just as diverse, moved, turned, and went up or down strings driven by little hidden motors, tracing arabesques in the air, but it was difficult to tell whether these constituted a game, a dance, or an aesthetic experiment. Small spheres, disks, bits of wood, spirals—each object followed an ideal circuit, a special, well-defined theme, came back to its stating point and then left again. I particularly remember two spheres of different sizes, one black and one white; they seemed to race against each other along an apparently inextricable tangle of wire, which was nevertheless intelligently conceived, until they finished their run. These inventions,

which were the fruit of a mind both mechanically oriented and artistic, belonged to no known technique, and could not fail to but intrigue even those connoisseurs familiar with the latest trends in art.

They delighted me so much that when I arrived back home I immediately wrote a detailed description of what I had just seen, including all the questions and thoughts that this absolutely new interpretation of the aesthetic issues of our time aroused. Many years have gone by, and a few days ago, I was called by good friends of mine to whom I had given, as wedding gift, forty years earlier, a table which had once belonged to me. They had just discovered, in one of the drawers that they had never opened, a folder full of papers, among which were some manuscript pages of Picabia's poems and two brief letters from Calder written in 1932, according to the stamp. I quote here some of the words that sealed our old friendship: "Arp tells me that you have written a nice article about me; I would like to read it." This article was published in the American magazine *Transition* which does not exist anymore, and its merit lies in the sincere interest with which I wrote it.

In 1932, Calder was more famous for his Circus than for his first mobiles (this term did not even exist then). Many of his current admirers do not know that at one time he motorized his mobiles.

In fact, it was the starting point of the extraordinary evolution that led him step by step to the construction of his big mobiles, controlled by the wind and by chance, and of which each country has a specimen, and to his impressive giant stabiles, which evoke elemental forms and forces.

Here in Saché, where I am writing, the last of these black monsters to arrive have been left to nature in front of Calder's workshop (which is built to their scale); they seem to have arisen from some cosmological cataclysm that, for some absurd reason, hurled them down from a distant world into the soft landscapes of Touraine.

Gabrielle Buffet-Picabia, "Comment j'ai connu Calder . . .," exh. cat. (Paris: Fondation Maeght, April 2–May 31, 1969), pp. 41–42. * French

Alexander Calder. Sculptor, Painter, Illustrator

Marcel Duchamp

Among all the artistic "innovations," that came about after the Great War, Calder's line was so distant from any established formula, that these was a need to invent a new name for his forms in motion: "mobiles." Through their way of counteracting gravity by gentle movements, they seem to "carry their own particular pleasures, which are quite unlike the pleasure of scratching oneself," to quote from Plato's *Philebus*. A light breeze, an electric motor, or both combined in the action of an electric fan, can set in motion a series of weights, counterweights, and levers that draw unpredictable arabesques in the air, producing a lasting feeling of surprise. Once color and sound join the party, the symphony is complete and all our senses are called to follow the invisible score.

Pure *joie de vivre*. Calder's art is the sublimation of a tree in the wind.

Marcel Duchamp, entry on Calder for the Société Anonyme catalogue (1950), reprinted in Marcel Duchamp, *Duchamp du Signe*, ed. Michel Sanouillet (Paris: Flammarion, 1975), p. 196. * French

Alexander Calder: 1898-1976

Josep Lluís Sert

I met Sandy in Paris in the early thirties. He was then considered by friends *un drôle d'Américain*. Inventive, young and playful, he belonged in their minds to the new America that was being discovered in those years.

Sandy enjoyed living twenty-four hours a day. He was alert to everything happening around him; even when he took brief naps, learning on the marble tops of the bistro tables, he was only half asleep and managed to pick up the conversations taking place around him. When he woke up, he was more awake than anybody in the party.

He enjoyed all his work, regardless of its importance. He spent much time finding solutions to ordinary household problems. In Roxbury or

Saché, he would knock off work on an important piece of sculpture just to repair a faucet, a doorknob, or a friend's valise. House accessories of all types show the Calder trademark. He had a rooted dislike for slick industrial design. His products were primitive in their own way but strong and natural. He enjoyed food, even when it was not too good. He enjoyed ordinary wine and ordinary people. In parties, he used to dance with anybody anywhere—in a small Italian restaurant on First Avenue in New York or in the streets of Rio de Janeiro during Carnival.

Important events and important people he took as they came. He treated everyone he liked in the same warm friendly fashion. He disliked pretentious people who believe or behaved as "important" members of a group of friends. He loved people in general and enjoyed their company and jokes. He had many friends that loved him.

He revolted against unfair things, such as exploitation, war, or hypocrisy, and with Louisa, his lifelong companion, he made his views very clear when he published a full-page statement in *The New York Times* in protest to the Vietnam war. I am sure he did not even consider for one moment how many commissions such openness would make him lose. Sandy was high above all such concerns or interests.

He was a great human being besides an outstandingly creative personality. His works show these qualities in the man. They are uncomplicated and healthy, rare virtues in our times. They are the direct expression of his *joie de vivre*. Everything he did is understandable and expresses the joy he experienced in the creative process, which is transmitted to the observer. This joy is contagious. This was evidenced in the large crowds of people of all ages that visited his last great show at the Whitney Museum in New York, which opened only a few weeks before his death. The show was justly called "Calder's Universe." There was a great variety of exhibits, from the early line drawings, the circus figures, the wire portraits, the first mobiles; the visitors then moved on to jewelry, tapestries, and paintings and then to

his great stabiles and more recent works. The continuity in his selection of forms, his use of bright colors, gave a feeling of life and movement that made one aware that the same mind and hand were always present making everything alive, harmonious, and balanced. Whatever he produced, he never hesitated in his choices.

Joan Miró was a lifelong friend of Sandy. In many ways, they have a similar approach to life and the world around them, their environments. Both are interested and moved by ordinary objects and the forms in nature or manmade forms. Their works are often inspired by what they find cast away at the roadside. Pure, primary colors are used by both, as they were by Léger and Mondrian, who were also close friends of Sandy. They shared the same years in Paris and were frequently together. This give-and-take is natural in the art world, just as it is in all activities of life.

But Sandy Calder stands unique from the start. It took him a full life to create his universe. The more he worked, the more unique his personality became. He shaped the places he lived in, his houses, the objects around him, the ways he dressed, even his cars. He was once given a brand new car, which was soon depreciated (in terms of its market value) by Sandy's transformations and additions. He changed the spirit of everything he touched; it became part of himself.

But, besides all this playful work, Sandy had an inherent greatness that enabled him to invent and produce his great sculptures. The facility and inventiveness of his early works seemed to develop naturally and without effort, into his later monumental pieces—the stabiles and the combined mobile-stabiles of his last years. They are considered "abstract," while still always evoking natural, living forms. They are in a way monumental and architectural, reminiscent of medieval structures. When looking at pictures of buildings, he expressed his preference for strong primitive looking structures that express, like his works, the ways they have been put together and why they do not fall apart. His large stabiles are buttressed like cathedrals.

These pieces really take possession of the sites they are conceived for. They are monumental from the start, in contrast with so many recent attempts by other sculptors that are nothing more than blow-ups of small objects.

Sandy was both a sculptor and a painter. As a painter, his flat forms, in moving, give way to many paintings; his colored cut-outs are more in the pictorial vocabulary than in that of the sculptor's. But, as they warp and twist, they take possession of space and become his own special kind of sculptures. He is also a strange kind of engineer: he had a genius for balance and movement.

Sometimes, when visiting a comprehensive one-man show, the work of a lifetime, you become aware of the limitations of the individual. No matter how good some works may be, they become repetitious and are more effective in isolation. With Calder's work, the effect is the reverse. They add up to make a totality or a whole, *his universe*, and you become more aware of his inexhaustible inventiveness.

Sandy left us all at the peak of his genius and glory. He was unique. He is irreplaceable. His friends and admirers will all miss him. To the world at large, he will remain one of the greatest artists of our time and, internationally, he was the most influential American sculptor of the twentieth century.

Josep Lluís Sert, "Alexander Calder 1898–1976." *Proceedings of the American Academy of Arts and Letters*, 2d ser., vol. 28 (1978). * English

Tinguely on Tinguely

Jean Tinguely

Antoine Pevsner, one of the artists—along with Gabo—who signed the Russian Constructivist manifesto, told me when I met him with Daniel Spoerri, that motion [in art] didn't exist, that it couldn't be done, that they had tried everything, to no avail; so I laughed a lot, because I felt that he had a deep longing for motion, as did an entire generation of artists, and that out of all of them, the only one to conquer the problem was Alexander Calder.

With his mobiles, Calder had found a strong, direct means of expression. He worked a quarter of a century before me and managed to create real, absolutely extraordinary sculpture, with joy and substantial humor. This gave me confidence. Let's just say that Alexander Calder, "syndical," as they called him, opened a door through which I could enter. So I strolled in that direction and discovered extraordinary possibilities of motion. That's the origin of some of my autodestructive works such as *Homage to New York*, a piece as ephemeral as a shooting star, intended above all not to be collected by a museum.

Jean Tinguely, from "Tinguely parle de Tinguely," Belgian French community television program presented by Jean-Pierre Van Thiegem, December 13, 1982, text reprinted in *Jean Tinguely*, exh. cat. (Paris: MNAM / Centre Georges Pompidou, 1989), p. 362. * French

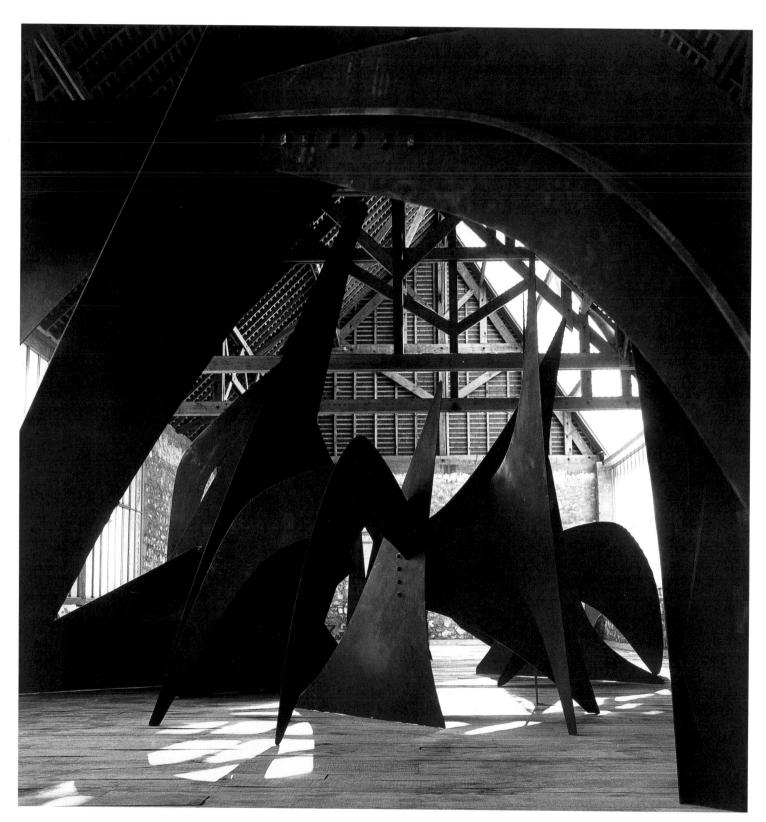

Slender Ribs, Saché, 1963 /
Photo: Ugo Mulas

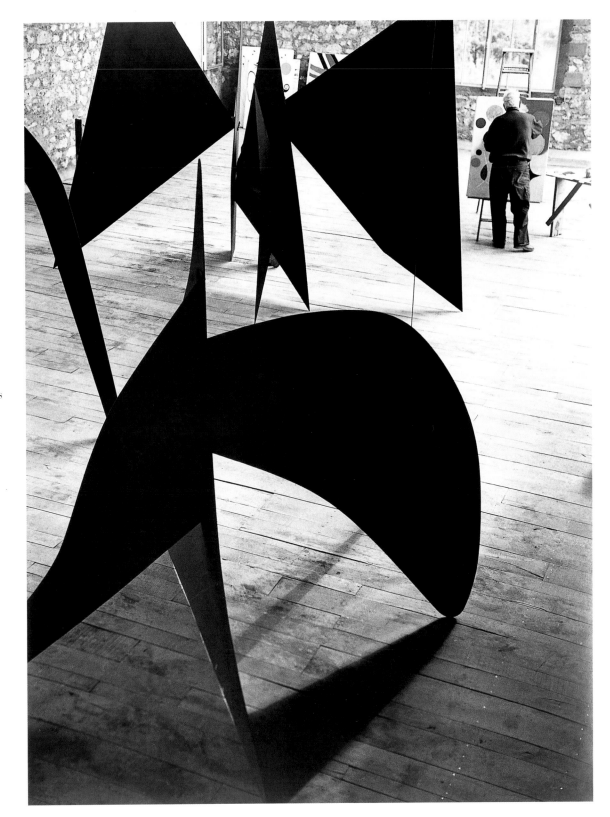

Calder painting in his studio in Saché, with his stabiles *Les Triangles* and *Le Cèpe* in the foreground, 1963 / Photo: Ugo Mulas

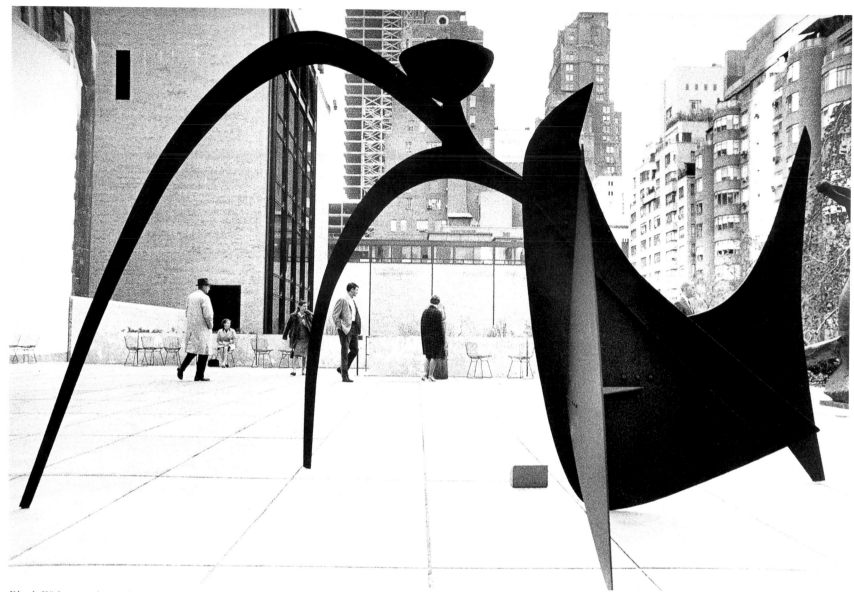

Black Widow, in the sculpture garden of the Museum of Modern Art, New York, ca. 1959 / Photo: Ugo Mulas

Selden Rodman

"I want to make things that are fun to look at."

If it is true, as William Carlos Williams says, that "the pure products of America go crazy," then it is also true that the almost-pure ones, the ones impure enough to absorb America wholeheartedly but sensitive enough to reject, even though unconsciously, the impurities, become the artists. Such a one is Calder. He is the embodiment of such characteristic American traits as canniness, geniality, acquisitiveness, energy, inventiveness, pragmatism. His distaste for theory and concept are American, and so is his dry humor. He has the advantage of having been an American so long through his heritage—both his father and his grandfather were American sculptors—that he can live in France a good part of every year without any sense of expatriate guilt and without becoming in the least bit French. And the fact that he didn't have to make a living was in his case an advantage too: the material ends and pecuniary rewards never meant anything to him. He could, and did, make things solely for the satisfaction of making them. If they were cleanly cut, cleverly arranged and ingeniously related, that was enough. They had to "work." And in his early mobiles, working meant more than balancing and freely swinging; hand cranks and even small motors were employed to give the sculptures a "life" approximating the ubiquitous American machine.

There is a resemblance between Calder's procedure and that of the Wright brothers. It occurred to me when I saw the interior of the sculptor's studio in Roxbury, Connecticut. This was no studio such as sculptors had traditionally worked in throughout the ages. No casts, no marble, no plaster, no armatures. Not a bicycle shop, to be sure, but certainly a machine shop. The floor was deep in steel shavings, wire, nuts and bolts, punched sheet metal. The benches sagged under lathes and power saws.

IV. INTERVIEWS
WITH CALDER

The air was busy with dangling "contraptions," as the brothers in Dayton used to call their experimental warped airfoils and rudimentary engines. But more significantly, I thought, the Wrights too were in love with simplicity, with perfection of motion and economy of means. They began and ended their work *as artists*. Gliding and work with kites came naturally to them. They *appropriated* a small motor and attached it to their wings; but the motor was an afterthought, a sort of concession to the American spirit—they wouldn't be outdone by some mere mechanic. Neither speed nor any of the commercial or military uses of aviation interested them at all. Business killed Wilbur Wright; it also caught up with Orville, reducing him to forty years of taciturn inertia. Calder, under no obligation to make his inventions compete or pay off, was more fortunate.

His home, like the man himself, could only have come out of the twenties. Ten years earlier, Calder would have been a Beaux Arts academician —the American artist was not then ready for such freedom. Ten years later he would have been preoccupied with social significance, or fighting against it angrily—like David Smith. As it was, he could enjoy all the advantages of being a dilettante, a bad boy, an expatriate, without having any of these aspects of his early development prey on his conscience. As a dilettante he could experiment to his heart's content with clever wire caricatures of celebrities and with the animated mechanical clowns and monkeys of his miniature "circus." As a bad boy he could flout the traditions of Philadelphia's Main Line and of generations of "classical" figure makers without a qualm. And, as an expatriate, Calder was supremely fortunate in finding an international style, at the height of its inventive vigor, ready to enrich his particular inventiveness with a wealth of similarly free-floating vocabularies, and eager to accept his unique contribution. Mondrian's vibrating linear geometry, Duchamp's gadgets and approximations of motion, Arp's biologic free forms, Miró's poetic

fantasy and pin-headed Freudian protagonists, the glass and plastic "constructions" of Gabo and Pevsner—all were not so much influences as encouragement and justification for the otherwise seemingly wayward trail he was already blazing. Without this community of effort, it is at least questionable whether Calder would have had the confidence to take his peculiar combination of inventiveness and humor seriously. Quite literally he forged, with these assists, his playfulness into a major artistic reflection of his world. Whether the result can be called a major art depends upon the degree of importance one places upon content, for it is surely in this department only that Calder's sculpture may ultimately be considered inconsequential.

Calder himself makes no hifalutin' claims. He is without pretensions. Disarmingly so. Only in respect to the original motivation of his work does he go beyond the simple justifications of having fun and giving pleasure. A vision of the celestial universe, he told me, started him off. Even before he studied engineering, he had been enthralled by eighteenth-century toys demonstrating the planetary system. "That was in the period when I was playing around with motors; I had as many as fifteen at one time. I felt that art was too static to reflect our world of movement. Then, in 1930, when I visited Mondrian's studio and saw the slabs and strips of colored cardboard the had tacked on his wall, I said to myself, 'Wouldn't it be amusing if they oscillated?' But I *painted* in the weeks that followed, and then made my first 'stabiles.'"

The same preoccupation is just as much with Calder today. Looking through one of my photograph albums, he stopped at a shot of Carl Milles's "Bellerophon" poised horizontally on one foot, in the Des Moines Art Center fountain. He shook his head.

"What's the matter with it?" I inquired.

"He never quite takes off!"

"He's trying hard," I said.

"Too hard. Miró doesn't try so hard as artists like Milles, but he achieves more." And he went on to tell me of a friend who had taken him and Miró to see an almost perfect studio in the South of France, hoping that the Spanish artist, who was at the moment without a studio of his own, might rent it. "Miró wasn't even looking at it. He had found a piece of pale blue cardboard in the bottom of an apple crate and was playing with it delightedly, mumbling, 'Isn't it wonderful!' We never could get him to look at that perfect studio. He'd found what he wanted."

I asked him whether the expression of tragic feeling in such sculptures as Michelangelo's "Slaves" in the Louvre appealed to him at all.

"The lugubrious aspect of such work is eliminated in my approach to sculpture," he said. "But the gay and the joyous, when I can hit it right, are there. Perhaps there's a depth of feeling lacking, as you imply. They call me a 'playboy,' you know." He chuckled. "I want to make things that are fun to look at, that have no propaganda value whatsoever. I'm frank to say that in religious pictures what moves me is the plastic forms or the wonderful colors. Or in Bosch, who is antireligious, I suppose, the endless invention of forms and symbols. My friend Peter Blume wants to say something. I don't. Who comes out best?"

He held up his hands as if to indicate it was a real question. I asked him if he was moved or inspired by forms in nature. His wife Louisa, who is a grand-niece of the philosopher William James, answered for him. "When we drive somewhere, Sandy always notices the beauty of things that most people consider ugly or take for granted. Like derricks, gas tanks, derelict machines covered with rust, bridges." Louisa Calder, though she is already a grandmother, is surprisingly young looking and attractive.

"I do like the dogwood tree," Calder interjected, "perhaps because it has a shape." He looked at one out the window. "A shape to hang things on. A rose has only the blush of youth. No shape." He returned to the question I had been asking him. "About my method of work: first it's the state of mind.

Elation. I only feel elation if I've got ahold of something good. I used to begin with fairly complete drawings, but now I start by cutting out a lot of shapes. Next, I file them and smooth them off. Some I keep because they're pleasing or dynamic. Some are bits I just happen to find. Then I arrange them, like *papier collé*, on a table, and 'paint' them—that is, arrange them, with wires between the pieces if it's to be a mobile, for the overall patern. Finally I cut some more on them with my shears, calculating for balance this time."

I didn't ask Calder how he knew when a piece was finished. The question had already been asked him on a television interview and appropriately answered—"When the dinner bell rings."

I asked him the same question I had asked Lipchitz: whether he enjoyed doing sculpture on commission, to complete or complement architecture. He did. "The sculptures are often improved by being related properly to site and scale. Once I had to design one that crept up a circular stairwell—a fascinating problem!"

It was a hot day to begin with, and a thunderstorm had made the atmosphere even stickier, so we decided to go for a swim. While searching for a pair of trunks that could be scaled from Calder's enormous girth to mine, we wandered through a good part of the house that seemed to be all on one level: one low-ceilinged room opening into another, and then another, like a telescope, with wonderful diminishing sunlit perspectives animated and made audible by mobiles hung from above which waved and tinkled in the breeze.

I've mentioned already that the house itself seems a product of the twenties. It's hard to say exactly why. The remade Colonial with bohemian touches? The photographs, letters and drawings massed from floor to ceiling on certain walls, even on the doors? The surrealist notes —like a tack through a face in one snapshot?

Calder had bought the lovely old farmstead with its seventeen acres for $3,000 before northern Connecticut became as fashionable as West-

chester County. A nearby farmer makes use of the fields *gratis*. Behind and to one side of the house is the two-floors-high studio, rebuilt out of an old barn. To the other side, and in front of the shallow swimming hole, is a small new house which the artist built for his mother, who is ninety and who spoke to us, vigorous in voice and keen of eye, as we walked back from our swim. I asked Calder if she liked his sculpture. "Well," he said, "let's say that she's gotten over regretting it's not like my father's." The only thing that really kept him from living all year round at his home in France, he said, was his mother, who develops alarming symptoms as soon as he's been away for any length of time. "As soon as I reach the deathbed, she's had a miraculous recovery. Of course our youngest daughter, who's in school at Putney, Vermont, keeps us here too."

We went to the studio to take some pictures. I noticed, among the anvils and welding irons, some objects that had escaped my attention before: driftwood treated as sculpture, roots, marionettes. I asked him whether he thought representational sculpture had any future. "Epstein and Germaine Richier still look alive," he said. I walked over to inspect a mobile made entirely of "found objects" and he guessed my thought. "It only works if you find something as good as the shape you were about to invent. I've used spoons as well as bits of bottles, but you can usually make something better, perhaps basing your design on what you've found. To come back to your original question about emotional content in sculpture," he drawled, "I believe that in modern work the spectator has to bring with him more than half the emotion. To most people who look at a mobile, it's no more than a series of flat objects that move. To a few, though, it may be poetry. I feel that there's a greater scope for the imagination in work that can't be pinpointed to any specific emotion. That is the limitation of representational sculpture. You're often enclosed by the emotion, stopped."

His wife, who had come in, was surprised to hear him talking this way. "Usually," she said, "Sandy makes jokes out of questions."

Sandy grinned through those heavy jowls, a little dourly but cheerfully, as though he might make a joke out of this statement. But he didn't. "His work is his religion," she went on. "He is always expressing his sense of pleasure and his *joie de vivre*. He isn't an unhappy man. He isn't tormented. He enjoys life." She gave him a look of complete devotion.

I looked at Calder, who was looking at her and then at his work. I believed her.

Selden Rodman, "Alexander Calder," in *Conversations with Artists* (New York: Devin-Adair, 1957), pp. 136–42. * English

I Am a Tinkerer
Ustinov

His red face, his shaggy beard, his white, tangled curly hair, his blackened teeth, and his crafty appearance give Alexander Calder the look of a peasant from Normandy. From a distance, as well as close up, he is as solid as a pyramid. This colossus is a peculiar combination of cynicism and tenderness.

Your mobile in front of the UNESCO *Palace, in the place Fontenoy, has caused something of a scandal.*

It will pass. The sculpture will remain.

What led you to the creation of mobiles?

I have always liked to tinker. One day, I visited Mondrian, and when I looked at his paintings, I felt the urge to make living painting, shapes in motion.

Do you like your contemporaries?

Yes of course, but they are all idiots.

Would you have preferred to live in another time?

In the Middle Ages. That's what we lack in America, and what I am searching for in France.

Do you like France?

The "bistros." The orderly space of Place de la Concorde, on a Sunday morning, when no one is there and it is very sunny.

What do you think of the Louvre Museum?

The courtyard is nice. It is well tarred.

Are you interested in the paintings of your contemporaries? Do you go to the galleries?

No. But I enjoy walking in the streets looking at the fences, the gray walls, the effects of light. That's what I call living paint.

Would you rather live in the U.S. or here?

When I am in France, there is always a bunch of annoying Americans who come to see me, whereas in the U.S., it is the Europeans who come and visit. I prefer the Europeans.

How are you regarded in America?

Badly! I am not a member of a union.

When you are not sculpting, what do you read?

I am astigmatic: the lines become blurred in front of my eyes. I read very little and very slowly. I like Gorky's *My Life as a Child* a lot.

Are you happy?

I don't know.

What are you short of?

Workers to make my mobiles.

Ustinov, "Je suis un bricoleur." *Arts, Lettres, Spectacles*, no. 687, September 9–16, 1958.
* French

Calder: No One Calls on Me When There Is a Horse to Be Done
Yvon Taillandier

When I began to make mobiles, everyone was talking about movement in painting and sculpture.

In reality, there wasn't much movement, only actions.

My mobiles are objects in space; I say I'm a sculptor to avoid a fuss.

What I want to avoid is the impression of mud piled up on the floor.

I'd like to sculpt a guy on a horse. But no one calls on me when there's a horse to be done.

My purpose is to make something like a dog, or like flames; something that has a life of its own.

The idea of making mobiles came to me little by little. I worked with whatever I had at hand.

My Scottish grandfather was a stone-cutter. He worked in London, then in America. My father was a sculptor. I never worked for him, except to pose for him.

I studied to be an engineer. But I didn't like numbers. My boss gave me geographical maps to paste up.

After leaving school, I worked as an engineer for four years.

Finally I came to the conclusion I was more of a painter.

Sometimes I paint for three and four months at a time.

I'd like to do more painting. But even in a big studio, like the one I have in America, the points of my mobiles threaten to puncture my canvases.

Sometimes I make sketches for my mobiles. But I can never know in advance what I'm going to do.

I cut out plates of different thicknesses, so that some will be heavier than others.

In 1932, a wooden globe gave me the idea of making a universe, something like the solar system.

That's where the whole thing came from.

I went from wooden globes to flat forms out of laziness.

Laziness is a product of leisure. You have to know how to use your free time, which is a good climate for invention.

I weld and cut out my metal plates myself. I cut out the big plates with a welding torch (acetylene torch). I get people in to help me.

You need a lot of patience to do all that cutting.

I haven't got that kind of patience.

When I cut out my plates, I have two things in mind. I want them to be more alive, and I think about balance.

Which explains the holes in the plates.

The most important thing is that the mobile be able to catch the air. It has to be able to move.

A mobile is like a dog-catcher. A dog-catcher of wind.

Dog-catchers go after any old dog; my mobiles catch any kind of wind, bad or good.

Myself, I'm like my mobiles: when I walk in the streets I latch onto things, too.

Yvon Taillandier, "Calder: Personne ne pense à moi quand on a un cheval à faire," XX° Siècle, no. 2, March 15, 1959. * French

Talks with Seventeen Artists: Calder

Katharine Kuh

Does your work satirize the modern machine?

No, it doesn't. That's funny, because I once intended making a bird that would open its beak, spread its wings and squeak if you turned a crank, but I didn't because I was slow on the uptake and I found that Klee had done it earlier with his "Twittering Machine" and probably better than I could. In about 1929, I did make two or three fish bowls with fish that swam when you turned a crank. And then, of course, you know about the Circus. I've just made a film of it in France with Carlos Vilardebo.

Which has influenced you more, nature or modern machinery?

Nature. I haven't really touched machinery except for a few elementary mechanisms like levers and balances. You see nature and then you try to emulate it. But, of course, when I met Mondrian I went home and

tried to paint. The simplest forms in the universe are the sphere and the circle. I represent them by disks and then I vary them. My whole theory about art is the disparity that exists between form, masses and movement. Even my triangles are spheres, but they are spheres of a different shape.

How do you get that subtle balance in your work?

You put a disk here and then you put another disk that is a triangle at the other end and then you balance them on your finger and keep on adding. I don't use rectangles—they stop. You can use them; I have at times but only when I want to block, to constipate movement.

Is it true that Marcel Duchamp invented the name "mobile" for your work?

Yes, Duchamp named the mobiles and Arp the stabiles. Arp said, "What did you call those things you exhibited last year? Stabiles?"

Were the mobiles influenced by your Circus?

I don't think the Circus was really important in the making of the mobiles. In 1926 I met a Yugoslav in Paris and he said that if I could make mechanical toys I could make a living, so I went home and thought about it awhile and made some toys, but by the time I got them finished my Yugoslav had disappeared. I always loved the circus—I used to go in New York when I worked on the *Police Gazette*. I got a pass and went every day for two weeks, so I decided to make a circus just for the fun of it.

How did the mobiles start?

The mobiles started when I went to see Mondrian. I was impressed by several colored rectangles he had on the wall. Shortly after that I made some mobiles; Mondrian claimed his paintings were faster than my mobiles.

What role does color play in your sculpture?

Well, it's really secondary. I want things to be differentiated. Black and white are first—then red is next—and then I get sort of vague.

It's really just for differentiation, but I love red so much that I almost want to paint everything red. I often wish that I'd been a *fauve* in 1905.

Do you think that your early training as an engineer has affected your work?

It's made things simple for me that seem to confound other people, like the mechanics of the mobiles. I know this, because I've had contact with one or two engineers who understood my methods. I don't think the engineering really has much to do with my work; it's merely the means of attaining an aesthetic end.

How do you feel about your imitators?

They nauseate me.

Do you make preliminary sketches?

I've made so many mobiles that I pretty well know what I want to do, at least where the smaller ones are concerned, but when I'm seeking a new form, then I draw and make little models out of sheet metal. Actually the one at Idlewild (in the International Arrival Building) is forty-five feet long and was made from a model only seventeen inches long. For the very big ones I don't have machinery large enough, so I go to a shop and become the workman's helper.

How do you feel about commissions?

They give me a chance to undertake something of considerable size. I don't mind planning a work for a given place. I find that everything I do, if it is made for a particular spot, is more successful. A little thing, like this one on the table, is made for a spot on a table.

Do you prefer making the large ones?

Yes—it's more exhilarating—and then one can think he's a big shot.

How do your mobiles differ from your stabiles in intention?

Well, the mobile has actual movement in itself, while the stabile is back at the old painting idea of implied movement. You have to walk around a stabile or through it—a mobile dances in front of you. You can walk through my stabile in the Basel museum. It's a bunch of triangles leaning against each other with several large arches flying from the mass of triangles.

Why walk through it?

Just for fun. I'd like people to climb over it but it isn't big enough. I've never been to the Statue of Liberty but I understand it's quite wonderful to go into it, to walk through.

Léger once called you a realist. How do you feel about this?

Yes, I think I am a realist.

Why?

Because I make what I see. It's only the problem of seeing it. If you can imagine a thing, conjure it up in space — then you can make it, and *tout de suite* you're a realist. The universe is real but you can't see it. You have to imagine it. Once you imagine it, you can be realistic about reproducing it.

So it's not the obvious mechanized modern world you're concerned with?

Oh, you mean cellophane and all that crap.

How did you begin to use sound in your work?

It was accidental at first. Then I made a sculpture called *Dogwood* with three heavy plates that gave off quite a clangor. Here was just another variation. You see, you have weight, form, size, color, motion and then you have noise.

How do you feel about your motorized mobiles?

The motorized ones are too painful—too many mechanical bugaboos. Even the best are apt to be mechanically repetitious. There's one thirty feet high in front of Stockholm's modern museum made after a model of mine. It has four elements, each operating on a separate motor.

How did you happen to make collapsible mobiles?

When I had the show in Paris during 1946 at Louis Carré's gallery, the plans called for small sculptures that could be sent by mail. The size limit for things sent that way was 18 x 10 x 2 inches, so I made mobiles that would fold up. Rods, plates, everything was made in two or three pieces and could be taken apart and folded in a little package. I sent drawings along showing how to reassemble the pieces.

You don't use much glass anymore, do you?

I haven't used it much lately. A few years ago I took all sorts of colored glass I'd collected and smashed it against the stone wall of the barn. There's still a mass of glass buried there. In my early mobiles I often used it.

Are there any specific works that you prefer and would like to have reproduced?

What I like best is the acoustic ceiling in Caracas in the auditorium of the university. It's made from great panels of plywood—some thirty feet long—more or less horizontal and tilted to reflect sound. I also like the work I did for UNESCO in Paris and the mobile called *Little Blue under Red* that belongs to the Fogg. That one develops hypocycloidal and epicycloidal curves. The main problem there was to keep all the parts light enough to work.

Do you consider your work particularly American?

I got the first impulse for doing things my way in Paris, so I really can't say.

Have American cities influenced you?

I like Chicago on the Michigan Avenue Bridge on a cold wintry night. There used to be no color but the traffic lights, occasional red lights among the white lights. I don't think that looking at American cities has really affected me. We went to India and I made some mobiles there; they look just like the others.

What's happened to that large sculpture, The City?

The City was purchased by the Museo de Bellas Artes in Caracas through the kind offices of my good friend, the architect Carlos Raul Villanueva.

I found it great. What do you think of it?

I'm slowly becoming convinced. I made the model for it out of scraps that were left over from a big mobile. I just happened to have these bits, so I stood them up and tried them here and there and then made a strap to hook them together—a little like *objets trouvés*. ["Found objects" usually refers to articles in nature and daily life, like shells, stones, leaves, torn paper, etc., which the artist recognizes and accepts as art.–Ed.] I decided on the final size by considering the dimensions of the room in the Perls Galleries where the work was to be shown.

What artists do you most admire?

Goya, Miró, Matisse, Bosch and Klee.

Katharine Kuh, "Calder." *The Artist's Voice: Talks with Seventeen Artists: Calder,* (New York and Evanston, Ill.: Harper & Row, 1962), pp. 38–51. * English

Calder's International Monuments

Robert Osborn

*A*t heart, Calder has always been an engineer. He has clothed the forces of his engineering with his joyful imagination and his lithe sense of beauty. But the wellspring of his art remains the thrusts, the tensions, the stress loads, the balances, the forces of gravity which he, the engineer, proceeds to adjust and join.

From the very start, from the "workings" of his Circus to the resulting wire sculpture and incredible creation of the mobiles, one observes his essential preoccupation with a logical, elegantly supported, immaculately balanced sculpture.

What has been most exciting to watch is the endless change and development of his creative process. Essentially simple and direct in its approach, never pompous or bombastic, that process has allowed him the greatest freedom in seeking the various combinations and mutations of structure, form and movement. And as with any engineer worth his salt, or any artist for that matter, the endless search goes on.

Of late Calder has turned toward monumentality and all of the massive problems this provides him. There has been a great deal of monumental sculpture set up in this world—at tremendous pain. Most of it turned out to be mediocre beyond belief because it was "monumental." The low-priced chiseling hand, the tiring back muscles and finally the easily satisfied artisan's eye faltered, leaving us coarse, often flatulent replicas of fine smaller works. With Calder this is not true; in fact this newly mastered size often imparts an added vitality and force not to be found in the small maquette or even its intermediate-stage development. Too, a grandeur is becoming ever more apparent in each succeeding piece.

It is worth noting that the same extraordinary ingenuity which now marks the conception and creation of these monumental pieces has been characteristic of Calder almost from early childhood. I suppose that nowhere in the entire stream of art, from Paleolithic man's solid stone sex symbols through Rodin, Maillol and Matisse's "solids" (for like "mobiles" and "stabiles" it is the only word one can apply to them), has one man, single-handed, in the span of half a lifetime, created, full-blown, an entirely new concept of sculpture. This is genius at its best.

Normally, an artist has learned laboriously from his heritage and his immediate predecessors and then slightly altered these gifts. But not Calder. He fought off his father's solid teaching, admonishments and deprecatory remarks and brought forth his entirely new concept of sculpture.

This is not easy to do in any field, and it is one of the marvels of Calder that he lifted off into space and then proceeded to slice it up or

pierce it as no one ever had before. Now in full command of his materials and armed at last with honor (which is never a detriment for any man), he can achieve the nobility he desires through a variety of new avenues, steadily explored and extended.

Sandy, how did the increase in scale start?

Well, in 1954 I'd done the Water Ballet for Eero Saarinen's General Motors Tecnological Center in Detroit. The concept there was a large one, I'd say. Jets of water. Lines of water can be monumental too. I took one hundred feet and had one jet at each end rising and falling at different speeds, and then that comes to a halt. There were seven smaller jets that were almost vertical; I called them the seven sisters because they were slender jets, and some rotated one way and some the other way and they made a rotating pattern against the sky. Then there is a bathtubful of water shot into the air to make a big boom when it hits. Then a bar rotating makes a fishtail—that's rather fine. They wanted the ballet, but now they are afraid to run it because the stockholders have complained that it costs money to run—probably waters their stock down—so it's only turned on for VIPs. I'm afraid I probably won't ever see it.

I did see it once when it was turned on, and it has tremendous fragile size to it, and a magnificence such as the Lincoln Center waterworks lack.

They probably haven't got the pressure there.

When did the large metal constructions begin?

It was when Eliot Noyes asked me to remake an object I'd made earlier to show at Pierre Matisse—*The Black Beast*—only make it of thicker metal. Before this I'd done Kennedy, which was heavy enough to flatten an ox if it fell. I'll tell you about that later—and I'd already done the one in 1958 for UNESCO in Paris and that was a pretty good size, but now I had the impulse and the means (two thousand dollars) to make things at a larger scale of one-quarter-inch iron plate. So, I decided to have a show

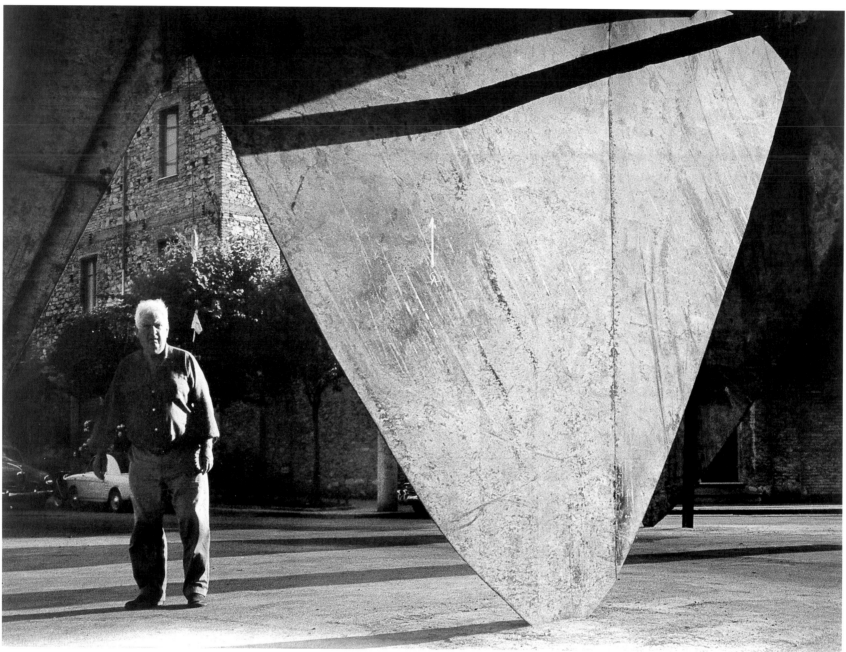

Calder with *Teodelapio* in Spoleto, Italy, ca. 1962. Courtesy Calder Foundation

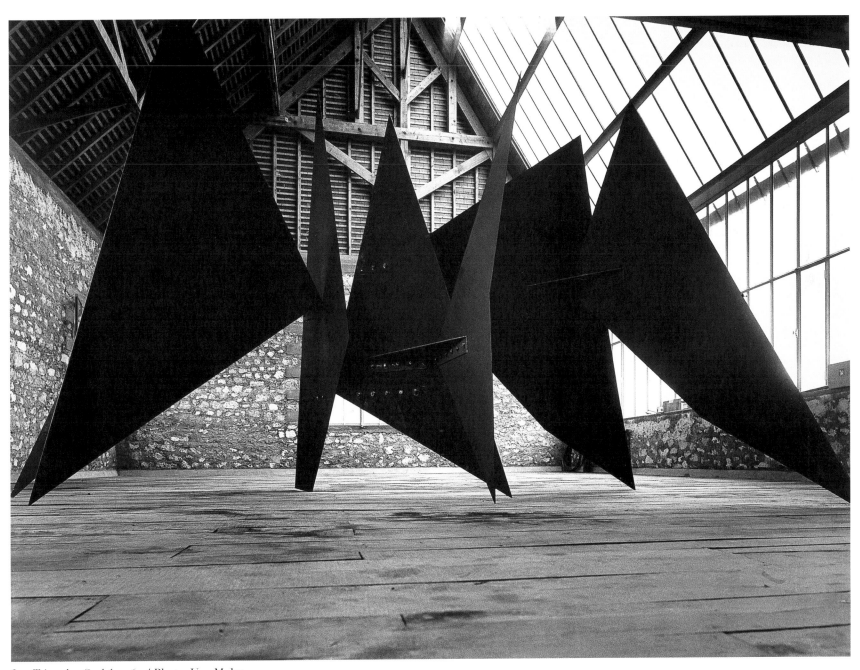

Les Triangles, Saché, 1963 / Photo: Ugo Mulas

of fairly large stabiles at Perls in the winter of 1958. We sold three of these, and in the winter of 1959 I sent the remainder of the Perls show to Paris with a number of other objects, about ten large stabiles I'd constructed for a show at Maeght's. Mrs. Maeght said, "You must have really had to scratch your brains to produce these things." But the night before the show opened they phoned me that they'd bought the whole show. This was the first time this had ever happened to me. So now I wanted to repeat my "triumph," and this time I had in mind something which could stand in that central inner court of the Louvre—you know the one.

The one that's closed on four sides?

Yes, but the French Government wasn't interested. They said they couldn't do it because it would disturb the flat beds of flowers.

They will be interested, have no fear. Give them time. The bureaucrats always lope up late.

It's getting late. Well anyway, Maeght was going to do over his gallery, lower the ceiling in order to put in a fancy new lighting system. I said, "Shit, that won't do at all." In order to show the big objects I had to have the full height of the gallery, and in order to make them I needed a shop like those in Waterbury. Jean Davidson—he's my son-in-law—and I had discovered [an] ironworks in Tours, the biggest one in France, so we went to ask if they'd make some big stabiles. A nice guy in a tweed jacket said no but kindly gave us the name of Biémont. They are just on the edge of Tours. I brought them eight models in the early fall of '62 and left for America. When I got back to France they had them all done. All eight pieces. They were standing there! The biggest one was six and a half meters high. They pleased me. I could begin to see the possibilities.

Tell me about the Biémont ironworks. How many men are employed there?

Between sixty and eighty work in the plant, but only three or four work on one piece.

Have certain men become specialists and therefore improved in doing your things?

Yes, but now they are all becoming "art critics."

But I should think it would be handy to be able now to just produce the model and then know that they can enlarge it without loss of power.

Yes, it's almost ideal now. But I always like to have a finger in the pie.

While we're on it, talk about the enlarging process.

I used to make a small model, then cut out full-sized parts in paper. Then the ironworkers in Waterbury would translate these paper templates into metal plates. Now the Biémont people are so trained that they make the templates themselves. Even Waterbury can do this now. The guy in Tours has a real mechanical department. They do real calculating. They can tell beforehand where to place the ring to hold it up, and they can tell which hole to hoist it up by so all the holes will line up with the holes in the plates which are already up.

What about the treatment of edges—because I should think so much force and beauty could be lost there. How much do you have to do with the final contours?

In France, they are very good—very careful. I look at the pieces every once in a while. Sometimes I throw my hands up and say "Shit!" Then they grind down the mistakes. Sometimes the final line is a little different. Maybe it lends a little variant.

I'm always amazed how your studies stand enlargement with no loss of vitality. In fact, the carefully conceived ribbing often increases the essential force. Tell me about the evolution of the bracing.

I try something new each time. With the model at three meters you can wobble it and see where it gives, where the vibrations occur, and then put your reinforcement there. If a plate seems flimsy, I put a rib on it, and if the relation between the two plates is not rigid, I put a gusset between them—that's the triangular piece—and butt it to both surfaces. How to

construct them changes with each piece; you invent the bracing as you go, depending on the form of each object.

This must account for the fact that the ribbing with its shadows has by now acquired an esthetic of its own which is there to be enjoyed along with the strength of the engineering.

I crossed the Atlantic once on the "Bremen." The partitions were all going "Baaroop, baaroo, baaroop, baaroo." That's what you have to avoid.

Incidentally, Sandy, think of trying to increase a splendid Maillol figure to forty or fifty feet—the lymph would be going out of it foot by foot.

The lymph goes out of the nymph!

But your six-inch concept is so solidly related that it can go up like a Corbusier building, simply gaining magnificence as it increases in scale and massiveness.

One key to this great sculptor is the fact that both of his parents were artists—as was his grandfather—and good ones too, and then he, the obstreperous bounce-out, turned into an engineer, and then, as he says, bounced back to become artist and engineer combined. It is this fortunate union, this rare combination, which is producing the latest beauty and gigantic vitality in Calder's work. As one thinks of it now, the word which comes to mind most often is magnificent. Calder will probably finally get to the stars, single-handed, propelled there no doubt by some circus rig of his own, flinging him end over end into space—his natural possessed element.

How did this one [Hextoped, 1995] *come about?*

I had the job to do it for Bunshaft. I knew the head of Amerika Haus in Frankfurt, and he introduced me to a bridge builder, Fries. They built the object for me in two days; it was all ready to be welded, but the Consulate didn't seem to be ready to receive it. So I called Ambassador Conant in Bonn and told him I wanted to put it up and then things began

to move. We had to get a Marine sergeant to unlock a door so we could get out the 368—or 368—volts for the welding machine. Then we welded it together in the courtyard of the Consulate. They've sent it out on exhibition since then, so they must have had to lift it out over the roof. Now it's placed on the front lawn.

Pittsburgh, 1958:

I won the Carnegie International with this in 1958. We had to install it in a horrible stairwell. I made my object twenty-seven feet high and twenty-seven feet wide, and Chippy Ieronimo and I put it together in the Waterbury foundry using window weights to represent the first three lower bars so that it would balance absolutely right. Eventually they had to represent 135 pounds. We'd read the number on the window weight and then hang it on. I never saw the final thing put together at all until we went to Pittsburgh later to install it at the airport. The mobile was purchased by David Thompson at the International and given to the airport.

When we went to the airport to put it up, they had all sorts of journalists standing around asking this, that and the other. I was trying to concentrate on getting the thing up. One of those guys asked me, "How long did it take you to make that?" I said, "Two or three months." Then I reconsidered and went back to him and said, "Hey, it took me thirty years." Those dolts just looked at me and then walked away.

When Thompson bought it from the Carnegie, it had white paddles and black bars. The guys at the airport wanted it to be the county colors, so they had it painted yellow and green.

County?

Yes, county. I suggested that they repaint it and said, "Paint it red." I sent them four little cans of my color, but they must have diluted it because now it's pink.

Man! The trials of the artist versus "they"!

Whirling Ear, 1958:

There's a little story about this. This one was built by Knight in Watertown, Connecticut. He had a young Scotchman working for him. I asked for two turns a minute and called it *The Whirling Ear*. Then I asked the Scot if the could reduce it to one turn a minute. He said, "Then you'll no be calling it *The Whirling Ear*." It was about twenty feet high and made from a twelve-inch model. The top is aluminum, the bottom is iron. The whole thing was painted black and the motor was inside it.

Back from Rio, 1959:

Where did that name come from? It's kind of high-flying!

Fifteen feet high. In 1959, I took six or eight pieces to Rio. They were going to buy them, but then they seemed to run out of money, so I had to bring them all back. No—in spite of everything, two remained down there. They were bought by Lota de Macedo Soares, that wonderful woman, and set up in the big park that she was designing for Rio. When this one got back it was pinked out by the sun in Rio. It was bought by Swarthmore as a memorial, and I'm glad to say it's been repainted.

.125, 1958:

How do you think of the relation between the mobile at Kennedy and the large stabiles?

People think monuments should come out of the ground, never out of the ceiling, but mobiles can be monumental too. Bunshaft had a model of the space at Kennedy. I made three models to scale, seventeen inches wide. The one that was bought had to be blown up to forty-five feet wide. Chippy Ieronimo at the Waterbury foundry made the big one.

Were there any structural problems?

No, only their problems.

What do you mean?

There was a three-quarter-inch stainless-steel cable at the first arch that had to be spliced on the spot. The guy's sweat fell down so much on the big black plaques I thought they'd been having tea up there in the air. Unfortunately, they used so much energy hoisting it up they bent a bar. So, on Monday, we had to go up there and put in a flat triangle to hold it together.

Two years later they took it down for Christmas to put up a big paper Christmas bell. When they put the mobile back up they didn't get it up right, so I was called in to prescribe again. They've learned their lesson: no more paper bells—I hope.

Spirale, 1958:

This was very nice. I made two models, Breuer selected one. I built everything that revolves in Waterbury, Connecticut. We were very cramped there —no head-room. To get the angles, Carmen Segre [owner of the Waterbury foundry] wanted to see if it would work. So we set up a derrick and supported it from above. It did work. We painted it there and sent some extra Japalac paint in a little box with the S hooks. Several months later in Paris, they couldn't find the hooks or the Japalac. A painter who had liked Noguchi when he did his garden had put all of the Japalac in the Jap, alack, rock garden.

Teodelapio, 1962:

Which was the first really monumental stabile—Spoleto?

Yes. Giovanni Carendente, assistant director of the Museum of Modern Art in Rome, organized the outdoor sculpture for Spoleto in 1962. I had had a show at the gallery L'Obelisco in 1956. I met him then. He wrote me in Roxbury, asking for my collaboration. One object lent itself to that large scale. Because it was to arch the crossroads at the entrance, I made the model higher in the crotch—thirty inches long, thirty inches high. Italsider, a shipbuilder in Genoa, built the thing. They put it on an

enormous trailer truck to bring it to Spoleto. Using two cranes, one to hold it and one for the welder, they put it up the way they build a ship. Unfortunately, I didn't see the operation. Carendente said they needed reinforcements; Sweeney wrote a postal, "Come quick, danger." Jean and I spent three days trying to get Carendente on the phone; finally I flew to Rome, took a train to Spoleto—there it is right in front of you at the station. I had a fine time with Carendente, suggested various flanges to stiffen it. That was done and it's still there.

Was it fun to do something that large?

Yes. People keep giving it a phallic meaning. I wasn't aware of any such influence, but that may give it its nice force.

Incidentally, the name of it refers to the Duke of Spoleto.

After Spoleto, I exhibited some other large pieces with other sculptors in Amsterdam and Stockholm.

The general growth process now began; one development led to another. Seeing the larger piece, Calder was inspired to do others, to try things at a new scale. The Spoleto piece was successful despite the need for better reinforcement. This need was from then on well considered, and the ribbing was carefully planned.

Four Elements, designed 1939, executed 1962:

Tell me about the Four Elements *in Stockholm.*

Well, they are thirty feet tall.

What makes them turn?

Each one has a separate motor, an electric motor housed in the base of the sculpture.

What year was this made? I find it marvelously fresh and full of life.

I had two models, thirty inches high, which I had made for the World's Fair in 1939, and no one even looked at them. When Hultén at the Mod-

erna Museet came along I showed them to him and he liked one. Then, once given the model, no one came back to me.

It's a help when they can be produced that way. I think it would be great if this could happen from now on. You make the models and simply turn them over to highly trained technicians for enlargement.

Le Guichet, 1963:

Was Le Guichet *selected from a group of pieces or done for the space? Moore's piece looks as though it were done for the water, yet he complains properly that "They didn't give me the water they promised."*

Mine was selected, not done for the space. It's too small for that spot. But the pigeons like Henry Moore than me.

Triangles and Arches, 1965:

I made that to have in the 1965 exhibition at the Musée d'Art Moderne in Paris. It will eventually go to the new Albany Mall and stand in front of the new building there. While I was making this one I also produced the *Têtes et Queue*. Werner Haftmann saw it in Paris and asked for it. Wietzhold came from Berlin and checked it, then thanks to money which came from the Springer Publications, it now stands beside Mies's new museum of modern art in Berlin. Springer had it set up for a while against The Wall, until the museum was finished.

Peace, 1965:

How did this installation come about?

Apparently I was very nice to Mrs. Goldberg [the wife of Arthur Golderg, U.S. representative to the United Nations 1965–68] a long time ago when she saw my work at a show in Chicago. She always admired me for that reason, and so she asked me to do something for the United Nations. I wanted to do something for peace. One night when I was com-

ing home on the train I saw this stabile standing outside Carmen's shop in Waterbury with the light on it and decided that it would be appropriate for the U.N., so I gave it to them.

Crossed Blades, 1966:

This was a nice commission. Harry Seidler, an architect, trained at Harvard, wrote me one day at Roxbury. I was in Saché; the letter finally came to Saché. Just as we were leaving for Roxbury, he showed up in Saché. Jean Davidson had him to lunch and discovered what the Australians wanted. Seidler said, "They have a tall tower by Nervi [Australia Square Tower] and need a piece by Calder." I have always thought that Nervi was a wonderful guy, so I wanted to help and I built something.

The whole thing was shipped by boat around the Horn because the Suez Canal was out of commission at the moment. Seidler wanted me to come out to set it up—and I said I really couldn't. I thought that he could probably get it up. He, of course, did.

La Grande Voile, 1966:

This one really knocked me down when I saw it. As one looked at the Voile a whole new set of elements, mostly crossed flanges, seemed to have entered the problem. Too, the ribs (the bracing) appeared bolder and cast deeper shadows, and they were beginning to assert their esthetic clearly.

This, of course, changes too with the sun. Let me tell you a little story. The first model I made I didn't like. Then I did another one, and they liked it; so we made an enlargement exactly to scale, eight feet high. From that model we went to the final piece, forty feet high. This we did in France. Since then we've always made a one-fifth scale model—to study the overlapping of the plates and the piercing of the holes.

The Spinner, 1966:

It is six meters high, and it has a mobile head on top and two or three disks that go around. They are slanting disks to catch the wind, and will go around much faster, I imagine, than vertical disks. The center part has ball bearings at the top and the bottom to increase the speed.

Man, 1967:

I called it *The Three Disks;* [the organizers of Expo 67] called it *Man.* They wanted it bare, which was natural because the Nickel Company put up the money, so they wanted it to look like nickel. It took almost a year to make because they had to install new machines to cut the stainless steel. All the metal it was made of came from Canada, and a lot of the material was sent over to France—not quite according to specification. Some of it had to be pared down and flattened out. That took some more time, and more money.

By now, the Fair was getting closer and closer. We had to get things moving and get it up. There was a big luncheon and honors in France for the send-off. Finally it was put into twelve cases in twelve flatcars, and they went on a Russian ship from Antwerp, and when we got to Montreal the erecting crew were all red Indians, American Indians. They have no fear of height and they work in the air without any safety belts. At Biémont they always wear safety belts putting up the big ones. I had two men with me from Biémont, and they assisted the Indians by handing them the right-length bolts.

We had some trouble with the bracing. The pieces had to be cut there, but the workmen who did that were sloppy. They just chopped up the metal bands and they were *gondolé.* They all had to be filed and straightened out. But we finally got it up.

Les Trois Pics, 1967:

I was asked to do something for the early '68 Winter Olympics, so I made an object of three rough triangles, each with a point piercing the

98

next one. We got M. Gilmon to come look at it in the shop. It was lying down because it was too tall to be put up inside the shop. He accepted it, and we put it up in front of the station in Grenoble.

There was a big group of sculptures there, and the people didn't like any of it very much: they kept saying the city shouldn't have spent the money on it. Now they are very proud of it. One journalist wrote me, "We like it so much we wish you'd make it bigger."

Gwenfritz, 1967:

I wanted great jets arching as from fire hoses over and in front of the piece and coming from the pool—they said: "No, everyone will get wet."

The title is for Gwendolyn Cafritz who donated the piece to the museum.

Monsieur Loyal, 1967:

What does the name mean?

It's called that because it's between two recreation parks, between a track and a recreation playground and a modest school. In France, the name of the circus ringmaster in any circus is Monsieur Loyal, so we called it that because he's in charge between the areas. It's black. It's nine meters high—that's about twenty-eight feet.

Cinq Ailes, 1967:

Where is Cinq Ailes *now?*

Temporarily it was in front of the Maison de la Culture in Bourges. Now it's in front of my studio at Saché.

I remember it so clearly, and my sons tell me they do too, set out there on that immense promontory in Saché. The subtle, almost petal-like curvature of each enormous plaque made us wonder how the Tours people could have done it. In a two-foot model one could imagine it being possi- ble, *but in these enormous plates of high-grade steel, one marvels at the unfaltering smoothness of each piece.*

They have long rollers and they can adjust the curvature of the plates between the rollers very exactly. When the maquette was studied minutiously, they could figure out how to do it.

El Sol Rojo, 1968:

I find this latest one great—such another step toward clarity and monumentality. It looks like a perfect Mendelian cross between [Mexico's] culture and your insides.

Yes, I like it.

Each one now seems to become more distilled, simpler in means and therefore more powerful. How high is this? It looks enormous.

Eighty feet.

The bracing system against the wind and gravity looks so discrete.

Yes, and the other side has rather special reinforcements too. They were afraid it might blow down in hurricanes, but it seems to withstand them.

I like the utter economy of the color—that immense blackness and the one vermilion disk.

So do I.

When I got to Mexico—I'd sent a three foot model of what I wanted ahead and suggested that they make one nine or ten feet high—they'd made this intermediate model and *welded* it all together. When I arrived they asked: "Now, where do we put the holes?"

They were going to bore them and bolt them after the fact. No matter. I like the way it looks.

The line between the painting and sculpture is becoming freer and freer, but on the whole you use it in these big pieces very economically— that one red disk in Mexico City against the black, the single overall

orange on the thirty-foot dragon Tom Whitney bought. There are very few with three or four colors, unlike the joyous gouaches which you are now pouring forth. How important do you feel the color is to the sculpture?

Against certain backgrounds, yes—it can help. For instance, a new one at Grand Rapids will be red because the piece is set against a black glass building. Actually, it will be pinker than vermilion: will be forty feet of raspberry. But otherwise, plain black will do it if I've made it right. One time Hilla Rebay came to me and asked if I would make a mobile for the middle of the Guggenheim. I said I'd make a big black one. She said, "Mr. Wright wants you to make it out of gold." I said, "All right, I'll make it out of gold but I'll paint it black."

Robert Osborn, "Calder's International Monuments," *Art in America* 57, no. 2, March–April 1969, pp. 32–49. * English

A Conversation with Alexander Calder

Robert Osborn

Should I tell you about Marcel's women? His greatest friend for many years was Mary Reynolds; I knew her well when I lived in Paris. She came to see my Circus, and then she brought her friend Mary Butts. That's how Marcel got there. Are you taking all this down?

I don't think he liked the Circus—I don't think so. But he liked the other things I was making. There was one object I am trying to reproduce now, because it was destroyed in the war: it was squashed flat, and I have the workmen in France trying to reproduce it from drawings. He saw that: I had just painted it, and he was so anxious to see it move that he pushed it, and he got all full of paint. That was in '32. It was then that he gave me the name mobile, which was what he called his things. He had a glass thing that rotated—he was bugs about glass. Mobile was a generic term. I made a drawing of one on a card and he got me to write on the card like restaurants do, "Calder, ses mobiles."

While you're at it you might as well put down about Arp. Arp said at the time of my mobile show in 1932 at the Galerie Vignon, "Well, if these are mobiles, what do you call those things you had in the show last year [1931, Galerie Percier]—were they stabiles?" So I took that term too.

I can tell you another little story. It's separate. One time I called on Marcel on 14th Street. Did you ever see the place? It was in a mansard. He was working on *Mon Secret*; do you know it? We have one inside. It's a rubber breast on black velvet. He was busy tinting the nipples—magenta, green and yellow. He had them spread on black velvet patches. We didn't discuss it. I understood immediately.

He used to work like hell. He had a glass gilded on the back and then made this circle and all the rays coming from it, spending months scraping off the excess gold. But my favorite work is the one with the shadow of the man on a bike and the bottle brush sticking straight out—you know, *Tu m'*.

He was a good friend of Katherine Dreier too. He and she took *La Mariée* [the *Large Glass*] all over South America. When they came back they put it in a truck and took it back to her place in the country. Bumping around in the truck took bites out of it. I told him once that I liked the bites. He didn't like that.

Robert Osborn, "A Conversation with Alexander Calder," *Art in America* 57, July–August 1969, p. 31. * English

Calder in his Roxbury studio,
1944 / Photo: Herbert Matter

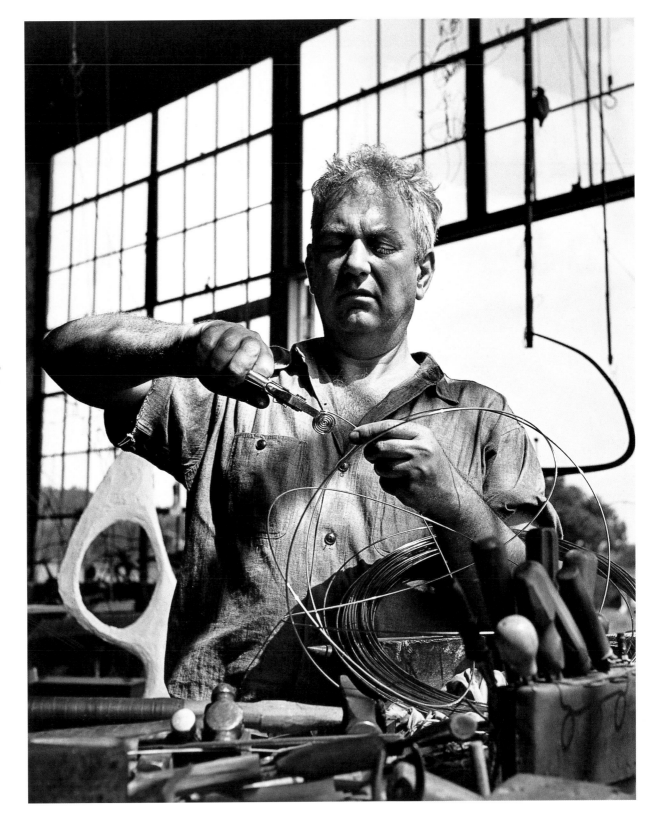

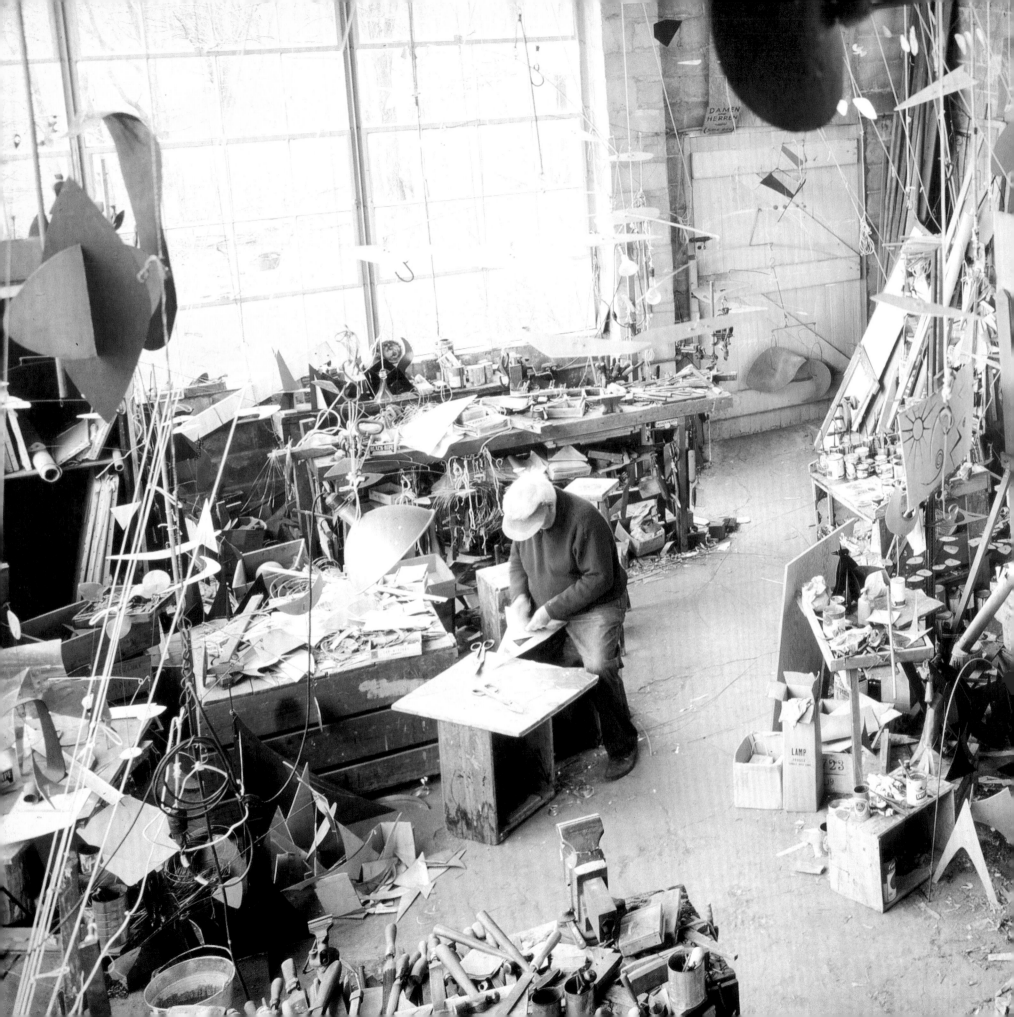

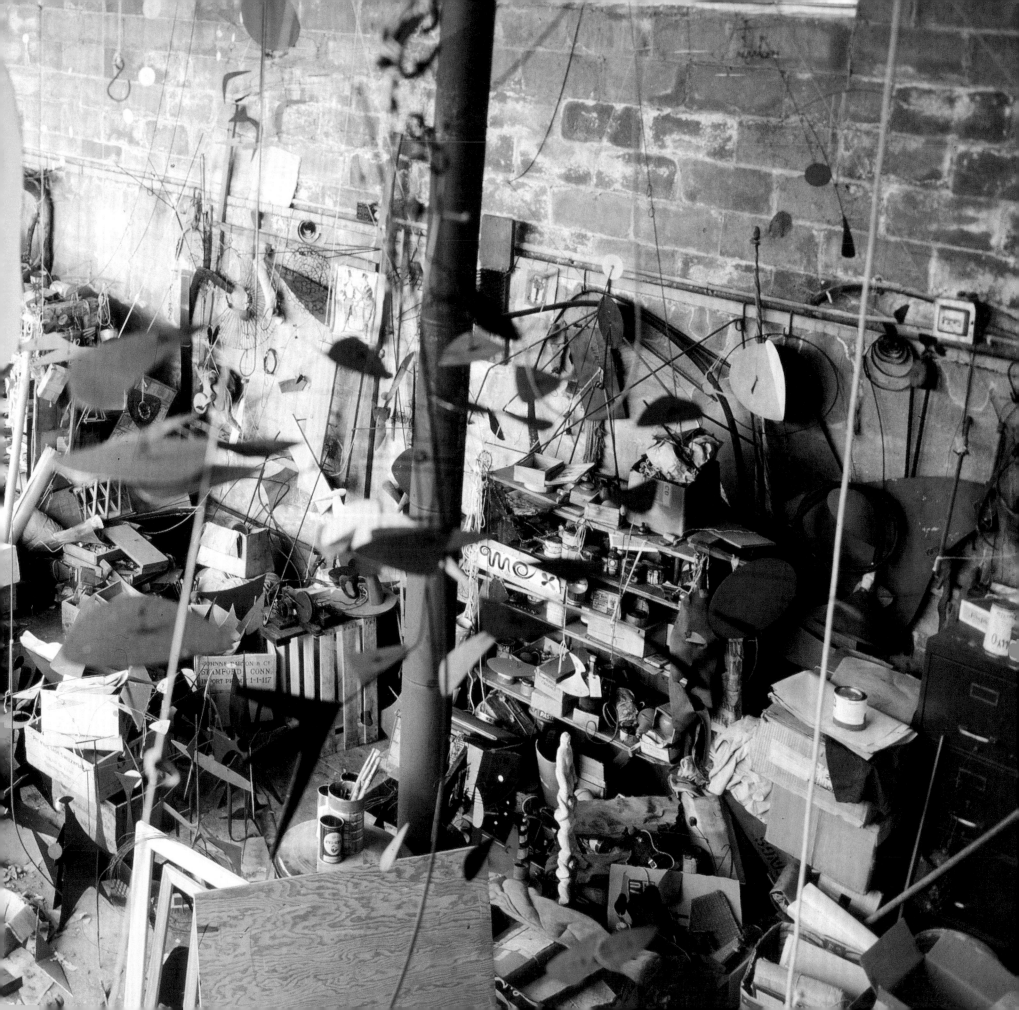

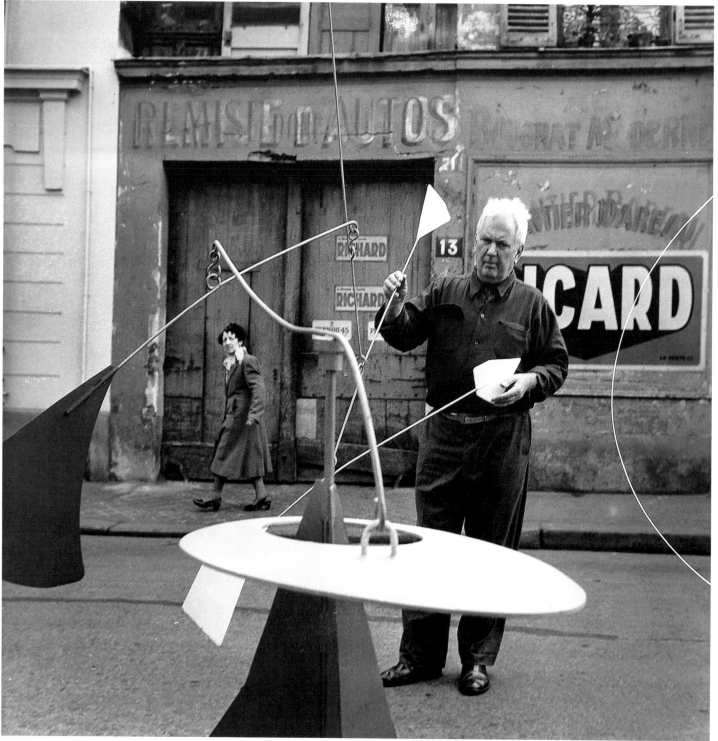

Calder with *Yellow Disc*, Paris, 1954. Courtesy Calder Foundation

◄ Calder working in his Roxbury studio, 1963 / Photo: Pedro E. Guerrero

PLATES

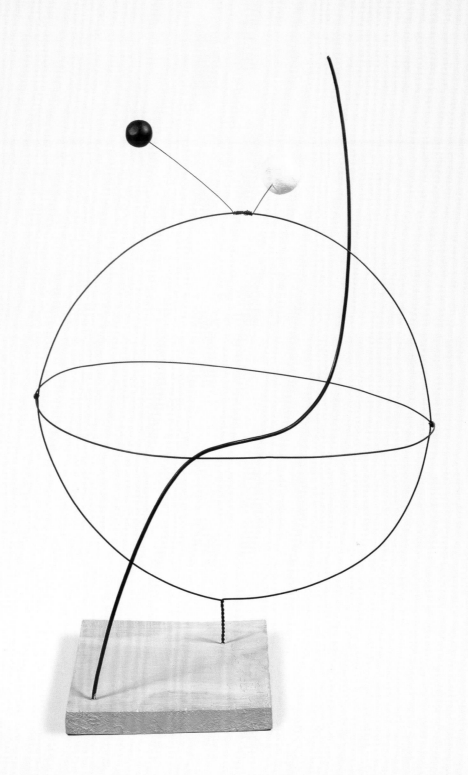

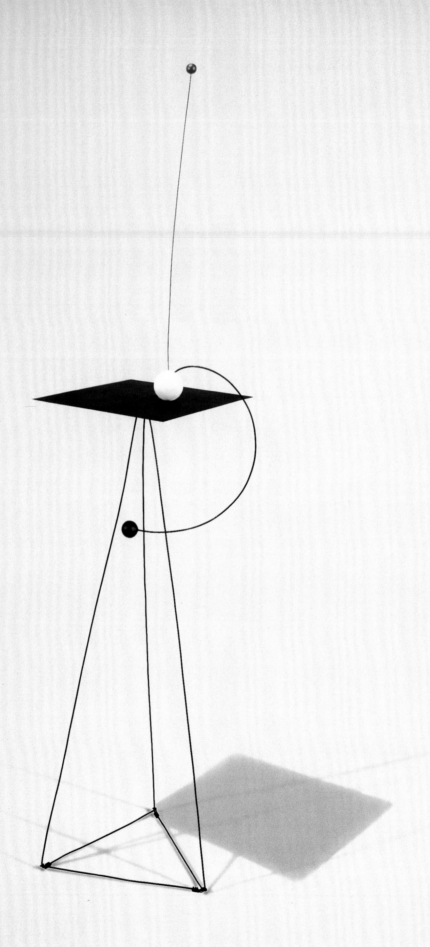

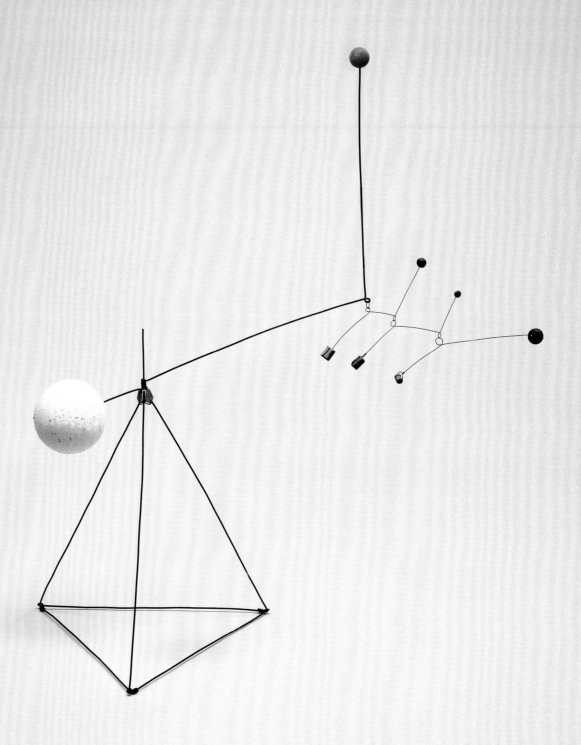

3

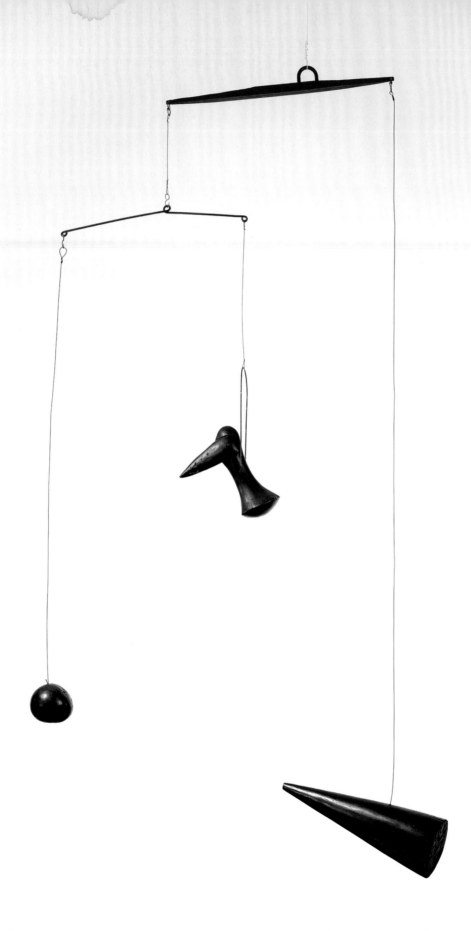

4

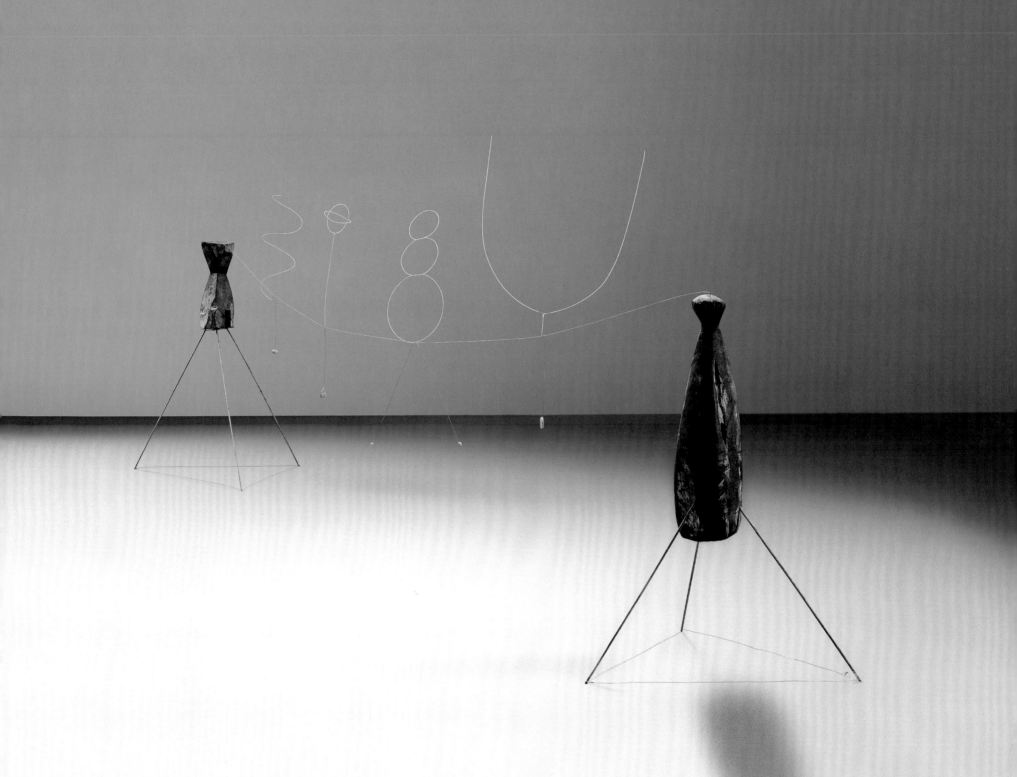

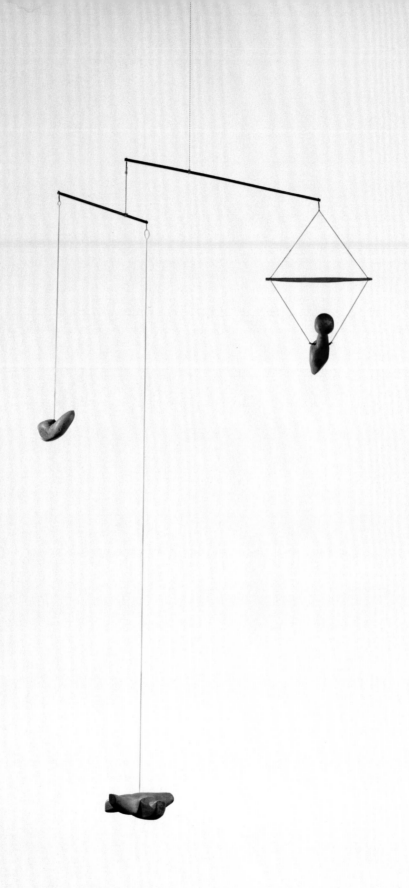

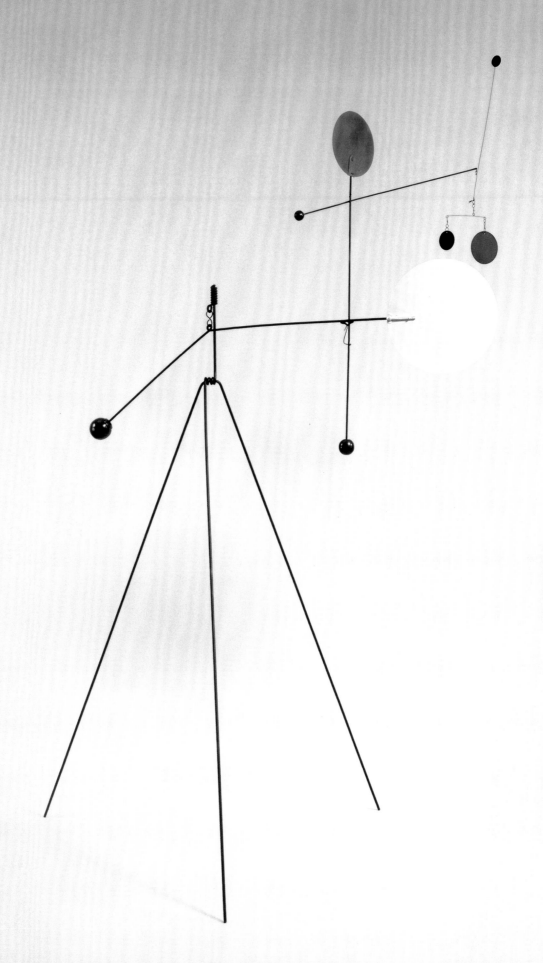

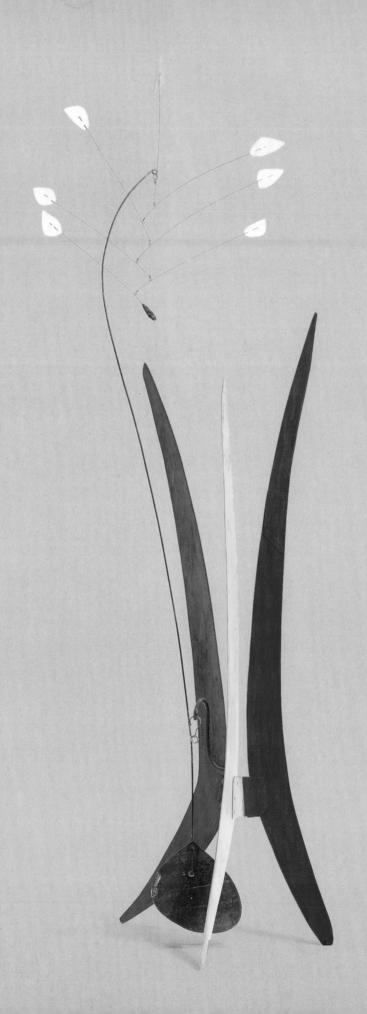

8

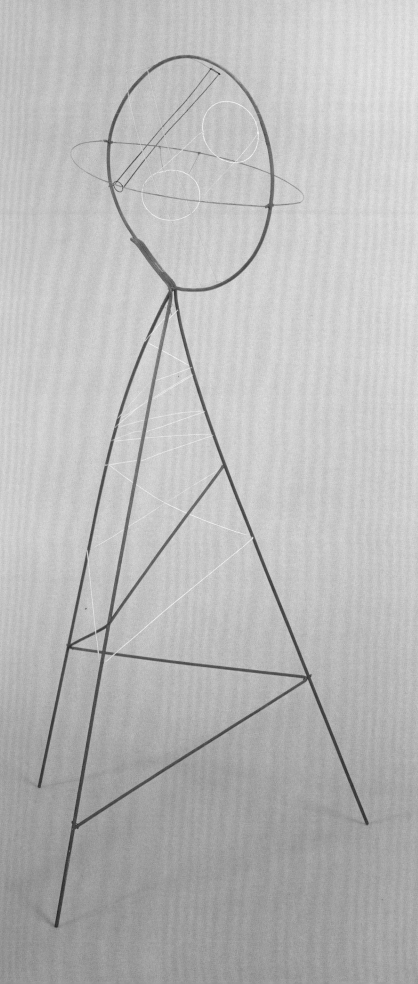

9

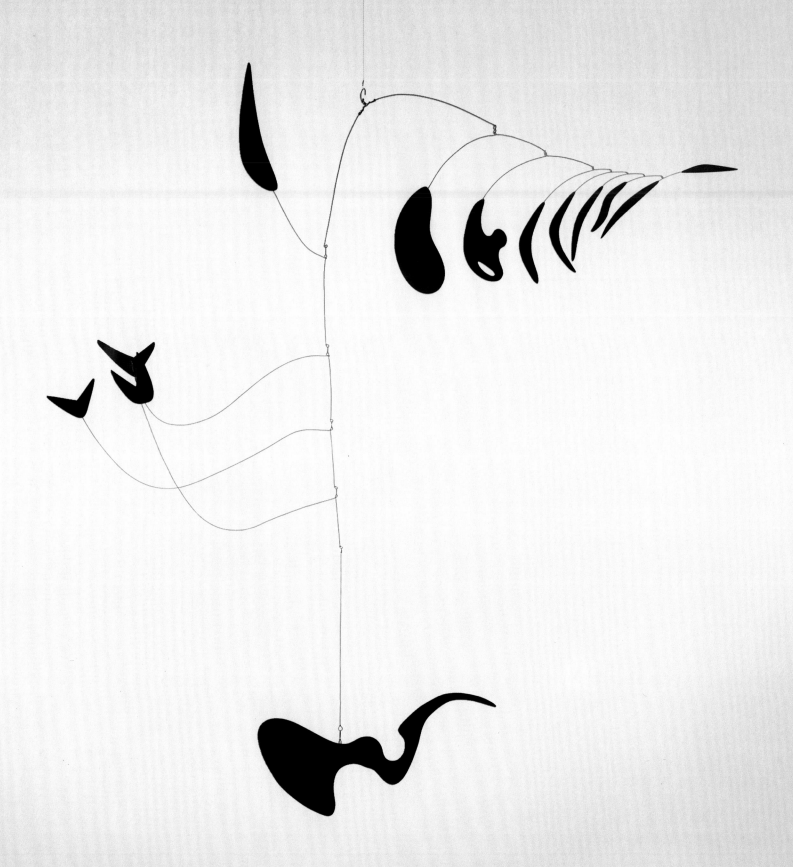

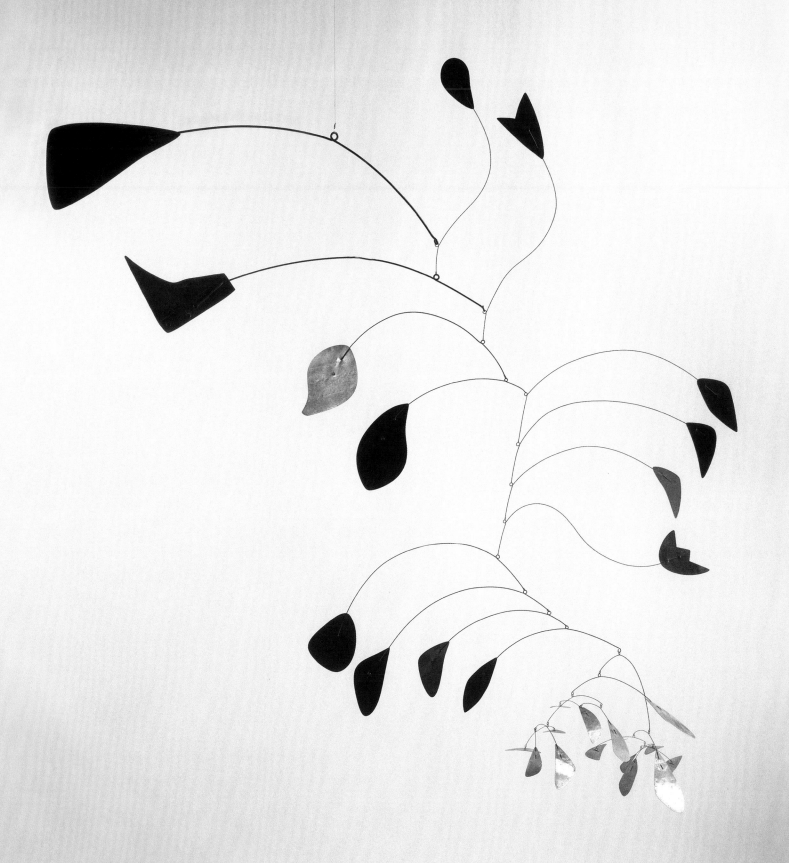

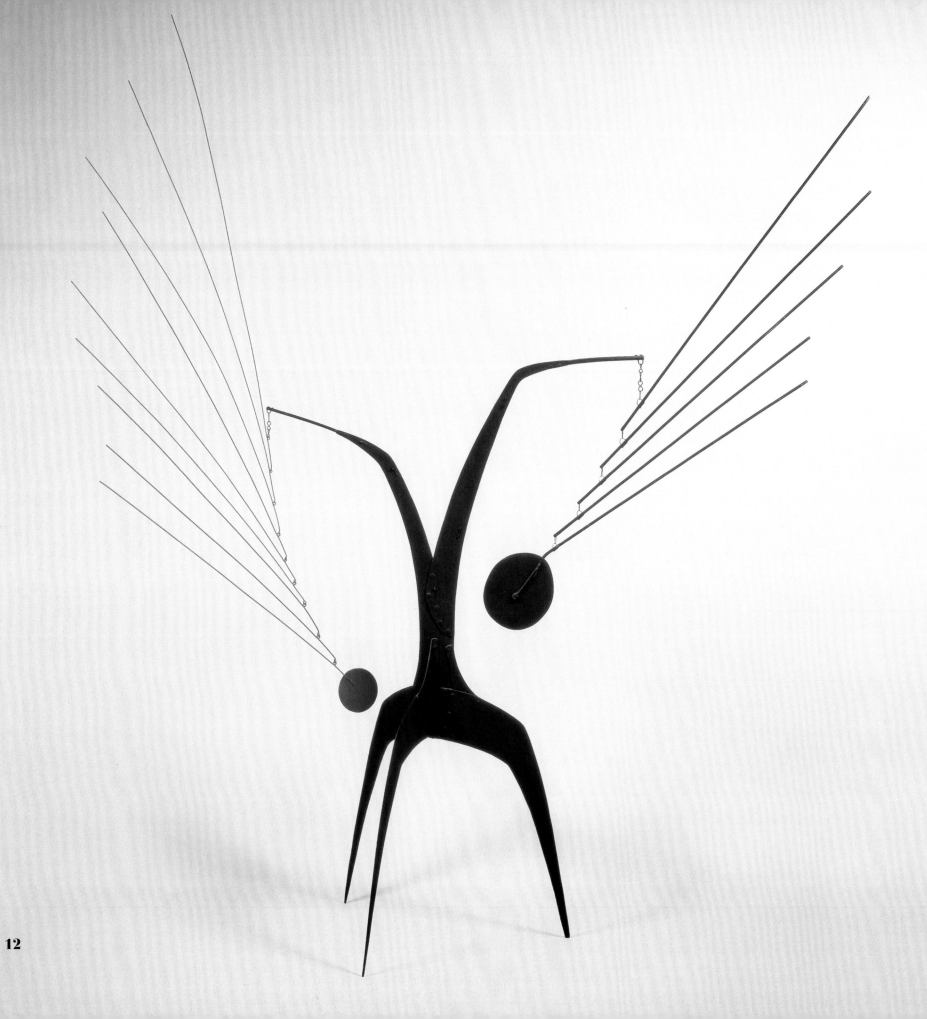

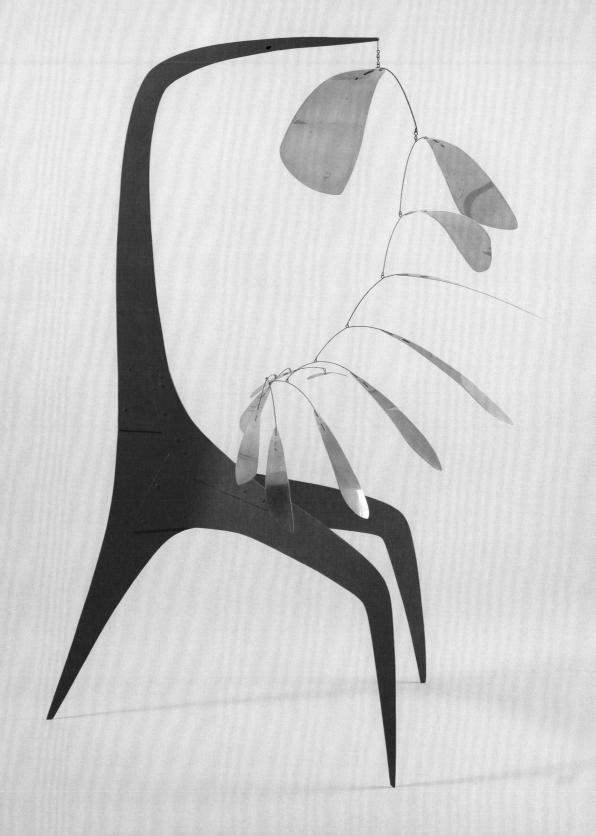

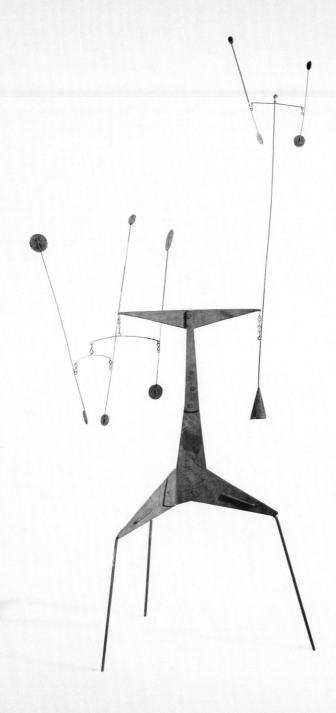

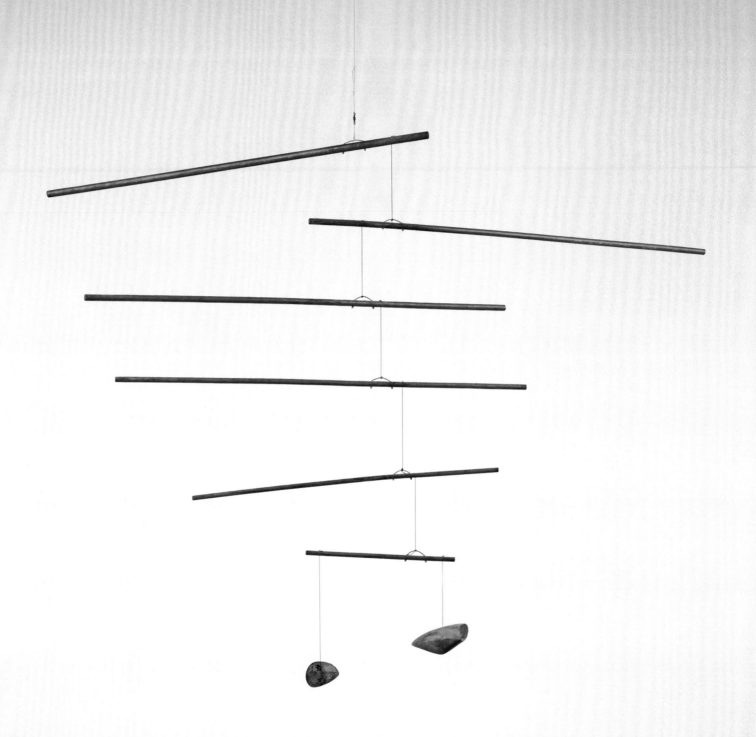

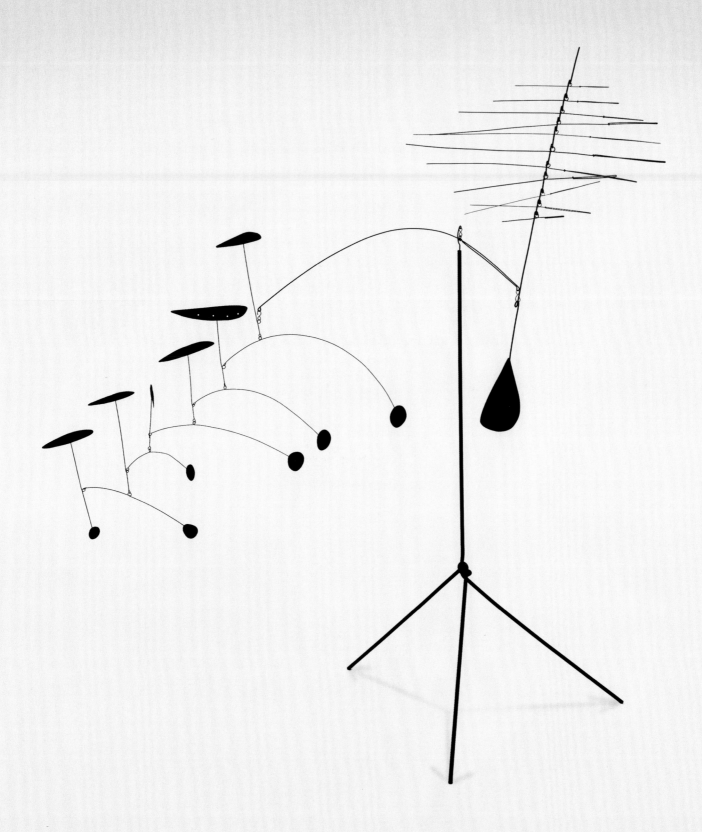

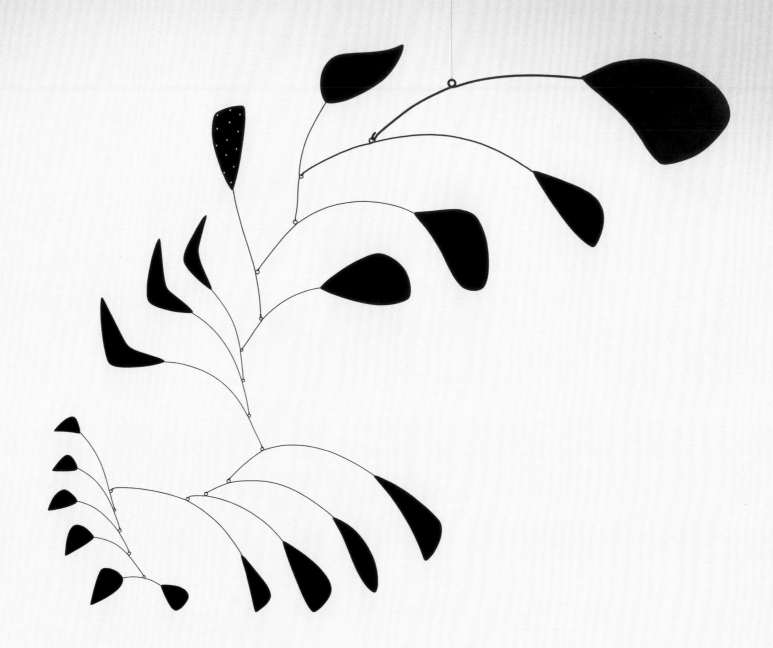

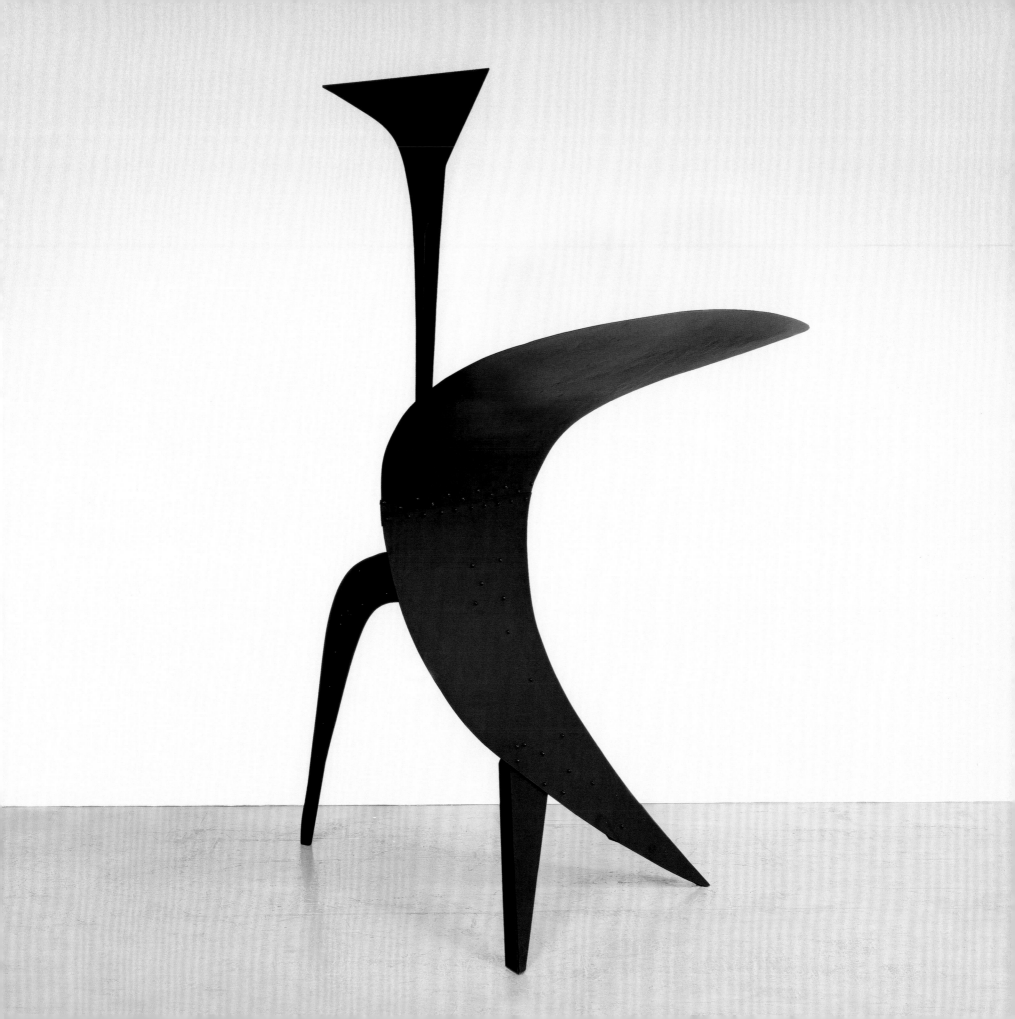

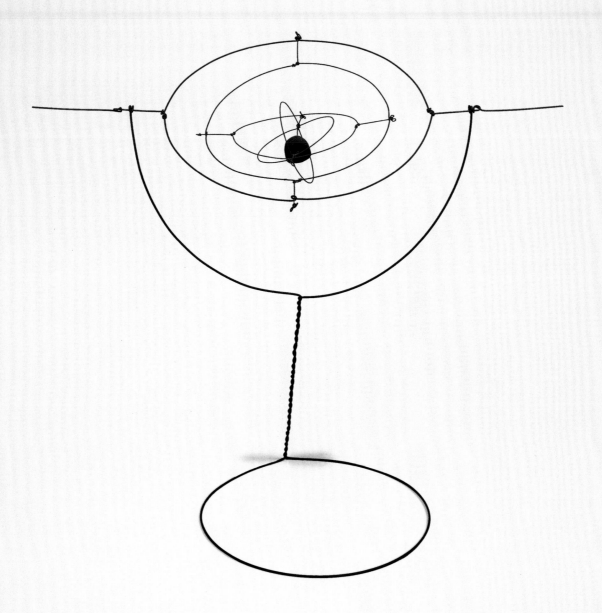

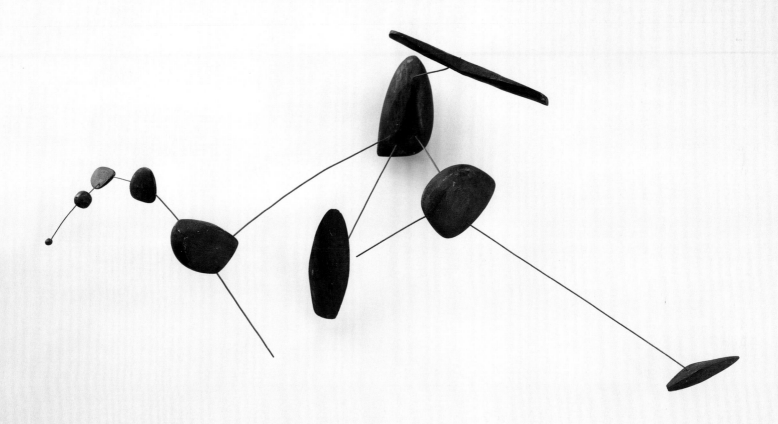

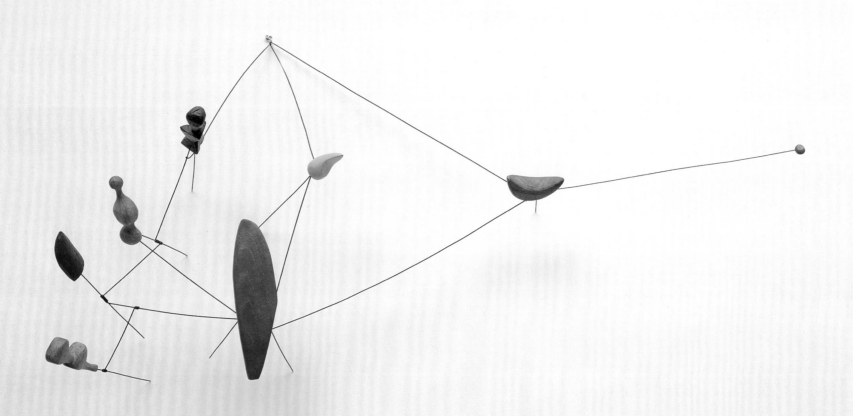

21

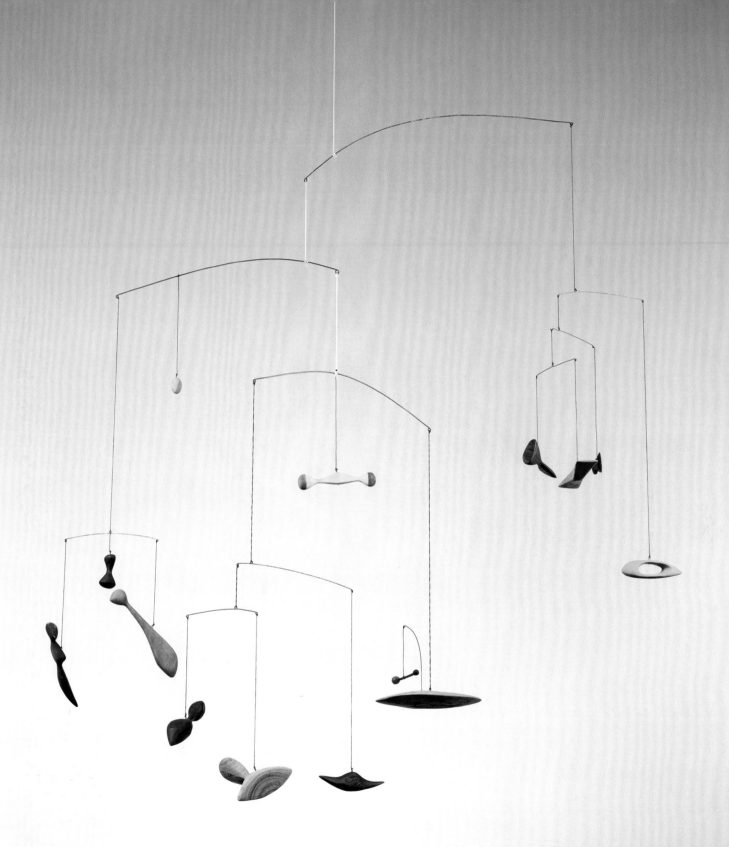

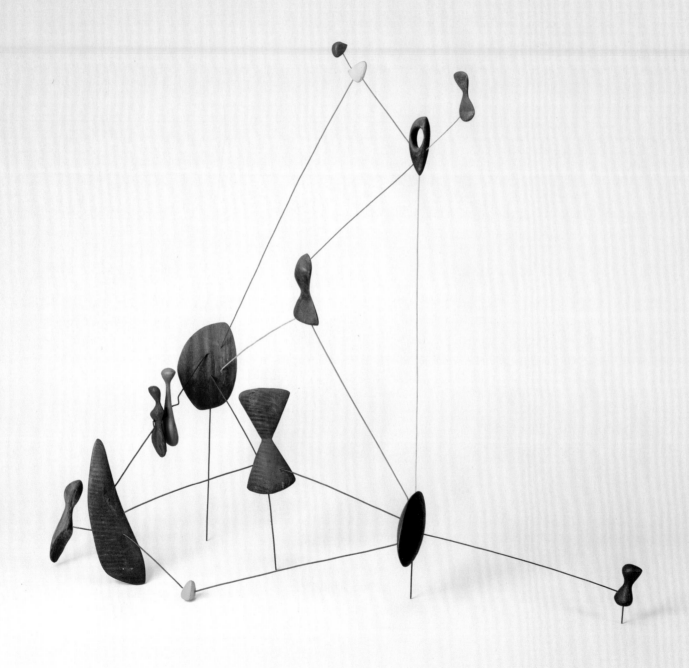

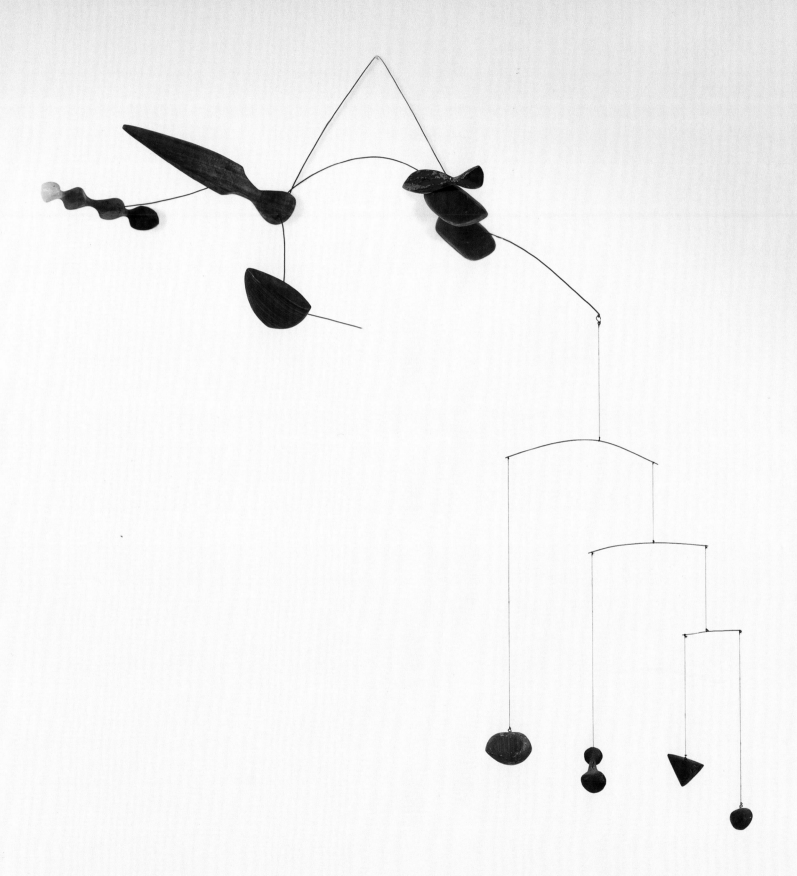

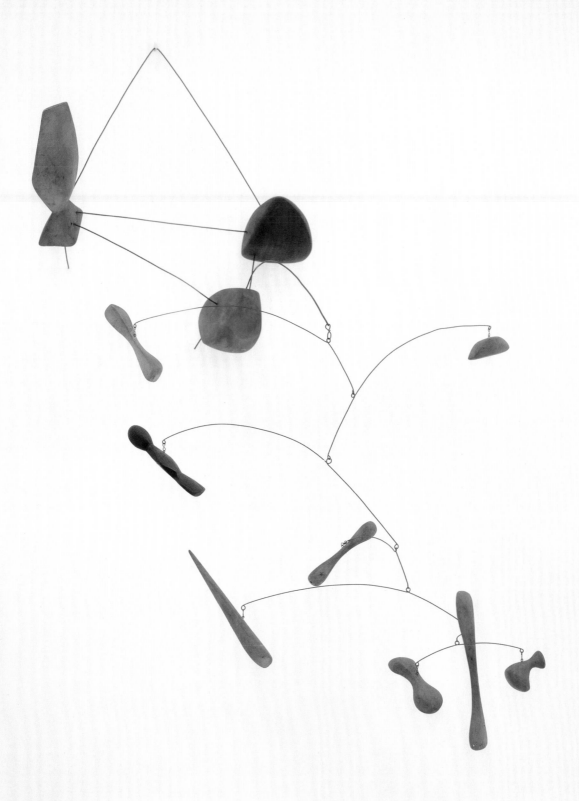

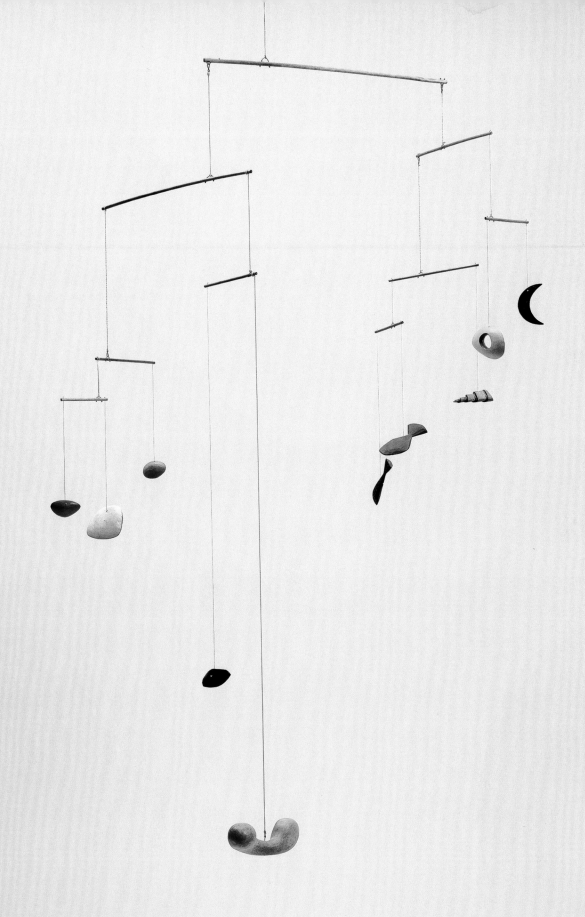

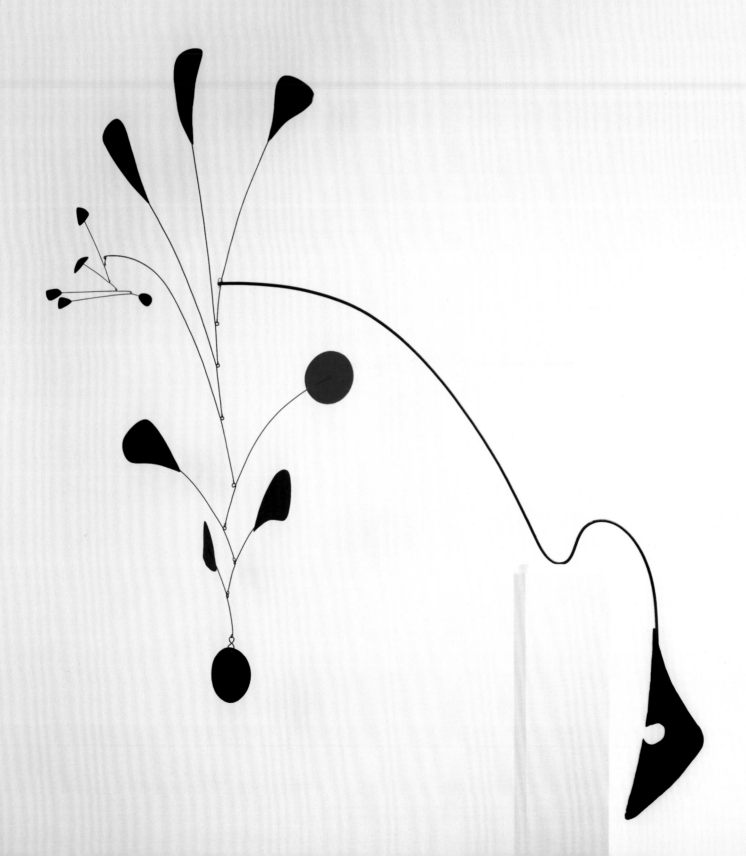

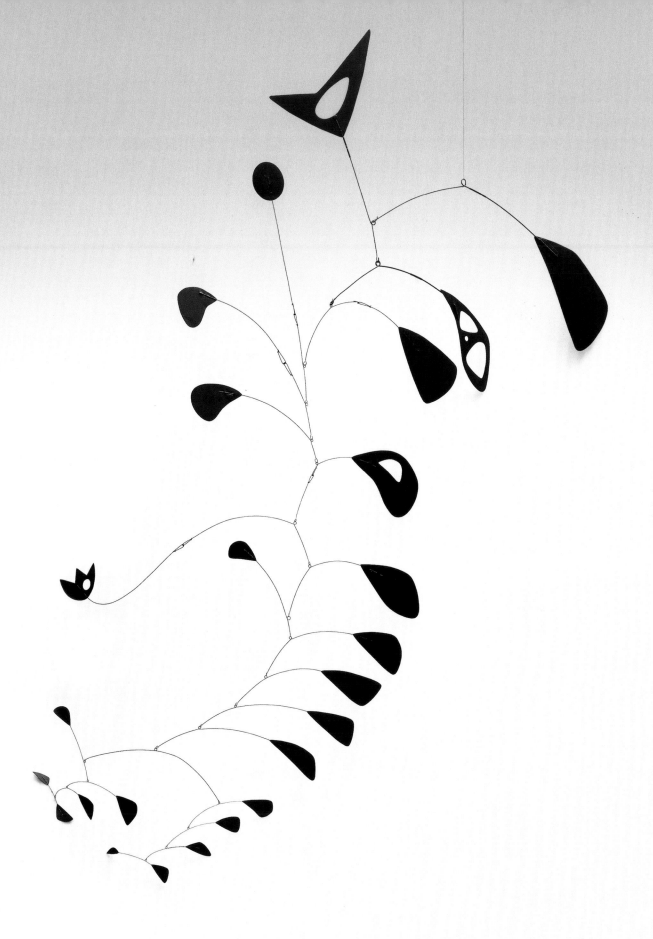

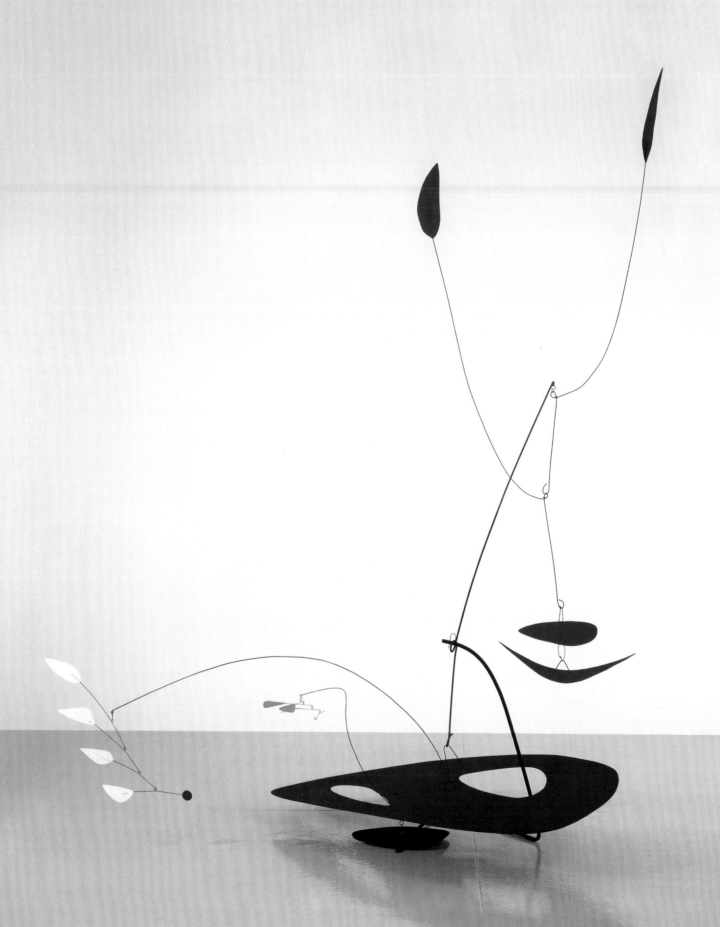

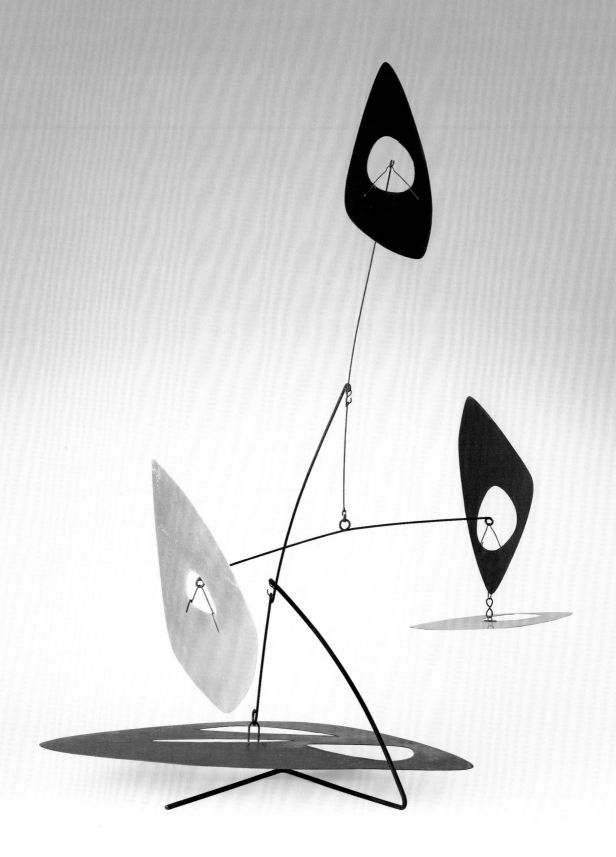

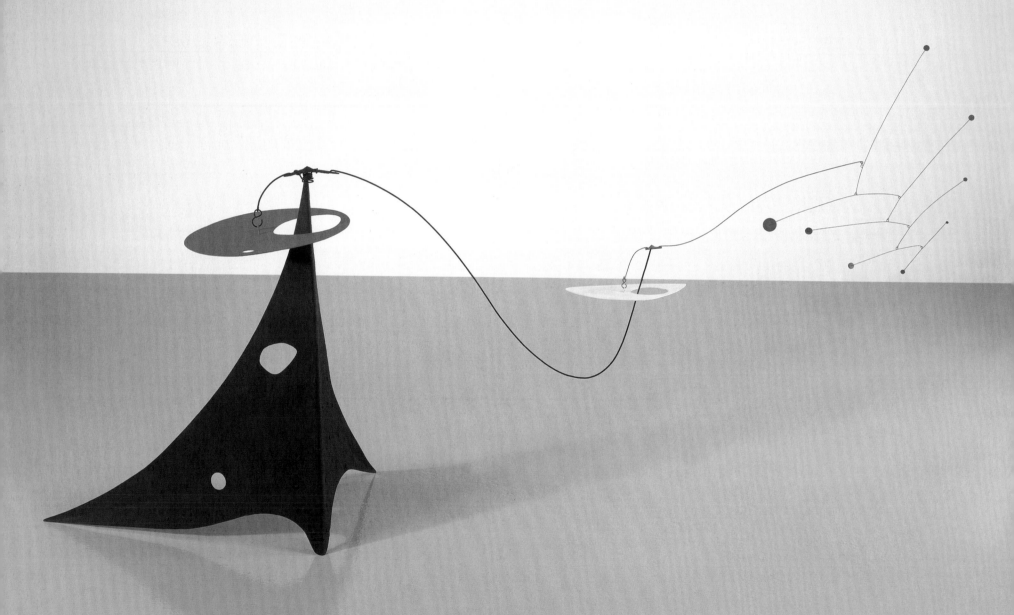

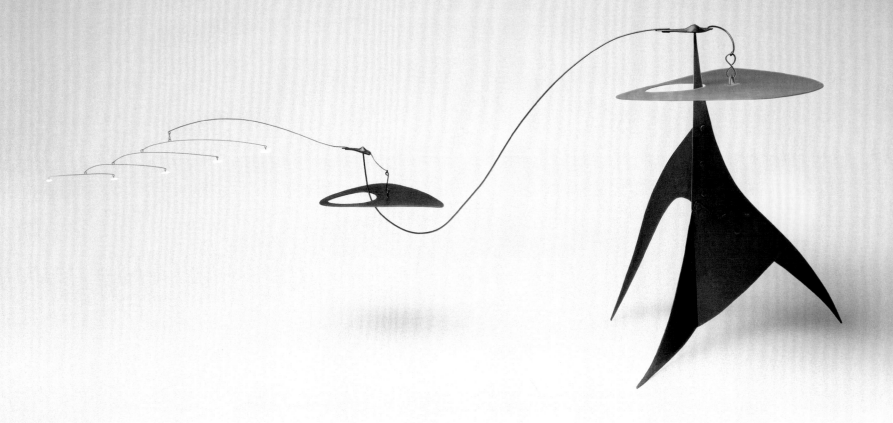

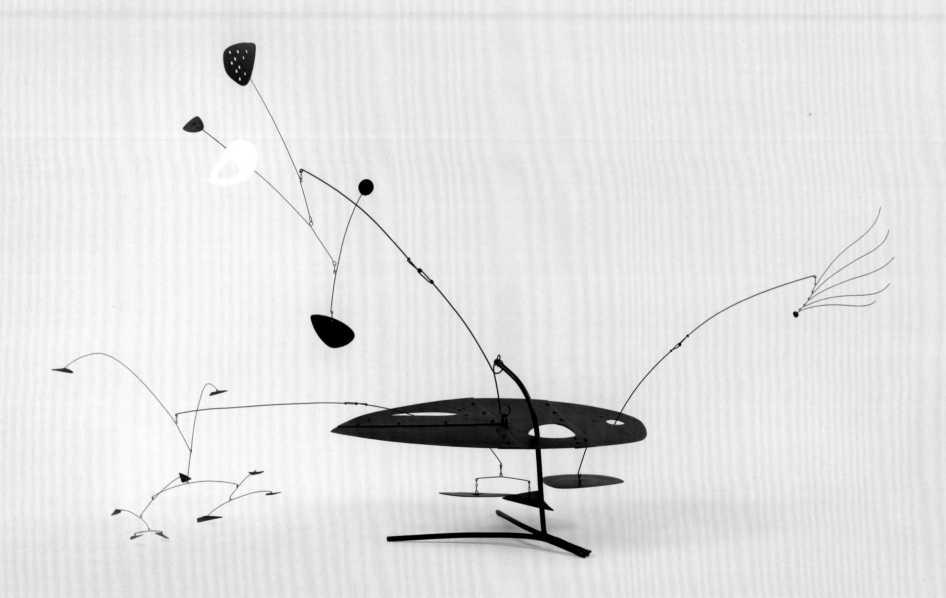

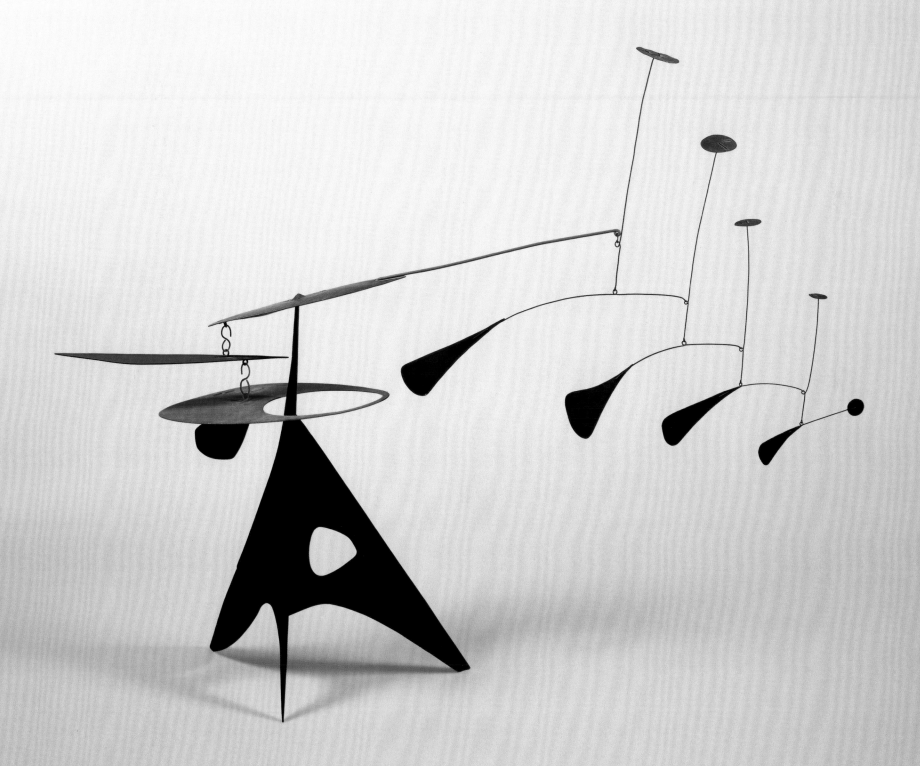

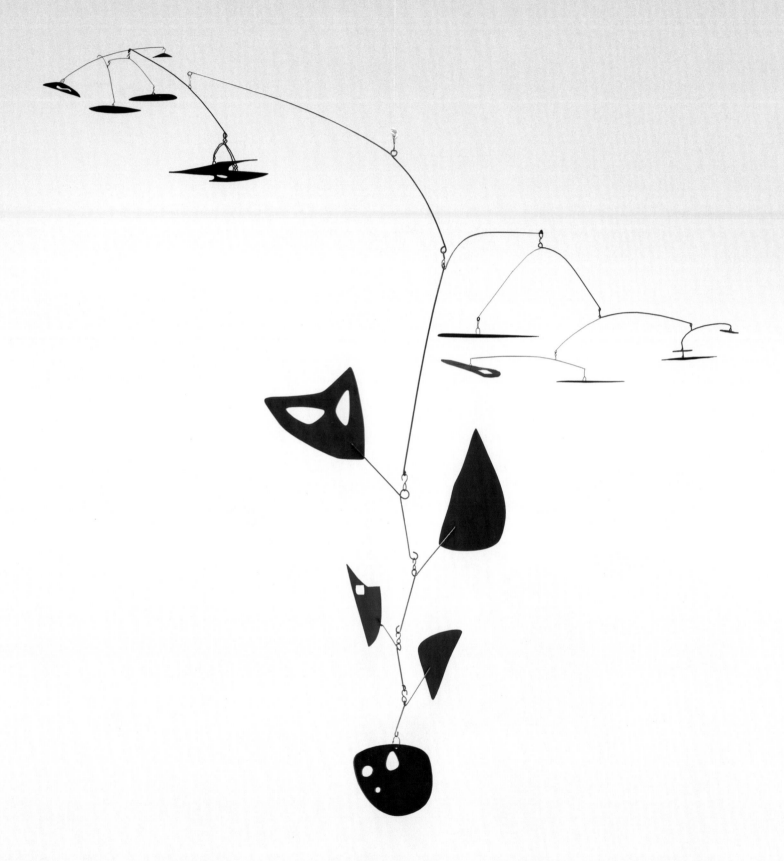

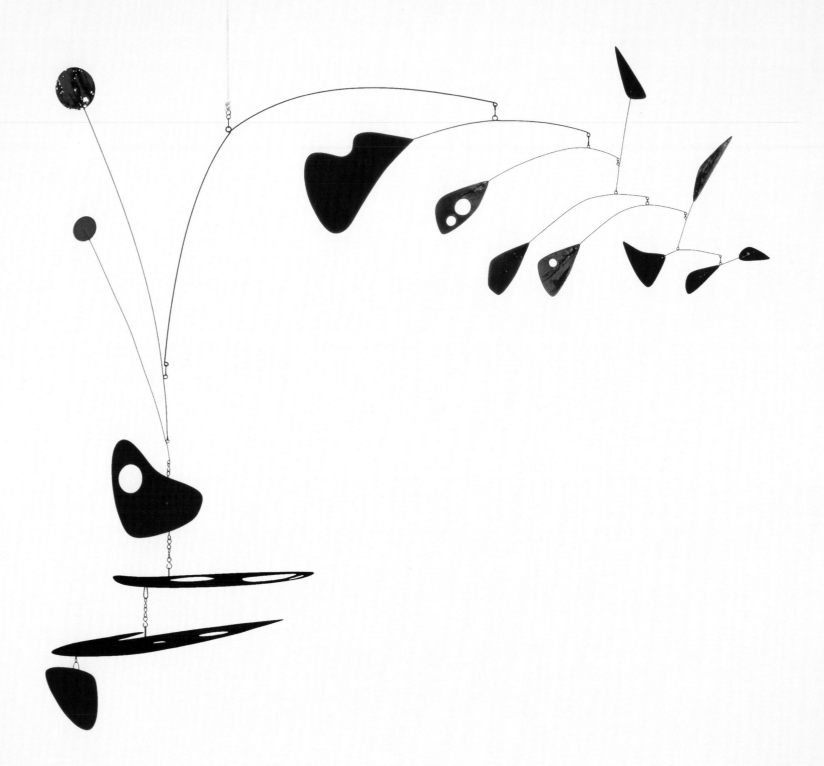

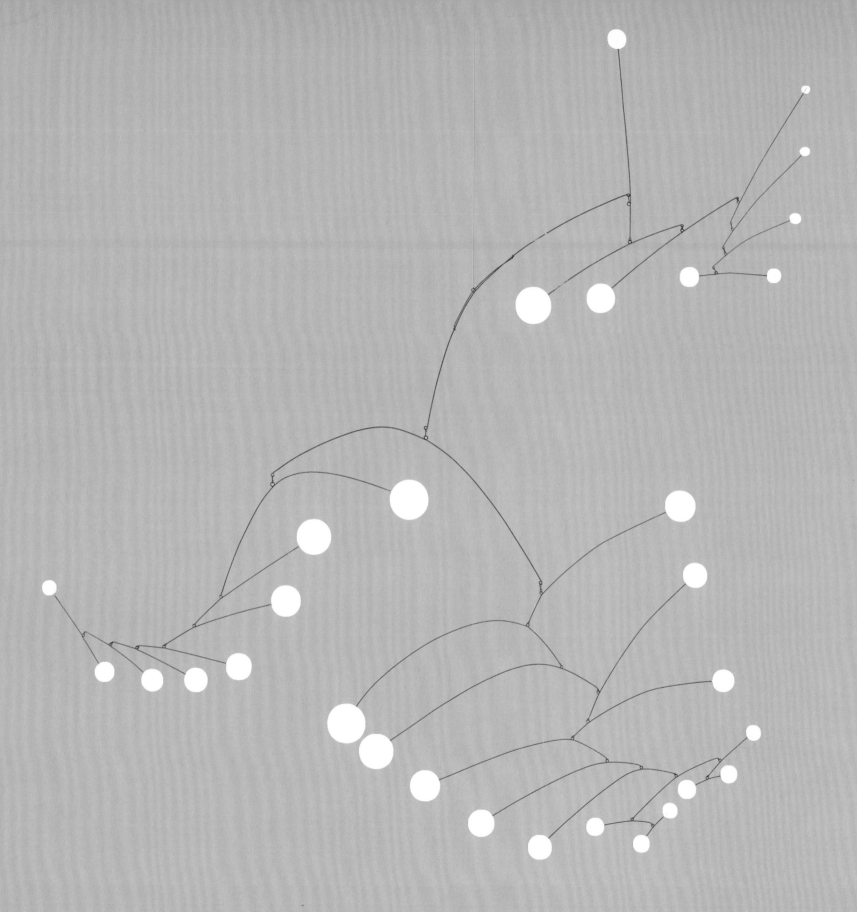

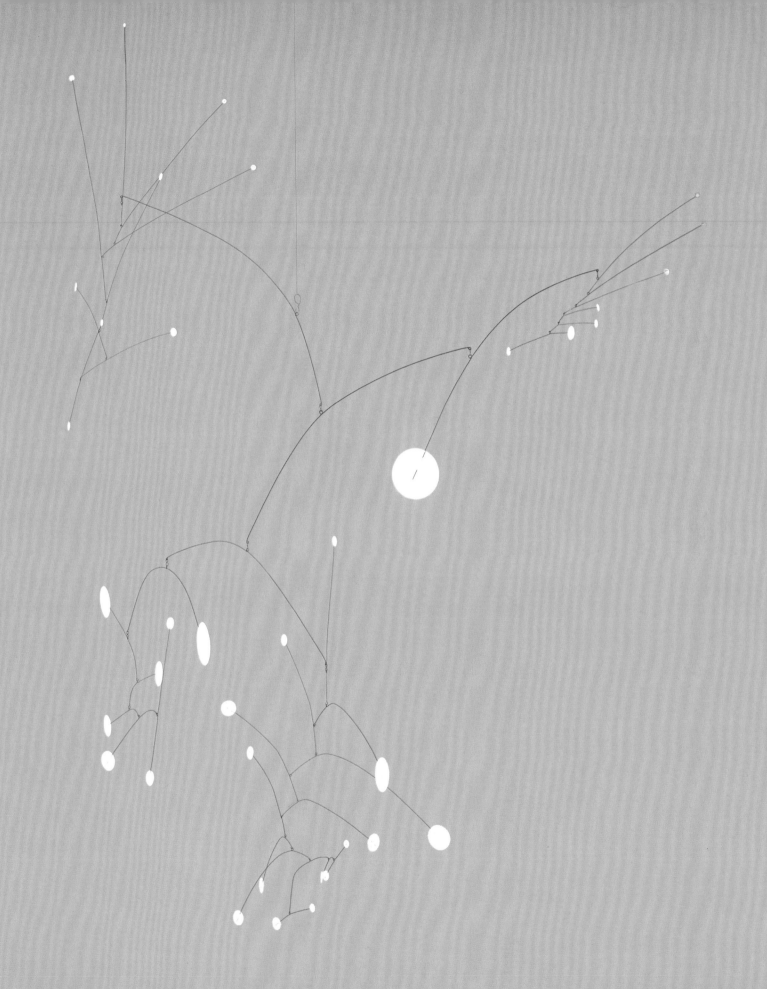

38

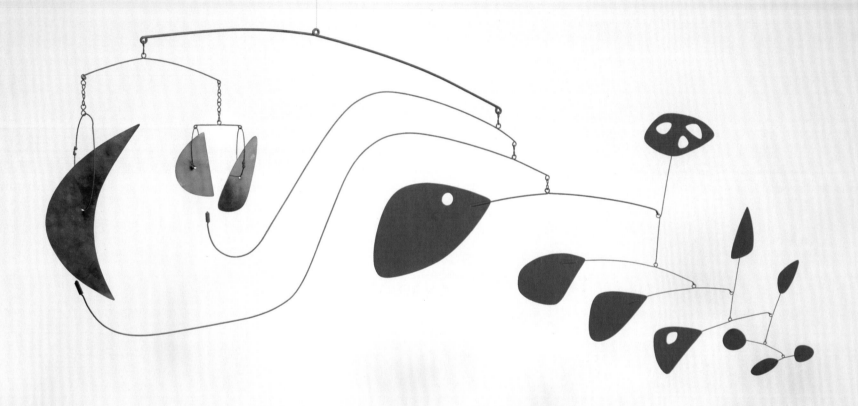

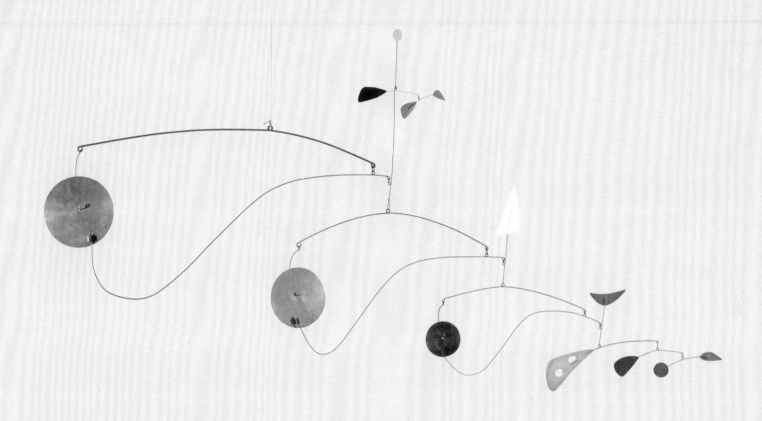

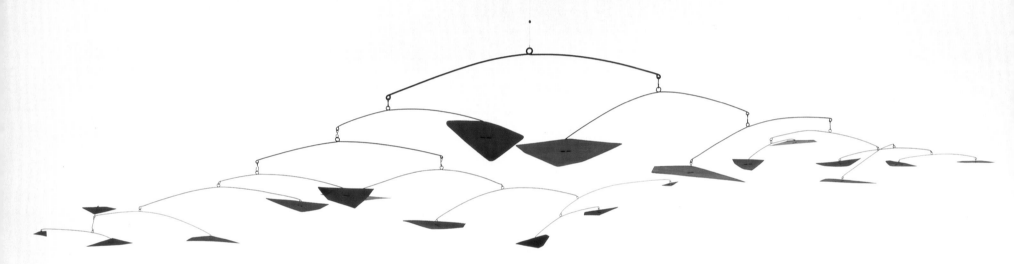

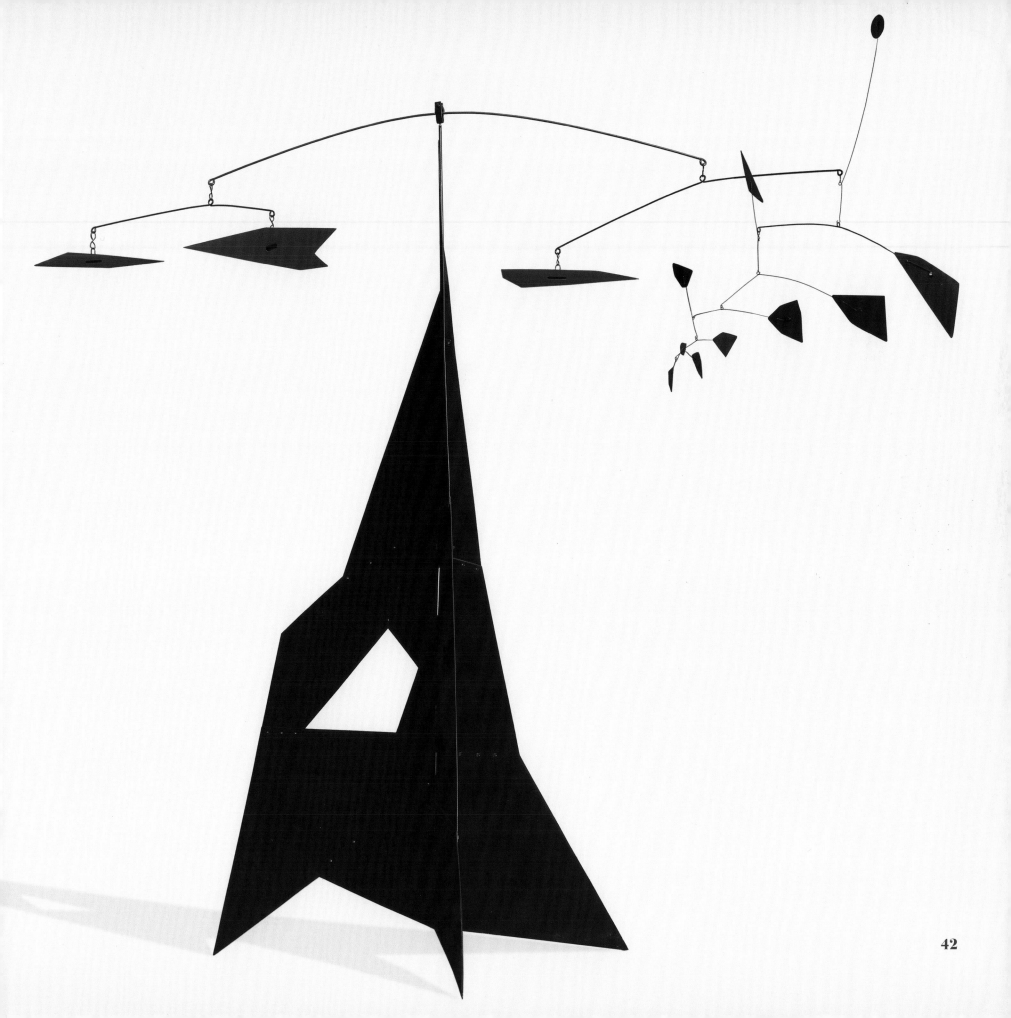

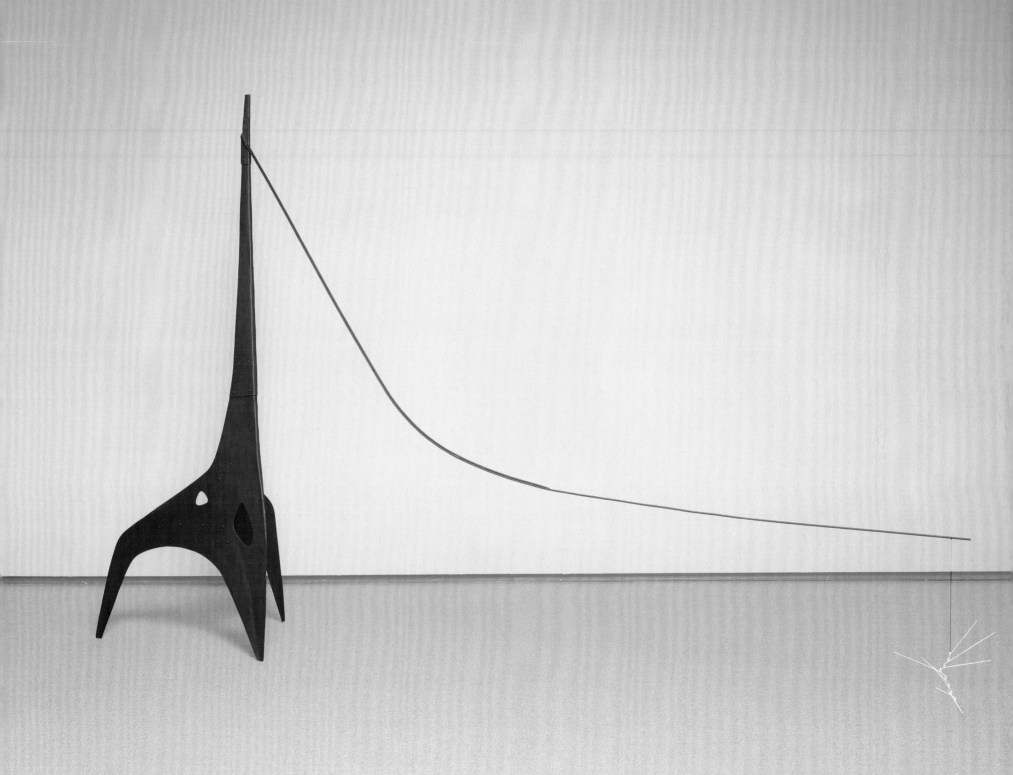

44

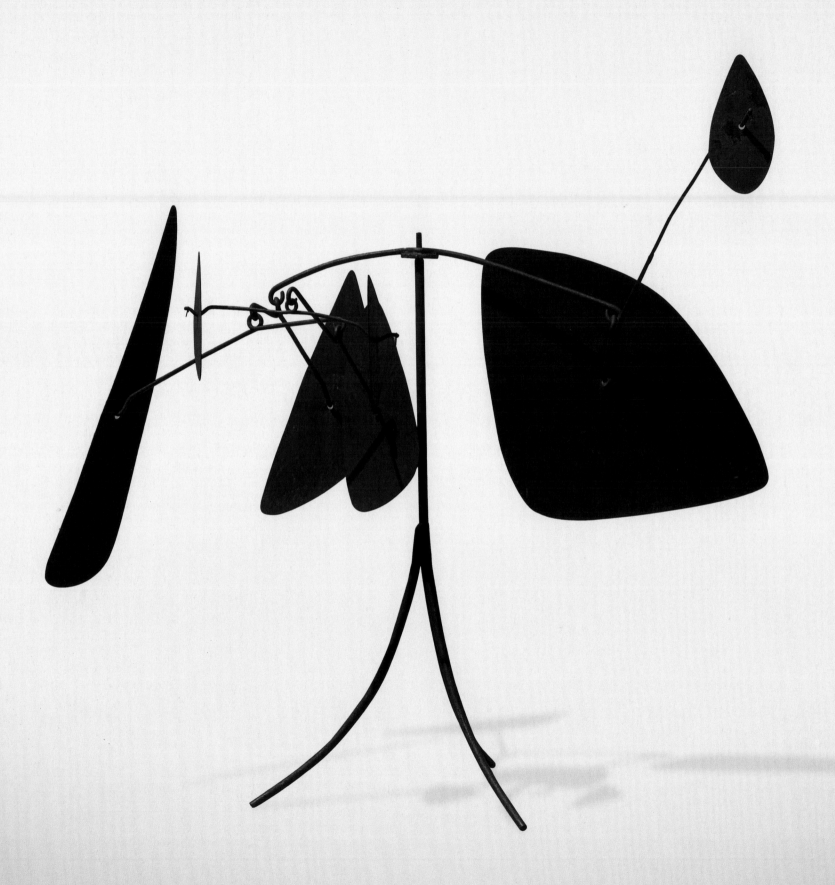

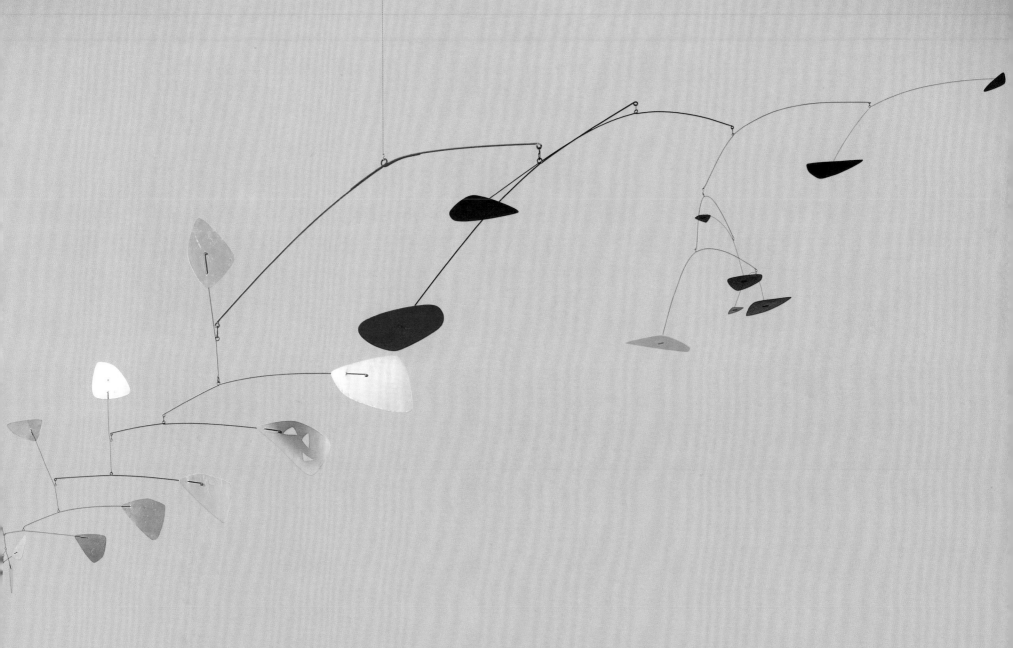

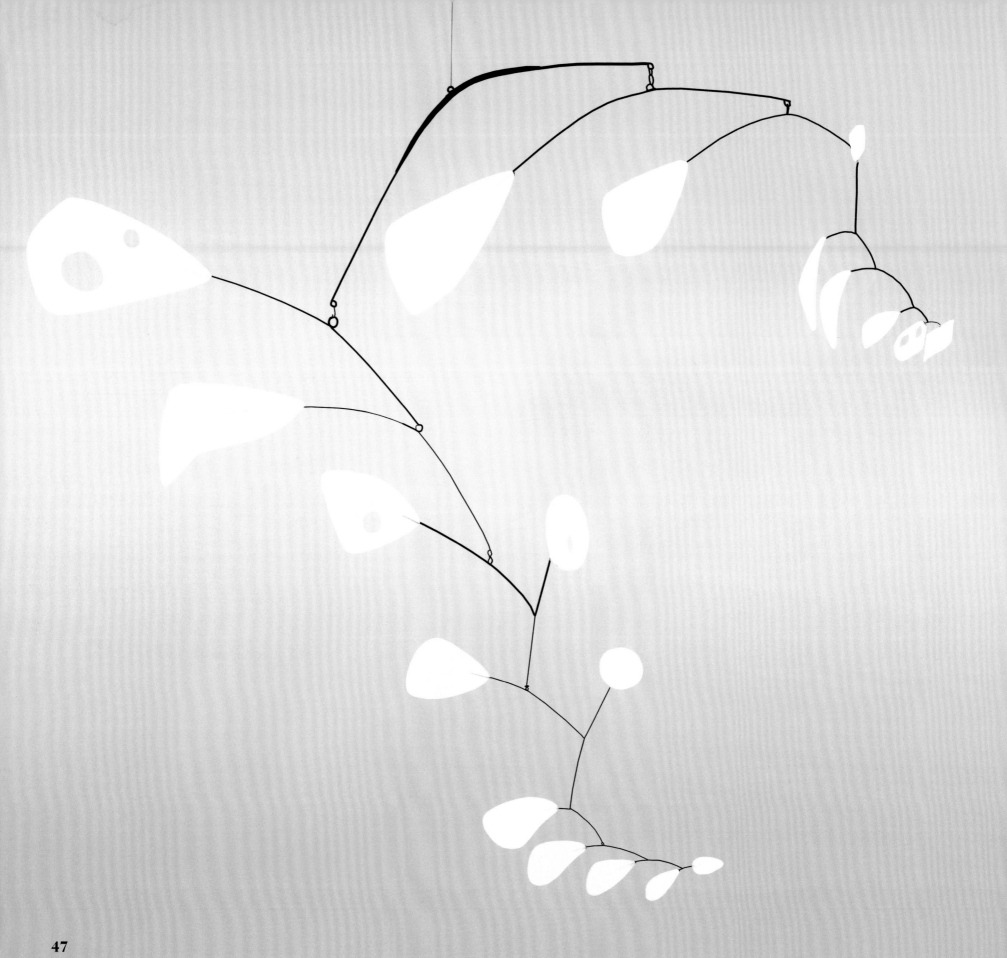

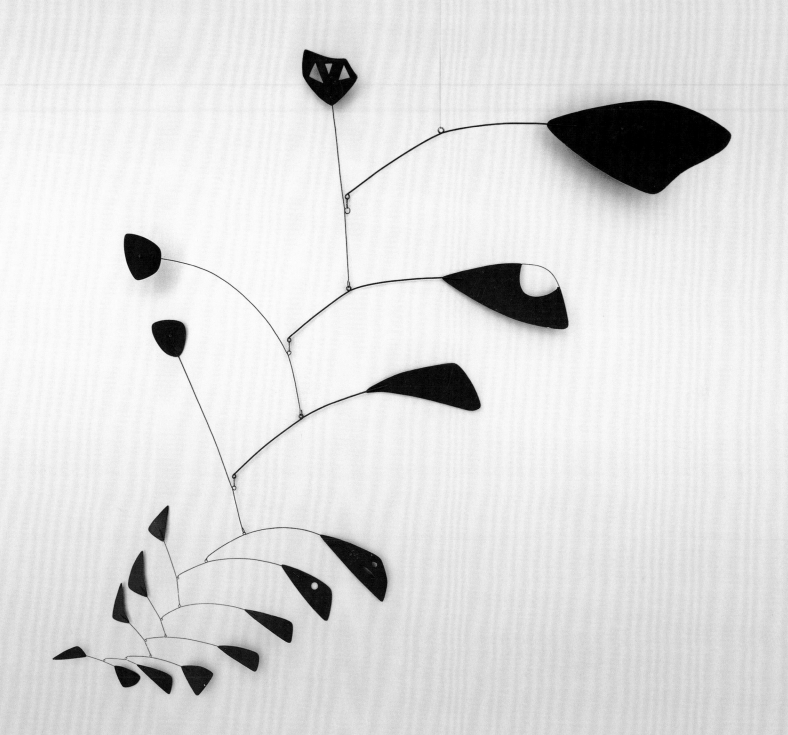

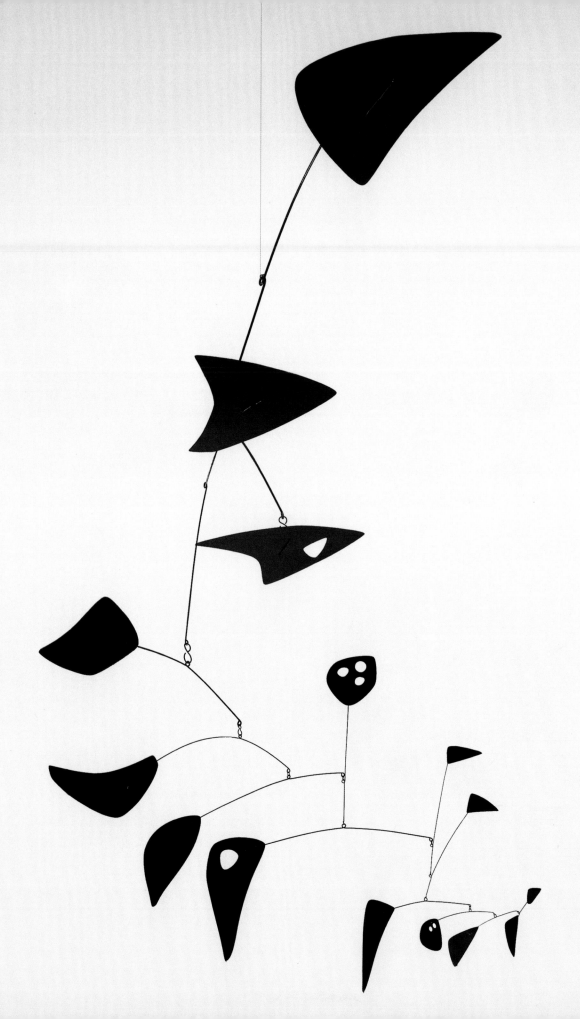

49

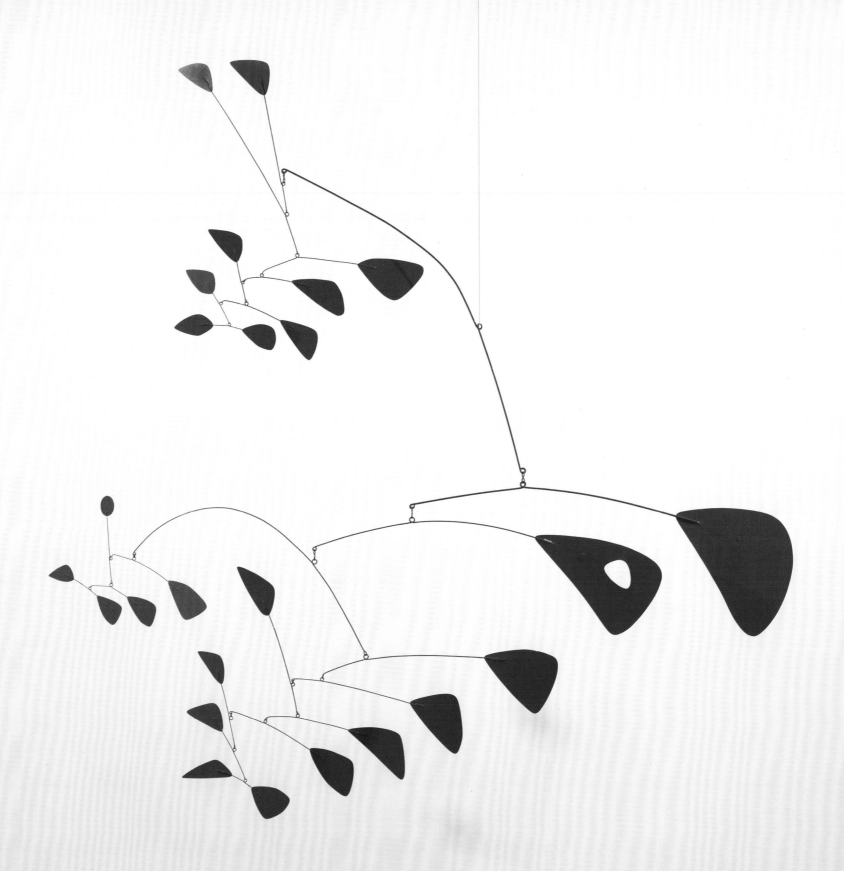

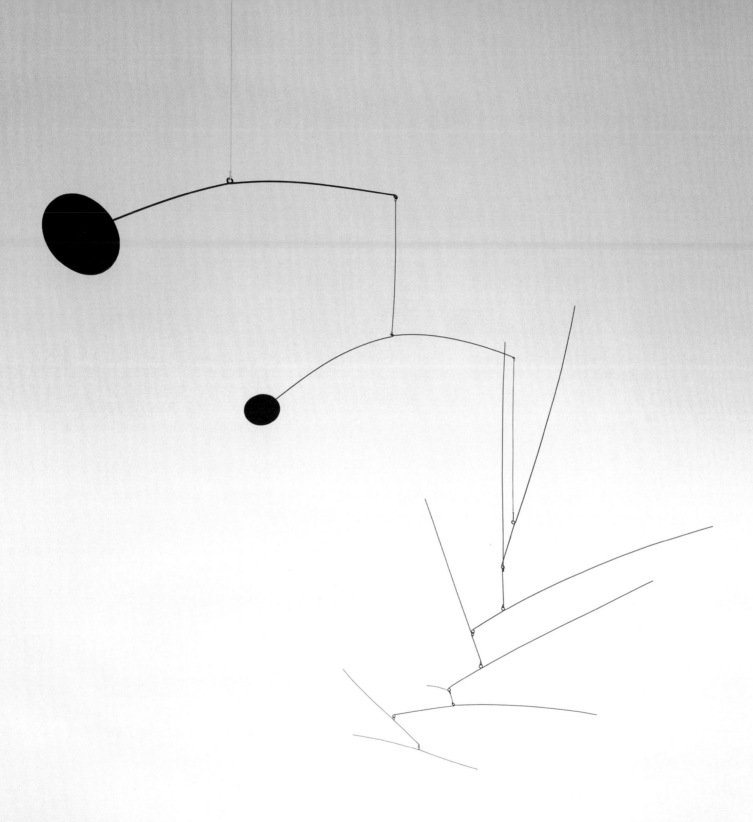

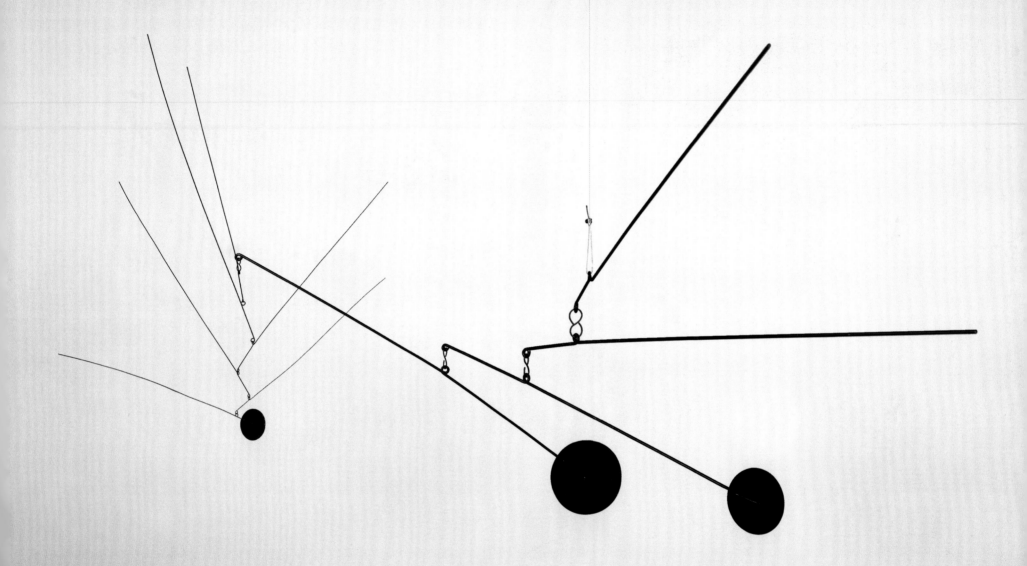

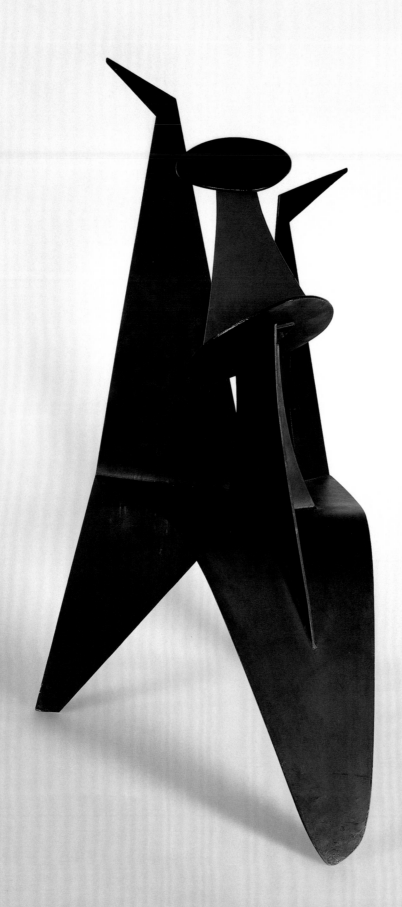

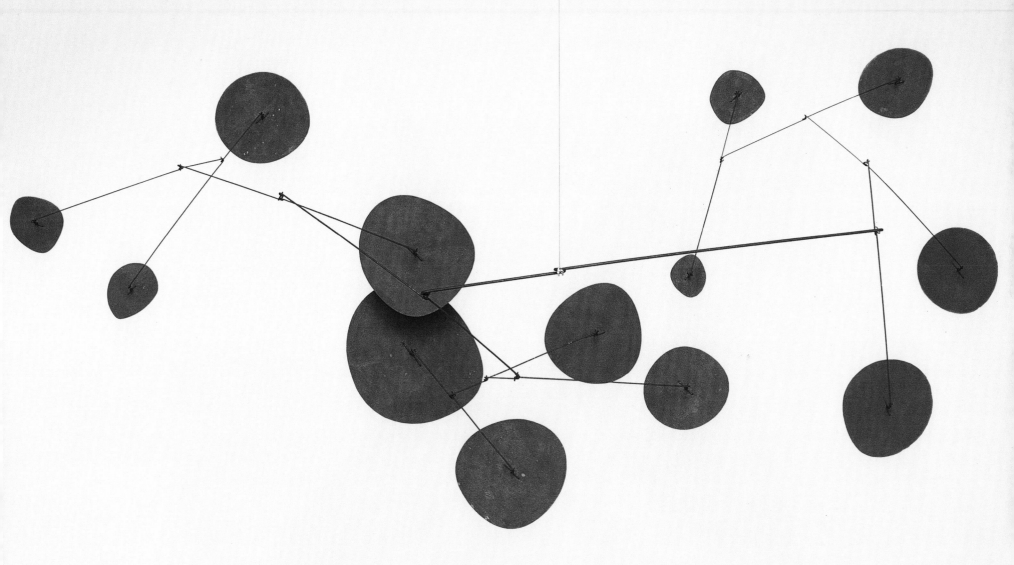

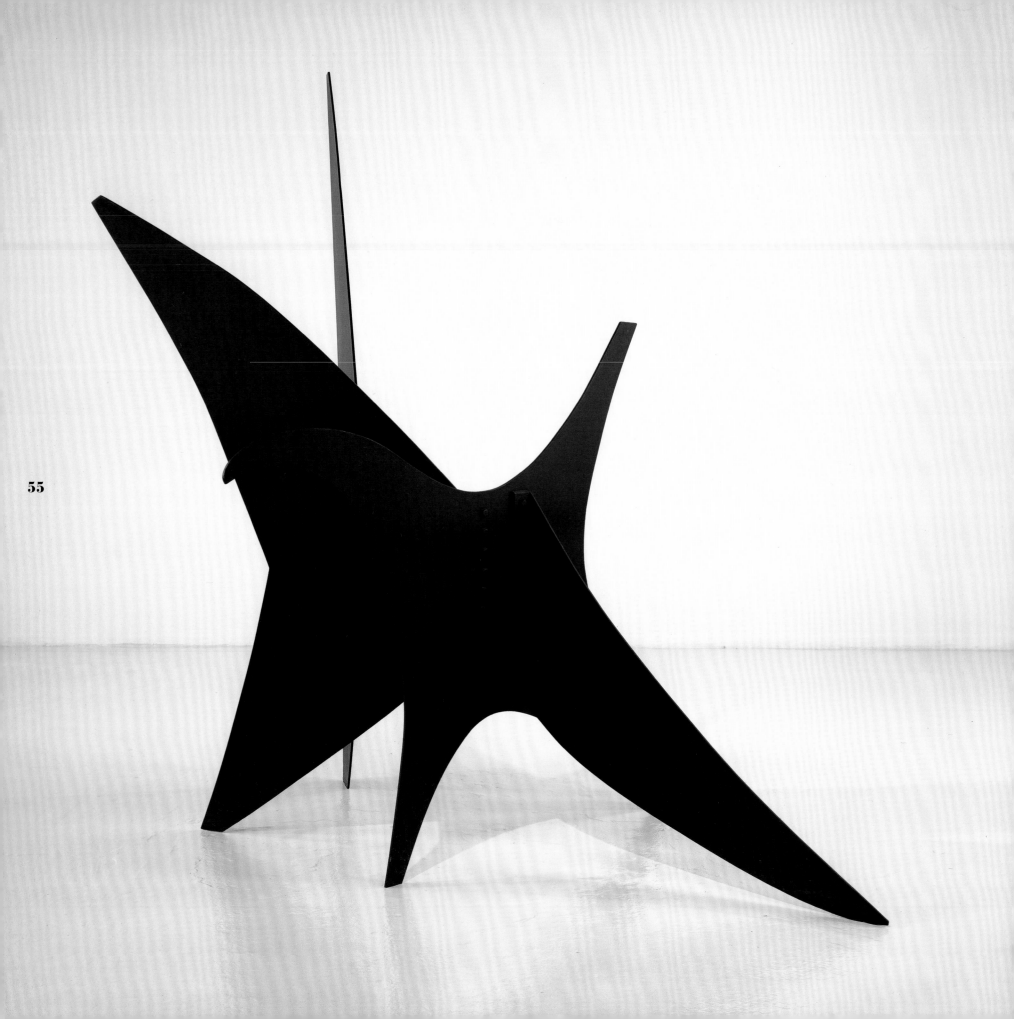

55

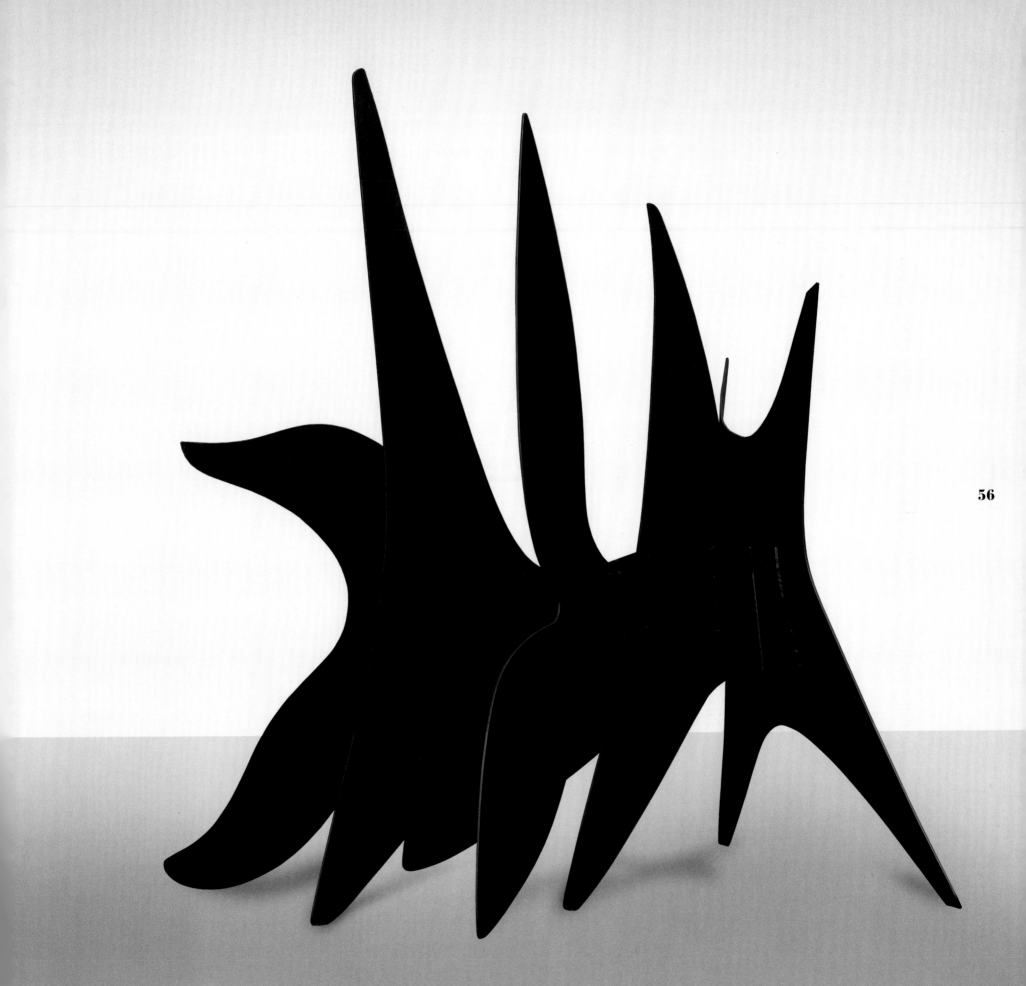

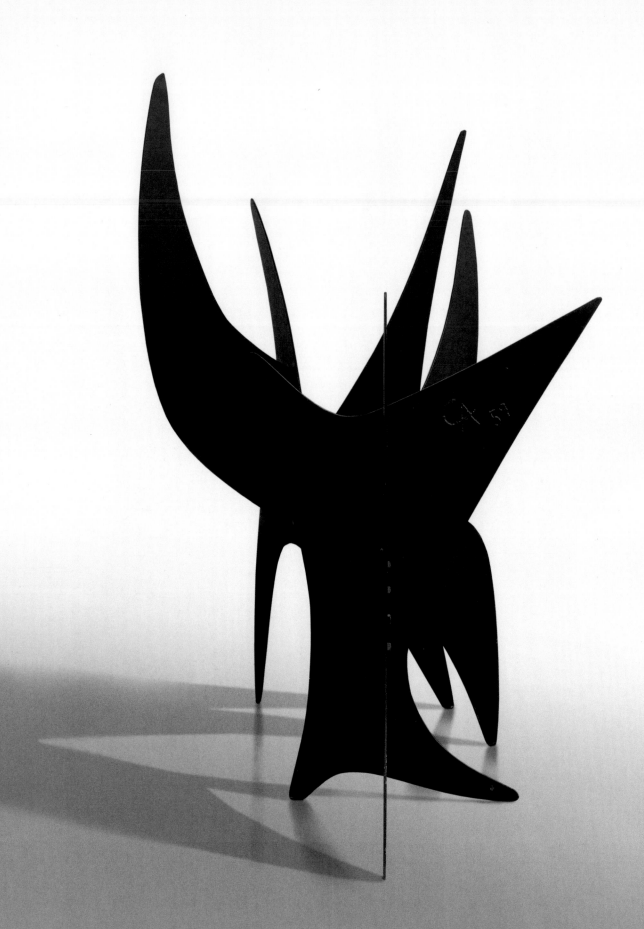

58

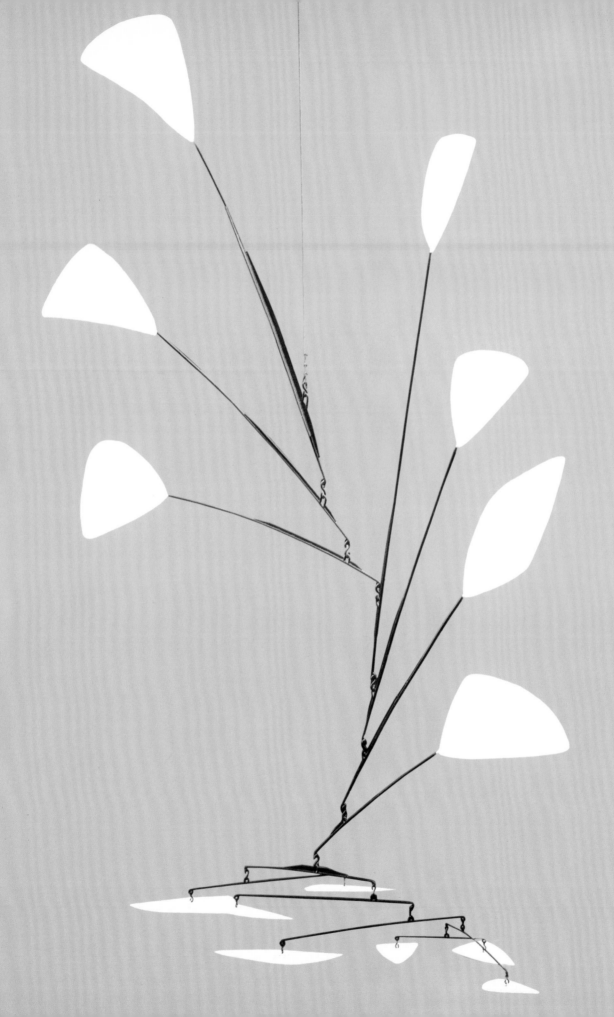

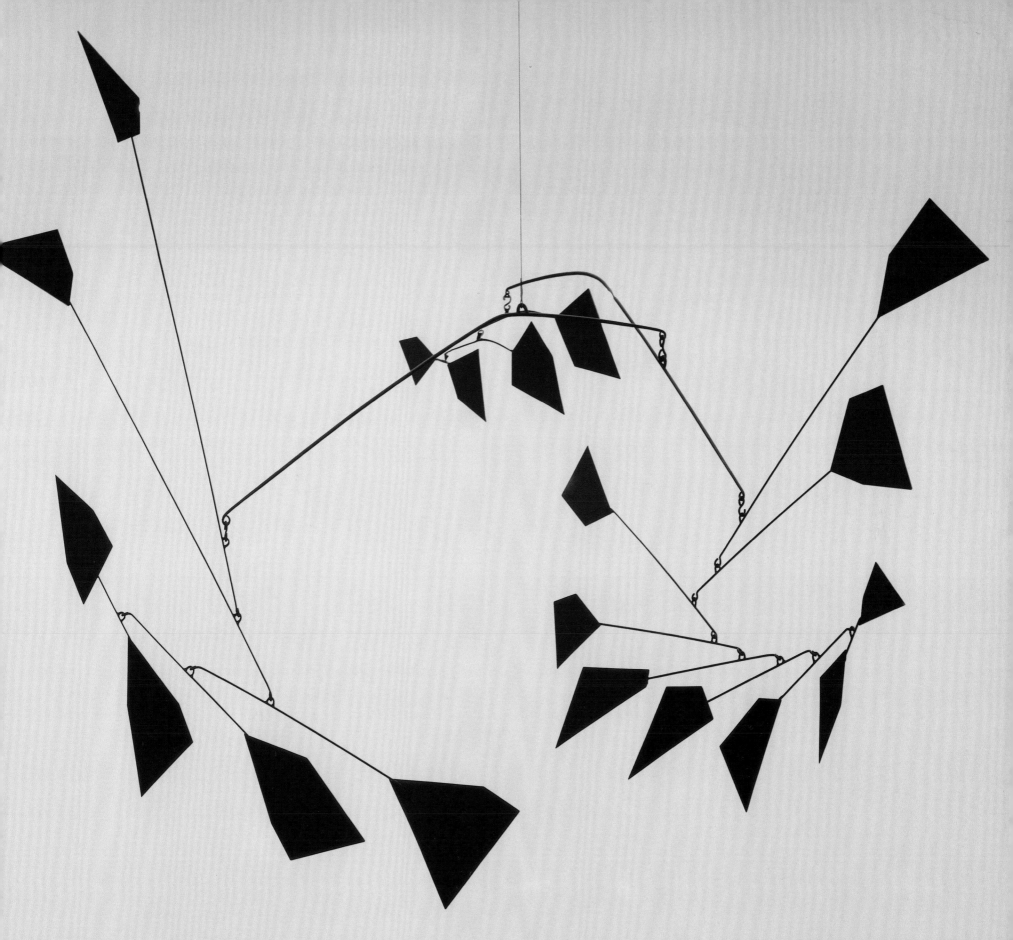

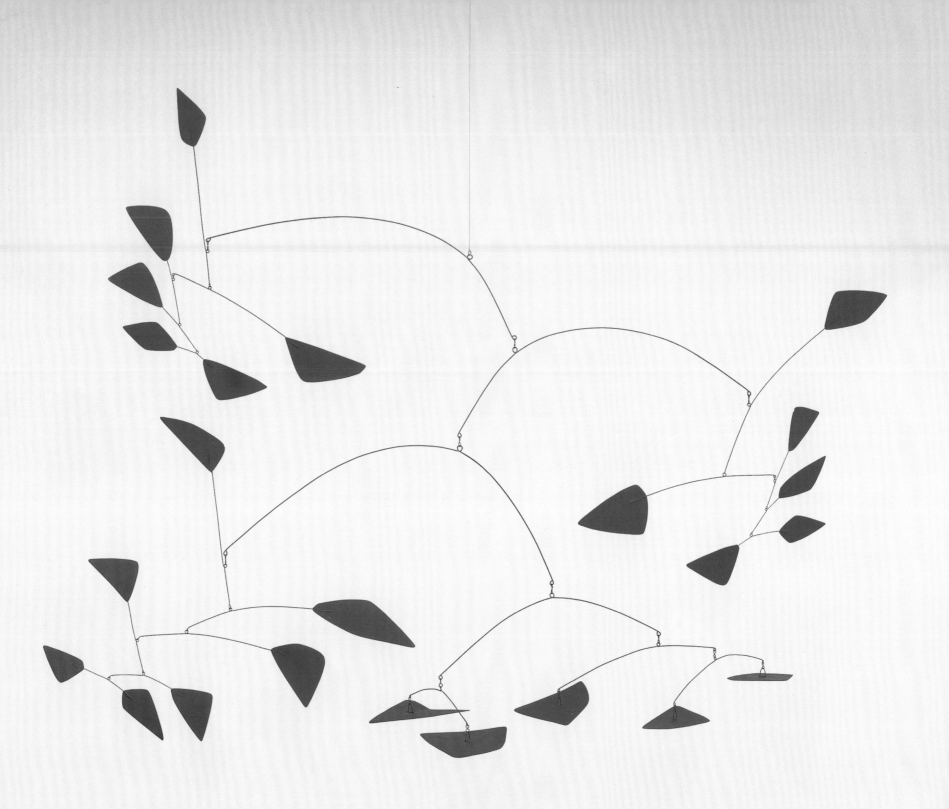

61

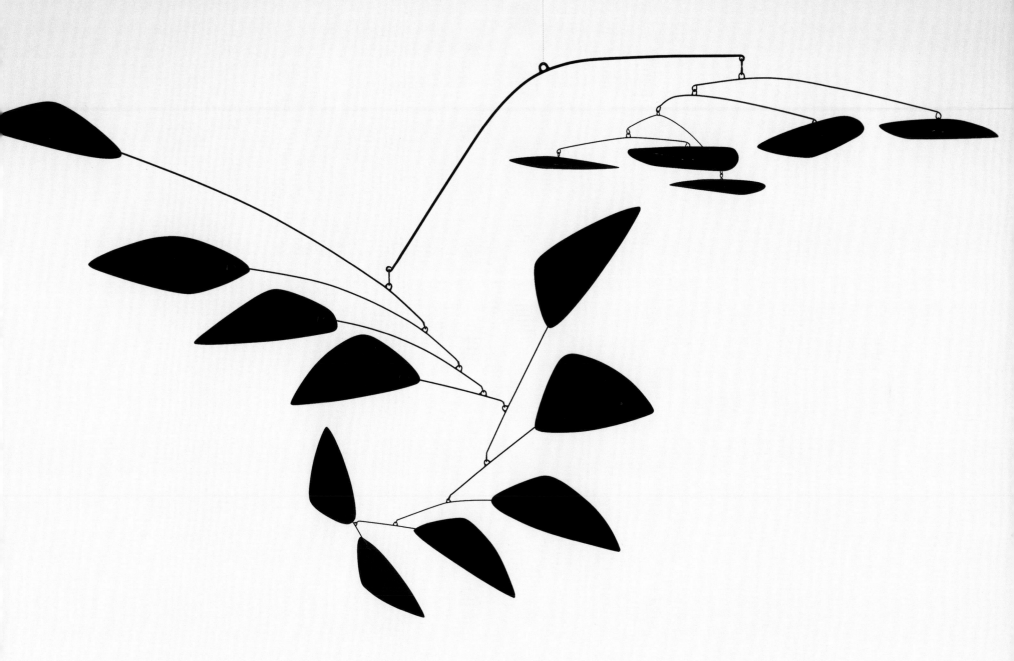

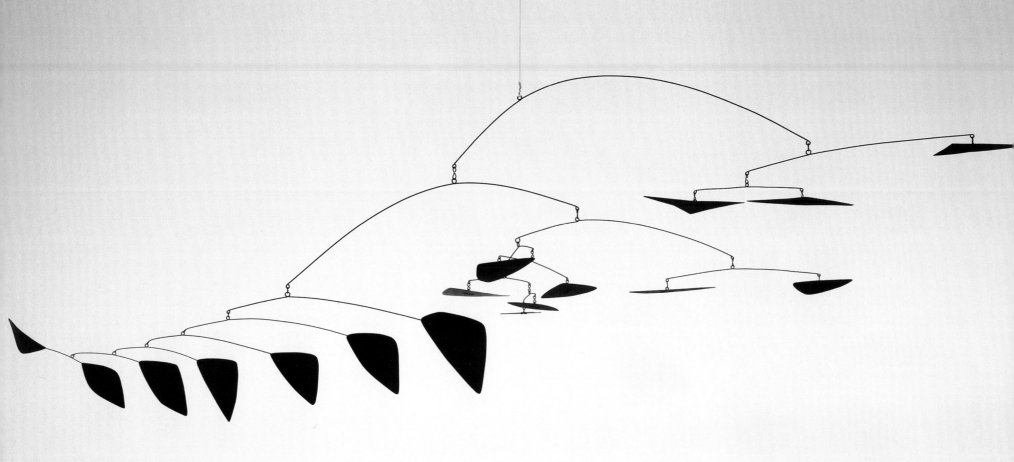

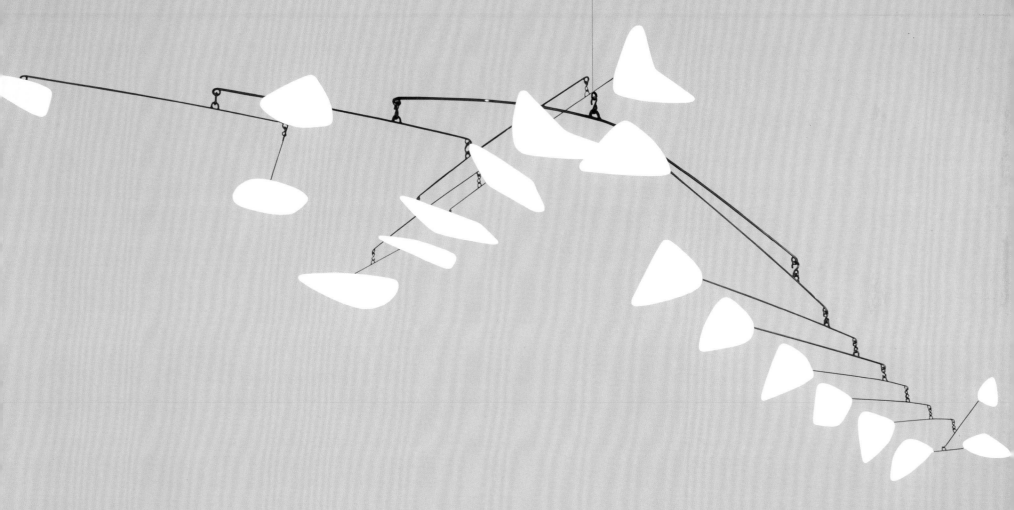

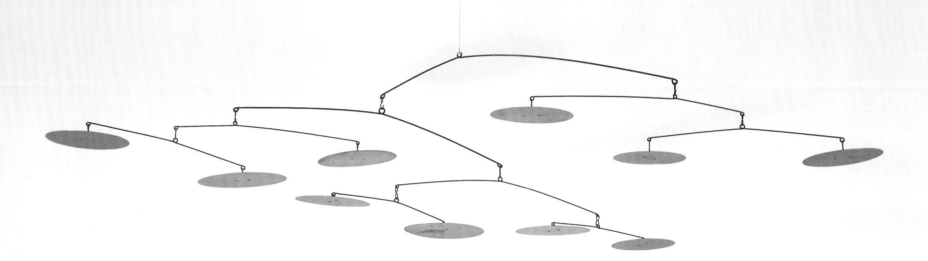

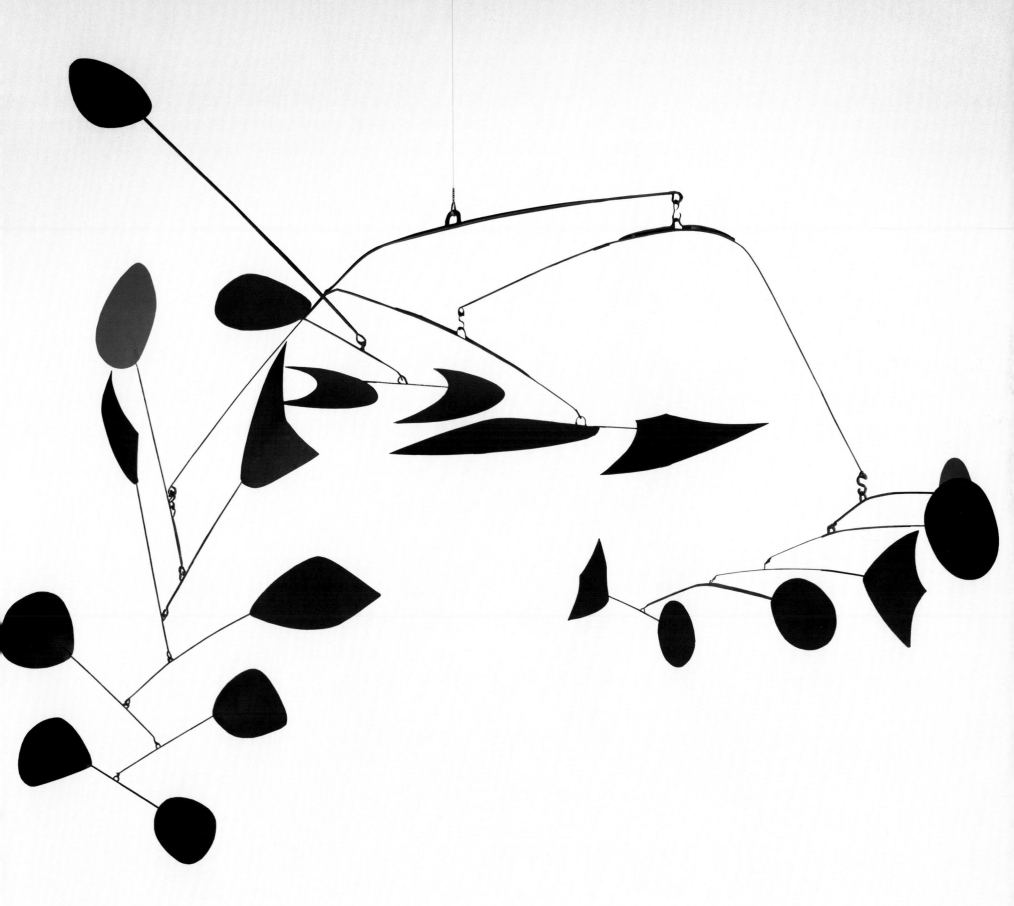

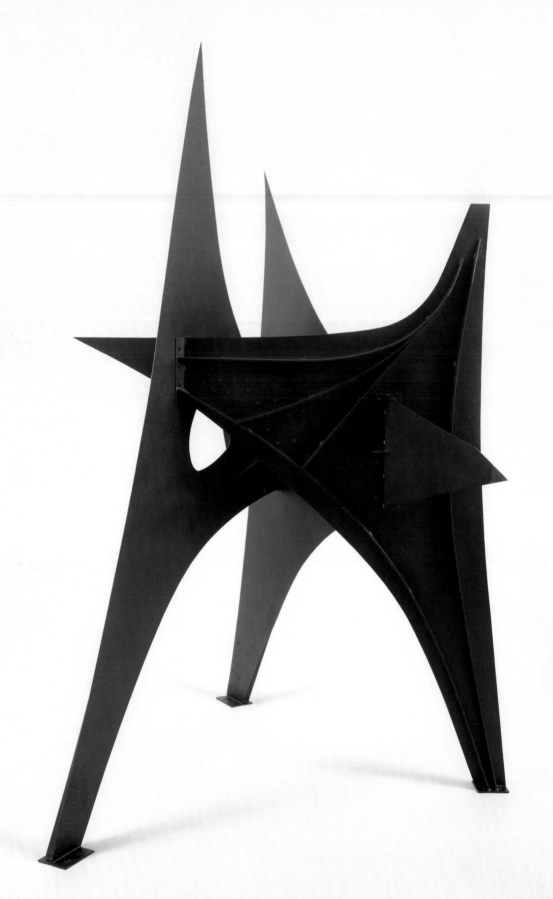

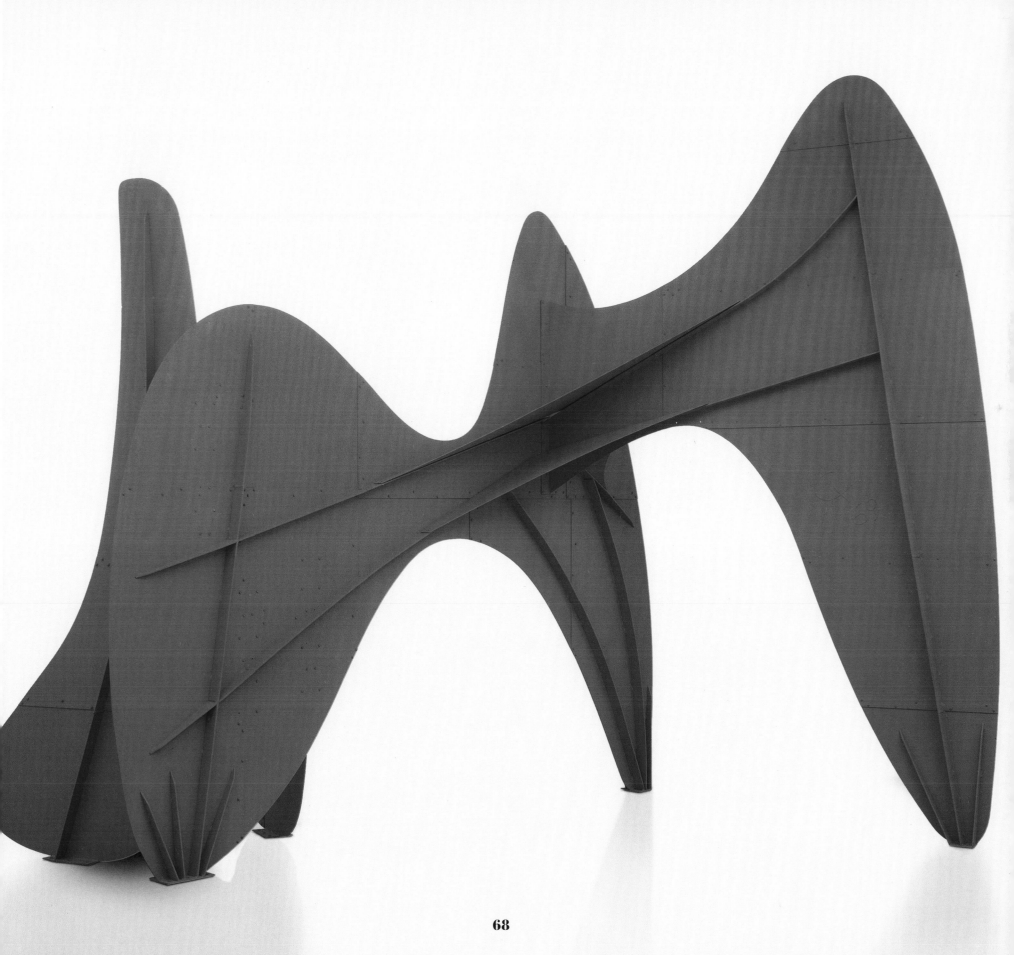

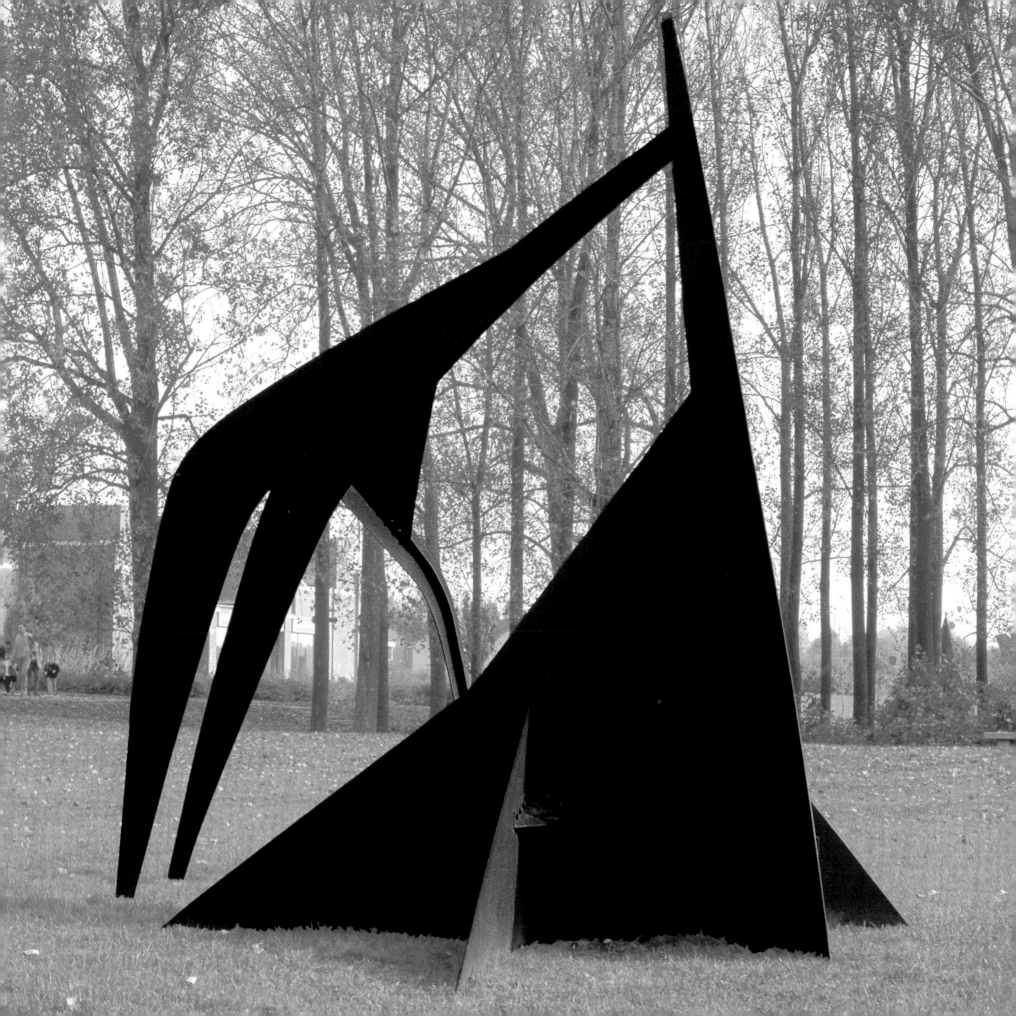

1. *Croisière*, 1931
Wire, wood & paint
37 x 23 x 23 in.
Courtesy Calder Foundation, New York
ACC272

2. *Little Ball with Counterweight*, ca. 1930
Sheet metal, wire, wood & paint
63 3/4 x 12 1/2 x 12 1/2 in.
Ms. Ruth Horwich
ACC269

3. *Feathers*, 1931
Wire, wood, lead & paint
38 1/2 x 32 x 16 in.
Courtesy Calder Foundation, New York
AC3086

LIST OF PLATES

4. *Cône d'ébène*, 1933
Ebony, rod, wire & paint
106 x 55 x 24 in.
Courtesy Calder Foundation, New York
ACC852

5. *Tightrope*, 1936
Ebony, wire, rod, lead & paint
45 1/2 x 27 1/2 x 138 1/2 in.
Courtesy Calder Foundation, New York
ACC271

6. *Starfish*, 1936
Wood, string, rod & wire
87 x 57 x 57 in.
Courtesy Calder Foundation, New York
A15213

7. *Untitled*, 1934
Sheet metal. wire. lead & paint
113 x 68 x 53 in.
Courtesy Calder Foundation. New York
A16632

8. *Yucca*, 1941
Sheet metal. wire & paint
73 1/2 x 23 x 20 in.
Solomon R. Guggenheim Museum. New York.
Hilla Rebay Collection. 1971. 71.1936 R54 a.-c.
A11244

9. *Sphere Pierced by Cylinders*, 1939
Wire & paint
83 x 34 x 43 in.
Courtesy Calder Foundation. New York
ACC682

10. *Eucalyptus*, 1940
Sheet metal. wire & paint
94 1/2 x 61 in.
Ms. Genevieve & Mr. Ivan Reitman
AC3747

11. *Arc of Petals*, 1941
Sheet metal. wire & paint
84 1/2 in.
Solomon R. Guggenheim Foundation. New York.
Peggy Guggenheim Collection. Venice. 1976. 76.2553 PG137
AC5659

12. *Un effet du japonais*, 1941
Sheet metal. rod. wire & paint
80 x 80 x 48 in.
Courtesy Calder Foundation. New York
ACC288

13. *Aluminium Leaves, Red Post*, 1941
Sheet metal. wire & paint
61 x 61 in.
The Lipman Family Foundation Inc.
ACC287

14. *Untitled*, 1942
Sheet metal. rod. wire & paint
20 1/2 x 11 1/2 x 10 1/2 in.
Solomon R. Guggenheim Museum. New York.
Hilla Rebay Collection. 1971. 71.1936R55 a.-b.
A11246

15. *Untitled*, ca. 1942
Wood. wire. string & paint
47 1/2 x 61 13/16 in.
Courtesy Calder Foundation. New York
AC1120

16. *Horizontal Spines*, 1942
Sheet metal. wire & paint
54 1/4 x 50 x 22 1/2 in.
Addison Gallery of American Art. Phillips Academy. Andover. Massachusetts.
1943.121.
ACC517

17. *Untitled*, 1942
Sheet metal. wire & paint
53 1/2 x 66 in.
Courtesy Calder Foundation. New York
A15493

18. *The Big Ear*, 1943
Sheet metal. bolts & paint
130 x 72 x 59 in.
Courtesy Calder Foundation. New York
A12866

19. **Black Spot on Gimbals,** 1942
Wire, wood & paint
16 x 19 x 8 1/2 in.
Courtesy Calder Foundation, New York
A00555

20. **Black Constellation,** 1943
Ebony & wire
17 x 41 1/2 x 8 in.
Courtesy Calder Foundation, New York
A00784

21. **Constellation,** 1943
Wood, wire & paint
22 x 44 1/2 in.
Solomon R. Guggenheim Museum,
Mary Reynolds Collection, Gift of her brother. 54.1393.
A00551

22. **Constellation Mobile,** 1943
Wood, wire, string & paint
53 x 48 x 35 in.
Courtesy Calder Foundation, New York
A16009

23. **Constellation,** 1943
Wood, wire & paint
33 x 36 x 14 in.
Courtesy Calder Foundation, New York
A00683

24. **Constellation with Mobile,** 1943
Metal & wood
37 x 37 in.
Private Collection
A05495

25. **Mobile Constellation,** ca. 1944
Wood, wire & paint
36 x 27 x 32 in.
Museo Nacional Centro de Arte Reina Sofía, Madrid
A09088

26. **Untitled,** ca. 1947
Wood, string, sheet metal & ceramic
67 x 65 in.
Solomon R. Guggenheim Museum, New York.
Mary Reynolds Collection, Gift of her brother. 54.1390
A00628

27. **Red Disc,** 1947
Sheet metal, wire, wood & paint
81 x 78 in.
Private Collection
A04774

28. **The S-Shaped Vine,** 1946
Sheet metal, wire & paint
98 1/2 x 69 in.
The Eli & Edythe L. Broad Collection
A08962

29. **Lily of Force,** 1945
Sheet metal, wire & paint
91 3/4 x 81 x 89 in.
Courtesy Calder Foundation, New York
A00566

30. **Red Is Dominant,** 1947
Sheet metal, wire & paint
55 1/2 x 44 x 33 in.
Courtesy Calder Foundation, New York
A15019

31. **Parasite,** 1947
Sheet metal, rod, wire and paint
41 x 68 x 28 in.
Courtesy Calder Foundation, New York
AC873

32. **Little Parasite,** 1947
Sheet metal, wire & paint
24 x 48 in.
Courtesy Calder Foundation, New York
A14067

33. **Baby Flat Top,** 1946
Sheet metal & paint
49 x 78 3/4 x 17 1/2 in.
Collection of The Sternberg Family Corp., Chicago
AC1774

34. **Blue Feather,** ca. 1948
Sheet metal, wire & paint
42 x 55 x 18 in.
Courtesy Calder Foundation, New York
AC565

35. **Jacaranda,** 1949
Sheet metal, wire & paint
131 7/8 x 175 3/16 in.
National Gallery of Canada, Ottawa
A1C327

36. **Vertical out of Horizontal,** ca. 1948
Sheet metal, wire & paint
63 x 52 in.
Private Collection
AC3125

37. **Snow Flurry,** 1948
Sheet metal, wire & paint
40 x 82 in.
Courtesy Calder Foundation, New York
AC1164

38. **Roxburry Flurry,** ca. 1948
Sheet metal, wire & paint
100 x 96 in.
Whitney Museum of American Art, New York, Gift of Louisa Calder
AC401

39. **Triple Gong,** 1951
Brass, sheet metal, wire & paint
31 x 68 in.
National Gallery of Art, Washington,
Gift of Mr. & Ms. Klaus G. Pearls. 1996.120.27.
AC629

40. **Triple Gong,** ca. 1948
Wire, brass, sheet metal & paint
39 x 75 x 2 3/4 in.
Courtesy Calder Foundation, New York
A15492

41. **Polygones Noirs,** 1947
Sheet metal, wire & paint
23 5/8 x 126 x 47 1/4 in.
Private Collection
AC323

42. **El Corcovado (Stabile & Mobile),** 1951
Sheet metal, rod, wire, bolts & paint
141 3/4 x 165 3/8 x 143 11/16 in.
Fundació Joan Miró, Gift of Josep Lluís Sert
AC304

43. *Bifurcated Tower*, 1950

Sheet metal, rod, wire, wood & paint

58 x 72 x 53 in.

Whitney Museum of American Art, New York.

Purchased with funds from the Howard and Jean Lipman Foundation,

Inc. and exchange

AC1125

44. *More Extreme Cantilever*, 1949

Sheet metal, rod, wire, string & paint

88 x 133 1/2 x 31 in.

Courtesy Calder Foundation, New York

A15575

45. *Les Boucliers*, ca. 1949

Sheet metal, wire & paint

86 1/4 x 114 15/16 in.

Centre Georges Pompidou, Paris.

Musée national d'art moderne / Centre de création industrielle

AC9286

46. *Otto's Mobile*, 1952

Sheet metal, wire & paint

210 x 96 in.

Fondation Beyeler, Riehen, Basel

AC5061

47. *Le 31 Janvier*, 1950

Sheet metal, wire & paint

147 5/8 x 236 1/4 in.

Centre Georges Pompidou, Paris.

Musée national d'art moderne / Centre de création industrielle

AC0324

48. *Black Mobile with Hole*, ca. 1954

Aluminum sheet, steel wire, copper & paint

90 x 83 in.

Courtesy Calder Foundation, New York

AC0559

49. *Mobile XII.V-III H*, 1955

Sheet metal, wire & paint

99 2/10 x 106 3/10 in.

Stedelijk Museum, Amsterdam

AC8525

50. *Untitled*, ca. 1953

Sheet metal, wire & paint

59 x 59.5 in.

Courtesy O'Hara Gallery, New York

A10302

51. *Cascading Spines*, 1956

Sheet metal, wire & paint

58 x 72 x 48 in.

Courtesy Calder Foundation, New York

AC0700

52. *Spines in All Directions*, 1956

Sheet metal, rod, wire & paint

44 x 105 in.

Private Collection, Gianna Sistu

AC7593

53. *Roman Rider*, 1957

Sheet metal, bolts & paint

74 8/10 x 49 2/10 in.

Museum Moderner Kunst Stiftung Ludwig, Wien

A11067

54. **Red Lily Pads,** 1956
Sheet metal, wire & paint
42 x 201 x 109 in.
Solomon R. Guggenheim Museum, New York. 65.1737.
AC1163

55. **Four-Cusped Hypocycloid,** 1959
Sheet metal, bolts & paint
86 x 94 x 60 in.
Private Collection, New York
AC4653

56. **7-Legged Beast,** 1957
Sheet metal, bolts & paint
84 x 84 x 48 in.
Whitney Museum of American Art, New York
AC8518

57. **La Botte,** 1959
Sheet metal, bolts & paint
76 3/4 x 74 8/10 in.
Museum Ludwig, Köln
AC5176

58. **The Arches,** 1959
Sheet metal, bolts & paint
105 9/10 x 107 1/2 x 87 in.
Whitney Museum of American Art, New York;
on extended loan from Jean Lipman
AC0443

59. **Pittsburgh,** 1958
Sheet metal, rod & paint
336 x 336 in.
City of Pittsburgh
AC2233

60. **Untitled (Mobile),** 1959
Sheet metal, rod & paint
240 x 240 in.
The JPMorgan Chase Art Collection
AC240

61. **Quatre Systèmes Rouges,** 1960
Sheet metal, wire & paint
76 3/4 x 70 7/8 x 70 7/8 in.
Louisiana Museum of Modern Art, Humlebæk, Denmark.
Donation: The New Calsberg Foundation
AC1191

62. **The "Y,"** 1960
Sheet metal, rod & paint
98 13/16 x 174 1/2 x 66 3/8 in.
The Menil Collection, Houston. 78-051 E
AC2711

63. **Lone Red Among Blacks,** 1961
Sheet metal, wire & paint
27 x 88 in.
Courtesy Ms. Mandy and Mr. Jonathan O'Hara, New York
AC7589

64. **Untitled,** 1963
Sheet metal, rod & paint
324 in.
Private Collection
AC0326

65. **Untitled,** 1968
Sheet metal & rod
31 x 134 x 39 in.
Courtesy Calder Foundation, New York
A2C216

66. *Rouge Triomphant*, 1963
Sheet metal, rod & paint
110 x 230 x 180 in.
Courtesy O'Hara Gallery, New York
AC1907

67. *Trois Pics* **(intermediate maquette)**, 1967
Sheet metal, bolts & paint
96 x 63 x 70 3/16 in.
Courtesy Calder Foundation, New York
AC3009

68. *La grande vitesse* **(intermediate maquette)**, 1969
Sheet metal, bolts & paint
101 15/16 x 135 1/6 x 93 in.
Courtesy Calder Foundation, New York
AC1443

69. *Guillotine pour Huit*, 1963
Sheet metal, bolts & paint
275 9/16 x 275 9/16 x 183 7/8 in.
Centre Georges Pompidou, Paris. Musée national d'art moderne / Centre de création industrielle. On deposit at Musée d'art moderne Lille Métropole, Villeneuve d'Ascq.
AM 1983-885
AC9293

Note: Titles and dates have been supplied by the Calder Foundation. A-numbers published here are from the Calder catalogue raisonné.

Calder's Roxbury studio, ca. 1965 / Photo: Pedro E. Guerrero ▶
The living-room at the new house with the new studio, ca. 1972 / Photo: Pedro E. Guerrero ▶▶

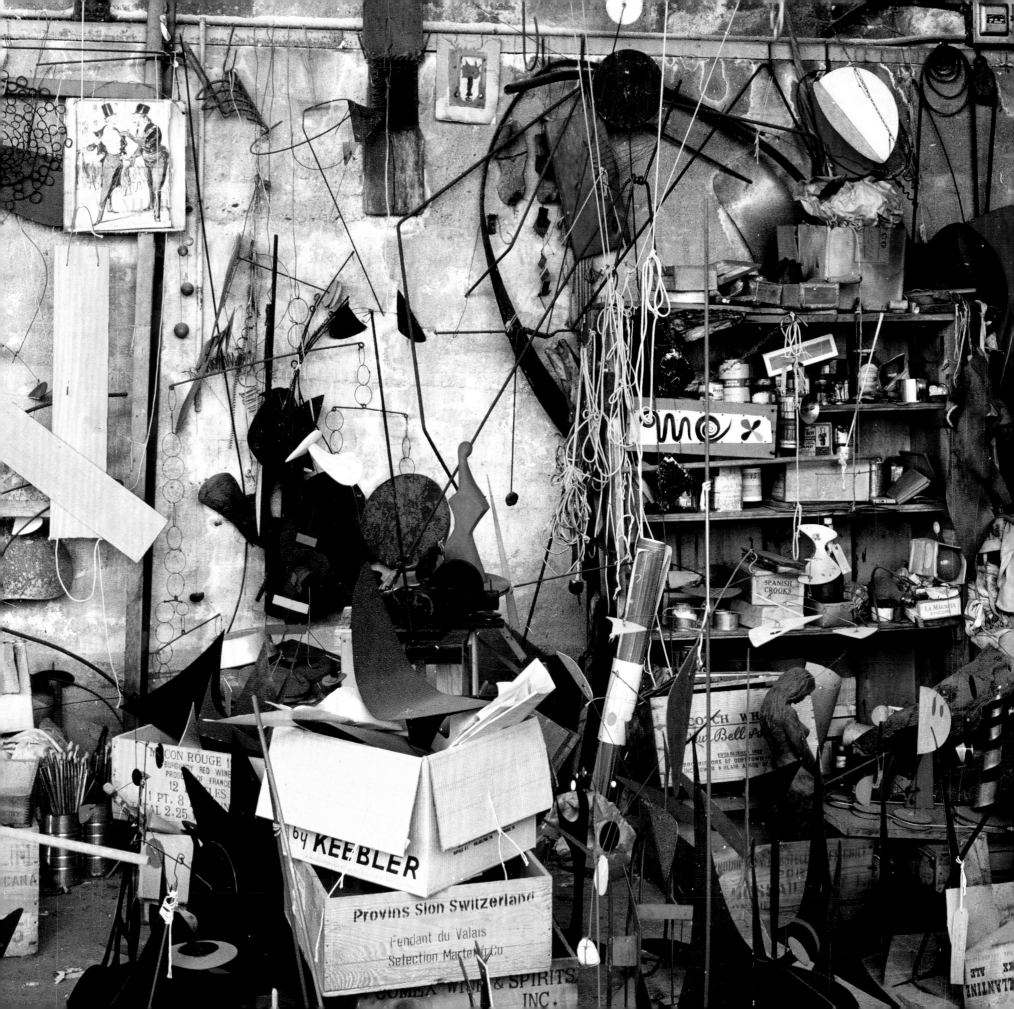

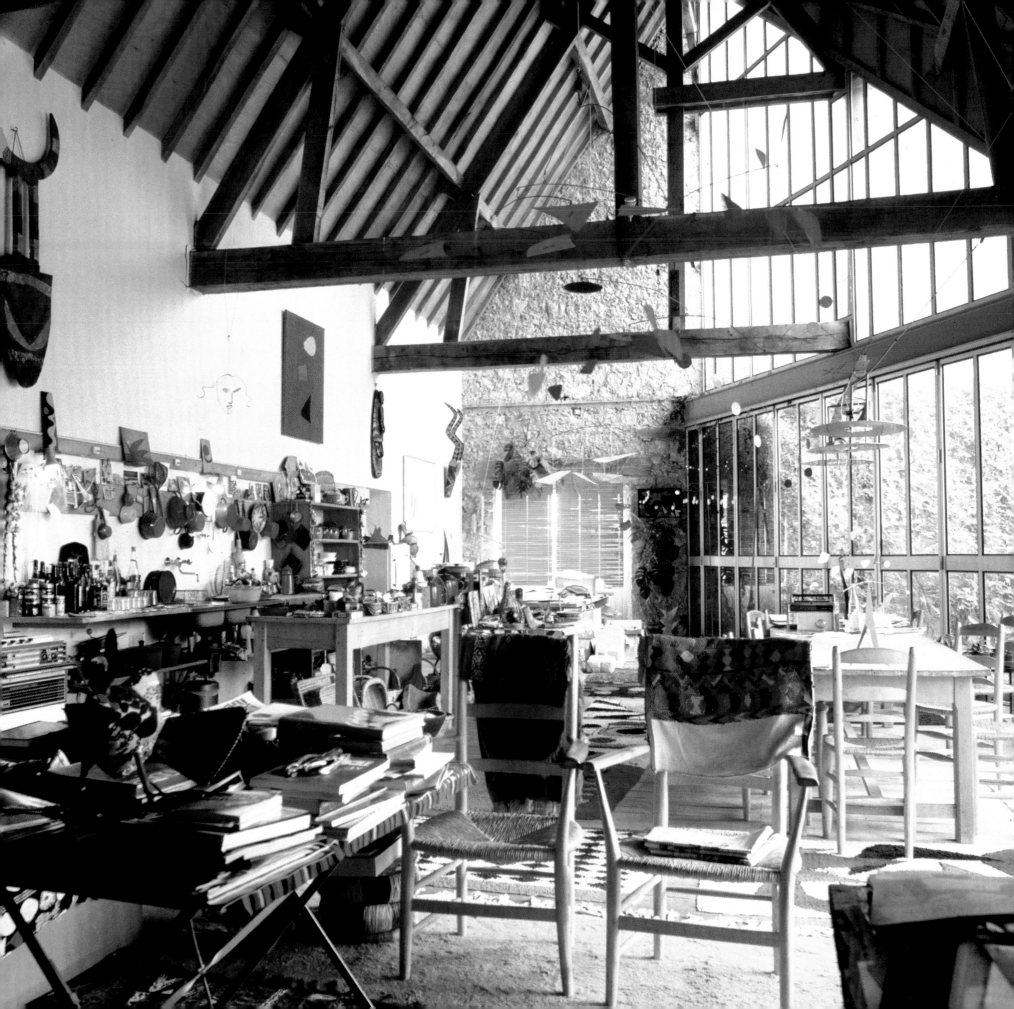

Bibliographic references are cited throughout the chronology. Abbreviations are used for some frequent references (see list below); for the others full references are provided in the bibliography.

List of chronology abreviations:

AAA: Archives of American Art, Smithsonian Institution, Washington, D.C.

ASL: The Art Students League, New York

CF: Calder Foundation, New York

Calder 1966: Alexander Calder and Jean Davidson, *Calder, an Autobiography with Pictures* (New York: Pantheon Books, 1966)

FJM: Fundació Joan Miró, Barcelona

FPJM: Fundació Pilar i Joan Miró, Mallorca

JJS: James Johnson Sweeney Letters (private collection)

JM: Carolyn Lanchner, *Joan Miró*, exh. cat. (New York: Museum of Modern Art, 1993)

MoMA: Museum of Modern Art, New York

NL: Newberry Library, Chicago: Special Collections

PM: Yves-Alain Bois, Joop Joosten, Angelica Zander Rudenstine, Hans Jennsen, *Piet Mondrian: 1872–1944*, exh. cat. (The Hague: Den Haags Gemeentemuseum; Washington, D.C.: National Gallery of Art, and New York: Museum of Modern Art, 1994–1996)

CHRONOLOGY
Alexander S. C. Rower

1898 22 JULY: Calder is born in Lawnton, Pennsylvania, to Nanette Lederer Calder, a painter, and Alexander Stirling Calder, a sculptor. His sister Peggy is two years old.

1902 (N.D.): In Philadelphia, Calder, age four, poses for his father's sculpture *Man Cub*. Calder sculpts his own clay elephant. (Calder 1966, 13)

1905 SPRING: Stirling Calder contracts tuberculosis. Calder's parents move to a ranch in Oracle, Arizona, leaving the two children in the care of Dr. Charles P. Shoemaker, a dentist and his wife, Nan. (Calder 1966, 15; Hayes 1977, 18)

1906 END OF MARCH: Nanette picks up Calder and Peggy and they rejoin Stirling in Oracle, Arizona. Calder befriends Riley, an elderly man recuperating at the ranch who shows him "how to make a wigwam out of burlap bags pinned together with nails." (Calder 1966, 16)
FALL: The Calder family moves to Pasadena, California. Calder attends second and third grades at William McKinley Elementary School. The cellar becomes his first workshop and he receives his first tools. Encouraged by his parents, he begins to make things, including jewelry from copper wire and beads for his sister's dolls. (Calder 1966, 19–21)

1907 1 JANUARY: Calder attends Pasadena's Tournament of Roses, where he experiences the four-horse chariot races. (Calder 1966, 22)

1909 (N.D.): The Calders move to a new house. Calder's workshop consists of a tent with a wooden floor. Calder attends fourth grade at Garfield School. (Calder 1966, 26–27)
DECEMBER: Calder makes *Dog* (A15560) and *Duck* (A16368) from sheet brass for his parents' Christmas gifts. (Hayes 1977, 41)

1910 BEFORE 11 JANUARY: Calder makes a game consisting of a wooden board with nails and five painted animals (lion, tiger, and three bears) for his father's birthday. (Hayes 1977, 42)
FALL: The Calder family returns east to Philadelphia. Calder attends Germantown Academy for two or three months while his parents search for a house close to New York City. (Calder 1966, 28)

1911 (N.D.): The Calders move to Croton-on-Hudson. Calder has the cellar room for his workshop. He attends Croton Public School. (Calder 1966, 28–29)

1912 (N.D.): The Calder family moves to Spuyten Duyvil, New York. The cellar becomes Calder's

workshop. Calder and Peggy attend Yonkers High School. Stirling Calder rents a studio in New York City. (Calder 1966, 34–35)

14 AUGUST: Stirling Calder is appointed acting chief. Department of Sculpture, of the Panama-Pacific International Exposition in San Francisco. He wrote the introduction to the catalogue entitled *The Sculpture and Mural Decorations of the Exposition*, published in 1915. (Calder 1966, 36)

1913 JUNE: The Calder family moves to San Francisco. Calder has a workshop in the cellar and attends Lowell High School. (Calder 1966, 36–37; Hayes 1977, 43–44)

1915 SPRING: Stirling and Nanette Calder move to Berkeley to be near his next commission. Calder stays with Walter Bliss, an architect, and his wife, in order to graduate from Lowell High School. (Calder 1966, 37–38; Hayes 1977, 52–53)
AUGUST: The Calder family moves back to New York City. (Calder 1966, 39; Hayes 1977, 55)
SEPTEMBER: Calder begins his studies at Stevens Institute of Technology, Hoboken, New Jersey. (Calder 1966, 39)

1916 SUMMER: Calder spends five weeks in the Plattsburg Civilian Military Training Camp, New York, drilling with Company H, Fifth Training Regiment, during World War 1. (Calder 1966, 46)

1918 FALL: Calder joins the Student's Army Training Corps, Naval Section, at Stevens Institute of Technology, where he is made guide of the battalion. (Calder 1966, 48)

1919 17 JUNE: Calder graduates from Stevens Institute of Technology with a degree in mechanical engineering.
(N.D.): Calder holds jobs with an automotive engineer in Rutherford, New Jersey, and as

a draftsman at New York Edison Company. (Calder 1966, 48–49)

1920 FALL: Calder joins the staff of the journal *Lumber* (St. Louis, Missouri) and stays for nine months. (Calder 1966, 48–50)

1921 SUMMER: Calder works for a hydraulics engineer, coloring maps for a water-supply project in Bridgeport, Connecticut. The efficiency engineers Miller, Franklyn, Bassett hire Calder and send him to do fieldwork for the Truscon Company in Youngstown, Ohio. (Calder 1966, 49–50)

1922 SPRING: Calder attends night classes in drawing with Clinton Balmer at the Forty-second Street New York Public School. (Calder 1966, 51)
JUNE: Serving on the *H. F. Alexander* as a fireman in the boiler room, Calder sails from New York to San Francisco via the Panama Canal. During the voyage, off Guatemala, he wakes on deck to an inspirational vision: a brilliant rising sun and a full moon on opposite horizons. (Calder 1966, 53–55)
MID-JUNE: Arriving in San Francisco, Calder takes a lumber schooner to Willapa Harbor, Washington, where he catches the bus for Aberdeen and meets his sister Peggy and her husband, Kenneth Hayes. Calder finds a job as a timekeeper at a logging camp in Independence, Washington. (Calder 1966, 55–56)
SUMMER: Inspired by mountain scenes and the logging camps, Calder paints some landscapes. (Calder 1966, 57–58)

1923 SPRING: Calder quits his logging camp job and commits himself to painting. (Calder 1966, 59)
SUMMER: Calder writes the Kellogg Company and suggests they modify their cereal packaging, putting the wax paper on the inside rather than on the outside of the boxes. The company adopts his

suggestion and sends him a note of thanks along with a case of Corn Flakes. (Hayes 1977, 76)
1 OCTOBER–DECEMBER: Calder begins classes at the Art Students League in New York, studying under John Sloan and George Luks (with Luks in October and November only). (Calder 1966, 59–61, 66–67; ASL, registration records)

1924 JANUARY–MAY: Calder takes classes at the Art Students League, studying under George Luks for the month of January, Guy Pène du Bois from January to April, and Boardman Robinson in March and April. (ASL, registration records)
APRIL: Calder takes an evening class in etching at the Art Students League. (ASL, registration records)
SPRING: Calder begins his first job as an artist. He illustrates for the *National Police Gazette*. (Calder 1966, 61, 67)
BEFORE 17 MAY: Calder moves into his father's studio at 11 East Fourteenth Street while his parents are traveling in Europe. (Calder 1966, 67, 70; Hayes 1977, 81)
OCTOBER–NOVEMBER: Calder studies under Boardman Robinson at the Art Students League. (ASL, registration records)

1925 MARCH: Calder studies drawing with Boardman Robinson at the Art Students League. (ASL, registration records)
(N.D.): Calder, as a member of the Society of Independent Artists, lists his address as 111 East Tenth Street, New York.
6–29 MARCH: Calder exhibits *The Eclipse* (A01041), a painting at the Ninth Annual Exhibition of the Society of Independent Artists, Waldorf-Astoria, New York. (CF, exhibition file)
BEFORE 23 MAY: Calder spends two weeks illustrating the Ringling Bros. and Barnum & Bailey Circus for the *National Police Gazette*. (Calder 1966, 73; *National Police Gazette*, 23 May)

FALL: Calder moves into a tiny, one-room apartment on Fourteenth Street, west of Seventh Avenue. There he makes his first wire sculpture, a sundial in the form of a "rooster on a vertical rod with radiating lines at the foot" to demarcate the time. (Calder 1966, 70–72, see A01381)

WINTER: Calder makes hundreds of brush drawings of animals at the Bronx Zoo and the Central Park Zoo.

DECEMBER: Calder takes a lithography class with Charles Locke at the Art Students League. (ASL, registration records)

WINTER: Calder travels to Florida. He visits Miami and Sarasota—where he sketches at the winter grounds of the Ringling Bros. and Barnum & Bailey Circus.

1926 JANUARY: Artists Gallery, New York, includes an oil painting by Calder in a group exhibition. (CF, exhibition file and Calder unpub. ms. 1954–55, 53, 173; Pemberton, *New Yorker*, 2 January)

27 FEBRUARY: Walter Kuhn organizes a stag dinner in honor of Constantin Brancusi, who is visiting the United States for the first time. Calder paints the *Firemen's Dinner for Brancusi* (A00413) commemorating the party at the Union Square Volunteer Fire Brigade (Tip Toe Inn, East Fourteenth Street, New York City). (Marter, *Journal of the Archives of American Art*, 1976; AAA, Louis Bouche Papers, dinner invitation)

5–28 MARCH: Calder exhibits *The Stiff* (A15753), a painting depicting a dissection class at a medical school, at the Tenth Annual Exhibition of the Society of Independent Artists at the Waldorf-Astoria. (CF, exhibition file)

SPRING: Calder receives an invitation from Betty Salemme to her rented house on a lake near Sherman, Connecticut. There he makes his first wood sculpture, *Flat Cat* (A04792), from an oak fence post. (CF, Calder unpub. ms. 1954–55, 174)

MAY: *Animal Sketching* (A00376), a teaching text written and illustrated by Calder, is published.

26 JUNE: Calder receives his U.S. passport in preparation for his voyage to Europe. (CF, passport)

2 JULY: With the help of his art instructor, Clinton Balmer, Calder joins the crew of the *Galileo*, a British freighter sailing for Hull, England. (Calder 1966, 76–77; CF, Calder to mother, 18 July)

19 JULY: Calder arrives in Hull, England, spends one night, and takes the noon train to London. (CF, Calder to parents, 18 July)

20 JULY: Calder arrives in London and stays four nights with Bob Trube, his fraternity brother from Stevens Institute of Technology. (CF, Calder to parents, 26 July)

24 JULY: Calder leaves England, taking the 10 a.m. train from Victoria Station for New Haven and the ferry to Dieppe, France. (CF, Calder to parents, 26 July)

24 JULY: Calder arrives in Paris and stays at the Hôtel de Versailles, 60 boulevard Montparnasse, where Bob Trube's father is also staying. (CF, Calder to parents, 26 July)

SUMMER: Calder starts drawing at the Académie de la Grande Chaumière and meets Arthur Frank, a painter, and Stanley William Hayter, a British printmaker. (Calder 1966, 78)

3 AUGUST: Calder's French *carte d'identité* is issued for 1926–27. (CF, *carte d'identité*)

26 AUGUST: Calder takes a room and studio at 22 rue Daguerre. (CF, Calder to parents, 26 August, Calder 1966, 79)

SEPTEMBER: Calder meets Lloyd Sloane, an advertising executive, who introduces him to staff at *Le Boulevardier*, including Marc Réal, artistic advisor. Calder has a drawing published in *Le Boulevardier*. (Calder 1966, 82–83)

FALL: Calder meets a Serbian toy merchant who encourages him to make mechanical toys. He had previously embellished a "humpty-dumpty circus

made by a Philadelphia toy company," including a mule, an elephant, and clowns that were articulated. Using wire, wood, metal, fabric, rubber, and leather, Calder begins making toys, which will soon develop into his *Cirque Calder* (A00019). (Calder 1966, 80; CF, Calder unpub. ms. 1954–55, 44)

FALL: Through Stanley William Hayter, Calder meets José de Creeft, a Spanish sculptor living on rue Broca. De Creeft suggests to Calder that he submit his works to the Salon des Humoristes. (Calder 1966, 80)

FALL: Clay Spohn, a painter friend from the Art Students League, visits Calder and sees two works made from wood and wire: a cow and a four-horse chariot. He suggests that Calder use only wire. Calder makes his first completely wire sculptures, *Josephine Baker* (A11566) and *Struttin' His Stuff* (A08308). (Calder 1966, 80–81)

8 SEPTEMBER: Calder leaves France for a quick round-trip voyage on the Holland-America Line ship *Volendam*; he sketches life on board ship for an advertising brochure for the Student Third Cabin Association. (Calder 1966, 79; CF, Calder to parents, ca. 26 September)

18 SEPTEMBER: Calder arrives in New York on the S. S. *Volendam*. (CF, Calder to parents, ca. 26 August)

1 OCTOBER: Calder returns to France on the S.S. *Volendam*. (CF, Calder to parents, ca. 26 August)

FALL: Calder shows his *Cirque Calder* (A00019) to Ms. Frances C. L. Robbins, who backed the Artists Gallery in New York. On her recommendation, English novelist Mary Butts brings Jean Cocteau to a performance. (CF, Calder unpub. ms. 1954–55, 68; Hawes, *Charm*, April 1928)

1927 (N.D.): Accompanied by Marc Réal, Paul Fratellini of Cirque Fratellini visits *Cirque Calder* (A00019).

Calder makes *Miss Tamara* (A15171), an enlarged version of the rubber-and-wire dog from his circus for Paul's brother Albert (a circus clown). (Calder 1966, 83)

1 MAY: Marc Réal brings Guy Selz and the circus critic Legrand-Chabrier to see *Cirque Calder* (A00019). (Calder 1966, 83; CF, Calder unpub. ms. 1954–55, 149–50)

17 JUNE: Calder's renews his *carte d'identité*. (CF, *carte d'identité*)

AUGUST: Galleries of Jacques Seligmann,Paris, exhibits animated toys by Calder. (CF, exhibition file; *Comoedia*, 29 August; "Les Jouets," *Les Échos des industries d'art*, August)

FALL: Calder returns to the United States and travels to Oshkosh, Wisconsin to contract with Gould Manufacturing Company. He designs and makes prototypes for a series of animal "Action Toys." (Calder 1966, 83–85)

WINTER: Calder returns to New York and stays with his parents at 9 East Eighth Street. He rents a room at 46 Charles Street and gives *Cirque Calder* (A00019) performances. (Calder 1966, 86–87; CF, Calder unpub. ms. 1954–55, 46)

1928 20 FEBRUARY–3 MARCH: Weyhe Gallery, New York, exhibits *Wire Sculpture by Alexander Calder*. (CF, exhibition file)

9 MARCH–1 APRIL: Twelfth Annual Exhibition of the Society of Independent Artists, Waldorf-Astoria, New York, exhibits Calder sculptures, including *Romulus and Remus* (A00247) and *Spring* (A00619). (CF, exhibition file)

SUMMER: Calder spends the summer working on wood and wire sculptures at the Peekskill, New York, farm of J. L. Murphy, the uncle of fraternity brother, Bill Drew. He carves a wooden horse, a cow, a giraffe, a camel, two elephants, a cat, several circus figures, a man with a hollow chest, and an ebony female figure "bending over dangerously" whom he calls *Liquorice* (A09834).

(Calder 1966, 88–89; CF, Calder unpub. ms. 1954–55, 47)

24 OCTOBER: The French Consulate, New York, grants Calder a visa. (AAA, passport)

3 NOVEMBER: Calder arrives at Le Havre after a voyage from New York on the *De Grasse*. He returns to Paris, where he rents a small building behind 7 rue Cels to use as his studio. (AAA, passport; Calder 1966, 91)

FALL: At the Café du Dôme, Paris, Calder sees his acquaintance, painter Yasuo Kuniyoshi, and meets "a small man in a bowler hat," who he learns is painter Jules Pascin, a friend of Stirling Calder. (Calder 1966, 91)

10 DECEMBER: At the suggestion of their mutual friend, Elizabeth "Babe" Hawes, Calder writes to Joan Miró in Montroig, Spain, suggesting that they meet when Miró returns to Paris. (Calder 1966, 92; FJM, Calder to Miró, 10 December)

END OF DECEMBER: Calder visits Joan Miró at his Montmartre studio, "a sort of metal tunnel, a kind of Quonset hut." Miró has no paintings in the studio, but he shows Calder a collage consisting of "a big sheet of heavy gray cardboard with a feather, a cork, and a picture postcard glued to it. There were probably a few dotted lines." Later, Miró attends one of the performances of the *Cirque Calder* (A00019) (Calder 1966, 92)

1929 18–28 JANUARY: Calder exhibits *Romulus and Remus* (A00247) and *Spring* (A00619) at the Salon de la Société des Artistes Indépendants, Paris. (CF, exhibition file)

25 JANUARY–7 FEBRUARY: Galerie Billiet-Pierre Vorms, Paris, exhibits *Sculptures bois et fil de fer de Alexander Calder*. Jules Pascin writes the preface for the exhibition catalogue.

4–23 FEBRUARY: Weyhe Gallery, New York, exhibits *Wood Carvings by Alexander Calder*. (CF, exhibition file)

SPRING: Sacha Stone, a Berlin photographer, sees the *Cirque Calder* (A00019) performed at the rue Cels studio. He suggests that Calder go to perform and exhibit in Berlin. (Calder 1966, 97)

15 MARCH: The German Consulate, Paris, stamps Calder's passport. (AAA, passport)

1–15 APRIL: Galerie Neumann-Nierendorf, Berlin, exhibits *Alexander Calder: Skulpturen aus Holz und aus Draht*. He makes his first piece of adult jewelry, a choker with a dangling wire fly, for Chantal Quenneville, a painter. (Calder 1966, 98; CF, Calder unpub. ms. 1954–55, 50)

APRIL: In Berlin, Dr. Hans Cürlis directs a film on Calder as part of the series *Artists at Work*. Calder makes a wire portrait of Cürlis (A00253). (CF, Calder to parents, ca. 1929)

MAY: *Pathé Cinema*, Paris, produces a short film of Calder at work in his rue Cels studio. Calder invites Kiki de Montparnasse to pose for a wire portrait (A17094) during the filming. (Calder 1966, 99; *New York Herald* [Paris edition], 21 May)

22 JUNE: Calder embarks for New York on the *De Grasse*, bringing his *Cirque Calder* (A00019) home. During the voyage, he meets Edward Holton James and his daughter Louisa. Calder later visits Louisa and her sister, Mary, at Eastham on Cape Cod. (AAA, passport; Calder 1966, 101)

28 AUGUST: Calder performs the *Cirque Calder* (A00019) at Babe Hawes' apartment, 8 West Fifty-sixth Street, New York. (AAA, circus poster)

29 OCTOBER: Calder performs the *Cirque Calder* (A00019) at art patron Mildred Harbeck's apartment, 306 Lexington Avenue, New York. (AAA, circus poster)

FALL: Calder performs the *Cirque Calder* (A00019) in an apartment on East Fortieth Street, New York, at the invitation of his friend Paul Nitze. (Calder 1966, 107)

30 NOVEMBER: After *New Yorker* magazine announces that performances of the *Cirque Calder*

(A00019) can be arranged through the Junior League entertainment center at Saks - Fifth Avenue. Calder is hired by Newbold Morris to perform in his Babylon, Long Island home; Isamu Noguchi operates a phonograph that provides the music.(*New Yorker*, 30 November; CF, Calder Unpub. ms. 1954–55, 142)

2–14 DECEMBER: Fifty-Sixth Street Galleries, New York, exhibits *Alexander Calder: Paintings, Wood Sculptures, Toys, Wire Sculptures, Jewelry, Textiles*.

DECEMBER: In an adjoining exhibition at the Weyhe Gallery, Calder sees mechanical birds that inspire him to make an even more complex fish tank than the wire *Aquarium* (A08296) he is currently exhibiting at the Fifty-sixth Street Galleries. He creates his first formal mechanized sculpture, *Goldfish Bowl* (A00274), as a Christmas gift for his mother: a crank-driven mechanism enables the two fish to writhe. (Hayes 1977, 225–26; Sweeney 1943, 25–26)

25 DECEMBER: Calder performs the *Cirque Calder* (A00019) in the home of Aline Bernstein on Park Avenue. Isamu Noguchi is present, as is Thomas Wolfe, who later incorporates a fictionalized account of the event into his novel *You Can't Go Home Again*. (Calder 1966, 106–07; Hayes 1977, 226)

31 DECEMBER: Calder performs the *Cirque Calder* (A00019) on New Year's Eve at the home of Jack and Edith Straus (art patrons) on West Fifty-seventh Street, New York. (CF, Calder unpub. ms. 1954–55, 142)

1930 27 JANUARY–4 FEBRUARY: Harvard Society for Contemporary Art, Cambridge, Massachusetts, exhibits *Wire Sculpture by Alexander Calder*. Calder gives performance of his *Cirque Calder* (A00019) for the faculty and students on 31 January. (CF, exhibition file)

MARCH: Calder sails for Europe on the Spanish freighter *Gabo-Mayor*. The ship docks briefly in

Málaga and Calder explores the town. Two days later, Calder debarks in Barcelona and stays at the Hotel Regina. He searches for Miró, but is unable to find him. He continues his journey by train to Paris, where he takes a studio at 7 Villa Brune. (Calder 1966, 108–10)

23 MAY: Calder writes to his parents, describing his inention to cast twelve sculptures in bronze at the Fonderie Valsuani, Paris. (CF, Calder to parents, 23 May)

23 MAY–27 JULY: Calder receives an invitation from Rupert Fordham to sail to L'Île Rousse in Corsica. They visit Antoni and Calvi on the west coast of Corsica. (Calder 1966, 110–12; CF, Calder to parents, 23 May, 27 July)

10 SEPTEMBER: Calder performs the *Cirque Calder* (A00019) at 7 Villa Brune. For seating, he invites spectators to bring their own boxes. (Klüver and Martin, *Kiki's Paris* (New York, 1989), 175)

MID-SEPTEMBER: Louisa James visits Calder in Paris. (CF, Louisa to Mother, 7 September)

14 OCTOBER: On the advice of Frederick Kiesler, a Viennese architect, Calder invites Fernand Léger, Carl Einstein (critic), Le Corbusier, Piet Mondrian, and Theo van Doesburg to a performance of the *Cirque Calder* (A00019) at 7 Villa Brune. To avoid conflicts, Kiesler insists that Calder send a telegram inviting van Doesburg for the following night. (Calder 1966, 112–13; AAA, circus poster)

15 OCTOBER: Theo van Doesburg and his wife, Pétronella, attend a performance of *Cirque Calder* (A00019). "I got more of a reaction from Doesburg than I had from the whole gang the night before." (Calder 1966, 113)

OCTOBER: Accompanied by another American artist, William "Binks" Einstein (from St. Louis), Calder visits Piet Mondrian's studio at 26 rue de Départ. Already familiar with Mondrian's geometric abstractions, Calder is deeply impressed by the studio environment: it is a work

in progress with a wall of colored paper rectangles that can be repositioned for compositional experiments. Calder later recounts that this studio visit gave him a "shock" toward complete abstraction. For the next three weeks, he makes geometric, non-objective paintings. (Calder 1966, 113)

(N.D.): Frederick Kiesler introduces Calder to composer Edgard Varèse, and Calder makes a wire portrait of him (A00259). Varèse, who feels that his own music resonates with Calder's new abstract sculpture,often visits Calder's studio. (Calder 1966, 125)

17–22 DECEMBER: Calder returns to New York on the *Bremen* (Calder 1966, 114; AAA, postcard, Wiser to Calder)

1931 1–16 JANUARY: Calder has postcards printed to announce performances of the *Cirque Calder* (A00019) at 903 Seventh Avenue, Store no.3 (northeast corner of Fifty-seventh Street), New York. Five performances are given; each audience includes about thirty spectators. (AAA, circus announcement; *The World*, 18 January)

17 JANUARY: Alexander Calder and Louisa James are married in Concord, Massachusetts. Calder performed the *Cirque Calder* (A00019) the evening before. (Calder 1966, 115)

22 JANUARY: The Calders sail for Europe on the *American Farmer*. They return to Calder's old studio at 7 Villa Brune. (Calder 1966, 116; CF, Calder to George Thomson)

FEBRUARY: *Abstraction-Création*, a group of artists, is founded; members include Jean Arp, Jean Hélion, Piet Mondrian, Robert Delaunay, Anton Pevsner, and William "Binks" Einstein. (Calder 1966, 114)

27 APRIL–9 MAY: Galerie Percier, Paris, exhibits *Alexander Calder: Volumes-Vecteurs-Densités; Dessins-Portraits*, the first showing of his abstract work. Fernand Léger writes the introduction to

the catalogue: *Eric Satie illustrated by Calder, why not?*

27 APRIL: Picasso arrives early for the opening of the exhibition at Galerie Percier and is introduced to Calder. (CF, Calder unpub. ms. 1954–55, 95)

2 MAY: The Calders move into a rented three-story house at 14 rue de la Colonie. (Calder 1966, 121; Hayes 1977, 252–53; AAA, taxi receipt)

MAY: Louisa buys a dog, a small Briard mix. She and Calder name it Feathers because of its wispy hair. Calder makes an abstract sculpture, *Feathers* (A03086), expressing the kinetic energy of this dog. (Calder 1966, 121–22; CF, Calder to parents, ca. 16 June)

END OF MAY: "Mary Reynolds is up from Villefranche for a few weeks, so we are seeing a bit of her and Marcel Duchamp." (CF, Calder to parents, ca. 5 June)

JUNE: Calder is invited to join *Abstraction-Création*. (Calder 1966, 114; CF, Calder to parents, 1 July)

12 JULY: Calder writes his parents of his new work: "I have been making a few new abstractions which have certain movements combined with their other features. I think there is something in it that may be good." (CF, Calder to parents, 12 July)

AUGUST–MID-SEPTEMBER: The Calders visit Majorca, staying at the Hotel Mediterraneo. They call on the Juncosas, Pilar Miró's family. After a month in Paguera, they return to Paris. (Calder 1966, 122–23)

AUGUST: *Fables of Aesop According to Sir Roger L'Estrange* (A00377), illustrated by Calder, is published by Harrison of Paris.

29–30 OCTOBER: Calder performs the *Cirque Calder* (A00019) in his studio 14 rue de la Colonie. (FJM, Calder to Miró, 1931)

FALL: Using cranks and small electric motors, Calder concentrates on making objects that involve motion. (Calder 1966, 126)

FALL: Marcel Duchamp visits the studio at 14 rue de la Colonie again. He suggests calling Calder's

new motorized sculptures "mobiles," a pun in French referring to both motion and motive. Duchamp arranges an exhibition of them at Marie Cuttoli's Galerie Vignon the following February. (Calder 1966, 127)

NOVEMBER: Calder donates a wire sculpture, from works exhibited at Galerie Percier, to the collection of the recently founded Museum Sztuki (Museum of New Art) in Lodz, Poland. (Calder 1966, 118) The work is lost during World War II.

NOVEMBER: In Paris, at the Porte de Versailles, Calder exhibits with the *Abstraction-Création* group. He performs the *Cirque Calder* (A00019). (CF, Calder to parents, 1 July; Lipman 1976, 331)

MID-NOVEMBER: The Calders visit Port-Blanc in the Côtes-du-Nord, Brittany. (Calder 1966, 125–26; CF, Louisa to Mother, 30 November)

1932 (N.D.): Calder publishes "Comment réaliser l'art?" for the first issue of *Abstraction-Création, Art Non Figuratif*. In describing the work illustrated he writes "each element can move, shift, or sway back and forth in a changing relation to each of the other elements in this universe. Thus they reveal not only isolated moments, but a physical law of variation among the events of life. Not extractions, but abstractions." (trans. in Arnason and Mulas 1971, 25)

12–20 FEBRUARY: Galerie Vignon, Paris, exhibits *Calder: ses mobiles*; exhibition title and invitation design by Marcel Duchamp. (CF, exhibition file; Calder 1966, 127)

FEBRUARY: Jean Arp suggests "stabiles" for the non-motorized constructions exhibited previously at Galerie Percier. (Calder 1966, 130)

20–22 FEBRUARY: Calder performs the *Cirque Calder* (A00019) at his studio in Paris. (AAA, circus poster)

MAY: The Calders rent their house to Gabrielle Picabia, the first wife of artist Francis Picabia, and travel from Antwerp to New York on a Belgian freighter. (Calder 1966, 136–37)

9 MAY: Calder writes to American art critic James Johnson Sweeney and invites him to his exhibition at the Julian Levy Gallery in New York, adding that Léger had suggested Sweeney should see his mobiles, which he describes to Sweeney as "abstract sculptures which move." (JJS, Calder to Sweeney, 9 May)

12 MAY–11 JUNE: Julien Levy Gallery, New York, exhibits *Calder: Mobiles/Abstract Sculptures*. (CF, exhibition file) The exhibition announcement reprints Fernand Léger's introduction for Calder's exhibition at Galerie Percier. Calder's father attends the exhibition.

SUMMER: The Calders visit Louisa's parents in Concord and Calder's parents in Richmond, Massachusetts. (CF, Calder unpub. ms. 1954–55, 146; *Concord Herald*, 16 June)

BY 10 SEPTEMBER: The Calders arrive in Barcelona after a fourteen-day passage on the *Cabo Tortosa*, García and Díaz Spanish line. After a stop in Málaga, they take a train from Barcelona to Tarragona. (Calder 1966, 138–39; FJM, Calder to Miró, 19 July)

12 SEPTEMBER: The Calders arrive at the Miró farm in Montroig for an eight-to-ten day visit. The Calders and Mirós visit Cambrils and Tarragona. (Calder 1966, 139–40; JM, 330)

AFTER 12 SEPTEMBER: During their visit at the Miró farm in Montroig, Calder performs the *Cirque Calder* (A00019) with the Mirós, the farmhands, and the neighbors in attendance. (Calder 1966, 139)

LATE SEPTEMBER: The Calders return to Barcelona and visit Gaudí's cathedral. Invited by the *Amics de l'Art Nou*, Calder performs the *Cirque Calder* (A00019) in the hall of the Grup d'Arquitects i Tecnics Catalans per al Progres de l'Arquitectura Contemporania (GATCPAC). (Calder 1966, 140; Gasch, *Mirador*, 29 September)

LATE SEPTEMBER: After Barcelona, the Calders return to Paris, 14 rue de la Colonie. (Calder 1966, 141)

1933 (N.D.): "I made an abstract ballet using a frame with rings in the 2 top corners through which strings passed from the hands to the objects – springs, discs, a weight with a little pennant. This was the 'music' – Varèse liked ballet (but not 'music'). I called it 'A Merry Can Ballet.'" (CF, Calder unpub. ms. 1954–55, 106–07; Calder in Evans 1937, 62–67)

19–31 JANUARY: Calder's work is included in the group exhibition Abstraction-Création. (CF, exhibition file)

29–30 JANUARY: The Calders take the train from Paris to Madrid. (CF, Calder to Peggy, 2 February)

FEBRUARY 1: Madrid, the Calders visit the Museo del Prado. (CF, Calder to Peggy, 2 February)

EARLY FEBRUARY: Sociedad de Cursos y Conferencias, Residencia de la Universidad de Estudiantes Madrid exhibits works by Calder. Calder performs his Cirque Calder (A00019) for the students on 1 and 2 February. (AAA, Circus program)

11 FEBRUARY: Calder performs his Cirque Calder (A00019) on 11 and 12 February. (CF, Louisa to Mother, 11 February; "El Circ," La Publicitat, 9 February)

13 FEBRUARY: Calder has a private exhibition of drawings and sculpture arranged by Miró at Galeries Syra, Barcelona. (CF, Louisa to Mother, ca. December 1932; Louisa to Mother, 11 February)

FEBRUARY: The Calders travel to Rome to visit Louisa's godmother, "Tanta" Bullard. (CF, Louisa to Mother, ca. December 1932)

10 MARCH: The Calders return to Paris. (FJM, Calder to Miró, 15 March)

MAY: Calder meets Gala and Salvador Dali. (Calder 1966, 142)

16–18 MAY: Galerie Pierre Colle, Paris, exhibits Présentation des oeuvres récentes de Calder.

SPRING: Louisa has a miscarriage. (Calder 1966, 142; JJS, Calder to Sweeney, 20 September 1934)

9–24 JUNE: Galerie Pierre, Paris, exhibits Arp, Calder, Miró, Pevsner, Hélion, and Seligmann. Anatole Jakovski writes the text for the catalogue.

JUNE: At the Galerie Pierre, Calder meets James Johnson Sweeney for perhaps for the first time. Sweeney becomes an avid proponent of Calder's work. (Calder 1966, 148; Lipman 1976, 331)

BY 22 JUNE: Miró stays with the Calders at 14 rue de la Colonie while he arranges an exhibition of his own recent paintings. On the 24th, Miró presents them with a painting. (FPJM, Mother to Miró, 29 June; JM, 330–31)

JUNE: The Calders give up their house and return to New York in the company of Jean Hélion. Louisa and Calder visit Louisa's parents in Concord, Massachusetts and the Calders in Richmond, Massachusetts. They begin their search for a new house along the Housatonic River in Massachusetts. They also search in Tarrytown, New York; New City, New York; Yaphank, Long Island, New York; Westport, Connecticut; Sandy Hook, Connecticut. (Calder 1966, 143–44)

12–27 AUGUST: The Berkshire Museum, Pittsfield, Massachusetts exhibits Modern Painting and Sculpture. Calder writes a statement for the catalogue. "Why not plastic forms in motion? Not a simple translatory or rotary motion, but several motions of different types, speeds and amplitudes composing to make a resultant whole. Just as one can compose colors, or forms, so one can compose motions." (CF, exhibition file)

AUGUST: The Calders visit a real-estate agency in Danbury, Connecticut. After seeing several properties, they discover an eighteenth-century farmhouse in Roxbury, Connecticut. Both Louisa and Calder claim to have been the first to exclaim, "That's it!" (Calder 1966, 144)

1 SEPTEMBER: The Calders purchase the farmhouse in Roxbury, Connecticut. Calder converts the adjoining icehouse into a modest dirt-floored studio. (Calder 1966, 144–45; CF, mortgage records)

1934 30 JANUARY: Calder performs the Cirque Calder (A00019) at the Park Avenue home of Mr. & Ms. Huntington Sheldon at 6 p.m. (JJS, Calder to Sweeney, ca. January 1934)

7 FEBRUARY: The Calders attend the premiere of Gertrude Stein's Four Saints in Three Acts, set to music by Virgil Thomson, at the Wadsworth Atheneum, Hartford, Connecticut. Afterward, they attend dinner at the home of A. Everett (Chick) Austin, Jr., director of the Atheneum, where they visit with old friends, including Thomson and Julien Levy, and new acquaintances, such as James Thrall Soby and Austin. (Calder 1966, 146)

MARCH: The First Municipal Art Exhibition, Radio City (Rockefeller Center), New York, includes two works by Calder. Alfred H. Barr, Jr. purchases A Universe (A00276), a motorized mobile, for the Museum of Modern Art. (CF, exhibition file; Calder 1966, 148)

6–28 APRIL: Pierre Matisse Gallery, New York, exhibits Mobiles by Alexander Calder. The exhibition announcement is written by James Johnson Sweeney.

SUMMER: In Roxbury, Calder works on a number of "frames" (elements set in open frames), and he constructs his first outdoor sculptures. (Sweeney 1951, 38; Lipman, Calder's Universe, 331)

BEFORE 20 SEPTEMBER: Calder takes Louisa to stay with her parents in Concord, Massachusetts, during her pregnancy. (Calder 1966, 150; JJS, Calder to Sweeney, 20 September)

WINTER: The Calders spend the winter in an apartment at Eighty-sixth Street and Second Avenue, New York. Calder rents a small store and converts it into a studio. (Calder 1966, 156)

1935 14–31 JANUARY: The Renaissance Society of the University of Chicago exhibits *Mobiles by Alexander Calder*. The exhibition announcement includes text by James Johnson Sweeney. Calder performs the *Cirque Calder* (A00019) on 16, 17, 20, and 24 January.

16–17 JANUARY: Calder gives performances of the *Cirque Calder* (A00019) in Weiboldt Hall at the University of Chicago for the Renaissance Society. He also gave a performance at Mr. and Ms. Walter S. Brewster home on 20 January. (Calder 1966, 153; *Chicago Tribune*, 16 January).

1–26 FEBRUARY: The Arts Club of Chicago exhibits *Mobiles by Alexander Calder*. Calder gives Sweeney *Object with Red Discs* (A00283). The Sweeney family enjoys the object immensely and Sweeney's brother, John, dubs it "Calderberry-bush." (Calder 1966, 148–49)

SPRING: Calder stops in Rochester to see Ms. Charlotte Allen, who commissions a standing mobile (A04793) for her garden, designed by landscape architect Fletcher Steele. (Calder 1966, 153–54)

20 APRIL: The Calders' first daughter, Sandra, is born. It is also Miró's birthday.

SUMMER: Calder makes mobile sets for Martha Graham's dance *Panorama*. (CF, project file)

5–6 AUGUST: Calder and Louisa visit Martha Graham in Bennington, Vermont, to preview *Panorama*. (CF, project file)

14–15 AUGUST: *Panorama* (A00144) premieres in Bennington at the Vermont State Armory. (CF, project file)

WINTER: Calder makes a group of six mobiles that are to be used as "visual preludes" for each dance in Martha Graham's *Horizons*. (CF, project file)

1936 FEBRUARY: Calder creates a mobile set for Erik Satie's *Socrate* (A00146), performed for the First Hartford Music Festival at the Wadsworth Atheneum, Hartford, Connecticut. The music is conducted by Virgil Thomson. (CF, project file)

FEBRUARY: Calder designs paper costumes for *A Nightmare Side Show* (A19001), one of thirteen group processions in the *Paper Ball: Le Cirque des Chiffonniers*, at the First Hartford Festival, Wadsworth Atheneum, Connecticut. (CF, project file)

10–29 FEBRUARY: Pierre Matisse Gallery, New York, exhibits *Mobiles and Objects by Alexander Calder*. (CF, exhibition file)

23 FEBRUARY: Martha Graham premieres *Horizons* at the Guild Theatre in New York City. Calder's mobile "visual preludes" are a success. (*Dance Observer*, April)

2 APRIL: Calder performs the *Cirque Calder* (A00019) in New York at Pierre Matisse Gallery. (AAA, Calder to Bunce, 26 March)

24–25 APRIL: *Socrate* (A00146) is performed at the Colorado Fine Arts Center, Colorado Springs. (CF, project file)

JULY: The Calders vacation at Eastham on Cape Cod. (AAA, Calder to Bunce, 13 July)

WINTER: Calder is commissioned by Paul Nelson, an architect, to design a trophy for CBS for their Annual Amateur Radio Award. The work is entitled the *William S. Paley Trophy* (A11306). (Calder 1966, 155)

15 DECEMBER: Calder performs the *Cirque Calder* (A00019) in his apartment at 244 East Eighty-sixth Street. (AAA, Calder to Bunce, 9 December)

1937 (N.D.): Calder designs sets and costumes for *HO to AA*, a playlet in two scenes written by Charles Tracy but never performed. (*Transition*, no. 26, Winter)

23 FEBRUARY–13 MARCH: Pierre Matisse Gallery, New York, exhibits *Stabiles and Mobiles*; Calder's first large-scale, bolted stabile, *Devil Fish* (A00507), is exhibited in this show. (CF, exhibition file)

15 APRIL: The Calders sail for Europe. They debark at Le Havre, France. (CF, passport; Calder 1966, 156)

LATE APRIL: Paul and Francine Nelson invite the Calders to visit them in Varengeville, on the Normandy coast. Léger and Pierre & Teeny Matisse also visit. (Calder 1966, 156–157)

LATE APRIL OR EARLY MAY: The Calders return to Paris, where they move to a house, 80 boulevard Arago, designed by Paul Nelson and owned by Calder's friend Alden Brooks. Visitors to the house include Alvar Aalto, a Finnish architect, and his wife Aino. Calder uses the garage, outfitted with an automotive turntable, for his studio. (Calder 1966, 157–58)

MAY: Calder and Miró visit the Spanish pavilion, which is under construction, at the site for the 1937 World's Fair in Paris. Calder meets Josep Lluis Sert and Luis Lacasa, the architects for the pavilion. (Calder 1966, 158)

MID-MAY: Sert commissions Calder to make *Mercury Fountain* (A00176) for the Spanish Pavilion. The mercury comes from Almadén in Spain and symbolizes Republican resistance to fascism. (Freedberg, *The Spanish Pavilion at the Paris World's Fair* [New York and London, 1986], 504–05)

SUMMER: The Calders rent a house in Varengeville. Calder uses the garage as his studio. Among the visitors are Paul and Francine Nelson, Joan Miró, Georges Braque, Herbert Read (art critic), Pierre Loeb (art dealer), John Piper and Myfanwy Evans, and Ben Nicholson and Barbara Hepworth. (Calder 1966, 162–63)

3 JUNE: Calder performs the *Cirque Calder* (A00019) at 80 boulevard Arago, Paris. (Bruguière Collection, Paris, circus invitation)

12 JULY: The Spanish Pavilion, featuring Picasso's *Guernica*, Miró's *Reaper*, and Calder's *Mercury Fountain* (A00176), opens at the Paris World's Fair. (CF, exhibition file)

21 OCTOBER: The Calders arrive in Folkstone, England. They take an apartment at Belsize Park, London. Calder sets up a studio in Camden Town

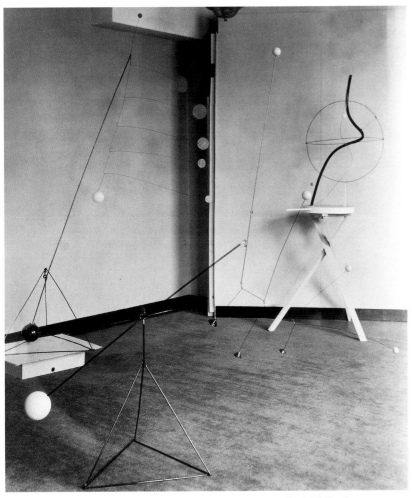

Installation photograph, Pierre Matisse Gallery, New York. *Mobiles by Alexander Calder*, April 6–28, 1934 / Photo: De Witt Ward

Calder in his New York studio with Pierre Matisse, 1936 / Photo: Herbert Matter

and gives *Cirque Calder* (A00019) performances. (CF, passport; Calder 1966, 164–65)

1938 1 MARCH: The Calders return to New York. They take another apartment in the same building at Eighty-sixth Street and Second Avenue. (Calder 1966, 167)

OCTOBER: Calder begins building a large studio on the foundation of his old burned-out barn in Roxbury. (Calder 1966, 169–70)

8–27 NOVEMBER: George Walter Vincent Smith Gallery, Springfield, Massachusetts, exhibits a retrospective, *Calder Mobiles*. The catalogue's foreword is written by James Johnson Sweeney. Alvar Aalto, Fernand Léger, Siegfried Giedion (architectural historian), and Katherine S. Dreier (art patron) attend the opening.

1939 (N.D.): The exhibition *III Salão de Maio*, São Paulo, Brazil, includes gouaches and a mobile by Calder. (Exhibition file)

(N.D.): Calder is commissioned by Wallace K. Harrison and André Fouilhoux, architects of Consolidated Edison's pavilion at the 1939 New York World's Fair, to design a "water ballet" for the pavilion's fountain. Although jets are put around the building, the water ballet is never executed. (Calder 1966, 176)

(N.D.): Calder is commissioned to make *Lobster Trap and Fish Tail* (A00310), a mobile that is installed in the principal stairwell of the Museum of Modern Art's new building on West Fifty-third Street, New York.

(N.D.): Calder is invited to make sculptures for the African Habitat being designed for the Bronx Zoo by Oscar Nitzschke. Calder is to create tree like sculptures that will be made of steel in order to withstand the abuse of wild animals. Although the African Habitat is never realized, Calder creates four models for the project: *Sphere Pierced by Cylinders* (A00682), *Four Leaves and Three Petals*

(A02140), *Leaves and Tripod* (A02191), and *The Hairpins* (A02610). (*New York Times*, 24 October 1970)

30 APRIL: Calder's sculpture made of Plexiglas wins first prize in a competition sponsored by Röhm and Haas, held at the Museum of Modern Art, New York. The work is exhibited at the Hall of Industrial Science during the New York World's Fair. (CF, exhibition file; Calder 1966, 175; *Architectural Record* 85 [June], 10)

9–27 MAY: Pierre Matisse Gallery, New York, exhibits *Calder Mobiles-Stabiles*. (CF, exhibition file)

25 MAY: The Calders' second daughter, Mary, is born.

SUMMER: Moncha and Josep Lluis Sert pay an extended visit to the Calders in Roxbury. (Calder 1966, 174)

1940 14 MAY–1 JUNE: Pierre Matisse Gallery, New York, exhibits Calder. (CF, exhibition file)

11–14 OCTOBER: A private exhibition of Calder's sculptures takes place inside and outside the home of architect Wallace K. Harrison and his wife Ellen in Huntington, Long Island. (MoMA, invitation; CF, Myra Martin to Ellen Harrison, 24 October)

3–25 DECEMBER: Willard Gallery, New York, exhibits *Calder Jewelry*. (CF, exhibition file)

1941 (N.D.): Calder is commissioned by architect Wallace K. Harrison to make a mobile for the ballroom of the Hotel Avila, Caracas. (CF, project file)

28 MARCH–11 APRIL: The Arts and Crafts Club of New Orleans, Louisiana, exhibits *Alexander Calder: Mobiles, Jewelry; and Fernand Léger: Gouaches, Drawings*.

27 MAY–14 JUNE: Pierre Matisse Gallery, New York, exhibits *Alexander Calder: Recent Works*. (CF, exhibition file)

27 SEPTEMBER–27 OCTOBER: The Design Project, Los Angeles exhibits, *Alexander Calder, Mobiles,

Stabiles, Jewelry; A Few Paintings by Paul Klee. (CF, exhibition file)

1942 (N.D.): Calder meets artist Saul Steinberg. (CF, Whitney memorial program)

(N.D.): The Calders move to an apartment at 255 East Seventy-second Street. (CF, Masson to Calder, 12 November 1942)

3 MARCH: Calder is commissioned to make *Red Petals* (A00513) for the Arts Club of Chicago. (Calder 1966, 185–86; CF, Rue Shaw to Calder, 3 March)

7–28 MARCH: Vassar College exhibits *Joan Miró–Alexander Calder*, featuring works by Joan Miró selected from a larger group exhibition circulated by the Museum of Modern Art, New York and supplemented with an equal number of works by Calder.

19 MAY–12 JUNE: Pierre Matisse Gallery, New York, exhibits *Calder: Recent Work*. (CF, exhibition file)

20 MAY: Calder performs the *Cirque Calder* (A00019) at Herbert & Mercedes Matter's apartment, 328 East Forty-second Street, New York. (CF, Calder to José de Creeft, 18 May)

JULY–NOVEMBER: Calder is classified 1-A by the army. He studies industrial camouflage at New York University and applies for a commission in camouflage work with the Marine Corps: "Although the army says that the painter is of little or no use in modern camouflage, I feel that this is not so, and that the *camoufleur* is still a painter, but on an immense scale . . . and in a negative sense (for instead of creating, he demolishes a picture and reduces it to nil . . .)." His application is rejected. (Calder 1966, 183; CF, Calder application to the Marine Corps, 21 September 1942)

OCTOBER–NOVEMBER: The Coordinating Council of French Relief Societies, Whitelaw Reid Mansion, New York, exhibits *First Papers of Surrealism*. André Breton and Marcel Duchamp curate the

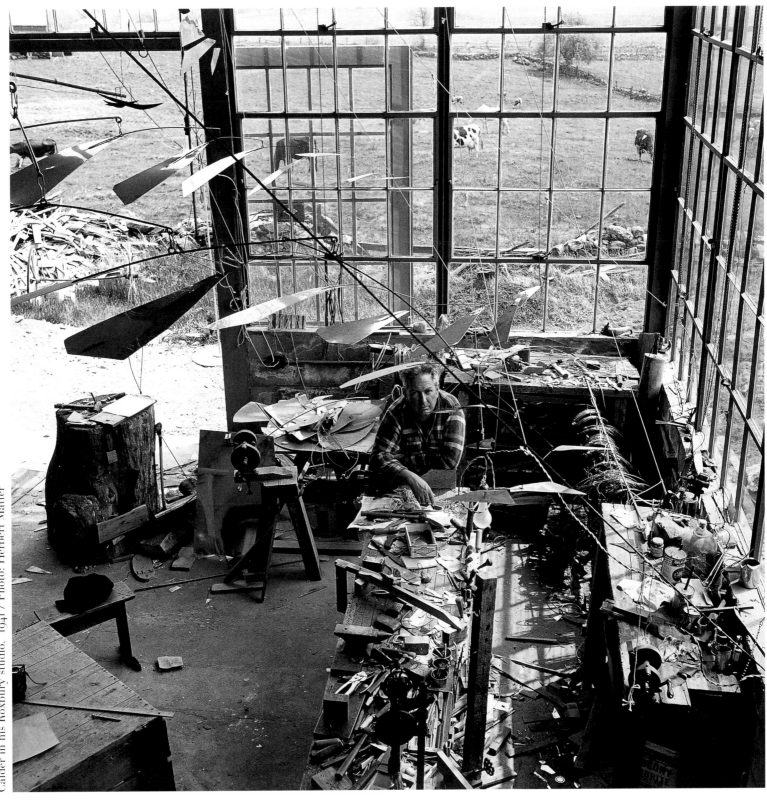

Calder in his Roxbury studio. 1941 / Photo: Herbert Matter

exhibition. Duchamp invites Calder to hang works from his *Mile of String*. Calder makes small paper elements, as a play on the title of the show, and begins to hang them on the string but Breton vetos the idea. Calder installs *The Spider* (A09262), a large standing mobile, instead.

WINTER: Calder works on a new open form of sculpture made of carved wood and wire. "They had a suggestion of some kind of cosmic nuclear gases- which I won't try to explain. I was interested in the extremely delicate, open composition." James Johnson Sweeney and Marcel Duchamp suggest the name "constellations" for them. (Calder 1966, 179; Arnason and Mulas 1971, 202)

7 DECEMBER 1942–22 FEBRUARY 1943: The Metropolitan Museum of Art, New York, exhibits *Artists for Victory: An Exhibition of Contemporary American Art*. Calder wins fourth prize. Prize-winners Alexander Calder, José de Creeft, and Philip Evergood are interviewed at the Metropolitan Museum for a program, entitled "Living Art", broadcast 8 December. (CF, exhibition file; AAA, oral history collection)

1943 (N.D.): Yves Tanguy and Kay Sage buy a house in Woodbury, Connecticut, and become close friends of the Calders. Rose and André Masson live nearby in New Preston. (Calder 1966, 180)

15 MAY–15 JUNE: Pierre Matisse Gallery, New York, exhibits *Calder: Constellationes*, Calder's last exhibition at the Matisse Gallery. (CF, exhibition file)

28 MAY–6 JULY: Addison Gallery of American Art, Andover, Massachusetts, exhibits *17 Mobiles by Alexander Calder*. Catalogue contains a statement by Calder, "At first [my] objects were static ("stabiles"), seeking to give a sense of cosmic relationship. Then . . . I introduced flexibility, so that the relationships would be more general. From that I went to the use of motion for its

contrapuntal value, as in good choreography." (*17 Mobiles 1943*, 6)

SUMMER: Calder writes an essay for James Johnson Sweeney for possible inclusion in the exhibition catalogue accompanying the Museum of Modern Art's 1943 retrospective of Calder's work: "Simplicity of equipment and an adventurous spirit in attacking the unfamiliar or unknown are apt to result in a primitive and vigorous art. Somehow the primitive is usually much stronger than art in which technique and flourish abound." (CF, unpub. ms. 1943)

29 SEPTEMBER–28 NOVEMBER: Museum of Modern Art, New York exhibits a major retrospective, *Alexander Calder*, which is extended to 16 January 1944. James Johnson Sweeney curates the exhibition with the help of Marcel Duchamp. Calder gives *Cirque Calder* (A00019) performances in the museum. In October, Calder also gives a performance of *Cirque Calder* at Sweeney's apartment. (AAA, Sweeney to Jean Lipman, July 1971)

1 DECEMBER: Calder arrives in Chicago to prepare for his exhibition of jewelry at the Arts Club (3–27 December). (CF, exhibition file; NL, Calder to Shaw, 13 November; Calder 1966, 185)

4 DECEMBER: While Calder is away in Chicago, the old icehouse studio and part of the Roxbury farmhouse are destroyed by an electrical fire. At the time, Louisa and the two girls are staying with the Serts in New York. (Calder 1966, 186; NL, Calder to Shaw, 14 December)

7 DECEMBER: Calder returns to New York. (NL, Calder to Shaw, 14 December)

1944 (N.D.): Agnes Rindge Claflin writes and narrates *Alexander Calder: Sculpture and Constructions*, a film based on the retrospective at the Museum of Modern Art, New York. Cinematography is by Herbert Matter.

(N.D.): In New York, Calder meets Henrique Mindlin, a Brazilian architect. (Calder 1966, 198)

(N.D.): The Calders live with Yves Tanguy and Kay Sage while the Roxbury house is being repaired. Calder leaves the burned icehouse to be reconstructed later. (Calder 1966, 187; Conversation with Mary Calder Rower, 16 November 1997)

(N.D.): Calder gives *Black Flower* (A13363) to the Museum of Western Art in Moscow. (Calder 1966, 185)

3 FEBRUARY: Calder attends the memorial service for Piet Mondrian at the Universal Chapel at Lexington Avenue and Fifty-second Street, New York. (PM, 85)

27 MARCH–9 APRIL: France Forever, Washington, D.C., exhibits *Calder: Paintings, Mobiles, Stabiles and Jewelry*, including *Black Flower* (A13363) borrowed back from the Russian Embassy. Calder performs the *Cirque Calder* (A00019) twice during the exhibition. (CF, exhibition file; Calder 1966, 184–85; AAA, Calder to Keith Warner, 3 April)

SUMMER: The Calder Family decides to take permanent residence at their home in Roxbury, Connecticut. (Conversation with Mary Calder Rower, 16 November 1997)

FALL: *Three Young Rats and Other Rhymes* (A04735), illustrated by Calder and edited by James Johnson Sweeney, is published. (CF, project file)

28 NOVEMBER–23 DECEMBER: Buchholz Gallery/Curt Valentin, New York, exhibits *Recent Work by Alexander Calder*, including plaster and bronze sculptures, and the drawings for *Three Young Rats and Other Rhymes*.

1945 6 JANUARY: Alexander Stirling Calder dies in Brooklyn. Calder and Louisa leave their daughters with the Massons and bury Stirling in Philadelphia. (Conversation with Mary Calder Rower, 16 November 1997)

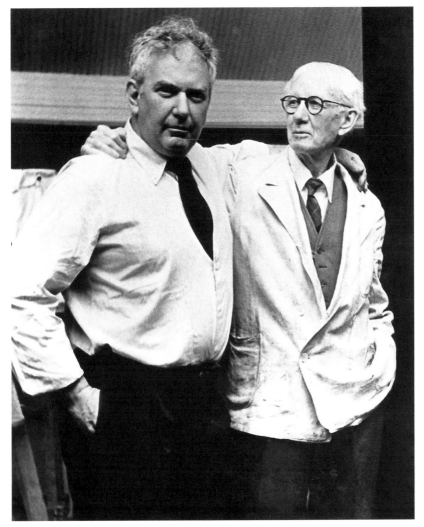

Calder with his father, sculptor Alexander Stirling Calder. Courtesy Calder Foundation

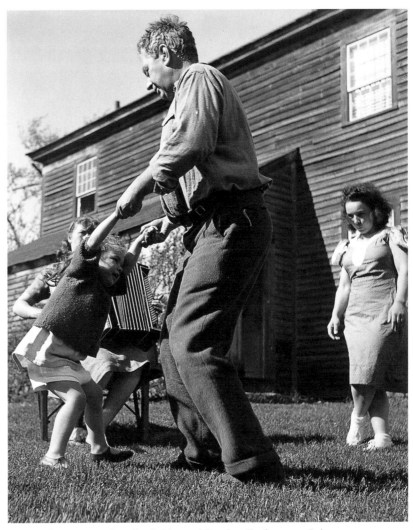

Louisa playing accordian for Calder and Sandra. Roxbury, 1938 / Photo: Herbert Matter

Sandra, Calder, and Mary at Keith Warner's house in Fort Lauderdale, Florida, 1946. Courtesy Calder Foundation

MARCH: Calder works on sketches for costumes and scenery for the dance project *Billy Sunday* (A12245), composed by Remi Gassman. The project, intended for the University of Chicago, is never performed. (AAA, Calder to Keith Warner, 6 March; AAA, Calder to Warner, 2 April)

(N.D.): Commissioned by the Museum of Modern Art, New York to make a work for the sculpture garden, Calder constructs *Man-Eater with Pennants* (A04737). (AAA, Calder to Warner, 1 June)

FALL: Calder makes a series of small-scale works, many from scraps trimmed in the process of making other objects. Marcel Duchamp visits the Roxbury studio and discovers a whole series of miniature sculptures. "Let's mail these little objects to Carré, in Paris," he suggests, "and have a show." He arranges the exhibition at Galerie Louis Carré while Calder creates larger, collapsible works capable of being mailed and reassembled in Paris. (Calder 1966, 188; CF, exhibition file)

FALL: André Masson brings Jean-Paul Sartre to visit Calder in Roxbury. He visits Calder again at his studio in New York. Calder gives him *Peacock* (A11645), a mobile whose elements are cut from flattened Connecticut license plates. (Calder 1966, 188–89)

13 NOVEMBER–1 DECEMBER: Buchholz Gallery/Curt Valentin, New York, exhibits *Works by Alexander Calder*.

1946 (N.D.): *The Rime of the Ancient Mariner* (A00379) by Samuel Taylor Coleridge, with illustrations by Calder and an essay by Robert Penn Warren, is published in New York by Reynal and Hitchcock.

(N.D.): Calder is commissioned by Thomas Emery's Sons, Inc., to construct a mobile for the Terrace Plaza Hotel, Cincinnati, designed by Gordon Bunshaft of Skidmore, Owings & Merrill. The mobile is named *Twenty Leaves and an Apple* (A01928). (CF, project file)

5–6 JUNE: Calder flies from New York to Paris to prepare for the exhibition at Galerie Louis Carré. (CF, passport)

23 JULY: The exhibition at Louis Carré is delayed and Calder returns to New York. He and Carré ask Jean-Paul Sartre to write an essay for the catalogue. (Calder 1966, 189; MoMA, Calder to Valentin, 6 August)

12 AUGUST: Calder and Louisa attend the premiere of Padraic Colum's play *Balloons*, with mobile sets by Calder, performed at the Ogunquit Playhouse, Maine. (AAA, Calder to Keith Warner, July)

7 SEPTEMBER: Calder performs the *Cirque Calder* (A00019) for his daughters. "I have to show the children how to run it so that they can carry on." (AAA, Calder to Warner, 30 August)

23 SEPTEMBER: Calder returns to Paris. (CF, passport)

25 OCTOBER–16 NOVEMBER: Galerie Louis Carré, Paris exhibits *Alexander Calder: Mobiles, Stabiles, Constellations*. The catalogue includes "Les Mobiles de Calder" by Jean-Paul Sartre and "Alexander Calder" by James Johnson Sweeney, with photographs by Herbert Matter. Henri Matisse attends the exhibition.

19–30 NOVEMBER: Calder sails from Le Havre to New York on the *John Ericsson*. (Calder 1966, 194; CF, passport)

1947 12 FEBRUARY: Joan and Pilar Miró and their daughter Dolores arrive in the United States. Calder meets them at La Guardia Airport and installs them in an apartment on First Avenue. (AAA, Calder to Keith Warner, 15 February)

BEFORE 7 MARCH: The Mirós arrive at the Calders' home in Roxbury for a visit. (Stedelijk Museum, Miró to Sandberg, 7 March)

(N.D.): Calder presents the *Cirque Calder* (A00019) at his home in Roxbury for the Mirós, Henri Seyrig (friend and director of the Institut Français

d'Archéologie), and Henrique and Helena Mindlin. (CF, Calder unpub. ms. 1954–55, 155)

20 APRIL: Miró celebrates his and Sandra Calder's birthday with the Calders at their apartment on East Seventy-second Street, New York. He gives Sandra a drawing and she gives Miró a drawing of a butterfly. Calder gives Miró a mobile figure constructed of bones. (Conversation with Mary Calder Rower, 16 November 1997)

AFTER 5 MAY: Calder trades the mobile *Polygones noirs* (A00323) for Miró's *Femmes et oiseaux dans la nuit*, 1947, a painting related to Miró's mural for the Terrace Plaza Hotel.

7 JULY: Galerie Maeght, Paris, exhibits *Le Surréalisme en 1947*. Calder does a lithograph for the catalogue. (Breton and Duchamp 1947)

DECEMBER: Calder begins converting the fire-damaged icehouse studio in Roxbury into a big living room. (AAA, Calder to Keith Warner, 13 December)

9–27 DECEMBER: Buchholz Gallery/Curt Valentin, New York, exhibits *Alexander Calder*.

1948 (N.D.): *Selected Fables* (A00380) by Jean de La Fontaine, translated by Eunice Clark, with etchings by Calder, is published in a special edition by Quadrangle Press.

(N.D.): Hans Richter's film, *Dreams that Money Can Buy*, is released after being in production since 1945. Two sequences are made with Calder's collaboration: "Ballet," the fifth dream, and "Circus," the sixth dream.

SPRING: Calder meets Burgess Meredith, who later visits the Calders in Roxbury to discuss making a film about Calder and his mobiles. Calder suggests Herbert Matter as the cinematographer. (Calder 1966, 197)

SPRING: Calder is invited to exhibit his work in Brazil. (Calder 1966, 199)

SUMMER: The Calders drive to the Grand Canyon, Death Valley, Reno, and Lake Tahoe, where they

spend two weeks with Kenneth and Peggy Hayes. While there, they receive word that Louisa's mother (Louisa Cushing James) has died. They drive to Berkeley, the Hayeses' home, where the Calders leave Sandra and Mary. Calder and Louisa fly to Los Angeles and continue on to Mexico City, where they are met by Fernando Gamboa, director of the Museo de Bellas Artes, and visit with their friend Luis Buñuel and his family. The next morning they fly to Panama City for a short stop. (Calder 1966, 198–99; conversation with Mary Calder Rower, 23 October 1997)

9 SEPTEMBER: The Calders arrive in Trinidad. (CF, passport)

10 SEPTEMBER: From Trinidad, the Calders fly to Belém, Brazil. On the plane they meet writer John Dos Passos. (CF, passport; Calder 1966, 199)

11 SEPTEMBER: Calder and Louisa arrive in Rio de Janeiro. (CF, passport)

SEPTEMBER: Museu de Arte Moderna, Ministerio da Educação, Rio de Janeiro, exhibits *Alexander Calder*. The catalogue includes "Les Mobiles de Calder" by Jean-Paul Sartre (reprint), "Alexander Calder" by Henrique Mindlin, and statements by André Breton, Nancy Cunard, and James Johnson Sweeney.

OCTOBER–NOVEMBER: Museu de Arte Moderna de São Paulo, Brazil, exhibits works by Calder. (CF, exhibition file)

29 OCTOBER: The Calders embark from Rio de Janeiro for the United States.

NOVEMBER: In Berkeley, Calder and Louisa are reunited with the children. The family spends a week with the Hayeses, before driving back across country, with side trips to Sante Fe and Texas. (Calder 1966, 204; CF, passport; conversation with Mary Calder Rower, 23 October 1997)

1949 (N.D.): Calder creates mobiles for *Symphonic Variations* (A00148), choreographed by Tatiana Leskova with music by César Franck. The dance is performed in Rio de Janeiro. (Lipman, *Calder's Universe*, 1976, 171)

(N.D.): Calder constructs his most ambitious mobile to date, *International Mobile* (A01158), for the *Third International Exhibition of Sculpture*, 15 May–11 September, Philadelphia Museum of Art in collaboration with the Fairmount Park Art Association. (CF, exhibition file)

30 NOVEMBER–17 DECEMBER: Buchholz Gallery/Curt Valentin, New York, exhibits *Calder*. The catalogue includes "The Studio of Alexander Calder" by André Masson and illustrations by Calder of the objects exhibited. (CF, exhibition file)

1950 6 JANUARY: *Happy As Larry*, a play written by Donagh MacDonagh and directed by Burgess Meredith with sets by Calder, opens in New York at the Coronet Theatre. (CF, project file)

4–10 MAY: The Calder family sails from New York on the *Île de France* and arrives in Le Havre. (Calder 1966, 204; CF, passport)

MID-MAY: In Paris, the Calders rent an apartment for four months on rue Penthièvre from their friend, Médé Valentine. (CF, passport; Calder 1966, 204; AAA, Calder to Warner, 5 February)

30 JUNE–27 JULY: Galerie Maeght, Paris, exhibits *Calder: Mobiles and Stabiles*. Calder, encouraged by Christian Zervos (publisher of *Cahiers d'Art*) to exhibit at Galerie Maeght, also illustrated the catalogue and the exhibition poster. The Nationalmuseum, Stockholm, purchases a mobile and the Musée National d'Art Moderne, Paris, purchases the large mobile *Le 31 Janvier*. (CF, exhibition file; Lipman 1976, 334)

JULY: The Calders travel around France visiting the caves of Lascaux, and Ritou Nitzschke and André Bac in La Roche Jaune, Brittany. (Calder 1966, 206; Lipman 1976, 334)

2–8 AUGUST: The Calders leave Paris and take a train to Antwerp. From there, the family takes a Finnish ship *Arcturus* to Helsinki. (Calder 1966, 206; CF, passport)

9–13 AUGUST: The Calders visit Maire Gullichsen, who takes them to her house, Villa Mairea, in Norrmark for a week. (Calder 1966, 206)

14 AUGUST: The Calders leave from Turku, Finland, and take a boat to Stockholm, arriving the next day. They stay in the Grand Hotel and visit Eric Grate, a Swedish sculptor. (CF, passport; Calder 1966, 208)

26–27 AUGUST: Departing Malmö, Sweden, the Calders take a train through Denmark and Germany, and arrive in Paris. (CF, passport; Calder 1966, 208)

31 AUGUST–11 SEPTEMBER: The Calders depart Paris for Antwerp, set sail the next day on the *Europa*, and arrive in New York. (CF, passport; Calder 1966, 208)

12 NOVEMBER: Calder is selected by the *New York Times Book Review* as one of the ten best children's book illustrators of the last fifty years. (*New York Times*, 12 November)

5 DECEMBER–14 JANUARY 1951: Massachusetts Institute of Technology, Cambridge, exhibits *Calder*, a retrospective. James Johnson Sweeney installed the exhibition while Calder recovered from an automobile accident. (CF, exhibition file; Calder 1966, 209)

1951 (N.D.): Josep Lluis Sert introduces Calder to architect Carlos Raúl Villanueva. (Calder 1966, 240)

24 JANUARY: After two years of filming and production, *Works of Calder* is previewed at the Museum of Modern Art, New York. Directed and filmed by Herbert Matter, produced and narrated by Burgess Meredith with music by John Cage.

5 FEBRUARY: Calder participates in a symposium, "What Abstract Art Means to Me," sponsored by the Museum of Modern Art, New York in conjunction with exhibition, *Abstract Painting and Sculpture in America*. "The idea of detached

bodies floating in space, of different sizes and densities, perhaps of different colors and temperatures, and surrounded and interlarded with wisps of gaseous condition, and some at rest, while others move in peculiar manners, seems to me the ideal source of form." (Calder 1951, 8–9)

17 APRIL–2 JUNE: Institute of Contemporary Arts, Washington, D.C., exhibits *Sculptures by Alexander Calder*. (CF, exhibition file)

APRIL: In Washington D.C., Calder sees Jean Davidson, a friend he had first met in 1944. Calder invites him to visit Roxbury. (Calder 1966, 212)

15 AUGUST: Eero Saarinen writes to Calder proposing a commission for a sculpture and fountain at the General Motors Technical Center, Warren, Michigan. Calder suggests a fountain without any sculpture. (CF, Saarinen to Calder, 15 August; CF, Saarinen to Tykle, 28 September)

1952 15 JANUARY–10 FEBRUARY: Curt Valentin Gallery, New York, exhibits *Alexander Calder: Gongs and Towers*. The catalogue texts are "Alexander Calder's Mobiles" by James Johnson Sweeney and "Calder" by Fernand Léger, with drawings by Calder of the objects exhibited.

19 MARCH: Calder arrives in Paris and stays with Paul Nelson. (CF, passport; Calder and Nelson to Louisa, 19 March)

SPRING: Carlos Raúl Villanueva meets Calder again in Paris and describes his project for Aula Magna, the auditorium of the Universidad Central de Venezuela. Villanueva suggests Calder make a mobile for the lobby. Calder suggests making something in the huge auditorium. (Calder 1966, 240)

APRIL: Calder designs the sets and costumes for *Nucléa*, written by Henri Pichette. (CF, project file; Calder 1966, 209–10)

3 MAY: Calder and Louisa attend the opening of *Nucléa* at the Théâtre du Palais de Chaillot, Paris. Directed by Jean Vilar with music by Maurice

Jarre, the play is performed by Théâtre National Populaire. (CF, project file; Calder 1966, 210)

6–10 MAY: Galerie Maeght, Paris exhibits *Alexander Calder: Mobiles*. (CF, exhibition file)

MID-MAY: The Calders visit André Masson and family in Aix-en-Provence. They ask Masson to find them a house to rent for the following year. From Aix-en-Provence they travel to Varengeville. (Calder 1966, 210–11; Lipman, *Calder's Universe*, 334)

29–30 MAY: Louisa flies from Paris to New York. Calder leaves Paris 30 May and arrives in Italy to prepare his works for the XXVI Biennale di Venezia. (CF, passport)

3 JUNE: Calder returns to Paris. (CF, passport)

6–7 JUNE: Calder flies from Paris and arrives in New York. (CF, passport)

14 JUNE–19 OCTOBER: Calder represents the United States in the XXVI Biennale di Venezia. James Johnson Sweeney installed the exhibition and wrote a short text for the exhibition catalogue. Calder wins the Grand Prize for sculpture.

28 JUNE: Calder accepts the commission from Carlos Raúl Villanueva to design an acoustic ceiling (A00181) for Aula Magna, the auditorium of the Universidad Central de Venezuela. He collaborates with the engineering firm Bolt, Bereneck, and Newman, Cambridge, Massachusetts. (Calder 1966, 240; CF, Calder to Villanueva, 28 June)

5–6 SEPTEMBER: Calder performs the *Cirque Calder* (A00019) in Roxbury. (CF, Calder to Rockefeller)

MID-SEPTEMBER: Calder arrives in Bonn on 10 September, with an invitation from the German State Department to tour West Germany. After two days he travels to Munich, where he meets Bruno Werner, a journalist who reviewed his first Berlin exhibition in 1929. He continues on to Mannheim and Darmstadt. (CF, passport and German identification card; Calder 1966, 211–12)

23–29 SEPTEMBER: Calder stays in Berlin. (Calder 1966, 211–12)

AFTER 29 SEPTEMBER: Calder travels to Hamburg (where he meets the dealer Rudolf Hoffmann), Hannover, Bremen, and Cologne, before returning to Bonn. (Calder 1966, 211–12)

9–10 OCTOBER: Calder flies from Bonn to New York. (CF, passport)

18 NOVEMBER–9 DECEMBER: Galerie la Hune, Paris, exhibits *Permanence du Cirque*. The exhibition commemorates the publication of a book by the same title, which includes an essay by Alexander Calder, "Voici une petite histoire de mon cirque." (CF, exhibition file)

WINTER: Calder presents the *Cirque Calder* (A00019) in Washington, D.C.; Jean Davidson invites "what seemed half of Washington, D.C., to see it." (Calder 1966, 213)

1953 1 MAY–13 JUNE: Frank Perls Gallery, Beverly Hills, exhibits *Alexander Calder: Mobiles*, previously shown at the Walker Art Center, Minneapolis, 22 March–19 April. (CF, exhibition file)

30 JUNE: The Calder family arrives at Le Havre after an eight-day voyage on the *Flandre*. Also on board is Ernest Hemingway. "He appeared suddenly and I presented myself, but it was not much use. For I had nothing to say to him and he had nothing to say to me. And that went for Louisa too." (Calder 1966, 213)

JULY: The Calders arrive in the hamlet of Les Granettes in Aix-en-Provence. Their house, the Màs des Roches, has little water and no electricity. Calder uses the carriage shed as his studio, where he works on gouaches. At a blacksmith shop nearby, he makes a series of large standing mobiles conceived for the outdoors. (Calder 1966, 214)

AUGUST: The Calders happen upon Jean Davidson, their future son-in-law, in the Loire valley. Jean has purchased a mill house, Moulin Vert, in the tiny town of Saché. (Calder 1966, 219–20; Calder to mother, 9 August)

SUMMER: Daughter Sandra goes to live in Paris.

30 SEPTEMBER: Calder receives a commission for a mobile from Middle East Airlines for their Beirut ticket office. (CF, Salaam to Calder, 30 September)

NOVEMBER: Back in Aix-en-Provence, the Calders find another house nearby, Malvalat, which has running water and electricity. Calder sets up a studio on the third floor and continues to concentrate on gouaches. (Calder 1966, 218; MoMA, Calder to Valentin, 2 November)

7 NOVEMBER: Calder leaves Aix for Paris to begin filming *Cirque de Calder*, directed by Jean Painlevé, with André Bac as cameraman. (CF, Calder to mother and the Sterns, 16 November)

11 NOVEMBER: The Calders visit Jean Davidson to see his renovated mill house in Saché. Calder agrees to a trade of three mobiles for "François Premier," a dilapidated seventeenth-century stone house built adjoining a cliff on Jean's property. (Calder 1966, 220–21)

MID-NOVEMBER: Calder rigs a studio in Jean's mill and constructs the mobiles. Through the winter, Jean organizes the renovation of François Premier and converts the wagon shed into a studio. A second small building across the street serves as the "gouacherie", a painting studio. (Calder 1966, 221; CF, Calder to mother and the Sterns, 16 November)

END OF NOVEMBER: Calder plans a trip to Beirut to visit his friend Henri Seyrig and to make the mobile (A07474) commissioned by Middle East Airlines. (Calder 1966, 222; CF, Calder to mother and the Sterns, 16 November)

15 DECEMBER 1953–28 FEBRUARY 1954: Museu de Arte Moderna de São Paulo, Brazil, presents the 2nd *Bienal*. United States representation consists of three exhibitions prepared by the Museum of Modern Art, New York: one is devoted to works by Calder.

1954

1–5 JANUARY: The Calder family travels on the Greek steamship *Aurelia* from Marseilles to Greece, where they spend the day in Athens. (CF, passport; Calder 1966, 222)

8 JANUARY: The Calders stop in Alexandria, Egypt. (CF, passport)

10 JANUARY: The Calders arrive in Beirut after a stop in Limassol, Cyprus. They reside with the Seyrigs for a month, visiting Syria and Jordan by car. (CF, passport; Calder 1966, 226)

JANUARY: Calder is given a room to serve as a studio in the Middle East Airlines ticket office, which is under construction. (Calder 1966, 226)

FEBRUARY: American University, Beirut, exhibits works Calder made during the last month. (CF, exhibition file)

4–6 FEBRUARY: The Calder family visits Jerusalem and Bethlehem. (CF, passport; Calder to mother, 9 February)

11 FEBRUARY: The Calders leave Beirut and return to Aix. (CF, passport; Calder 1966, 227)

15 MARCH: Calder leaves Paris, traveling through Amsterdam to Hannover, where an exhibition of his work is scheduled to open at the Kestner-Gesellschaft. (CF, passport)

18 MARCH–2 MAY: Kestner-Gesellschaft, Hannover, exhibits *Alexander Calder: Stabiles, Mobiles, Gouaches*. (CF, exhibition file)

19 MARCH: Calder returns to Paris. (CF, passport)

7–13 MAY: Louisa and daughter Mary sail from Le Havre to New York. (CF, passport)

15–16 JUNE: Calder flies from Paris to New York; daughter Sandra remains in France. (CF, passport; Calder 1966, 231)

24 JULY: The renovation of François Premier is completed. (CF, Davidson to Calder, 24 July)

19 AUGUST: Calder's dealer, Curt Valentin, dies in Italy. (Calder 1966, 231)

20 OCTOBER: Calder returns to France, arriving in Le Havre. (CF, passport)

13 NOVEMBER–15 DECEMBER: Galerie Maeght, Paris, exhibits *Aix. Saché. Roxbury: 1953–54*. The catalogue texts are "Poème offert à Alexander Calder et à Louisa" by Henri Pichette and "Calder" by Frank Elgar.

23 NOVEMBER: Calder leaves Paris and arrives in New York. (CF, passport)

7 DECEMBER: A visa is issued for the Calders' trip to India. He and Louisa have been invited by Gira Sarabhai, an architect and designer, to a tour of India in exchange for works of art. (Calder 1966, 231–32)

29 DECEMBER: Calder and Louisa leave New York and arrive in Paris. (CF, passport)

1955

9–10 JANUARY: En route to Bombay, Calder and Louisa fly from Paris to Beirut. They visit the Seyrigs and show the film *Works of Calder* at the American University. (CF, passport; Calder 1966, 232)

12 JANUARY: The Calders arrive in Bombay. They journey by train to Gira Sarabhai's home in Ahmedabad, where Calder makes eleven sculptures and some gold jewelry. (CF, passport; Calder 1966, 232–33)

27 FEBRUARY: After visiting Patna, the Calders arrive in Kathmandu in Nepal. (CF, passport; Calder 1966, 237)

1 MARCH: The Calders leave Kathmandu for Patna from which they visit Delhi and Jaipur before returning to Bombay. (CF, passport; Calder 1966, 237–39)

8 OR 9 MARCH: Calder has a private exhibition in Bombay of the works he has made in India. He contracts pneumonia and stays a few extra days to recover. (Calder 1966, 239–40)

11–12 MARCH: The Calders leave Bombay, returning to Paris via Cairo and Athens. (Calder 1966, 240; CF, passport)

21–22 MARCH: The Calders fly from Paris to New York. (CF, passport)

25 MARCH: Jehangir Art Gallery, Bombay, exhibits Calder's work. (CF, exhibition file)

17 MAY–4 JUNE: Curt Valentin Gallery, New York, exhibits *Alexander Calder*. Calder agrees to hold the show as scheduled, in spite of Valentin's death the previous year. Nothing is sold. (Calder 1966, 240)

15 AUGUST: Calder arrives in Caracas. He sets up a studio at the metal shop of the Universidad Central de Venezuela and sees *Acoustic Ceiling* (A00181) installed in Aula Magna for the first time. Louisa planned to join Calder in Caracas, but Connecticut is hit by a tornado that causes extensive flooding, and she cancels her trip. (CF, passport; Calder 1966, 242)

11–25 SEPTEMBER: Carlos Raúl Villanueva arranges *Exposición Calder* at Museo de Bellas Artes de Caracas. (Calder 1966, 242; CF, exhibition file)

12–13 SEPTEMBER: Calder leaves Caracas, arriving in New York en route to Roxbury. (CF, passport)

19 OCTOBER: The Calders arrive in France for the marriage of their daughter, Sandra, to Jean Davidson. (CF, passport; Calder 1966, 246)

28 OCTOBER: Sandra Calder and Jean Davidson are married in Saché.

9 NOVEMBER: The Calders and Davidsons leave Paris and arrive in Germany, where Calder has been commissioned to make a stabile for the American Consulate in Frankfurt. The Calders stay at the Frankfurter Hof. He works with the bridge builders, Fries et Cie, to construct the monumental stabile *Hextopus* (A08476). (Calder 1966, 247)

16 NOVEMBER: The Calders return to France by car. (CF, passport)

19–20 NOVEMBER: From Paris, the Calders take a train to Brussels. They fly to New York and return to Roxbury. (CF, passport)

DECEMBER: *A Bestiary* (A10016), edited by Richard Wilbur, with illustrations by Calder, is published by Pantheon Books. (CF, project file)

1956 6 FEBRUARY–10 MARCH: Perls Galleries, New York, exhibits *Calder*. This is Calder's first show with his new dealers, Klaus and Dolly Perls. (CF, exhibition file)

18 FEBRUARY: The Calders arrive in France. (CF, passport)

1 MARCH: The Calders drive to Italy, entering via Ponte S. Luigi. (CF, passport)

11–12 MAY: The Calders leave Paris, arriving in New York. (CF, passport)

MAY: Calder completes his fountain commission, *Water Ballet* (A00174), for the General Motors Technical Center, Warren, Michigan. There is a dedication on 15 May. (CF, Saarinen to Calder, 27 April; CF, John Dinkeloo to Calder, 17 May)

8 SEPTEMBER: The Calders arrive in Paris en route to Saché. (CF, passport)

4 OCTOBER: The Calders' grandson, Shawn, is born in Tours, France, to Sandra and Jean Davidson.

13–14 NOVEMBER: The Calders fly from Paris to New York. (CF, passport)

1957 (N.D.): Hans Richter brings together Jean Arp, Paul Bowles, Alexander Calder, Jean Cocteau, Marcel Duchamp, Jose Lluis Sert, and Yves Tanguy in a film entitled *8x8*.

18 FEBRUARY–16 MARCH: Frank Perls Gallery, Beverly Hills, holds an exhibition of Calder's work. (CF, exhibition file)

15 MARCH: The Committee of Art Advisors at UNESCO approves Calder's maquette for a standing mobile. Titled *La Spirale* (A09643), the mobile top is made by Calder at Segré's Iron Works in Connecticut and the stabile bottom is made with the collaboration of Jean Prouvé in France. (CF, Evans to Calder, 15 March)

9 APRIL: At Waterbury Ironworks in Connecticut, Calder finishes the mobile commissioned by the Port Authority of New York. He titles it *.125* (A00332), the gauge of the aluminum elements. The mobile is placed in a storeroom near the International Arrivals Building of Idlewild Airport (now John F. Kennedy International Airport), where the mobile is to be installed upon completion of the terminal. (CF, project file)

12 JUNE: The Calders and their daughter Mary arrive in Paris. (CF, passport)

25–30 JULY: The family arrives in Spain for a visit with Peter Bellew (writer) and his wife Ellen. They also visit Artigas (ceramicist) in Gallifa (Barcelona) before returning to France. (CF, passport)

27 JULY–4 NOVEMBER: Uffici Palazzo dell'Arte al Parco, Milan, exhibits the 11th *Triennale di Milano*. Calder makes the stabile *Funghi Neri* (A00601), enlarged from a maquette of circa 1942, for the exhibition. (CF, exhibition file and project file)

22 AUGUST: The Calders and daughter Mary leave Paris for London. (CF, passport)

2 SEPTEMBER: The Calders and Mary leave London and arrive in New York. (CF, passport)

17 SEPTEMBER: While visiting Ritou Nitzschke and André Bac in La Roche Jaune, Brittany, the Calders buy an old customs house, Le Palud, located at the mouth of the Tréguier River. A few times a year, at high tide, the house site becomes an island. (Calder 1966, 252–53)

1958 JANUARY: Calder completes the motorized, monumental sculpture *Whirling Ear* (A07496), a commission made for the pool in front of the United States Pavilion at the Brussels World's Fair. The sculpture was made by Calder at Gowans-Knight, in Watertown, Connecticut. (CF, project file; Calder 1966, 258, 260)

10 FEBRUARY–8 MARCH: Perls Galleries, New York, exhibits *Calder, Recent Works*. (CF, exhibition file)

SPRING: Calder builds a second studio in Roxbury. (Lipman, *Calder's Universe*, 335)

5–29 JUNE: *The Glory Folk*, a ballet choreographed by John Butler with sets by Calder,

is performed during the Festival of Two Worlds, Spoleto, Italy. Calder flies to Spoleto to oversee the construction of his sets. (CF, project file)

11 JUNE: The Calders arrive in Paris. (CF, passport)

22–23 AUGUST: Calder installs *La Spirale* (A09643), a monumental standing mobile, at UNESCO in Paris and attends the dedication ceremony on the following day. (Calder 1966, 258–59)

17 SEPTEMBER: The Calders arrive in New York. (CF, passport)

20 SEPTEMBER: Calder and Louisa see *.125* (A00332) installed in the International Arrivals Terminal of John F. Kennedy Airport for the first time.

5 DECEMBER 1958–8 FEBRUARY 1959: Carnegie Institute, Pittsburgh, presents *The 1958 Pittsburgh Bicentennial International Exhibition of Contemporary Painting and Sculpture*. Calder wins first prize in the sculpture category for *Pittsburgh* (A02233), a monumental mobile, which is purchased and installed at the Greater Pittsburgh Airport. (CF, Carnegie exhibition catalogue)

1959 4 FEBRUARY: Calder goes to Paris to arrange his solo exhibition at Galerie Maeght. (FJM, Calder to Prats, 24 March)

6 MARCH–13 APRIL: Galerie Maeght, Paris, exhibits *Calder: Stabiles*. The catalogue texts are "Stabiles" by Georges Salles and "Le Luron aux protège-genoux" by Jean Davidson; illustrations by Calder.

10 MARCH: Calder leaves Paris. (FJM, Calder to Prats, 24 March)

15 MAY–22 JUNE: Stedelijk Museum, Amsterdam, exhibits *Alexander Calder, stabilen, mobilen*. The catalogue texts are "Stabiles" by Georges Salles and "Calder und die mobiles" by Willem Sandberg. The exhibition travels to Hamburg, Krefeld, Mannheim, Wuppertal, and Zurich.

2 JUNE: The Calders arrive in The Netherlands. (CF, passport)

3 JUNE: The Calders arrive in Le Bourget, France. (CF, passport)

31 AUGUST: The Calders receive a visa from the Brazilian Consulate in Paris. (CF, passport)

SEPTEMBER: The Calders depart Paris and arrive in Rio de Janeiro, where they spend a month at the Gloria Hotel. During their stay, they visit Brazil's new capital, Brasília. (CF, passport; Calder 1966, 253)

1 OCTOBER: The Calders leave Brazil. (CF, passport)

1960 24 FEBRUARY: Calder is elected to the National Institute of Arts and Letters, New York. (New York World Telegram, 24 February, 1960. Author and title unknown)

25 FEBRUARY: The Calders return to Brazil for the Carnaval. (CF, passport)

7 MARCH: The Calders leave Brazil, returning to the United States. (CF, passport)

12 MARCH: Calder's mother, Nanette Lederer Calder, dies.

15 MARCH–9 APRIL: Perls Galleries, New York, exhibits *Alexander Calder "1960."*

25 MAY: Calder is inducted as a member of the National Institute of Arts and Letters, New York. (CF, N.I.A.L. Induction Ceremony Program)

23 JUNE: *Poètes Peintres Sculpteurs*, published by Maeght Éditeur, includes "Un Souffle Ombilical," a poem by Jean Davidson with an original lithograph by Calder.

1961 26 JANUARY: The Calders' granddaughter, Andréa, is born in Tours, France, to Sandra and Jean Davidson.

21 FEBRUARY–1 APRIL: Perls Galleries, New York, exhibits *Alexander Calder/Joan Miró*. The catalogue includes texts each artist wrote about the other.

10 MARCH: The Calders return to France. (CF, passport)

(N.D.): Carlos Vilardebo films *Le Cirque Calder*, with narration by Calder. (CF, *Le Cirque Calder*, 1961)

4 APRIL: Mary Calder and Howard Rower are married in New York. (Calder 1966, 284)

BEFORE 12 OCTOBER: On their way to Le Havre, Calder and Louisa pay a visit to painter Pierre Tal Coat in Normandy. Calder is envious of the size of his studio, and is inspired to build a much larger studio of his own. "But the size of the studio gnawed at me the moment I saw it, and I became very jealous. So, after our arrival in Roxbury, I immediately wrote Jean at the Moulin Vert, in Saché, asking to have a big studio built as soon as possible." (Calder 1966, 260)

12 OCTOBER: The Calders leave Europe via Le Havre on the ship *Liberté*. (CF, passport; AAA, Calder to Perls, 24 August)

18 OCTOBER: The Calders arrive in New York. (CF, passport)

1962 19 JANUARY: A grandson, Holton, is born in New York, to Mary and Howard Rower.

20 MARCH–21 APRIL: Perls Galleries, New York, exhibits *Alexander Calder: 1962*. (CF, exhibition file)

27 MARCH: In a letter to Giovanni Carandente, Calder agrees to a proposal to make a sculpture for the Spoleto Festival, in Italy. He decides to make "a stabile, which will stand on the ground, & arch the roadway." His work results in *Teodelapio* (A00355), a monumental stabile, which is completed in August 1962. (Carandente 1996, 18–9)

1 JUNE: Calder travels to France. (CF, passport)

(N.D.): Calder finds Etablissements Biémont, an ironworks near Saché, to fabricate his monumental works. (Calder 1966, 264)

22 JUNE: Calder flies to London. (CF, passport)

4 JULY–12 AUGUST: Tate Gallery, London, exhibits *Alexander Calder: Sculpture-Mobiles*, a retrospective. The catalogue's introduction is written by James Johnson Sweeney.

Louisa with Calder's ring, ca. 1963 / Photo: Herb Weitman

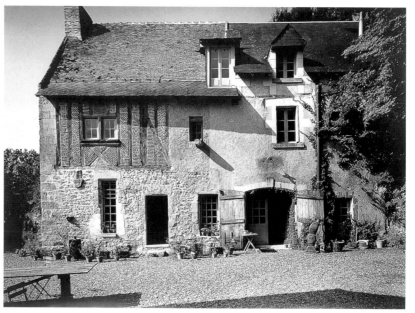

François Premier, the Calders' house in Saché, ca. 1965 / Photo: Ugo Mulas

Calder with *Le faucon* and *Les trois ailes*, Saché, 1963. Courtesy Calder Foundation

Christmas at the Calder house in Roxbury, 1964. *From left:* Howard Rower with his son, Alexander Rower; Alexander Calder; Louisa holding Holton Rower; Mary Calder Rower; Andrea Davidson; Sandra Calder Davidson, and Jean Davidson with his son Shawn / Photo: Pedro E. Guerrero

1 AUGUST: Calder flies to Rome. (CF, passport)

8 OCTOBER: Calder, along with Alfred H. Barr, Jr., receives the *Art in America* Annual Award for an Outstanding Contribution to American Art from *Art in America* magazine. (CF, *Art in America*, vol. 50, no. 4, Winter 1962, 19)

16 OCTOBER: Calder returns to New York. (CF, passport)

1963 (N.D.): Hans Richter directs and films *Alexander Calder: From the Circus to the Moon*.

MID-JANUARY: Calder leaves Roxbury and flies to France to oversee work on six large stabiles at Etablissements Biémont. (Calder 1966, 265)

15 FEBRUARY: Calder returns to the United States. (CF, passport)

13 MARCH–12 APRIL: Frank Perls Gallery, Beverly Hills, exhibits *Calder: Mobiles, Stabiles and Gouaches*. (CF, exhibition file)

19 MARCH–27 APRIL: Perls Galleries, New York, exhibits *Alexander Calder: 1963*.

2 MAY: The Calders' grandson, Alexander, is born in New York, to Mary and Howard Rower.

16 JUNE: The Calders return to France. (CF, passport)

FALL: After eighteen months, the new studio at Saché is completed. (Calder 1966, 264)

22 NOVEMBER: Galerie Maeght, Paris, exhibits *Alexander Calder: Stabiles*. Catalogue essays include "L'ombre de l'avenir" by James Jones and "Qu'est-ce qu'un Calder?" by Michel Ragon; cover and illustrations by Calder.

24 DECEMBER: La Comédie de Bourges performs *La Provocation* with sets designed by Calder, and costumes and choreography by Pierre Halet. The play opens in Bourges, and is performed the following year in Tours, 10 May, and Paris, 4 November.

1964 JANUARY: The Calders spend two weeks in Morocco; they visit Marrakech, Fès, Ouarzazate and Casablanca. (AAA, Calder to Gray, 2 February)

18 FEBRUARY: Calder and fellow artist Ben Shahn organize the *Exhibition in Tribute to Siqueiros* to call for the release of the Mexican painter, David Alfaro Siqueiros. Siqueiros had been under arrest since 1960. Siqueiros is freed June 14, 1964.

22 MAY: The Calders sail on the *France* for New York, departing from Le Havre. (CF, passport; AAA, Calder to Gray, 5 May)

27 MAY: The Calders arrive in New York and return to Roxbury. (CF, passport)

13 OCTOBER–14 NOVEMBER: Perls Galleries, New York, exhibits *Calder: Circus, Ink Drawings 1931–1932*. (CF, exhibition file)

6 NOVEMBER 1964–31 JANUARY 1965: Solomon R. Guggenheim Museum, New York, exhibits *Alexander Calder: A Retrospective Exhibition*. Thomas M. Messer curates the exhibition. The exhibition travels to Saint Louis, Toronto, Milwaukee, and Des Moines.

24 NOVEMBER–13 DECEMBER: The Museum of Fine Arts, Houston, exhibits *Alexander Calder: Circus Drawings, Wire Sculpture and Toys*. James Johnson Sweeney curates this exhibition.

1965 JANUARY: Before leaving for France, Calder meets with I.M. Pei to discuss a large stabile for the Massachusetts Institute of Technology. (Calder 1966, 273)

5–11 JANUARY: The Calders sail on the *France*, arriving at Le Havre. (Calder 1966, 270; CF, passport)

19 MAY: The American Academy of Arts and Letters, New York, formally inducts Calder as a member.

8 JULY–15 OCTOBER: Musée National d'Art Moderne, Paris, exhibits *Calder*, a retrospective. The catalogue's preface is written by Jean Cassou.

23 JULY: Calder arrives in Brussels. (CF, passport)

27 JULY: Calder departs from Belgium. (CF, passport)

(N.D.): Calder designs sets for *Eppur Si Muove*, a ballet choreographed by Joseph Lazzini and performed at the Marseilles Opera.

15 OCTOBER: The Calders return from Europe, arriving in New York. (CF, passport)

15 NOVEMBER: Calder dedicates *Le Guichet* (A00365), 1963, a monumental stabile installed in Lincoln Center Plaza, New York.

27 NOVEMBER: Calder, a member of Artists for SANE (Committee for a Sane Nuclear Policy), participates in a march in Washington, D.C., to protest against the Vietnam War. (Lipman, *Calder's Universe*, 337)

1966 (N.D.): Carlos Vilardebo films *Mobiles*, narrated by Calder and produced by Pathé Cinema, Paris.

2 JANUARY: On behalf of SANE, the Calders take out a full-page ad in the *New York Times*: "A New Year, New World. Hope for: An end to hypocrisy, self-righteousness, self interest, expediency, distortion and fear, wherever they exist. With great respect for those who rightly question brutality, and speak out strongly for a more civilized world. Our only hope is in thoughtful Men—Reason is not treason." (*New York Times*, 2 January)

10 JANUARY: The Calders set sail on the United States and return to Saché. (CF, passport; Calder 1966, 276)

FEBRUARY: In a hopeful gesture, Calder donates *Object in Five Planes*, a monumental stabile, to the United States Mission at the United Nations, New York, and dubs it *Peace* (A07499). The dedication ceremony takes place in May, when Calder returns from Europe. (*New York Times*, 8 February; CF, project file)

12 FEBRUARY–12 MARCH: Perls Galleries, New York, exhibits works by Calder. (CF, exhibition file)

18 FEBRUARY: Galerie Maeght, Paris, exhibits *Calder: Gouaches et Totems*. The catalogue includes "Oiseleur du fer," a poem by Jacques Prévert; "Alexander Calder" by Meyer Schapiro;

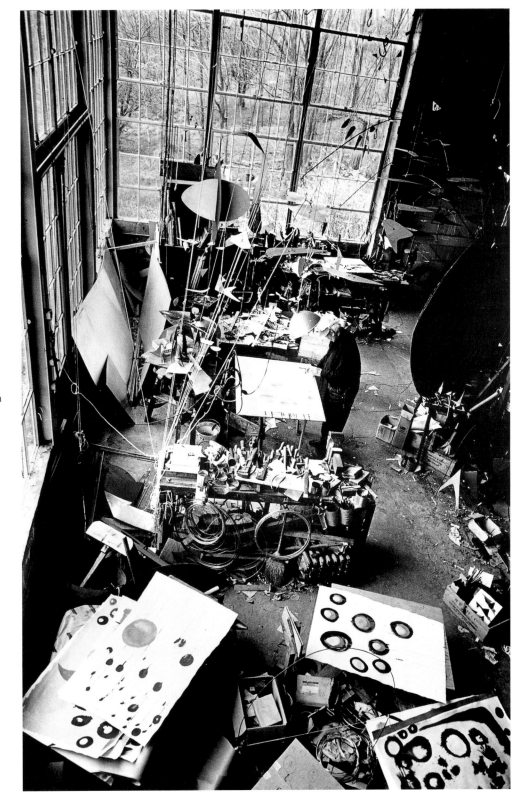

Calder in his Roxbury studio, 1963 / Photo: Inge Morath

"Les Gouaches de Calder" by Nicholas Guppy; and "De l'Art Students League aux Totems" excerpted from Calder's autobiography. Cover and illustrations are by Calder.

7 MARCH: The Calders return to New York. (CF, passport)

16 MARCH: The Calders return to France. (CF, passport)

(N.D.): Calder: An *Autobiography with Pictures* is published by Pantheon Books. Calder had been dictating the text to his son-in-law Jean Davidson over the past year and a half. (Calder 1966, 5)

5 MAY: The Calders return to the United States. (CF, passport)

7 MAY: Calder attends the dedication of the monumental stabile *La Grande Voile* (A00359) in McDermott Court at the Massachusetts Institute of Technology.

16 JUNE: Calder is awarded an honorary Doctor of Arts degree from Harvard University. (CF, diploma)

22 JUNE: The Calders return to France. (CF, passport)

10 OCTOBER: The Calders return to the United States. (CF, passport)

15 NOVEMBER–17 DECEMBER: Perls Galleries, New York, exhibits *Calder: Jewelry*. (CF, exhibition file)

19 NOVEMBER: The Calders return to France. (CF, passport)

26–27 DECEMBER: Calder and Louisa fly from Paris to Monaco to see his monumental standing mobile *Monaco* (A13286), which has recently been installed. They attend the dedication the following morning with Princess Grace and Prince Ranier, returning to Paris that afternoon. (CF, Calder to Ben/Shahn, 9 January 1967)

1967 (N.D): Diego Masson commissions Earle Brown to compose a piece of music for four percussionists. The two men collaborate with Calder. They conceive a mobile that functions both as a "conductor," determining the sequence and speed of the music, and as one of the instruments whereupon the elements are struck or "played." Calder creates monumental standing the mobile *Chef d'orchestre*, and Earle Brown composes the score *Calder Piece*. It is performed by Diego Masson and the Percussion Quartet of Paris at the Théâtre de l'Atelier. After the premiere, Calder remarks "I thought you were going to hit it harder." (CF, Susan Sollins-Brown to Alexander S. C. Rower, 23 November 1993)

(N.D.): Calder makes a gift of the large standing mobile *Frisco* (A11125), to the Museo de la Habana, Cuba. The Cuban Government issues a postage stamp of it.

1 FEBRUARY–5 APRIL: Museum of Modern Art, New York exhibits *Calder: 19 Gifts from the Artist*. (CF, exhibition file)

MARCH–APRIL: Mathias Goeritz, an architect, writes to Calder in Saché, inviting him to create a stabile for the 1968 Olympic Games in Mexico; Calder agrees. (CF, Calder to Goeritz, 29 April)

14 MARCH: The Calders return to the United States. (CF, passport)

12 APRIL: The Calders return to France. (CF, passport)

MAY: Calder's monumental stabile in unpainted stainless steel (A00357), commissioned by the International Nickel Company, is presented at the 1967 exposition in Canada (Expo '67), whose theme is "Man and His World." "In the beginning I called it *Three Discs*, but when I got over to Canada, they wanted to call it *Man*." (Arnason and Mulas 1971, 205; CF, project file)

24 MAY: Calder travels to Berlin. (CF, passport)

FALL: The Calders travel to Italy. At the suggestion of Giovanni Carandente, Calder is commissioned by Massimo Bogianckino, artistic director of the Teatro dell'Opera, Rome, to develop a work for the stage. Calder begins *Work in Progress* in December 1967. (CF, project file)

OCTOBER: New York City holds an outdoor group exhibition, *Sculpture in Environment*. Given the choice of any site in the city, Calder places two stabiles, *Little Fountain* (A10715) and *Triangle with Ears* (A02056), in Harlem. (*New York Times*, 2 September)

8 NOVEMBER: Calder sends final instructions from Saché for *El Sol Rojo* (A10649), the stabile he created for the Olympic Games. (CF, Calder to Goeritz, 8 November)

14 NOVEMBER–23 DECEMBER: Perls Galleries, New York, exhibits *Calder: Early Work—Rediscovered*.

14 DECEMBER: The Calders return to the United States. (CF, passport)

31 DECEMBER: After spending Christmas in the United States, the Calders arrive in Mexico City, where Calder oversees work on the intermediate maquette for *El Sol Rojo* (A07373). (CF, Calder to Goeritz, 8 November)

1968 11 JANUARY: Calder and Louisa journey to the Yucatán.

1–23 FEBRUARY: The Calders stop off in New York for a few weeks before returning to France. (CF, passport)

11 MARCH: Calder's *Work in Progress* is performed by the Teatro dell'Opera, Rome. (CF, project file)

21 JULY: To celebrate Calder's seventieth birthday, Klaus Perls gives an intimate party at the Fondation Maeght in Saint-Paul-de-Vence. Miró attends. (*New York Times*, 28 July)

10 OCTOBER–NOVEMBER: Galerie Maeght, Paris, exhibits *Flèches*. The catalogue text includes "Un géant enfant" by Giovanni Carandente and "Note sur les flèches" by Jacques Dupin; cover and illustrations by Calder.

12 OCTOBER: The Calders return to the United States. (CF, passport)

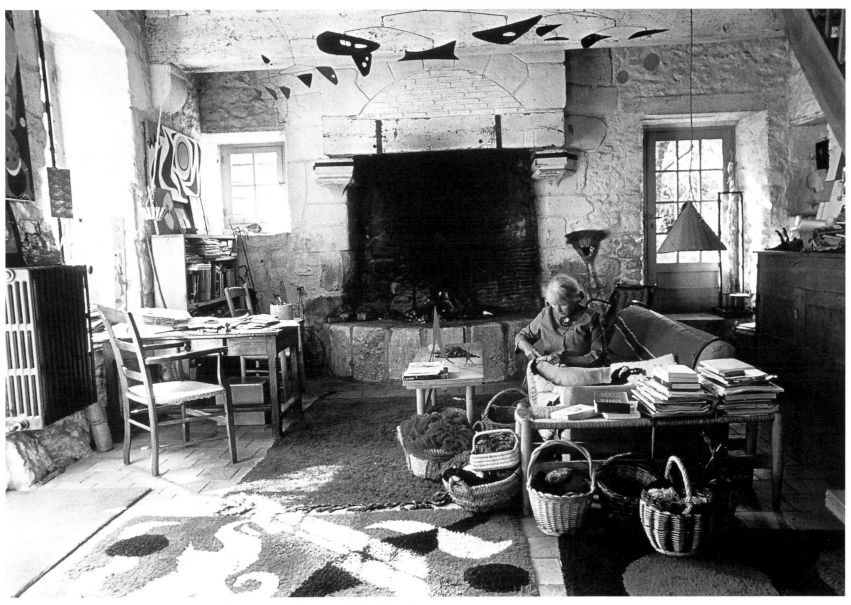

Louisa Calder hooking rugs designed by Calder, ca. 1965. Courtesy Calder Foundation

15 OCTOBER–9 NOVEMBER: Perls Galleries, New York, exhibits *Calder / Space: Drawings 1930–1932; Gouaches 1967–1968.*

11 DECEMBER: The Calders return to Mexico City, where they view *El Sol Rojo* (A10649) in place at Aztec Stadium. (CF, Calder to Goeritz, 2 December)

22 DECEMBER: The Calders return to France. (CF, passport)

1969 (N.D.): Calder builds a new house, Le Carroi, adjacent to the hilltop studio in Saché. (Lipman 1976, 338)

(N.D.): Calder designs sets and costumes for *Métaboles*, choreographed by Joseph Lazzini, scored by Henri Dutilleux, and produced by Théâtre Français de la Danse. (CF, project file)

2 APRIL–31 MAY: Fondation Maeght, Saint-Paul-de-Vence, exhibits *Calder.* Calder installs *Morning Cobweb* (A01006), a monumental, walk-through stabile, as the entrance to the exhibition.

21 MAY: The Calders return to the United States. (CF, passport)

3 JUNE: Calder attends the dedication ceremony for his commissioned monumental stabile *Gwenfritz* (A01867), which is installed outside the Museum of History and Technology, Smithsonian Institution, Washington, D.C. (CF, project file)

7 JUNE: Stevens Institute of Technology awards Calder the degree of Doctor of Engineering, Honoris Causa, on the fiftieth anniversary of his graduation.

14 JUNE: Calder attends the dedication ceremony for *La grande vitesse* (A00367), a monumental stabile commissioned by the city of Grand Rapids, Michigan, in August 1967. This is the first sculpture to be funded by the public art program of the National Endowment for the Arts (NEA). (CF, project file)

7 OCTOBER–8 NOVEMBER: Perls Galleries, New York, exhibits *Alexander Calder: Bronze Sculptures of 1944.*

1970 (N.D.): The Calders move into the new house at Saché. (Lipman 1976, 338)

(N.D.): In France, Calder makes *The Stevens Mobile* (A05361) to commemorate Stevens Institute of Technology's one hundredth anniversary. (CF, project file)

12 JANUARY: The Calders return to the United States. (CF, passport)

APRIL: Calder is commissioned by Klaus Perls, Robert Graham, and Morton Rosenfeld to design a sidewalk strip on Madison Avenue between Seventy-eighth and Seventy-ninth Streets. (CF, project file)

18 SEPTEMBER: Calder's black-and-white sidewalk (A00173) is installed.

15 OCTOBER: The Calders return to the United States. (CF, passport)

20 OCTOBER–28 NOVEMBER: Perls Galleries, New York, exhibits *Alexander Calder: Recent Gouaches-Early Mobiles.*

1971 (N.D.): Calder designs sets and costumes for the ballet *Amériques*, choreographed by Norbert Schmuki, scored by Edgard Varèse, and performed by the Ballet-Théâtre Contemporain in Amiens, France.

12 FEBRUARY: Galerie Maeght, Paris, exhibits *Calder: Stabiles, Animobiles.* The catalogue text includes "Calder la liberté" by Carlos Franqui; cover and illustrations by Calder.

26 MAY: Calder is awarded the Gold Medal for Sculpture by the American Academy of Arts and Letters and the National Institute of Arts and Letters. Calder's work is shown in the Academy's group exhibition, 27 May–2 June.

30 SEPTEMBER: The Calders return to the United States. (CF, passport)

5 OCTOBER–6 NOVEMBER: Perls Galleries, New York, exhibits *Calder: Animobiles—Recent Gouaches.* Catalogue text is written by Klaus Perls. (Perls 1971)

1972 31 MAY: The Calders sponsor an ad in the *New York Times* calling for Richard Nixon's impeachment: "Upon the Impeachment of Richard Nixon, 'for high crimes and misdemeanors,' the Constitution of the United States, provides that he, among others 'shall be removed from office . . . for conviction of, treason, bribery, or other high crimes and misdemeanors.'" (*New York Times*, 31 May)

10 OCTOBER–11 NOVEMBER: Perls Galleries, New York, exhibits *Alexander Calder: Oil Paintings.*

1973 (N.D.): Calder gives the *Mercury Fountain* (A00176) to the Fundació Joan Miró, Barcelona. The museum was designed by Josep Lluis Sert, who had also designed the original site of the fountain, the Spanish Pavilion at the 1937 Paris World's Fair. The fountain is installed in June 1975.

(N.D.): Calder donates a lithograph, *Balloons* (A01544) to the Nicaragua Earthquake Relief, organized to aid the victims of the earthquake in Managua. (CF, project file)

24 JANUARY–24 FEBRUARY: Galerie Maeght, Paris, exhibits *Calder: Recent Mobiles.* The catalogue text includes "Retour au mobile" by Maurice Besset and "Calder ou le poids de l'air" by André Balthazar; cover and illustrations by Calder.

24 MAY–JULY: Galerie Maeght, Zurich, exhibits *Alexander Calder: Retrospektive.* The catalogue's introduction is written by C. Giedion-Welcker.

4 JUNE: Calder is commissioned by the Board of Trustees of the National Gallery of Art to make a monumental sculpture for its new building.

3 OCTOBER–3 NOVEMBER: Perls Galleries, New York, exhibits *Calder at 75—Works in Progress.* (CF, exhibition file)

10 OCTOBER: Calder attends the dedication ceremony for the monumental stabile *Stegosaurus* (A00356), held at Burr Memorial Mall, University

of Hartford. He receives an honorary Doctorate of Fine Arts from the university.

30 OCTOBER–2 NOVEMBER: Calder's commission from Braniff International Airlines, the DC-8 jet *Flying Colors* (A00178), makes its inaugural flight from Dallas, with stops in Los Angeles, Washington, D.C., Miami, and Latin America. (Lipman, 1976, 339)

1974 (N.D.): The film *Gouaches de Calder*, directed by Carlos Vilardebo, is released.

FEBRUARY: Calder is awarded the Commandeur de la Légion d'Honneur of France; the presentation is made by Michel Debré, the former French premier. (CF, awards file)

24 JUNE: Calder is named Citoyen d'Honneur de la Commune by the Mayor of Saché. (CF, awards file)

JULY: The large standing mobile *Saché* (A00308), which Calder donated, is installed in the main square of the town of Saché. (Lipman 1976, 339)

15 OCTOBER–16 NOVEMBER: Perls Galleries, New York, exhibits *Alexander Calder: Crags and Critters of 1974*.

25 OCTOBER: The festival Alexander Calder Day in Chicago includes a circus parade with the Schlitz "forty-horse hitch" and the dedications of the motorized *Universe* (A00282), at the Sears Tower, and the monumental stabile *Flamingo*, at the Federal Center Plaza. *Flamingo* (A07498) is the first work of art commissioned by the General Services Administration (GSA) under the new federal program wherein .5 percent of the budget for new construction goes toward commissioning art. (CF, exhibition file)

18 DECEMBER: Calder receives the Grand Prix National des Arts et des Lettres from the French Minister of Culture. (CF, awards file)

1975 (N.D.): Calder is awarded the United Nations Peace Medal, and Louisa Calder receives the Woman of

the Year Award from the World Federation of the United Nations Associations. (CF, awards file)

22 JANUARY–23 FEBRUARY: Galerie Maeght, Paris, exhibits *Calder: Crags and Critters*. The catalogue text includes the essay "Un tournant chez Calder" by Mario Pedrosa; cover and illustrations by Calder. The exhibition travels to Zurich.

11–18 APRIL: The Calders visit Israel to discuss a monumental sculpture project with the Mayor of Jerusalem, Teddy Kollek. (*New York Times*, 12 May)

10 MAY–13 JULY: Haus der Kunst, Munich, exhibits *Calder*, a retrospective. Catalogue includes the essay, "Entstehung des Mobile" by Maurice Besset.

15 MAY: The Calders, Marcel Breuer, and others who worked on the UNESCO building in Paris protest UNESCO's expulsion of Israel in a *New York Times* ad: "We artists who are citizens of the world urge the General Conference to reverse itself and end all sanctions against Israel, and let the building we created be saved as a vision of hope, not as a symbol of tragedy." (*New York Times*, 15 May)

29 MAY–1 JUNE: *Flying Colors* (A00178; see 1973 on p. 214) is exhibited at the Thirty-First Paris Air Show; on 31 May, the plane is flown over France with the Calders and their guests aboard. Calder hand paints the plane's engine covers. (Lipman 1976, 340)

SEPTEMBER–OCTOBER: Galerie Maeght, Zurich, exhibits *Calder: Crags and Critters*.

14 OCTOBER–15 NOVEMBER: Perls Galleries, New York, exhibits *Alexander Calder: Recent Mobiles and Circus Gouaches*.

17 NOVEMBER: Commissioned again by Braniff Airlines, Calder designs *Flying Colors of the United States* (A00177) for the flagship of the airline's United States fleet. The plane is dedicated by Betty Ford at Dulles International Airport, Washington, D.C. Calder flies back to Kennedy Airport, New York, where he is presented with

the Bicentennial Medal of New York City. (Slavin, "Calder's 727 '*Flying Colors*,'" *Preview*, 25 November 1975, 8)

1976 18 JUNE: Calder and Louisa attend the opening of Fundació Joan Miró, Barcelona. (FJM)

1–10 OCTOBER: The Greater Philadelphia Cultural Alliance organizes the Alexander Calder Festival. The event includes the dedication of *White Cascade* (A01931) on 7 October at the Federal Reserve Bank, and the premiere of *Under the Sun*, a dance tribute to Calder performed by the Pennsylvania Ballet. During the week-long celebration, Calder receives an honorary degree from the University of Pennsylvania.

12 OCTOBER–13 NOVEMBER: Perls Galleries, New York, exhibits *Alexander Calder: Works on Paper 1925–1976*. (Perls exhibition catalogue)

14 OCTOBER 1976–6 FEBRUARY 1977: The Whitney Museum of American Art, New York, with Jean Lipman as curator, exhibits *Calder's Universe*, a major retrospective. The exhibition travels to fifteen cities throughout the United States and Japan.

20 OCTOBER: Calder is honored at a dinner at the Whitney Museum of American Art. Attending are sixty guests, including Georgia O'Keeffe, Arthur Miller, Louise Nevelson, Marcel Breuer, John Cage, Merce Cunningham, Virgil Thomson, Robert Penn Warren, and Philip Johnson. (*New York Times*, 21 October)

BEFORE NOVEMBER: President Gerald Ford offers the Medal of Freedom to Calder. Calder replies: "I was pleased to receive your invitation last week, but felt I could not accept in a case where my acceptance would imply my accord with the harsh treatment meted out to conscientious objectors and deserters. As from the start I was against the war and now am working with 'Amnesty' I didn't feel I could come to Washington. When there will be more justice for these men I will feel differingly

[*sic*]." Ford posthumously awards Calder the Medal of Freedom. Louisa Calder declines to attend the ceremony: "freedom should lead to amnesty after all these years and it doesn't seem as though it were going to happen. Freedom means freedom for all." (CF, Calder to Gerald Ford, ca. 20 October; telegram, Louisa Calder to Gerald Ford, 4 January 1977)

10 NOVEMBER: Calder returns with Louisa to New York from Washington, D.C., where he has finalized the details for *Mountains and Clouds* (A10923), a monumental stabile and mobile for the Hart Senate Building, Washington, D.C.

11 NOVEMBER: Calder dies in New York City at the home of his daughter Mary.

1 DECEMBER 1976–8 JANUARY 1977: Galerie Maeght, Paris, exhibits *Calder: Mobiles and Stabiles*. The catalogue text includes the essay "L'art et la comédie" by Jean Frémon, and "Forme Humaine" by Jean Davidson; cover and illustrations by Calder.

6 DECEMBER: A memorial service is held by the Whitney Museum of American Art. Officiating is director Tom Armstrong, with remarks by James Johnson Sweeney, Saul Steinberg, Robert Osborn (cartoonist), and Arthur Miller, and with a solo violin performance by Alexander Schneider.

1977

10–11 NOVEMBER: "A National Tribute to Alexander Calder" celebrates the artist with a program that includes a production of *Socrate* (A00146) by Erik Satie with mobile sets recreated from Calder's designs, and *Four Saints in Three Acts* by Gertrude Stein and music by Virgil Thomson; performed by Joel Thome and the Orchestra of Our Time, at the Beacon Theater, New York.

15 NOVEMBER–30 DECEMBER: In New York, the American Academy and Institute of Arts and Letters holds the "Alexander Calder Memorial."

"Beware of the dog!" sign at the house in
Saché / Photo: Ugo Mulas

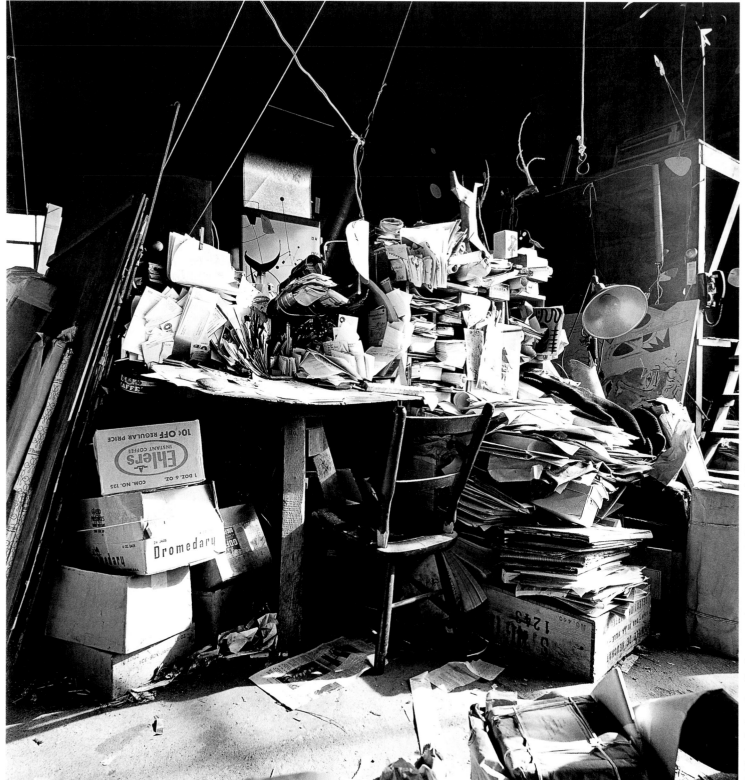

Calder's desk in his Roxbury studio, ca. 1964 / Photo: Herb Weitman

BIBLIOGRAPHY
Alexander S. C. Rower

Unpublished sources

AAA: Archives of American Art. Smithsonian Institution. Washington, D.C. Alexander Calder Papers. In 1963 Calder donated letters, photographs, press clippings, exhibition announcements, and two recorded interviews to the AAA. Most valuable is Calder's scrapbook, a large album of clippings and memorabilia that he kept from 1927 to 1932.

CF: Calder Foundation, New York. The CF's archive consists of more than 120,000 documents (including correspondence and unpublished manuscripts), 26,000 photographs, and thousands of press clippings, articles, books, and films. In addition, the CF's catalogue raisonné project maintains a database on more than 20,000 works of art by Calder (with photographs, physical data, provenance, and publication and exhibition history for each piece).

MNAM: Musée National d'Art Moderne, Centre Georges Pompidou, Paris. Alexander Calder files. MNAM's Calder archive includes newspaper and magazine clippings, exhibition catalogues, letters, invitations, and photographs.

MoMA: Museum of Modern Art, New York. Alexander Calder files. The Calder material is in two departments: the material in the Museum Library includes exhibition catalogues as well as a scrapbook of Calder catalogues, exhibition brochures, invitations, announcements, and clippings (accessible in microfiche form); the material in the Museum Archives includes the Curt Valentin Gallery papers, museum exhibition documents, publicity scrapbooks, event photographs, and exhibition guest books.

WMAA: Whitney Museum of American Art, New York. Artists File, Alexander Calder. The file is in two sections: miscellaneous correspondence, clippings, exhibition announcements and catalogues, press releases, photographs; and documentation of Calder's work in the museum collection, including questionnaires he completed.

Statements & Interviews

Ramond, Edouard. "Sandy Calder ou le fil de fer devient statue." *Paris Montparnasse*, no. 5 (15 June 1929). pp. 34–40.

"Pourquoi j'habite Paris . . ." *Nord-Sud* (March 1931).

Calder, Alexander. "Comment réaliser l'art?" *Abstraction-Création, Art Non Figuratif*, no. 1 (1932). p. 6.

Calder, Alexander. "Mobiles." In *The Painter's Object*, edited by Myfanwy Evans, pp. 62–67. London: Gerold Howe, 1937.

Calder, Alexander. "Mercury Fountain." *Technology Review* 40, no. 5 (March 1938), p. 202.

Calder, Alexander. "Mercury Fountain." *Stevens Indicator* 55, no. 3 (May 1938), pp. 2–3, 7.

Calder, Alexander. "A Water Ballet." *Theatre Arts Monthly* 23, no. 8 (August 1939), pp. 578–79. Includes graphic diagram by Calder of his "choreography" for a water ballet.

Calder, Alexander. "How Can Art Be Realized?" In *Art of This Century . . . 1910 to 1942*, edited by Peggy Guggenheim, pp. 96–97. New York: Art of this Century, [1942].

"Living Art." Radio interview with exhibition prize-winners Alexander Calder, Philip Evergood and José de Creeft at the Metropolitan Museum of Art, *Artists for Victory*, aired by WABC Radio on 8 December 1942.

Calder, Alexander. "The Ides of Art: 14 Sculptors Write." *The Tiger's Eye* 1, no. 4 (15 June 1948), p. 74.

Soby, James Thrall. *Calder, Matisse, Matta, Miró: Mural Scrolls*. New York: Katzenbach and Warren, 1949. A small silk-screened reproduction of Calder's mural entitled *A Piece of My Workshop '48* is located on p. 8. Statement is an untitled paragraph on p. 5.

Calder, Alexander. "What Abstract Art Means to Me." *Museum of Modern Art Bulletin* 18, no. 3 (Spring 1951), pp. 8–9.

Grafly, Dorothy. "Alexander Calder: Creator of Moving Forms in Space." *American Artist* 15, no. 8 (October 1951), pp. 36–39, 69–70.

Calder, Alexander. "Alexander Calder." In *Témoignages pour l'art abstrait* 1952, edited by Julien Alvard and Roger Van Gindertael, pp. 43–49. Paris: Editions Art d'Aujourd'hui, 1952. Introduction by Léon Degand with photographs by Serge Vandercam.

Calder, Alexander. "Voici une petite histoire de mon cirque." In *Permanence du Cirque*. Paris: Revue Neuf, 1952, pp. 37–42. An exhibition at the Galerie la Hune

(18 November–December 1952) coincided with the publication of this book.

Rodman, Selden, editor. *Conversations with Artists.* New York: Devin-Adair Co., 1957, pp. 136–42. Paperbound edition with introduction by Alexander Eliot. New York: Capricorn Books, 1961.

"Je suis un bricoleur." *Arts, Lettres, Spectacles,* no. 687 (9–16 September 1958).

Staempfli, George W. "Interview with Alexander Calder." *Quadrum (Brussels),* no. 6 (1959), pp. 9–11. Extract published in *Les Arts plastiques au nouveau siège de l'Unesco,* 1959.

Taillandier, Yvon. "Calder: Personne ne pense à moi quand on a un cheval à faire." *XXe siècle,* no. 2 (15 March 1959).

Kuh, Katherine. *The Artist's Voice: Talks with Seventeen Artists.* New York and Evanston, Ill.: Harper & Row, 1962, pp. 38–51.

Osborn, Robert. "Calder's International Monuments." *Art in America* 57, no. 2 (March-April 1969), pp. 32–49. Cover by Calder.

Osborn, Robert. "A Conversation with Alexander Calder." *Art in America* 57 (July–August 1969), p. 31.

Bruzeau, Maurice. "Alexander Calder, a Blacksmith in the Town." *Revue Française des Télécommunications,* December 1973, pp. 47–51.

Solo Exhibition Catalogues

Galerie Billiet-Pierre Vorms, Paris. *Sculptures bois et fil de fer de Alexander Calder.* 25 January–7 February 1929. 4 pp. Text by Jules Pascin.

Galerie Neumann-Nierendorf, Berlin. *Alexander Calder: Skulpturen aus Holz und aus Draht.* 1–15 April 1929. 4 pp.

Fifty-Sixth Street Galleries, New York. *Alexander Calder: Paintings, Wood Sculpures, Toys, Wire Sculptures, Jewelry, Textiles.* 2–14 December 1929. 7 pp. Text by Murdock Pemberton (excerpt from *New Yorker* 23 February 1929).

Galerie Percier, Paris. *Alexander Calder: Volumes – Vecteurs – Densités / Dessins-Portraits.* 27 April–9 May 1931. 12 pp. Preface by Fernand Léger.

Pierre Matisse Gallery, New York. *Mobiles by Alexander Calder.* 6–28 April 1934. 2 pp. Text by James Johnson Sweeney.

George Walter Vincent Smith Gallery, Springfield, Massachussetts. *Calder Mobiles.* 8–27 November 1938. 4 pp. Foreword by James Johnson Sweeney.

Pierre Matisse Gallery, New York. *Calder Mobiles — Stabiles.* 9–27 May 1939. 4 pp. Catalogue includes drawings by Calder of works exhibited.

Pierre Matisse Gallery, New York. *Alexander Calder: Recent Works.* 27 May–14 June 1941. 4 pp. Catalogue includes drawings by Calder of works exhibited.

Addison Gallery of American Art, Andover, Massachusetts. *17 Mobiles by Alexander Calder.* 28 May–6 July 1943. 6 pp. Brief text includes statement by Alexander Calder, p. 6.

Museum of Modern Art, New York. *Alexander Calder.* 29 September–28 November 1943 (extended to 16 January 1944). 64 pp. Text by James Johnson Sweeney. Revised, enlarged, and issued as a monograph in 1951.

Buchholz Gallery / Curt Valentin, New York. *Recent Work by Alexander Calder.* 28 November–23 December 1944. 8 pp.

Buchholz Gallery / Curt Valentin, New York. *Alexander Calder.* 13 November–1 December 1945. 8 pp.

Galerie Louis Carré, Paris. *Alexander Calder: Mobiles, Stabiles, Constellations.* 25 October–16 November 1946. 44 pp. Texts by Jean-Paul Sartre and James Johnson Sweeney (excerpt from MoMA 1943).

Mattatuck Historical Society, Waterbury, Connecticut. *Alexander Calder.* 10–28 March 1947.

Buchholz Gallery / Curt Valentin, New York. *Alexander Calder.* 9–27 December 1947. 8 pp. Text by Jean-Paul Sartre (reprint from Carré 1946).

Museu de Arte Moderna do Rio de Janeiro, Ministerio da Educaçao e Saude. *Alexander Calder.* September 1948. 18 pp. Texts by Jean-Paul Sartre (reprint from Carré 1946), James Johnson Sweeney (excerpt from MoMA 1943), Henrique E. Mindlin, André Breton, and Nancy Cunard.

Buchholz Gallery / Curt Valentin, New York. *Calder.* 30 November–17 December 1949. 13 pp. Text by André Masson. Sketches of mobiles by Calder.

Galerie Maeght, Paris. *Calder: Mobiles and Stabiles.* 30 June–27 July 1950. *Derrière le Miroir,* no. 31 (July 1950).

8 pp., unbound. Contains two original color lithographs printed at Editions Pierre à Feu, Maeght Editeur, Paris. Texts by James Johnson Sweeney, Henri Laugier, Henri Hoppenot, and Fernand Léger. The cover design by Calder was also used as poster for the exhibition.

Stedelijk Museum, Amsterdam. *Alexander Calder.* 6 October–15 November 1950. 9 pp.

Galerie Blanche, Stockholm. *Alexander Calder: Mobiles and Stabiles.* December 1950. 8 pp. Introduction by Eric Grate.

Lefevre Gallery, London. *Mobiles and Stabiles by Alexander Calder.* January 1951. 8 pp. Foreword by James Johnson Sweeney (reprint from Maeght 1950).

Neue Galerie, Vienna. *Alexander Calder.* 10 May–15 June 1951. 15 pp. Foreword by Fernand Léger.

Curt Valentin Gallery, New York. *Alexander Calder: Gongs and Towers.* 15 January–10 February 1952. 14 pp. Texts by James Johnson Sweeney (reprint from Maeght 1950) and Fernand Léger (reprint from Maeght 1950). Drawings by Calder of objects in the exhibition.

Galerie Parnass, Wuppertal, Germany. *Calder Mobile.* 5–20 June 1952. 6 pp.

Walker Art Center, Minneapolis, Minnesota. *Alexander Calder Mobiles.* 22 March–19 April 1953.

Museu de Arte Moderna, São Paulo, Brazil. 2nd *Bienal do Museu de Arte Moderna de São Paulo.* 15 December 1953–28 February 1954. Introduction by Sergio Milliet; foreword for the United States section by René d'Harnoncourt.

Kestner Gesellschaft, Hannover, Germany. *Alexander Calder: Stabiles, Mobiles, Gouachen.* 18 March–2 May 1954. 20 pp. Texts by Alfred Hentzen and Jean-Paul Sartre (reprint from Carré 1946).

Galerie Rudolf Hoffman, Hamburg, Germany. *Calder.* 12–30 June 1954. 14 pp. Foreword by Christian-Adolf Isermeyer.

Galerie Maeght, Paris. *Aix, Saché, Roxbury: 1953–54.* 13 November–15 December 1954. *Derriére le Miroir,* nos. 69–70 (13 November 1954). 10 pp., unbound. Cover and 2 illustrations by Calder. Poem by Henri Pichette; text by Frank Elgar.

Lefevre Gallery, London. *Mobiles by Calder.* January 1955. 4 pp.

Graduate School of Design, Harvard University, Cambridge, Massachusetts. *Calder.* 25 April–25 May 1955.

Duveen-Graham, New York. *Attilio Salemme, 1911–1955.* 2–31 May 1955. 14 pp. Alexander Calder's tribute to Attilio Salemme (p. 3).

Curt Valentin Gallery, New York. *Alexander Calder.* 17 May–4 June 1955. 8 pp.

Museo de Bellas Artes, Caracas, Venezuela. *Exposición Calder.* 11–25 September 1955. 13 pp. Foreword by Alejo Carpentier; texts by Jean-Paul Sartre (reprint from Carré 1946) and Fernand Léger (reprint from Maeght 1950); and handwritten statement by Alexander Calder. Illustrations of objects are by Calder.

Institute of Contemporary Art, Boston. *Jewelry and Drawings by Alexander Calder.* 18 October–21 November 1956.

Kunsthalle Basel, Switzerland. *Alexander Calder.* 22 May–23 June 1957. 22 pp. Foreword by Arnold Rüdlinger.

Städelsches Kunstinstitut, Frankfurt, Germany. *Alexander Calder.* 17 July–25 August 1957. 3 pp. Preface by Ernst Holzinger.

Galerie Artek, Helsinki. *Alexander Calder: Exposition.* 29 January–2 June 1958. 17 pp. Statement by Calder (reprint from *Abstraction-Création, Art Non Figuratif* 1932).

Galerie Maeght, Paris. *Calder: Stabiles.* 6 March–13 April 1959. *Derrière le Miroir,* no. 113 (1959). 26 pp., unbound. Contains designs lithographed from Calder's sketches. Editions Pierre à Feu, A. Maeght, Editeur. Texts by Georges Salles and Jean Davidson.

Stedelijk Museum, Amsterdam. *Alexander Calder, Stabilen, Mobilen.* 15 May–22 June 1959. 26 pp. Text by Georges Salles; poem by Willem Sandberg.

Museu de Arte Moderna do Rio de Janeiro. *Alexander Calder: Escultura, Guache.* 23 September–25 October 1959. 11 pp. Texts by Fernand Léger (reprint from Maeght 1950) and Mario Pedrosa.

Haus der Jugend, Wuppertal-Barmen, Germany. *Alexander Calder, Stabilen, Mobilen.* 10 January–21 February 1960.

Perls Galleries, New York. *Alexander Calder "1960."* 15 March–9 April 1960. 12 pp.

Palais des Beaux-Arts, Brussels. *Alexander Calder.* 3 April–1 May 1960. 17 pp. Text by George Salles (reprint from Maeght 1959).

Kunstgewerbemuseum, Zürich. *Kinetische Kunst; Alexander Calder, Mobiles und Stabiles aus den letzten Jahren.* 21 May–26 June 1960. 63 pp. Introduction by Hans Fischili and Willi Rotzler; essay by Carola Giedion-Welcker.

Wilmington Society of Fine Arts, Delaware Art Center, Delaware. *Calder / Alexander Milne, Alexander Stirling, Alexander.* 7 January–19 February 1961. 14 pp. Foreword by Bruce St. John.

Lincoln Gallery, London. *Alexander Calder: Gouaches.* November 1961. 20 pp. Introduction by Nicholas Guppy.

Martha Van Rensselaer Art Gallery, Cornell University of New York, Ithaca, New York. *Works of Alexander Calder.* 7 May–1 June 1962. 4 pp.

Butor, Michel. *Cycle sur neuf gouaches d'Alexandre Calder.* Paris: la Hune, 1962. 15 pp. Edition of 500 copies, numbered 1 to 500, signed by the artist and the author. Served as the catalogue for the exhibition at Galerie la Hune in June 1962 (as on pp. 221–256).

Brook Street Gallery, London. *Alexander Calder: Gouaches 1948–1962.* July 1962. 8 pp.

Arts Council of Great Britain, Tate Gallery, London. *Alexander Calder: Sculpture — Mobiles.* 4 July–12 August 1962. 30 pp. Text by James Johnson Sweeney (excerpt from MoMA 1943).

Musée de Rennes, France. *Alexander Calder: Mobiles, Gouaches, Tapisseries.* 4 December 1962–20 January 1963. 30 pp. Preface by Jean Cassou.

Perls Galleries, New York. *Alexander Calder: 1963.* 19 March–27 April 1963. 8 pp.

Galerie Alex Vömel, Düsseldorf. *Gouachen von Calder.* May–June 1963. 6 pp. Introduction by Alfred Hentzen.

Galerie Maeght, Paris. *Alexander Calder: Stabiles.* 22 November 1963. *Derrière le Miroir,* no. 141 (November 1963). 32 pp., unbound. Cover and 7 color lithographs by Calder. Texts by James Jones and Michel Ragon. Also published in a deluxe slipcased edition of 150 numbered examples on Rives vellum signed by the artist, and including a separate print of one of the original lithographs.

Solomon R. Guggenheim Museum, New York. *Alexander Calder: A Retrospective Exhibition.* 6 November 1964–31 January 1965. 87 pp. Text by Thomas M. Messer.

Museum of Fine Arts, Houston. *Alexander Calder: Circus Drawings, Wire Sculptures and Toys.* 24 November–13 December 1964. 32 pp. Introduction by James Johnson Sweeney (excerpt from MoMA 1943).

The Art Gallery of Toronto. *Mobiles and Stabiles by Calder, the Man Who Made Sculpture More.* 1–30 May 1965. 16 pp. Text by David Brooke.

Musée National d'Art Moderne, Paris. *Calder.* 8 July–15 October 1965. 56 pp. Preface by Jean Cassou.

Galerie Maeght, Paris. *Calder: Gouaches et Totems.* 18 February 1966. *Derrière le Miroir,* no. 156 (February 1966). 32 pp., unbound. Cover by Calder. 5 plates lithographed from his gouaches, and photographs of Totems and gouaches. Poem by Jacques Prévert; texts by Meyer Schapiro, Nicholas Guppy (reprint from Lincoln Gallery 1961), and Alexander Calder (excerpt from Calder 1966). Also published in a deluxe slipcased edition of 150 numbered examples on Rives vellum, signed by the artist; includes a separate print of one of the original lithographs.

Richard Gray Gallery, Chicago. *Alexander Calder.* 29 April–29 May 1966. 4 pp.

Galerie Jan Krugier & Cie, Geneva. *Alexander Calder.* 9 June–30 July 1966. 28 pp. Introduction by Giovanni Carandente.

Berkshire Museum, Pittsfield, Massachusetts. *Mobiles by Alexander Calder.* 2–31 July 1966. 2 pp. Introduction by Stuart C. Henry.

Institute of Contemporary Arts, London. *Calder, the Painter.* 29 September–29 October 1966. 6 pp.

Centre Culturel Municipal de Toulouse, France. *Calder (Le Mois USA).* 26 October–28 November 1966. Text by Sam Hunter.

Galerie Françoise Mayer, Brussels. *Totems, mobiles et gouaches récentes.* 19 November–17 December 1966. 6 pp.

Openluchtmuseum voor beeldhouwkunst Middelheim, Antwerp. *Totems et Gouaches.* 10 February–5 March 1967. 4 pp.

The Phillips Collection, Washington, D.C. *Recent Stabiles by Alexander Calder.* 8 April–30 May 1967. 6 pp.

Arco d'Alibert, Studio d'Arte, Rome. *Calder*. 21 April–28 May 1967. 22 pp. Text by Giovanni Carandente (reprint from Jan Krugier 1966).

Akademie der Künste, Berlin. *Alexander Calder*. 21 May–16 July 1967. 112 pp. Preface by Hans Scharoun; poem by Willem Sandberg; texts by Dr. Herta Elisabeth Killy, Stephan Waetzoldt, and Jean-Paul Sartre (reprint from Carré 1946); and an excerpt from Calder, 1966; and reprint of two 1929 reviews.

Perls Galleries, New York. *Calder: Early Work — Rediscovered*. 14 November–23 December 1967. 12 pp. Catalogue includes a reprint of a letter by Calder.

Dayton's Gallery 12, Minneapolis, Minnesota. *Calder*. 17 April–11 May 1968. 23 pp. Exhibition in collaboration with Perls Galleries, New York.

Kiko Galleries, Houston. *Calder*. Fall 1968. 33 pp.

Galerie Maeght, Paris. *Flèches*. 10 October–November 1968. *Derrière le Miroir*, no. 173 (October 1968). 24 pp. with 8 pp. supplement, unbound. Cover by Calder, 6 plates lithographed from his gouaches and photographs of Flèches. Texts by Giovanni Carandente and Jacques Dupin. Also published in a deluxe slipcased edition of 150 numbered examples on Lana vellum signed by the artist and including a separate print of one of the original lithographs.

Perls Galleries, New York. *Calder / Space: Drawings 1930–1932; Gouaches 1967–1968*. 15 October–9 November 1968. 16 pp.

Fondation Maeght, Saint-Paul-de-Vence, France. *Calder*. 2 April–31 May 1969. 231 pp. Texts by James Johnson Sweeney, Michel Butor, Jean Davidson, Giovanni Carandente, Pol Bury, Jean-Paul Sartre (reprint from Carré 1946), Fernand Léger (reprint from Maeght 1950), Gabrielle Buffet-Picabia, and Francis Miroglio; chronology by Daniel Lelong.

Manitou Gallery, Grand Valley State College, Allendale, Michigan. *Calder*. 4 May–15 June 1969. 6 pp.

Grand Rapids Art Museum, Michigan. *Alexander Calder: Mobiles and Stabiles*. 18 May–24 August 1969. 4 pp. Statement by Calder (excerpt from Kuh 1962).

Louisiana Museum of Modern Art, Humlebæk, Denmark. *Calder*. 29 June–7 September 1969. *Louisiana Revy* 10,

no. 1 (June 1969). 39 pp. Serves as catalogue. Texts by James Johnson Sweeney, Jean Davidson, Michel Ragon, Giovanni Carandente, Gabrielle Buffet-Picabia, Michel Butor, Francis Miroglio, and Fernand Léger (all reprints from Maeght 1969); Jean-Paul Sartre (reprint from Carré 1946), Thomas Messer (excerpt from Guggenheim 1964), James Jones, and Gunnar Jespersen; chronology by Daniel Lelong (reprint from Maeght 1969). Texts in Danish.

Fundación Eugenio Mendoza, Caracas, Venezuela. *Calder en Venezuela*. 6 July–3 August 1969. 65 pp. Text by Lourdes Blanco.

Stedelijk Museum, Amsterdam. *Calder*. 4 October–16 November 1969. 44 pp. Texts by Fernand Léger (reprint from Maeght 1950), Yaacov Agam, and Jean-Paul Sartre (reprint from Carré 1946).

Perls Galleries, New York. *Alexander Calder: Bronze Sculptures of 1944*. 7 October–8 November 1969. 20 pp.

Gimpel Fils, London. *Alexander Calder: Large Standing Mobiles*. 18 February–15 March 1969. 15 pp.

Museum of Modern Art, New York. *A Salute to Alexander Calder*. 22 December, 1969–15 February 1970. 31 pp. Essay by Bernice Rose.

Galerie Blanche, Stockholm. *Alexander Calder: Mobiler, Stabile-Mobiler, Gouacher 1961–1970*. 1970. 8 pp. Introduction by Gustaf Engwall.

Long Beach Museum of Art, California. *Calder Gouaches: The Art of Alexander Calder*. 11 January–8 February 1970. 25 pp. Introduction by Wahneta T. Robinson.

Galerie Vömel, Düsseldorf. *Calder*. 1 July–31 August, 1970. 8 pp.

Galerie Gunzenhauser, Munich. *Calder*. 24 September 1970. 6 pp.

Perls Galleries, New York. *Alexander Calder: Recent Gouaches—Early Mobiles*. 20 October–28 November 1970. 24 pp.

Galerie Maeght, Paris. *Calder: Stabiles, Animobiles*. 12 February 1971. *Derrière le Miroir*, no. 190 (February 1971). 26 pp., unbound. Cover by Calder, 5 plates lithographed from his gouaches and photographs of stabiles and Animobiles by Clovis

Prevost. Text by Carlos Franqui. Also published in a deluxe slipcased edition of 150 numbered examples signed by the artist and including a separate print of one of the original lithographs.

Studio Marconi, Milan. *Calder*. April–May 1971. 23 pp. Introduction by Marco Valsecchi.

Galerie d'Art Moderne Marie-Suzanne Feigel, Basel, Switzerland. *Alexander Calder: Mobiles, Mobiles / Stabiles, Bronzes, Gouaches et Lithographies*. 3 April–5 June 1971. 7 pp.

Gimpel Fils, London. *Alexander Calder: Sculptures and Gouaches*. 15 April–15 May 1971. 6 pp.

Museo Nacional de Bellas Artes, Buenos Aires, Argentina. *Escultura, acuarelas y dibujos, grabados, libros ilustrados y joyas de la Coleccion del Museum of Modern Art de Nueva York*. 6 May–6 June 1971. 36 pp. Introduction by Bernice Rose.

John Berggruen Gallery, San Francisco. *Alexander Calder*. 13 May–14 June 1971. 6 pp.

L'Obelisco, Rome. *Calder*. June 1971. Introduction by Giovanni Carandente.

Musée Toulouse-Lautrec, Albi, France. *Calder*. 23 June–15 September 1971. 37 pp. Preface by Jean Devoisins.

Badischer Kunstverein, Karlsruhe, Germany. *Alexander Calder: Mobiles, Stabiles, Bilder, Teppiche*. 29 August–3 October 1971.

Perls Galleries, New York. *Calder: Animobiles—Recent Gouaches*. 5 October–6 November 1971. 28 pp. Text by Klaus Perls.

Whitney Museum of American Art, New York. *Alexander Calder: Tapestries*. 5 October–14 November 1971. 4 pp. Text by John I. H. Baur.

Museo Universitario de Ciencias y Arte, Mexico City. *Alexander Calder, esculturas, acuarelas, dibujos, grabados, libros ilustrados, joyería*. 28 October–28 November 1971. 32 pp. Introduction by Bernice Rose. In Spanish.

Taft Museum, Cincinnati, Ohio. *Alexander Calder: Early Works c. 1927–1944*. 12 December, 1971–31 January, 1972. 8 pp. Foreword by Katherine Hanna; introduction by Jayne Merkel.

Leonard Hutton Galleries, New York. *Calder: Aubusson Tapestries*. 14 April–31 May 1972. 16 pp.

Whitney Museum of American Art, New York. *Calder's Circus.* 20 April–11 June 1972. 4 pp. Introduction by Jean Lipman. The *Circus* exhibition coincides with the publication of Jean Lipman's *Calder's Circus.* 172 pp.

Sala Pelaires, Palma de Mallorca, Spain. *Calder.* September–October 1972. 52 pp. Poem by Joan Miró.

Perls Galleries, New York. *Alexander Calder: Oil Paintings.* 10 October–11 November 1972. 28 pp. Text by Calder (excerpt from *Calder* 1966).

Delta International Art Center, Rome. *Alexander Calder.* 27 October–22 November 1972. 16 pp. Introduction by M. Fagiolo dell'Arco.

The Arts Club of Chicago. *Aubusson Tapestries by Alexander Calder.* 15 November–30 December 1972. 9 pp. Held in cooperation with Art Vivant, New Rochelle, N.Y.

Galerie Der Spiegel, Cologne, Germany. *Calder, 22 Teppiche aus den Ateliers Pinton Aubusson.* 1973. 20 pp. Preface by Dr. J.W. von Moltke.

Galerie Maeght, Paris. *Calder: Recent Mobiles.* 24 January–24 February 1973. *Derrière le Miroir,* no. 201 (January 1973). 28 pp., unbound. With cover by Calder, 4 plates lithographed from his gouaches and photographs of 8 mobiles and stabiles. Texts by Maurice Besset and André Balthazar. Also published in a deluxe slipcased edition of 150 numbered examples on Doré rag paper signed by the artist and including a separate print of one of the original lithographs.

Paine Art Center & Arboretum, Oshkosh, Wisconsin. *Tapestries by Calder.* 11 February–4 March 1973. 9 pp. Held by the Paine Art Center in cooperation with Art Vivant, New Rochelle, N.Y.

Palais des Beaux-Arts, Charleroi, Belgium. *Calder: Sculptures en plein air: Plaine des Manœuvres; Gouaches et petits mobiles: Bibliothèque communale.* 13 May–15 July 1973. Essays by Robert Rousseau and André Balthazar.

Galerie Maeght, Zürich. *Alexander Calder: Retrospektive.* 24 May–July 1973. 26 pp. Introduction by C. Giedon-Welcker.

Sala Gaspar, Barcelona. *Calder: Escultures; Exposicio Calder Pintures.* September 1973. 47 pp. Poem by Joan Miró.

Galleria d'Arte "La Bussola," Turin, Italy. *Calder.* October 1973. Introduction by A. Galvano.

Centre National d'Art Contemporain, Paris. *Calder: Mobiles et Lithographies.* 9 February–24 March 1974. 7 pp. Text by Marianne et Serge Lemoine.

Katonah Gallery, Katonah, New York. *Alexander Calder.* 9 February–24 March 1974.

Leonard Hutton Galleries, New York. *Aubusson Tapestries by Calder.* April–June 1974. 6 pp. Introduction by Leonard Hutton.

Galleria Angolare, Milan. *Gouaches di Calder.* June 1974. 10 pp.

Perls Galleries, New York. *Alexander Calder: Crags and Critters of 1974.* 15 October–16 November 1974. 16 pp.

Denise René / Hans Meyer, Düsseldorf. *Alexander Calder: Mobiles, Stabiles, Gouachen.* 17 October–22 November 1974. 4 pp.

Museum of Contemporary Art, Chicago. *Alexander Calder: A Retrospective Exhibition—Works from 1925–1974.* 26 October–8 December 1974. 32 pp. Foreword by Stephen Prokopoff; text by Albert E. Elsen.

Galerie Maeght, Paris. *Calder: Crags and Critters.* 22 January–23 February 1975. *Derrière le Miroir,* no. 212 (January 1975). 24 pp., unbound. With 8 lithographs by Calder. Text by Mario Pedrosa. Also published in a deluxe slipcased edition of 150 numbered examples on Arches vellum signed by the artist and including a separate print of one of the original lithographs.

Center for the Arts Gallery, Wesleyan University, Middletown, Connecticut. *Alexander Calder: Tapestries.* 31 January–1 March 1975. 2 pp. Introduction by Richard Wood.

Galleria Morone 6, Milan. *Opere di Alexander Calder.* February 1975.

Haus der Kunst, Munich. *Calder.* 10 May–13 July 1975. 140 pp. Text by Maurice Besset.

Kunsthaus, Zürich. *Calder.* 23 August–2 November 1975. 109 pp. Texts by Max Bill and Maurice Besset.

Galerie Maeght, Zürich. *Calder: Crags and Critters.* September–October 1975. 24 pp. Text by Mario Pedrosa.

Renaissance du Vieux Bordeaux, France. *Calder: Tapisseries — Mobiles.* 3–26 October 1975. 2 pp. Poem by Jacques Prévert (excerpt from Maeght 1966).

Perls Galleries, New York. *Alexander Calder: Recent Mobiles and Circus Gouaches.* 14 October–15 November 1975. 20 pp.

Galeria Bonino, Rio de Janeiro. *Alexander Calder. Redes — Tapecarias.* 23 March–17 June 1976.

Galleria Marlborough, Rome. *Alexander Calder: Arazzi e amache.* April 1976.

Artcurial, Paris. *Calder: Tapisseries Choisies.* 7–30 April 1976. 6 pp.

Galleria Rondanini, Rome. *Dai Mobiles ai Critters.* 12 April 1976. Texts by Marcel Duchamp (reprint), M. Fagiolo dell'Arco, and Giovanni Carandente.

Whitney Museum of American Art, New York. *Calder's Universe.* 14 October 1976–6 February 1977. 351 pp. Text by Jean Lipman. Revised and issued as a monograph in 1989.

Galerie Maeght, Paris. *Calder: Mobiles and Stabiles.* 1 December 1976–8 January 1977. *Derrière Le Miroir,* no. 221 (December 1976). 24 pp., unbound. With cover and 6 plates by Calder and photographs of mobiles and stabiles. Texts by Jean Frémon and Jean Davidson. Also published in a deluxe slipcased edition of 150 numbered examples on Arches vellum signed by the artist and including a separate print of one of the original lithographs.

Galeria Maeght, Barcelona. *Calder: Exposició Antológica (1932–1976).* April–May 1977. 32 pp. Poems by Carlos Franqui, P. Palazuelo, and Joan Miró.

Center for the Arts, Muhlenberg College, Allentown, Pennsylvania. *Calder Festival.* 19 April–5 May 1977. 22 pp.

Missal Gallery, Scottsdale, Arizona. *Alexander Calder Lithographs: A Memorial Tribute.* 6–20 November 1977. 4 pp.

American Academy and Institute of Arts and Letters, New York. *Alexander Calder: Memorial Exhibition.* 15 November–30 December 1977. 16 pp.

Galerie Tokoro, Tokyo. *Alexander Calder: Mobiles and Gouaches.* 4 September–7 October 1978. 73 pp. Texts by Yoshiaki Inuii (in Japanese), Masakazu Horiuchi (in Japanese), and Jean Lipman (in English, reprint from *Calder's Universe,* 1976).

M. Knoedler & Co., Inc., New York. *Alexander Calder: Sculpture of the 1970's.* 4 October–2 November 1978. 35 pp.

Théâtre Maxime Gorki, Petit Quevilly, France. *Calder: lithographies, mobiles, stabiles.* 2 March–10 April 1979. 4 pp. Introduction by Jean Pierrre Jouffroy.

Rolly-Michaux Gallery, Boston. *Alexander Calder—The Man and His Work.* 29 April–16 June 1979. Catalogue is a special issue of the *Vernissage* newsletter (no. 4, Feb. 1979).

The Seibu Museum of Art, Tokyo. *Calder's Universe.* 23 September–29 October 1979. 168 pp. Introduction by Tadashi Inumaru.

Galleria Pieter Coray, Lugano, Switzerland. *Calder.* 26 October–24 November 1979. 43 pp. Text by Calder (excerpts from Calder 1966).

Kettle's Yard, Cambridge, England. *Calder.* 12 July–10 August 1980. 16 pp. Text by Nicholas Guppy.

M. Knoedler & Co., Inc., New York. *Alexander Calder: Standing Mobiles.* 4 December, 1980–2 January 1981. 19 pp. Text by James Johnson Sweeney.

Galerie Brusberg, Hannover, Germany. *Alexander Calder: Mobiles, Stabiles, Grafik, und Critters.* 6 December 1980–1 March 1981. 132 pp. Introduction by Alfred Hentzen (pp. 25–36).

Galeria Jean Boghici, Rio de Janeiro. *Alexander Calder: Mobiles, Pintura, Guaches.* 18 December 1980–18 January 1981. 32 pp. Texts by Calder (excerpts from Calder 1966), Pietro Maria Bardi, Jean-Paul Sartre (reprint from Carré 1946), Mario Pedrosa, and Antonio Bento.

Whitney Museum of American Art, New York. *Alexander Calder: A Concentration of Works from the Permanent Collection at the Whitney Museum of American Art.* 17 February–3 May 1981. 32 pp. Text by Patterson Sims.

Mayor Gallery and Waddington Galleries, London. *Calder.* 1–25 April 1981. 54 pp.

Waddington Galleries, London. *Calder.* 1–25 April 1981. 54 pp.

Galerie Maeght, Paris. *Calder.* October 1981. *Derrière le Miroir,* no. 248 (October 1981). 18 pp., unbound. Includes manuscript letters from Calder to Galerie Maeght and reproductions of sketches for mobiles.

Galerie Maeght, Zürich. *Calder.* 16 April–June 1982. 29 pp. Text by Jacques Prévert (revised and expanded from Maeght 1966).

Galleria dell'Immagine, Rimini, Italy. *Le fotografie di Alexander Calder a Saché e a Roxbury 1961–1965.* 24 April–29 May 1982. 41 pp. Photographs by Ugo Mulas: introduction by Giulio Carlo Argan.

M. Knoedler & Co., Inc., New York. *Alexander Calder: Small Scale Works and Gouaches.* 15 May–3 June 1982. 16 pp.

Museo de Arte Moderno, Mexico City. *Tapices de Alexander Calder.* 20 July–29 August 1982. 24 pp. Preface by John Gavin: text by Jean Lipman (excerpt from *Calder's Universe,* 1976).

University Art Museum, Berkeley, California. *Alexander Calder.* 3 November 1982–16 January 1983. 4 pp.

Flint Institute of Arts, Michigan. *Alexander Calder: Mobiles, Stabiles, Gouaches, Drawings from the Michigan Collections.* 20 February–27 March 1983. 39 pp. Preface by Richard Wattenmaker: text by Jean-Paul Sartre (reprint from Carré 1946).

M. Knoedler & Co., Inc., New York. *Alexander Calder: Stabiles.* 14 May–2 June 1983. 20 pp.

Palazzo a Vela, Turin, Italy. *Calder: A Retrospective Exhibition.* 2 July–25 September 1983. 250 pp. Text by Giovanni Carandente.

Whitney Museum of American Art, Fairfield County, Stamford, Connecticut. *Calder: Selections from the Permanent Collection of the Whitney Museum of American Art.* 20 January–21 March 1984. 8 pp. Text by Pamela Gruninger Perkins and Susan Lubowsky.

Grand Rapids Art Museum, Michigan. *Calder in Grand Rapids.* 1–17 June 1984.

The Pace Gallery, New York. *Calder's Calders.* 3 May–8 June 1985. 64 pp. Text by Jean Lipman (excerpt from *Calder's Universe,* 1976).

Hudson River Museum, Yonkers, New York. *Calder Creatures Great and Small.* 21 July–15 September 1985. Organized in in cooperation with the Whitney Museum of American Art.

Bakalar Sculpture Gallery, List Visual Arts Center, Massachusetts Institute of Technology, Cambridge. *Alexander Calder: Artist As Engineer.* 31 January–13 April 1986. 8 pp. Text by Joan Marter.

Le Château Biron, Dordogne, France. *Calder.* June–30 September 1986. 88 pp. Introduction by Gilberte Martin-Méry: essay by Frank Maubert.

Ancienne École, bourg de Plouguiel, Côtes-du-Nord, France. *Calder à La Roche-Jaune: Mobiles, Gouaches, Bijoux.* 14 July–15 August 1986. 39 pp. (with English insert). Texts by Alexander Calder (excerpts from Calder 1966), André Breton (excerpt from *View,* 1942), Arthur Miller (excerpt from Memorial Service, Whitney Museum of American Art, 1976), and Michel Ragon (excerpt from Ragon 1967).

Sheldon Memorial Art Gallery, University of Nebraska, Lincoln, Nebraska. *Alexander Calder: An American Invention.* 13 September–16 November 1986. 32 pp. Preface by George W. Neubert: text by Vivian Kiechel.

Galerie Adrien Maeght, Paris. *Calder.* 18 June–September 1987. 33 pp. Text by Giovanni Carandente.

Whitney Museum of American Art, New York. *Alexander Calder: Sculptures of the Nineteen Thirties.* 14 November 1987–17 January 1988. 55 pp. Text by Richard Marshall.

Linssen Gallery, Cologne, Germany. *Calder Retrospective: 1898–1976.* 25 November 1987–January 1988. 120 pp. Poem by Willem Sandberg: text by Jean-Paul Sartre (reprint from Carré 1946).

Gallerie Seno, Milan. *Alexander Calder: Standing and Hanging Mobiles 1945–1976.* 6 October–16 November 1988. 36 pp. Introduction by Getulio Alviani.

Edward Totah Gallery, London. *Alexander Calder: Standing and Hanging Mobiles 1945–1976.* December 1988. 35 pp.

Galeria Maeght, Barcelona. *Calder.* February–March 1989. 32 pp. Text by Giovanni Carandente (reprint from Maeght 1987).

Musée des Arts Décoratifs, Paris. *Calder Intime.* 15 February–21 May 1989. Paris: Solange Thierry, Editeur. 400 pp. Text by Daniel Marchesseau. English edition: *The Intimate World of Alexander Calder,* translated by Eleanor Levieux and Barbara Shuey.

Galería Theo, Madrid. *Calder.* 16–31 March 1989. 8 pp. Text by Fernando Huici.

The Pace Gallery, New York. *Calder: Stabiles.* 5 May–17 June 1989. 24 pp.

Galerie Bonnier, Geneva. *Calder: Dix Gouaches 1970–1973.* 6 November 1990–15 January 1991. 4 pp.

Whitney Museum of American Art, New York. *Celebrating Calder*. 13 November 1991–2 January 1992.

Galerie Maurice Keitelman, Brussels. *Calder Mobiles*. 29 November 1991–1 February 1992. 18 pp. Text by Margaret Calder Hayes (excerpt from Hayes 1977).

Crane Gallery, London. *Calder: Oils, Gouaches, Mobiles and Tapestries*. 5 March–1 May 1992.

Royal Academy of Arts, London. *Alexander Calder*. 13 March–7 June 1992. 32 pp. Texts by John Russell and Stephen Bann.

Galerie Municipale Prague. *Alexander Calder*. 23 June–30 August 1992. 115 pp. Texts by Olga Mala and Karel Srp, Jacques Prévert (excerpt from Maeght 1966), Jean-Paul Sartre (reprint from Carré 1946), Fernand Léger (reprint from Maeght 1950), Michel Butor (reprint from Maeght 1969), Jean Davidson (reprint from Maeght 1969), and Gérard-Georges Lemaire; poem by Henri Pichette (reprint from Maeght 1954).

La Défense, Parvis de La Défense et Galerie Art 4, Paris. *Les Monuments de Calder*. 7 October 1992–3 January 1993. *Beaux-Arts* special issue of (September 1992). 34 pp. Serves as catalogue. Interviews with Alain Maugard and with Daniel Abadie; texts by Arnauld Pierre and Catherine Leclercq; and chronology by Marie-Hélène Dampérat.

Museum of Contemporary Art, Chicago. *Alexander Calder from the Collection of the Ruth and Leonard J. Horwich Family*. 21 November 1992–31 January 1993. 24 pp. Foreword by Kevin E. Consey; essay by Lynne Warren.

Kunst-und Ausstellungshalle, Bonn. *Alexander Calder: Die Grossen Skulpturen*. 2 April–30 September 1993. *Der Andere Calder*. 30 April–30 September 1993. 167 pp. Text and biography by Daniel Abadie. Catalogue for both exhibitions.

O'Hara Gallery, New York. *Alexander Calder: Sculpture, Paintings, Works on Paper*. 1–30 May 1993.

Musée Picasso, Château Grimaldi, Antibes, France. *Calder: Mobiles, stabiles, gouaches, bijoux*. 2 July–27 September 1993. 102 pp. Preface by Pol Bury; texts by Calder (reprint from Taillandier in *XXe siècle*, 1959), Jean-Paul Sartre (reprint from Carré 1946), Michaël Gibson, and Nicholas Guppy (reprint from Lincoln Gallery 1961).

Gagosian Gallery, New York. *Monumental Sculpture*. 18 September–30 October 1993. 6 pp. Essay by Richard D. Marshall.

Ho Gallery, Hong Kong. *Calder*. 9 September–29 October 1994.

Musée de Québec. *L'Homme de Calder*. 29 September, 1994–15 January 1995. 7 pp. Text by Daniel Drouin.

Musée du Québec. *Alexander Calder: L'imaginaire et l'équilibre*. 29 September 1994–15 January 1995. 7 pp. Text by John Russell.

O'Hara Gallery, New York. *Alexander Calder: Selected Works 1932–1972*. 18 October–3 December 1994. 32 pp. Statements by Calder (excerpt); essay by Richard D. Marshall.

A/D Gallery, New York. *Calder Jewelry*. 20 May–30 June 1995 (extended to 28 July).

Bruce Museum, Greenwich, Connecticut. *The Mobile, the Stabile, the Animal; Wit in the Art of Alexander Calder*. 14 September–31 December 1995. 44 pp. Text by Sam Hunter.

Louisiana Museum of Modern Art, Humlebæk, Denmark. *Alexander Calder: Retrospective*. 6 October 1995–21 January 1996. *Louisiana Revy* 36, no. 1 (Summer 1995). 96 pp. English version. 45 pp. Serves as catalogue. Foreword and introduction by Lars Grambye; texts by Giovanni Carandente, Knud W. Jensen, Arnauld Pierre, Hein Heinsen, Jens Toft, Jean-Paul Sartre (reprint from Carré 1946), Alexander S. C. Rower, Joan Marter; chronology by Alexander S. C. Rower. Texts in Danish and English.

PaceWildenstein, Beverly Hills, California. *Alexander Calder: The 50's*. 9 November–29 December 1995. 81 pp. Essay by Mildred Glimcher.

Moderna Museet, Stockholm. *Alexander Calder (1898–1976)*. 30 March–27 May 1996. 110 pp. Foreword by Olle Granath; introduction by Monica Nieckels; texts by Giovanni Carandente (reprint from Louisiana 1995) and Jean-Paul Sartre (reprint from Carré 1946); chronology by Alexander S. C. Rower.

Donjon de Vez, France. *Calder au Donjon de Vez*. 26 May–29 September 1996. 55 pp.

Calder. *Beaux-Arts* special issue of (July 1996). Published on occasion of solo exhibition at Musée d'Art Moderne de la Ville de Paris. Essays by Elizabeth Couturier, Arnauld Pierre, Hervé Vanel, and Catherine Leclerc.

Musée d'Art Moderne de la Ville de Paris. *Alexander Calder: 1898–1976*. 10 July–6 October 1996. 224 pp. Preface by Suzanne Pagé; introduction by Lars Grambye; texts by Daniel Marchesseau, Arnauld Pierre, Alexander S. C. Rower, Jean de Loisy, Miriam Simon, and Stanislav Kolibal; anthology of brief texts compiled by Arnauld Pierre and Miriam Simon; biography by Daniel Marchesseau; selected bibliography and list of exhibitions by Arnauld Pierre and Marianne Sarkari; and filmography by Anne Bertrand and Arnauld Pierre.

Indianapolis Art Center, Indiana. *Indiana Collects Calder*. 13 September–1 December 1996. 20 pp.

National Gallery of Art, Washington, D.C. *Alexander Calder: The Collection of Mr. and Mrs. Klaus Perls*. 9 March–26 May 1997 (extended to 6 July). 32 pp. Foreword by Earl A. Powell III; introduction by Marla Prather; interview of Klaus and Dolly Perls by Marla Prather.

Salas de Exposiciones de la Sociedad Económica de Amigos del País, Obra Socio Cultural de Unicaja, Málaga, Spain. *Alexander Calder*. 23 May–19 June 1997. 54 pp. Essays by Artemis Olaizola and Arantza Fernandez.

Palais Bénédictine, Fécamp (Seine Maritime), France. *Exposition Calder*. 20 June–21 September 1997. Organized by Galerie Maeght, Paris.

Fundació Joan Miró, Barcelona. *Calder*. 20 November 1997–15 February 1998. 186 pp. Essays by Joan Punyet Miró, Dore Ashton, Mildred Glimcher, Antoni Tàpies, and Vicenc Altaió.

Fundaçao Arpad Szenes–Vieira da Silva, Lisbon, Portugal. *Calder*. 19 March–24 May 1998. 74 pp. Texts by Jean-Paul Sartre (reprint from Carré 1946) and Gérard-Georges Lemaire (reprint from Municipale Prague 1992).

National Gallery of Art, Washington, D.C. *Alexander Calder: 1898–1976*. 29 March–12 July 1998. 367 pp. Foreword by Earl A. Powell III; essays by Marla Prather and Arnauld Pierre; chronology, exhibition history, and bibliography by Alexander S. C. Rower.

Scottsdale Museum of Contemporary Art, Arizona. *Alexander Calder: Le Grand Cirque.* 19 December 1998–21 March 1999. 10 pp.

The Phillips Collection, Washington, D.C. *An Adventurous Spirit: Calder at The Phillips Collection.* 23 January–8 June 1999 (extended to 18 July). 8 pp. Text by Elizabeth Hutton Turner and chronology by Elsa Mezvinsky Smithgall.

O'Hara Gallery, New York. *Motion–Emotion: the Art of Alexander Calder.* 21 October–4 December 1999. 96 pp. Foreword by Jonathan O'Hara: essay by Arnauld Pierre.

Wadsworth Atheneum, Hartford, Connecticut. *Calder in Connecticut.* 28 April–6 August 2000. 168 pp. Foreword by Elizabeth Mankin Kornhauser; essays by Alexander S. C. Rower, Eric M. Zafran with Elizabeth Mankin Kornhauser and Cynthia Roman, and Arthur Miller.

Pelaires Centre Cultural Contemporani, Palma de Mallorca, Spain. *Calder.* October 2000. 156 pp. Texts by Joan Miró (reprint from *Calder's Circus* 1964) and Robert Osborn (reprint from Osborn 1969).

Japan Art and Culture Association. *Motion and Color.* 3 November 2000–7 April 2002. 200 pp. Foreword by Alexander S. C. Rower; essays by Richard D. Marshall and Katsunori Fukaya.

Ameringer Yohe Fine Art. *Calder: Four Maquettes, Two Stabiles & a Little Bird Too.* 19 September–12 October 2002. 32 pp.

Newspaper Articles

Legrand-Chabrier. "Paris-Montparnasse et son cirque." *Patrie* (6 May 1927).

Legrand-Chabrier. "Un petit cirque a domicile." *Candide*, no. 171 (23 June 1927). p. 7.

"About Buyers." *New York Herald* (Paris edition). 1 August 1927. Two (possibly more) drawings by Calder.

"About Buyers." *New York Herald* (Paris). 31 July 1927. One (possibly more) drawing by Calder.

"Futurist Toys for Advanced Kiddies Created by Calder, Artist-Engineer." *New York Herald* (Paris edition). 4 August 1927. p. 7.

"Copper Wire Wins Place in Art Show." *New York Times*, 7 March 1928. Review of exhibition at the Waldorf-Astoria Hotel. New York.

"Pictures Reflect the News Throughout the Nation and Abroad." *Cleveland Plain Dealer* (13 March 1928). Photograph of Calder and his *Romulus and Remus* at the Waldorf-Astoria Hotel.

"Sculpturing by Wire Is New Achievement of Alexander Calder at Galerie Billiet." *Chicago Tribune* (Paris edition), January or February 1929. Review of exhibition at Galerie Billiet–Pierre Vorms, Paris.

"Pascin Préfacier." *Paris-Soir* (30 January 1929). Review of exhibition at Galerie Billiet–Pierre Vorms, Paris.

Bal, George. "Paris Art Notes." *New York Herald*, 31 January 1929. Review of exhibition at Galerie Billiet–Pierre Vorms, Paris.

"Sculpture sur Fil de Fer." *Paris Midi* (2 February 1929). Review of exhibition at Galerie Billiet–Pierre Vorms, Paris.

Harris, Ruth Green. "Paintings and Sculpture Show." *New York Times*, 20 February 1929.

"Wire Sculpture." *Steering Wheel*, no. 2548H (April 1929). Review of exhibition at Galerie Neumann-Nierendorf, Berlin. Text in Russian.

M.S. "Der 'Bildhauer.' der alles aus Draht macht!" *Acht Uhr Abendblatt* (Berlin). 8 April 1929.

"Kunst der Neuen Welt." *Der Berliner Weiten*, Berlin-Wilmersdorf (13 April 1929). Review of exhibition at Galerie Neumann-Nierendorf, Berlin.

Frejaville, Gustave. "Les Attractions de la Quinzaine: Les poupées acrobates du cirque Calder." *Comoedia* (24 April 1929).

"Alexander Calder's Startling Figures Appear Once More." *New York Herald Tribune* (15 May 1929). Review of group exhibition at Salon des Tuileries, Paris.

New York Herald (Paris edition). 21 May 1929. Article concerning the Pathé movie short made of Calder's studio, including the sitting for the wire portrait of Kiki.

Lazareff, Pierre. "Un cirque dans un couvercle de carton à chapeau." *Paris-Midi* (21 May 1929). Review of *Cirque Calder.*

Lechenperg, Harald. "Atelierfest am Montparnasse." *Illustrierte Zeitung* (Leipzig edition). 29 August 1929. Article about *Cirque Calder.*

Wilms, Rosemonde R. "Au Cirque Calder." *Intransigeant*, October 1930. Mentions a performance of the *Cirque Calder* at Calder's studio.

Powell, Hickman. "His Elephants Don't Drink." *The World*, 18 January 1931. Article about Calder's *Circus.*

Brissac, Jacques. "Le Plus Petit Cirque du Monde." *Paris-Midi* (23 April 1931).

Brown, Don. "American Artist Wins Praise for His Work in Wire." *Chicago Tribune* (Paris edition), (2 May 1931). Review of the exhibition at Galerie Percier, Paris.

"Kunst im Hochsommer." *Germania* (Berlin), (24 July 1931). Review of exhibition at the Künstlerhaus, Berlin.

"Berliner Kunstchronik." *Deutsche Tageszeitung* (31 July 1931). Review of exhibition at the Künstlerhaus, Berlin.

Tériade, E. (Calder). *Intransigeant* (26 October 1931). Review of exhibition at Parc des Expositions, Porte de Versailles.

Richard, Marius. "Sculptures à moteur." *Patrie* (February 1932). Review of the exhibition at Galerie Vignon, Paris.

Jewell, Edward Alden. "Alexander Calder's Mobiles at the Julien Levy Gallery Suggest Majestic Swing Through Space." *New York Times*, 13 May 1932. Review of exhibition at Julien Levy Gallery, New York.

"Other Art Events." *New York Evening Post*, 21 May 1932. Review of exhibition at Julien Levy Gallery, New York.

McBride, Henry. "Sculpture That Moves May Be Art and May Be Machinery." *New York Sun*, 21 May 1932. Review of exhibition at Julien Levy Gallery, New York.

Gutman, Walter. "In the Galleries: Wire-work Art." *Worcester Times* (21 May 1932). Review of exhibition at Julien Levy Gallery, New York.

"Objects to Art Being Static, So He Keeps It in Motion." *New York World-Telegram*, 11 June 1932. Review of exhibition at Julien Levy Gallery, New York.

Ferrero, Miguel Perez. "Hoy, Alejandro Calder ha presentado el circo más pequeño del Mundo en la Sociedad de Cursos y Conferencias." *Heraldo de*

Madrid, 1 February 1933. Calder performed his *Cirque Calder* on 1 and 2 February.

"A. Calder." *Mirador* (February 1933). Article mentions the performance of his *Cirque Calder* for ADLAN, and the exhibition at Galerie Syra.

"El 'Circ més petit del món.' de l'escultor Alexandre Calder, a Barcelona." *La Publicitat* (9 February 1933). Article mentions the performance of Calder's *Cirque Calder* for ADLAN (Barcelona).

"Alexander Calder's 'Mobiles.'" *Brooklyn Daily Eagle* (22 April 1934). Review of exhibition at Pierre Matisse Gallery, New York.

"A Playful Abstractionist." *New York Herald Tribune* (February 1936). Review of exhibition at Pierre Matisse Gallery, New York.

A. B. Review. *Brooklyn Daily Eagle* (10 February 1936). Review of exhibition at Pierre Matisse Gallery, New York.

Bill Holman. "Sculpture Taken on Electric Ride: Gangling Contraptions Whirl in Private Universe of Alexander Calder." *New York Post* (15 February 1936). Review of exhibition at Pierre Matisse Gallery, New York.

"Calder's 'Mobiles' Are Like Living Miró Abstractions." *New York World-Telegram* (15 February 1936). Review of exhbition at Pierre Matisse Gallery, New York.

Jewell, Edward Alden. "Alexander Calder's Mobiles." *New York Times* (16 February 1936). Review of exhibition at Pierre Matisse Gallery, New York.

Genauer, Emily. "What's New in Art: Calder Work Original, At Least." *New York Herald Tribune* (27 February 1937). Review of exhibition at Pierre Matisse Gallery, New York.

McBride, Henry. "Two Extreme Modernists: Calder's Gay Mobiles Suggest the War Is Over: Tommy Says No." *New York Sun* (27 February 1937). Review of exhibition at Pierre Matisse Gallery, New York.

Klein, Jerome. (Calder). *New York Post*, 27 February 1937. Review of exhibition at Pierre Matisse Gallery, New York.

A. B. "Calder: Artist as Toymaker." *Brooklyn Daily Eagle* (28 February 1937). Review of exhibition at Pierre Matisse Gallery, New York.

McCausland, Elizabeth. "Stabiles and Mobiles by Alexander Calder." *Springfield Sunday Union and Republican* (28 February 1937). Review of exhibition at Pierre Matisse Gallery, New York.

Jewell, Edward Alden. Review. *New York Times*, 28 February 1937. Review of exhibition at Pierre Matisse Gallery, New York.

Vaughan, Malcolm. "Alexander Calder." *New York American* (6 March 1937). Review of exhibition at Pierre Matisse Gallery, New York.

Juliette. "Vernissage av modernt hos Artek." *Nya Pressen* (30 November 1937). Review of exhibition at Artek, Helsinki.

"Motion, by Rail and Wire." *Daily Express* (London). (2 December 1937). Review of exhibition at Mayor Gallery, London.

"An American Wire-Sculptor." *Scotsman* (8 December 1937). Review of exhibition at Mayor Gallery, London.

Blunt, Anthony. *The Spectator* (10 December 1937). Review of exhibition at Mayor Gallery, London.

"Synthetic Circus." *Evening Standard* (10 December 1937). Review of exhibition at Mayor Gallery, London.

"Alexander Calder at the Mayor Gallery." *New Statesman and Nation* (11 December 1937). p. 1016. Review of exhibition at Mayor Gallery, London.

Gordon, Jan. "A Mobile Art." *Observer* (12 December 1937). Review of exhibition at Mayor Gallery, London.

Newton, Eric. "Two and Three Dimensions: Techniques in Carving and Painting." *Sunday Times* (London). (12 December 1937). Review of exhibition at Mayor Gallery, London.

"An Artist's Circus." *Star* (15 December 1937). Review of exhibition at Mayor Gallery, London.

Earp, T. W. "A Gay Plastic Fantasy." *Daily Telegraph* (24 December 1937). Review of exhibition at Mayor Gallery, London.

"Mobiles." *Manchester Guardian* (28 December 1937). Review of exhibition at Mayor Gallery, London.

Rogers, William G. "Local Color." *Springfield Union*, 9 November 1938. Review of exhibition at George Walter Vincent Smith Gallery, Springfield, Massachusetts.

S. "Alexander Calders smycken hos Artek." *Nya Pressen*, 9 December 1938. Review of the exhibition at Galerie Artek, Helsinki.

"Mobile Sculptures in Gallery Shows." *New York World-Telegram* (13 May 1939). Review of exhibition at Pierre Matisse Gallery, New York.

"Mobiles and Stabiles." *New York Herald Tribune* (14 May 1939). Review of exhibition at Pierre Matisse Gallery, New York.

Jewell, Edward Alden. "Calder Mobiles." *New York Times* (14 May 1939). Review of exhibition at Pierre Matisse Gallery, New York.

McBride, Henry. Review. *New York Sun*, 18 May 1940. Review of exhibition at Pierre Matisse Gallery, New York.

Klein, Jerome. "Fanciful Game." *New York Post* (18 May 1940). Review of exhibition at Pierre Matisse Gallery, New York.

"Mobiles and Stabiles." *New York Herald Tribune* (19 May 1940). Review of exhibition at Pierre Matisse Gallery, New York.

McBride, Henry. Review. *New York Sun*, 7 December 1940. Review of exhibition at Willard Gallery, New York.

McCausland, Elizabeth. "Some Shows of the Holiday Season." *Springfield Sunday Union and Republican*, 15 December 1940. Review of exhibition at Willard Gallery, New York.

Upton, Melville. "Calder Shows New 'Mobiles.'" *New York Sun*, 31 May 1941. Review of exhibition at Pierre Matisse Gallery, New York.

E. G. "Calder at Matisse." *New York World-Telegram* (31 May 1941). Review of exhibition at Pierre Matisse Gallery, New York.

Burrows, Carlyle. "Calder's Mobiles." *New York Herald Tribune* (1 June 1941). Review of exhibition at Pierre Matisse Gallery, New York.

Jewell, Edward Alden. "Mobiles." *New York Times* (1 June 1941). Review of exhibition at Pierre Matisse Gallery, New York .

Burrows, Carlyle. "Calder's Mobiles." *New York Herald Tribune* (May 1942). Review of exhibition at Pierre Matisse Gallery, New York.

McBride, Henry. Review. *New York Sun* (21 May 1943). Review of exhibition at Pierre Matisse Gallery, New York.

Jewell, Edward Alden. "Calder Sculpture on Display Today." *New York Times* (29 September 1943). Review of exhibition at Museum of Modern Art, New York.

Genauer, Emily. "Calder's Mobiles and Other Shows of the Week." *New York World-Telegram* (2 October 1943). Review of exhibition at Museum of Modern Art, New York.

Burrows, Carlyle. "The Calder Exhibition." *New York Herald Tribune* (3 October 1943), p. 5. Review of exhibition at Museum of Modern Art, New York.

Jewell, Edward Alden. "Calder in Retrospect." *New York Times* (3 October 1943). Review of exhibition at Museum of Modern Art, New York.

McBride, Henry. "The Age of Metal: Sandy Calder's Steel Constructions Tremble Poetically Like Aspens." *New York Sun* (29 October 1943). Review of exhibition at Museum of Modern Art, New York

Pedrosa, Mario. "Alexandre Calder, Escultor de Cata-Ventos." *Correio da Manhã*, 10 December 1944, pp. 1, 4.

Pedrosa, Mario. "Alexandre Calder, O Escultor de Cata-Ventos, Part II." *Correio da Manhã*, 17 December 1944, pp. 1, 4.

"Paris Still Art World Center, Says Calder." *Waterbury Republican* (11 August 1946).

Lessa, Elsie. "Calder, o artista criancão." *O Globo*, 20 September 1948, pp. 1, 11. Review of exhibiton at Ministerio da Educação e Saude, Rio de Janeiro.

Driscoll, Edgar J., Jr. "Exhibition of 'Mobiles' Mystifies or Fascinates." *Boston Sunday Globe* (30 October 1949), p. 40–A. Review of exhibition at Margaret Brown Gallery, Boston.

Adlow, Dorothy. "Alexander Calder's Sculpture." *The Christian Science Monitor* (31 October 1949). Review of exhibition at Margaret Brown Gallery, Boston.

Preston, Stuart. "New West, Old East." *New York Times* (4 December 1949) Review of exhibition at Buchholz Gallery / Curt Valentin, New York.

H. L. "Works of Calder et L'Histoire d'Agnes." *Gazette du Cinema* (September 1950). Review of the film *Works of Calder.*

"Half Century's Best." *New York Times Book Review*, 12 November 1950. The children's book section selects Calder as among the ten best illustrators.

"Vital." *New York Times* (20 January 1952). Review of exhibition at Curt Valentin Gallery, New York.

Peju, Marcel. "Alexander Calder, Sculpteur du Mouvement Met Ses Atomes Crochus au Service du Théâtre 'Nucléaire.'" *Samedi-Soir* (16 April 1952).

"Ces fils de fer sont le 1er décor atomique." *Paris-Presse L'Intransigeant* (21 April 1952). Review of *Nucléa*, including brief statement by Calder.

Mannoni, Eugene. "Joujoux Pour Adultes les 'Mobiles' de Calder Tournaient Doucement." *Combat* (9 May 1952). Review of exhibition at Galerie Maeght, Paris.

G. F. "Alexander Calder, lo scultore del fil di ferro." *La Nuova Sardesna Sassari* (2 July 1952).

"U.S. Sculptor Honored." *New York Times* (16 June 1952). The international jury for the XXVI Biennale of Venice awarded Calder the special prize for a foreign sculptor.

Ott, Günther. "Schwebende Drahtplastiken." *Rundschau* (Cologne), Nr. 138 (19 June 1952). Review of exhibition at Galerie Parnass, Wuppertal.

Oswald, Marianne. "Ce n'était pas avec du Chatterton." *Combat* (20 June 1952). Article includes a quote from Calder.

Lombard, Suzanne. "Alexander Calder." *Le Soir* (8 July 1952). Review of Calder's work.

"Optische Aeolsharfe: 'Calder-Mobiles' — Abstraktes Spielzeug." *Stuttgarter Nachrichten* (27 September 1952).

Vietta, Egon. "Calder, der Ariel der eisernen Zivilisation." *Frankfurter Allgemeine* (13 November 1952).

Remszhardt, Godo. "Alexander Calder: Vitalität und Esprit." *Frankfurter Rundschau* (23 November 1952).

Kreuther, Hellmut. "Der amerikanische Glasperlenspieler." *Der Kurier* (Berlin), (19 January 1953). Review of exhibition at Galerie Springer, Berlin.

Schumann, Werner. "Drei Berliner Künstler." *Die Neue Zeitung* (10 February 1953).

Sherman, John K. "Don't Let That Space Dangle There Empty." *Minneapolis Tribune* (10 April 1953). Review of exhbition at Walker Art Center, Minneapolis.

Ray, E. Roy. "Much Ado About Mobiles." *Hartford Courant Magazine* (11 October 1953), p. 3. Preview of exhibition at Wadsworth Atheneum.

"Sweeney Calls Moderns Explorers in Sculpture." *Hartford Times* (28 October 1953), p. 52. Review of exhibition at Wadsworth Atheneum, Hartford.

Louchheim, Aline B. "Cultural Diplomacy: An Art We Neglect." *New York Times Magazine* (3 January 1954). Review of exhibition at Museu de Arte Moderna de São Paulo.

"From Shantiniketan" (in Bengalese). *Anandabazaar Patrika* (Bengal) (1 March 1955).

Canaday, John. "Two Sculptors: Alexander Calder and Leonard Baskin." *New York Times* (20 March 1960), p. 20. Review of exhibition at Perls Galleries, New York.

Canaday, John. "Calder and Miró." *New York Times* (26 February 1961). Review of exhibition at Perls Galleries, New York.

Canaday, John. "Moore and Calder." *New York Times* (25 March 1962). Review of exhibition at Perls Galleries, New York.

Guppy, Nicholas. "Chez Calder." *Observer Weekend Review* (8 July 1962), p. 23.

Gosling, Nigel. "Flirting with the Fourth Dimension." *Observer Weekend Review* (8 July 1962), p. 23. Review of exhibition at Tate Gallery, London.

Ashberry, John. "Calder Depicts 'Poetry of Flight' in Paris Show of Stabiles." *New York Herald Tribune* (Paris edition), 27 November 1963, p. 5. Review of exhibiton at Galerie Maeght, Paris.

Genauer, Emily. "Tribute to Calder: A Time for 'Toys.'" *New York Herald Tribune Magazine*, 8 November 1964, p. 31. Review of exhibition at Solomon R. Guggenheim Museum, New York.

Chastel, André. "Le naturalisme de Calder." *Le Monde* (9 July 1965), p. 9. Review of exhibition at Musée d'Art Moderne, Paris.

Root, Waverly. "The Greatest Living American Artist: The Picasso of Iron." *New York Journal-American* (9 September 1965).

Kempton, Murray. "Mr. Calder Laughs." *New York World Telegram & Sun*, 16 November 1965. Account of the dedication of *Le Guichet* at Lincoln Center.

Kramer, Hilton. "American Sculpture, Public and Private." *New York Times*, 13 February 1966. Review of exhibition at Perls Galleries, New York.

Neugass, Fritz. "Alexander Calder-Schöpfer einer heiteren Kunst." *Tages Anzeiger Zürich* (23 April 1966). Review of exhibition at Perls Galleries, New York.

Knox, Sanka. "Two Stabiles May Stay Put After Move to Harlem." *New York Times*, 2 September 1967.

Schwartz, Paul Waldo. "Calder and Miró, Now Past 70, Feted in France." *New York Times* (23 July 1968).

Zimmerman, Diane. "Artist in Perpetual Motion: Calder at 74." *Daily News* (New York), 24 May 1972, p. 64.

Russell, John. "Alexander Calder, Leading U.S. Artist, Dies." *New York Times*, 12 November 1976, pp. A1, D14.

Shattuck, Roger. "When Calder and Satie Joined Forces." *New York Times*, 6 November 1977. Review of performance of *Socrate* at the Beacon Theater, New York City, Nov. 10, 1977.

Carandente, Giovanni. "Sandy, uno scultore che parla col vento." *Il Giornale dell'Arte* (23 May 1982).

Monographs

Calder, Alexander. *Animal Sketching*. Pelham, New York: Bridgman Publishers, 1926. 62 pp. 141 illustrations. Sixth edition revised, with additional illustrations by Charles Leidl, 1936. 78 pp. Paperbound reprint of first edition, New York: Dover, 1973.

Sweeney, James Johnson. *Alexander Calder*. New York: Museum of Modern Art, 1951. 80 pp. Revised and enlarged edition of the 1943 exhibition catalogue; includes condensed version (p. 70) of previously unpublished essay by Calder. Bibliography by Bernard Karpel.

Calder, Alexander and Jean Davidson. *Calder, an Autobiography with Pictures*. New York: Pantheon Books, 1966. 285 pp. Paperbound edition, Boston: Beacon Press, 1969. French edition, *Calder Autobiographie*, translated by Jean Davidson. Paris: Maeght Éditeur, 1972. 209 pp. Second edition with an introduction by Jean Davidson, 1977. 288 pp. Italian edition, *Alexander Calder Autobiografia*, translated by Nicoletta Moriconi. Venice: Marsilio Editori, 1984.

Arnason, H. Harvard, and Pedro E. Guerrero. *Calder*. New York: D. Van Nostrand, 1966. 192 pp. Text by H. H. Arnason; photographs by Pedro Guerrero.

Ragon, Michel. *Calder: Mobiles et Stabiles*. Petite Encyclopédie de l'Art, no. 87. Paris: Fernand Hazan, 1967. 25 pp. English edition: *Calder: Mobiles and Stabiles*. New York: Tudor Publishing Co., 1967. 25 pp.

Carandente, Giovanni. *Calder: Mobiles and Stabiles*. New York and Toronto: New American Library (Mentor-UNESCO Art Books), 1968. 24 pp. Revised edition as *Calder: Mobiles-Stabiles*. Lausanne and Paris: UNESCO / Editions Rencontre, 1970. 65 pp., with 24 color plates.

Bellew, Peter. *Calder*. Barcelona: Ediciones Polígrafa, S.A., 1969. 183 pp. J. Prats Vallès, editor; photographs by Clovis Prevost. English edition: New Jersey: Chartwell Books, Inc., 1969. 139 pp. German edition: Düsseldorf / Lausanne: Verlag A. & G. de May.

Mancewicz, Bernice Winslow. *Alexander Calder / A Pictorial Essay*. Grand Rapids, Mich. William B. Eerdmans, 1969. 64 pp.

Calder, l'artiste et l'oeuvre. Archives Maeght, no. 1. Paris: Maeght Editeur, 1971. 134 pp. Text by James Johnson Sweeney (reprint from Maeght 1969); chronology by Daniel Lelong (reprint from Maeght 1969). English edition, *Calder, the Artist, the Work*, Boston: Boston Book and Art Publisher, 1971.

Arnason, H. Harvard and Ugo Mulas. *Calder*. New York: Viking Press, 1971. 216 pp. Introduction by H. H. Arnason, text by Alexander Calder (excerpt from Calder 1966), and photographs by Ugo Mulas. Statements by Calder, pp. 201–06. French edition, *Calder*. Paris: Chêne, 1971.

Haulica, Dan. *Calder: Variatiuni pe tema "Homo Faber."* Bucharest: Éditons Meridiane, 1971, 70 pp.

Lipman, Jean and Nancy Foote, eds. *Calder's Circus*. New York: E. P. Dutton & Co., Inc. in association with Whitney Museum of American Art, 1972. 171 pp. Reprinted in 1983.

San Lazzaro, Gualtieri di, ed. *Homage to Alexander Calder*. Special issue of *XXᵉ siècle* (Paris), 1972. English edition. New York: Tudor Publishing Co., 1972. 107 pp.

Contributors: San Lazzaro, Stanley William Hayter, Patrick Waldberg, Alain Jouffroy (reprint from Maeght 1968), Jean Davidson, Gilbert Lascault, Jacques Dupin (reprint from Maeght 1968), Pierre Descargues, Giovanni Carandente, Charles Chaboud, Daniel Lelong, and Yvon Taillandier. This issue also includes "remembrances" by Fernand Léger, Jules Pascin, Henri Hoppenot, Pierre Guéguen, and Jean-Paul Sartre, reprinted from other sources.

Bruzeau, Maurice. *Calder à Saché*. Paris: Éditions Cercle d'Art, 1975. Photographs by Jacques Masson. Designed by Charles Feld. 199 pp. English edition, *Calder*. New York: Harry N. Abrams, Inc., 1979. 171 pp.

Hayes, Margaret Calder. *Three Alexander Calders/A Family Memoir*. Middlebury, Vt. Paul S. Eriksson, 1977. 300 pp. Introduction by Malcolm Cowley. Reissued in 1987, New York: Universe Books.

Bourdon, David. *Calder: Mobilist / Ringmaster / Innovator*. New York: Macmillan Publishing Co., 1980. 149 pp.

Fischer, Yona, ed. *Calder: El Sol Rojo*. Jerusalem: The Israel Museum, 1980. 45 pp. The first of a two-volume publication documenting the making of *El Sol Rojo*. (See next entry.)

Fischer, Yona, ed. *Calder: The Jerusalem Stabile*. Jerusalem: Israel Museum, 1980. 76 pp. The second of a two-volume publication documenting the making of *El Sol Rojo*.

Lipman, Jean and Margaret Aspinwall, eds. *Alexander Calder and His Magical Mobiles*. New York: Hudson Hills Press, Inc. in association with Whitney Museum of American Art, 1981. 96 pp.

Storia di una mostra Torino, 1983. Preface by Umberto Agnelli; introduction by Alberto Moravia. Text by Pier Paolo Benedetto and Massimo Dini; photographs by Gianni Berengo Gardin. Milan: Gruppo Editoriale Fabbri, Bompiani, Sonzogno, Etas Libri, 1983.

Lipman, Jean, and Margi Conrads. *Calder Creatures Great and Small*. New York: E. P. Dutton in association with Hudson River Museum and Whitney Museum of American Art, 1985. 80 pp.

Gibson, Michael. *Calder*. Paris: Fernand Hazan, 1988. 109 pp.

Marter, Joan M. *Alexander Calder*. Cambridge: Cambridge University Press, 1991. 302 pp. Reprint, 1993. Paperbound edition with nine additional illustrations, 1997.

Waltke-Lampmann, Petra. *Alexander Calder: Hellebardenträger*. Frankfurt am Main and Leipzig: Insel Verlag, 1995. 145 pp.

Pierre, Arnauld. *Calder: La sculpture en mouvement*. Paris: Découvertes Gallimard / Paris-Musées, 1996. 112 pp.

Carandente, Giovanni. *Teodelapio: Alexander Calder*. Milan: Edizioni Charta, 1996. 103 pp.

Marcardé, Jean-Claude. *Calder*. Paris: Flammarion, 1996. 159 pp.

Lemaire, Gérard-Georges. *Calder*. Barcelona: Ediciones Polígrafa, S.A., 1997. 64 pp. English edition, New York: Harry N. Abrams, Inc.

Rower, Alexander S. C. *Calder Sculpture*. New York: Universe Publishing, 1998. 80 pp.

Guerrero, Pedro E. *Calder at Home: The Joyous Environment of Alexander Calder*. New York: Stewart, Tabori & Chang, 1998. 160 pp. Foreward by Alexander S. C. Rower.

Baal-Teshuva, Jacob. *Alexander Calder*. Cologne, Taschen, 1998. 95 pp.

Calder: The Whirling Ear. Preface by Henri Simons. Texts by Pierre Baudson, Isabelle Corten, and Patrice Neirinck. Brussels: Universal and International Exhibition in the Brussels World's Fair. 2000. 40 pp. Texts in French and Dutch.

Lelong, Daniel. *Avec Calder*. Paris: L'Echoppe, 2000. 64 pp.

Magazine Articles

Pemberton, Murdock. "Review of Exhibitions." *New Yorker* (2 January 1926), p. 21. Review of exhibition at Artists Gallery, New York.

"Les Jouets de Calder." *Les Echos des Industries d'Art*, no. 25 (August 1927), p. 23.

Reproduction of Calder's wire Stallion. *Transition*, no. 7 (October 1927).

"The Wonders of Our Age: Portraits by Wire!" *American Sketch* (1928), p. 36. Photographs of Calder's wire sculptures at Weyhe Gallery.

Hawes, Elizabeth. "More than Modern-Wiry Art." *Charm* (April 1928), pp. 47, 68.

Haskell, Douglas. "Design in Industry, or Art as a Toy." *Creative Art*, vol. 4 (February 1929), pp. lvi–lvii (supp.). Review of exhibition at Weyhe Gallery, New York.

Pemberton, Murdock. "The Art Galleries: Pigment and Tea Leaves." *New Yorker* (23 February 1929). Review of exhibition at Weyhe Gallery, New York.

Werner, Bruno. "Porträts, Skulpturen, Drahtplastiken." *Deutsche Allgemeine Zeitung* (12 April 1929).

"Art in Wire." *The Sphere* (April 20, 1929), p. 129. Seven of Calder's wire figures reproduced.

Legrand-Chabrier. "Alexandre Calder et son cirque automatique." *La Volonté* (19 May 1929).

Transition, no. 16–17 (June 1929). *Umbrella Lamp* and *Woman with Square Umbrella* reproduced.

Szittya, Emil. "Alexander Calder." *Kunstblatt*, vol. 13 (6 June 1929), pp. 185–86.

"Le Cirque en fil de fer." *Lectures pour tous* (July 1929), pp. 92–95.

"Wire Sculpture by Calder." *Vanity Fair* (December 1929), pp. 86–87. Review of exhibition at Fifty-sixth Street Galleries New York.

Pemberton, Murdock. "Calder's Circus." *New Yorker* (7 December 1929).

"The Art Galleries: One Man and Some Wire." *New Yorker* (14 December 1929). Review of exhibition at Fifty-sixth Street Galleries, New York.

"We Nominate for the Hall of Fame Because. . .". *Vanity Fair* (March 1930). Mentions Calder's wire sculpture, the *Circus*, and his engineering degree.

"Wire and Wood Sculptures Resemble Caricatures." *Popular Mechanics*, 53, no.3 (March 1930), p. 394.

Berthelot, Pierre. "Alexander Calder." *Beaux-Arts*, vol. 9 (May 1931), p. 24. Review of exhibition at Galerie Percier, Paris .

Westheim, Paul. "Legenden aus dem Künstlerleben." *Kunstblatt*, vol. 15 (August 1931), pp. 246–48.

Gasch, Sebastián. "El escultor americano Calder." *AC* (Barcelona) no. 7 (1932), p. 43.

Gallotti, Jean. "Sculpture automobile." *Vu* (6 April 1932). Review of exhibition at Galerie Vignon, Paris.

Buffet-Picabia, Gabrielle. "Alexander Calder, ou le roi du fil de fer." *Vertigral* 1, no. 1 (15 July 1932), p. 1. Review of exhibition at Galerie Vignon, Paris.

Gasch, Sebastián. "El circ d'un escultor." *Mirador* (Barcelona), no. 191 (29 September 1932). Performance of the *Circus* at GATCPAC.

Jakovski, Anatole. "Alexander Calder." *Cahiers d'Art*, no. 5–6 (1933), pp. 244–46.

Jacobson, John. "Vroeger ingenieur . . . nu ijzerdraad-dunstenaar." *Wereldkroniek* (1933). Article about Calder's *Circus*.

Alexander Calder. "Un 'Mobile.'" *Abstraction-Création, Art Non Figuratif*, no. 2 (1933), p. 7.

Recht, Paul. "Dans le mouvement, les sculptures mouvantes." *Mouvement*, no. 1 (June 1933), pp. 48–49. Review of exhibition at Pierre Colle Gallery, Paris.

"Alexander Calder." *Abstraction-Création, Art Non Figuratif*, no. 3 (1934), p. 8.

"Museums acquire Calder's art in motion." *Art Digest*, no. 32 (1 November 1934), p. 16.

Sweeney, James Johnson. "Alexander Calder." *Axis*, vol. 1, no. 3 (July 1935), pp. 19–21.

Benson, Emanuel Merwin. "Seven Sculptors: Calder, Gargallo, Lehmbruck, Lipchitz, Manolo, Moore, Wolff." *American Magazine of Art*, 28, no. 8 (August 1935), pp. 468–69.

Sayre, A. H. "Mobiles and Objects in the Abstract Language." *Art News*, no. 34 (22 February 1936), p. 8. Review of exhibition at Pierre Matisse Gallery, New York.

Lane, J. W. "Exhibition of mobiles." *Parnassus*, vol. 8 (March 1936), p. 25. Review of exhibition at Pierre Matisse Gallery, New York.

"Martha Graham and Dance Group." *Dance Observer* (April 1936), p. 40. Review of *Horizons* performance of with discussion of Calder's mobiles.

Abbott, Jere. "A Collage and a Mobile." *Bulletin of Smith College Museum of Art*, no. 17 (June 1936), pp. 16–17.

"Art Galleries: Spring, Circuses, and Sport." *New Yorker* (February 1937). Review of exhibition at Pierre Matisse Gallery, New York.

"Stabiles and Mobiles." *Time Magazine* (1 March 1937), pp. 46–47. Review of exhibition at Pierre Matisse Gallery. New York.

Frankel, Robert. "Calder: A Humorous and Inventive Artist." *Art News*, no. 35 (13 March 1937), pp. 14–22. Review of exhibition at Pierre Matisse Gallery. New York.

Tracy. Charles. "HO to AA. a Stage Playlet in Two Scenes." *Transition*, no. 26 (Winter 1937), pp. 134–40. Two plates by Calder include stage setting, back drop, and two characters: Gobble-Gobble on a scooter and Snick-wee on a velocipede.

"Genius in Wire." *News Review* (28 December 1937), p. 40. Review of the Mayor Gallery, London.

Sweeney. James Johnson. "L'Art Contemporain: Allemagne, Angleterre, Etats-Unis." *Cahiers d'Art* 13. no. 1–2 (1938), pp. 1–2.

"Mobile Sculpture." *Architectural Review* 83, no. 494 (January 1938), pp. 52, 56.

"Springfield: A Calder show." *Art News*, no. 37 (19 November 1938), p. 18. Review of exhibition at George Walter Vincent Smith Gallery, Springfield, Massachusetts.

"Mobile en mouvement." *Cahiers d'Art* 14, nos. 1–4 (1939). p. 74.

Sweeney. James Johnson. "Alexander Calder: Movement as a Plastic Element." *Plus*, no. 2 (February 1939), pp. 24–29.

"Fantastic and ingenious constructions." *Art News*, no. 37 (13 May 1939). p. 13. Review of exhibition at Pierre Matisse Gallery, New York.

"Art to Move." *Cue* (13 May 1939). Review of exhibition at Pierre Matisse Gallery, New York.

Bird. P. "Calder and Nature." *Art Digest*, no. 13 (15 May 1939), pp. 22–23. Review of the exhibition at Pierre Matisse Gallery. New York.

"Motion Man." *Time Magazine*, no. 33 (29 May 1939). Review of exhibition at Pierre Matisse Gallery, New York.

Breuning. Margaret. "Calder mobiles and stabiles." *American Magazine of Art* 32. no. 6 (June 1939). p. 361. Review of exhibition at Pierre Matisse Gallery, New York.

J. W. L. "Annual Calder Mobile Parade." *Art News*, no. 38 (18 May 1940). p. 11. Review of exhibition at Pierre Matisse Gallery, New York.

"Circus in Wire." *Newsweek* (27 May 1940), pp. 41–42. Review of exhibition at Pierre Matisse Gallery, New York.

"Calder's 'Mobiles.'" *Art Digest* 14, no. 17 (1 June 1940). p. 21. Review of exhbition at Pierre Matisse Gallery, New York.

Lane, James. "Alexander Calder as Jewelry Designer." *Art News*, no. 39 (1 December 1940), pp. 10–11. Review of exhibition at Willard Gallery, New York.

"Novel Handmade Jewelry on Exhibit." *Women's Wear Daily* (4 December 1940). Review of exhibition at Willard Gallery, New York.

R. F. "Alexander Calder." *Art News*, no. 40 (1–30 June 1941). p. 30. Review of exhibition at Pierre Matisse Gallery, New York.

Hellman, Geoffrey T. "Profiles: Everything Is Mobile." *New Yorker*, no. 17 (4 October 1941). pp. 25–30. 33.

Coan. Ellen Stone. "The Mobiles of Alexander Calder." *Vassar Journal of Undergraduate Studies*, vol. 15 (May 1942), pp. 1–19.

"Tinkling Metal." *Art Digest*, no. 16 (1 June 1942). p. 12. Review of exhibition at Pierre Matisse Gallery, New York.

J. W. L. "Calder." *Art News* (June–July 1942). Review of exhibition at Pierre Matisse Gallery, New York.

Coates. Robert M. (Calder). *New Yorker* (29 May 1943). Review of exhibition at Pierre Matisse Gallery, New York.

M. R. "Modern Opens Retrospective Show of Calder's Light-Hearted Art." *Art Digest* 18. no. 1 (1 October 1943). p. 6. Review of exhibition at Museum of Modern Art, New York.

"Calder's Circus." *Newsweek* 22. no. 15 (11 October 1943). p. 104. Review of exhibition at Museum of Modern Art, New York.

Greenberg, Clement. "Alexander Calder: Sculpture, Constructions, Jewelry, Toys, and Drawings." *The Nation*, no. 157 (23 October 1943). pp. 480. Review of exhibition at Museum of Modern Art, New York.

"A Connecticut Constructivist Sets a Challenge." *Interiors*. vol. 103. no. 4 (November 1943), pp. 36–39, 62–63.

Frost, Rosamund. "Calder Grown Up: A Museum-Size Show." *Art News* 42. no. 12 (1–14 November 1943). p. 11.

"American sculptor of this age." *Design*, vol. 45 (November 1943). pp. 14–15.

Sweeney. James Johnson. "El Humor de Alexander Calder. Le Imprime Gracia y Fantasia a su Arte." *Norte* 4. no. 3 (January 1944). p. 4.

"Alexander Calder." *Architectural Forum* 80. no. 1 (January 1944), pp. 6, 114. Review of exhibition at Museum of Modern Art, New York.

Sweeney, James Johnson. "The Position of Alexander Calder." *Magazine of Art* 37, no. 5 (May 1944). pp. 180–183. Reprinted in *Stevens Indicator* (October 1944).

"Speaking of Pictures." *Life* 17, no. 14 (2 October 1944). pp. 12–14.

Buffet-Picabia, Gabrielle. "Sandy Calder, forgeron lunaire." *Cahiers d'Art*, no. 20–21 (1945–46), pp. 324–33.

Mounin, Georges. "L'objet de Calder." *Cahiers d'Art*, no. 20–21 (1945–46). pp. 334–35.

Mindlin, Henrique. "Alexander Calder." *Enba*, no. 3 (September 1945). pp. 10–11.

"Calder in Gouache." *Art Digest*, no. 19 (15 September 1945). p. 22. Review of exhibition at Samuel M. Kootz Gallery, New York.

"Back to the Wall." *Time Magazine*, no. 46 (17 September 1945). p. 57. Review of exhibition at Samuel M. Kootz Gallery, New York.

"Calder." *Art News* 44. no. 15 (15 November 1945), pp. 26–27. Review of exhibition at Buchholz Gallery / Curt Valentin, New York.

"Alexander Calder." *Arts and Architecture* 63. no. 1 (January 1946), pp. 28–30. 54. Photograph of Calder's *Constellation* on the cover.

"Alexander Calder." *Current Biography* 7. no. 4 (April 1946), pp. 7–9.

Cunard, Nancy. "Arts Parallel: A note on Calder. Léger and Vilato." *Jazz Forum*, no. 4 (April 1947), pp. 15–16.

Schneider-Lengyel, I. "Alexander Calder, der Ingenieur-Bildhauer." *Prisma* (Munich), vol. 1, no. 6 (14–15 April 1947), pp. 14–15.

A. and G. Bouxin. "Portraits." *Style en France* 2, no. 5 (15 April 1947), pp. 26–34.

Giedion, Siegfried. "The Hammock and Alexander Calder." *Interiors* 106, no. 10 (May 1947), pp. 100–104.

Payne, E. H. "Mobile by Calder." *Detroit Institute Bulletin*, vol. 26 (September 1947), pp. 6–8.

Veronesi, Giulia. "Braque, Picasso, Calder." *Emporium* 106, no. 635–36 (November–December 1947), pp. 121–23.

Gibbs, Jo. "It May Not Be Sculpture, But It's Vital." *Art Digest* 22, no. 6 (15 December 1947), p. 17. Review of exhibition at Buchholz Gallery / Curt Valentin, New York.

Janis, Harriet. "Mobiles." *Arts and Architecture* 65, no. 2 (February 1948), pp. 26–28, 56–59.

Todd, Ruthven. "An Illuminated Poem: Alexander Calder." *Here and Now* (Toronto) 1, no. 2 (May 1948), p. 69. Illustrated with line cut of Calder's etching from 1947.

Masson, André. "L'atelier de Calder." *Cahiers d'Art* 24, no. 2 (1949), pp. 274–80.

Soby, James Thrall. "Calder, Matisse, Miró, Matta." *Arts and Architecture* 66, no. 4 (April 1949), pp. 26–28.

"Stabiles." *Architectural Review* (London), vol. 106, no. 632 (August 1949), pp. 117–19.

S. K. "Calders carry on in Philadelphia." *Architectural Forum* 91, no. 5 (November 1949), p. 126.

"Alexander Calder." *Art News* 48, no. 8 (December 1949), p. 45. Review of exhibition at Buchholz Gallery / Curt Valentin, New York.

Krasne, Belle. "Caldermobiles, 1950." *Art Digest* 24, no. 6 (15 December 1949), p. 16. Review of exhibition at Buchholz Gallery / Curt Valentin, New York.

Clapp, Talcott. "Calder." *Art d'Aujourd'hui*, no. 10–11 (May–June 1950), pp. 2–11.

Degand, Léon. "Notes sur Calder." *Art d'Aujourd'hui*, no. 10–11 (May–June 1950), pp. 12–13.

"Glass is beautiful, glass is useful." *Flair* 1, no. 9 (October 1950), pp. 66–67. Glass mobile commissioned by *Flair*.

Schiller, Ronald. "Calder." *Portfolio*, 1951, pp. 79–93.

"Gala pa Galleri." *Vecko-Journalen*, no. 1 (4 January 1951), pp. 22–23.

"Connecticut Yankee." *Time Magazine*, no. 57 (8 January 1951), pp. 43–44. Review of exhibition at Massachusetts Insitutute of Technology, Cambridge.

Sylvester, David. "Mobiles and Stabiles by Alexander Calder." *Art News and Review* (London) 2, no. 26 (27 January 1951), p. 4.

Middleton, Michael. "Toys for Highbrows." *Picture Post* 50, no. 5 (3 February 1951), pp. 26–28.

Cunliffe, Mitzi. "Mobiles by Calder." *Building*, vol. 26, no. 5 (May 1951), pp. 164–66.

Alfons, Sven. "Exkurser Kring Calder." *Konstrevy* 27, no. 1 (September–October 1951), pp. 3–13.

Degand, Léon. "A. Calder." *Art d'Aujourd'hui* 3, no. 1 (December 1951), p. 5. Review of exhibition at Charlottenborg Palace, Copenhagen.

"Gongs and Towers." *Art News* 50, no. 9 (January 1952). p. 40. Review of exhibition at Curt Valentin Gallery, New York.

Fitzsimmons, James. "Master Toymaker." *Art Digest* 26, no. 9 (1 February 1952), pp. 15–16. Review of exhibition at Curt Valentin Gallery, New York.

"New mobiles at the Curt Valentin Gallery." *Interiors*, vol. 111 (March 1952), p. 10. Review of exhibition at Curt Valetin Gallery, New York.

Gómez Sicre, José. "Master of Space and Time." *Américas* 4, no. 4 (April 1952), pp. 12–15, 44–45.

Courthion, Pierre. "Calder et la poésie de l'espace." *XXᵉ siècle*, series 2, no. 3 (June 1952), pp. 55–57.

Mellquist, Jerome. "Alexander Calder et Hans Fischer: hommes d'un langage nouveau." *Arts Plastiques* (Brussels) 5, no. 6 (June 1952), pp. 427–34.

"Mobiles et mouvantes, les robes des demi-collections." *Elle*, no. 341 (6 June 1952), pp. 18–21.

Mellquist, Jerome. "Venice Biennale, 1952: Seeing a United Nations of Art." *Art Digest* 26, no. 19 (August 1952), pp. 7–8. Review of the Venice *Biennale*.

Newton, Eric. "A Critic Wiretaps Alexander Calder." *New York Times Magazine* (10 August 1952), pp. 16–18.

Seiberling, Dorothy. "Calder, his Gyrating 'Mobile' Art Wins International Fame and Prizes." *Life* 33, no. 8 (25 August 1952), pp. 83–88, 90.

Brest, Jorge Romero. "La XXVI Bienal de Venecia." *Ver y Estimar* 8, nos. 29–30 (November 1952). Calder won the Grand Prize for sculpture.

Joffroy, Pierre. "Calder." *Paris Match*, no. 233 (12 September 1953), pp. 26–30.

Schmidt, George. "Alexander Calder's 'Mobiles.'" *Du* (Zurich), vol. 13 (December 1953), pp. 60–61.

Bruguière, Pierre-Georges. "L'objet-mobile de Calder." *Cahiers d'Art* 29, no. 2 (1954), pp. 221–28.

Jotterand, Franck. "Alexandre Calder ou la sculpture en mouvement." *France Illustration*, no. 416 (November 1954), pp. 66–71.

"Calder le sculpteur qui voudrait être le Bon Dieu." *Jours de France* (18–25 November 1954), p. 49.

Lebel, Robert. "Calder et la nouvelle sculpture." *Preuves* (February 1955), p. 75–76.

"Mobiles at The Lefevre Gallery." *Studio* (May 1955), pp. 156–57. Review of exhibition at Lefevre Gallery, London.

Vernis. "L'arte é mobile." *Connoisseur* (American edition), vol. 135 (May 1955), p. 184. Review of exhibition at Lefevre Gallery, London.

"Calder." *Arts Digest*, no. 29 (June 1955), p. 22. Review of exhibition at Curt Valentin Gallery, New York.

Posani, Juan Pedro. "Reseñas." *A, hombre y expresión* (September 1955). Review of exhibition in Caracas.

L. C. "Alexander Calder." *Art News*, no. 55 (March 1956), p. 52. Review of Calder's work at Perls Galleries, New York.

"Portrait." *Art in America*, no. 44 (Spring 1956), p. 39.

"En Touraine Calder a délaissé les mobiles pour les gouaches." *Paris Match*, no. 372 (26 May 1956), p. 15.

Eudes, Georges. "Le fief Calder en Touraine." *Art and Décoration*, no. 55 (November 1956), pp. 18–23.

Sweeney, James Johnson. "Alexander Calder: Work and Play." *Art in America* 44, no. 4 (Winter 1956–57), pp. 8–13. Reprinted in *Art in America* 51, no. 4, 1963.

Schlösser, Manfred. "Fernand Léger und Alexander Calder Ausstellung in der Basler Kunsthalle." *Baukunst und Werkform* (Nüremberg) 10, no. 9 (1957), pp. 549–51.

"Mobiles und stabiles." *Werk*, vol. 44 (July 1957), supp. 132–33. Review of exhibition at Kunsthalle, Basel.

Posani, Juan Pedro. "Aula Magna, Cuidad Universitaria." *Integral*, no. 9 (November 1957). Discussion of architect Carlos Raúl Villanueva and Calder's acoustic ceiling (Venezuela).

Sweeney, James Johnson. "Le cirque de Calder, Paris 1926–1927." *Aujourd'hui; Art et Architecture*, 3, no. 17 (May 1958), pp. 50–51.

"A Visit with Calder." *Look* 22. no. 25 (9 December 1958), pp. 54–57.

Restany, Pierre. "L'autre Calder." *Art International* (Zurich) 3. nos. 5–6 (1959), pp. 46–47.

Prévost, Alain. "Calder." *Le Mercure de France*, no. 1147 (March 1959), pp. 385–96.

"Un Américain à Paris: Calder, le 'maître du déséquilibre.'" *Jours de France* (28 March 1959). Review of exhibition at Galerie Maeght, Paris.

Gasser, Helmi. "Alexander Calder." *Werk* (Bern) 46, no. 12 (December 1959), pp. 444–50.

Coates, Robert M. "Art in 3-D." *New Yorker* (1960), p. 106. Review of exhibition at Perls Galleries, New York.

Kuh, Katherine. "A New Freedom for the Molders of Space." *Saturday Review* (14 May 1960), p. 39. Review of exhibition at Perls Galleries, New York.

Hellman, Geoffrey T. "Onward and Upward with the Arts: Calder Revisited." *New Yorker* (22 October 1960). pp. 163–64, 167–72, 175-78.

Tajan, A. "Calder." *La Tribune Graphologique*, no. 49 (1961), pp. 2–7.

"Sculptor's Dynasty." *Time Magazine* (20 January 1961), p. 62. Review of exhibition at Delaware Art Center, Wilmington.

"Personalities." *Progressive Architecture News Report* (March 1961). Calder received the Fine Arts Gold Medal from the American Institute of Architects.

Canaday, John. "Mobile Visit with Alexander Calder." *New York Times Magazine* (25 March 1962), pp. 32–33, 125.

Hunebelle, Danielle. "Calder et ses mobiles." *Réalités*, no. 196 (May 1962), pp. 66–73.

Piper, Myfanwy. "Calder." *Harper's Bazaar* (London) 66, no. 4 (July 1962), pp. 16–17, 70.

"Please Do Touch." *Newsweek*, no. 60 (6 August 1962), p. 51. Review of exhibition at Tate Gallery, London.

Rickey, George. "Calder in London." *Arts Magazine* 36, no. 10 (September 1962), pp. 22–27. Review of exhibition at Tate Gallery, London.

Davidson, Jean. "Calder en Campagne." *Horizon Magazine* 5, no. 2 (November 1962), pp. 10–17.

Davidson, Jean. "Four Calders." *Art in America* 50, no. 4 (Winter 1962), pp. 68–73.

"The Art in America Annual Award for an Outstanding Contribution to American Art: Alfred H. Barr, Jr. and Alexander Calder." *Art in America* 50, no. 4 (Winter 1962), p. 19.

Agam, Yaacov. "Calder en pleine nature." *XXᵉ siècle* (new series) 24 no. 20 (Winter 1962), pp. 79–82.

Chabrun, Jean-François. "En pleine Touraine Calder bâtit son musée de titan." *Paris Match*, no. 725 (2 March 1963), pp. 112–13.

Joffroy, Pierre. "Ses stabiles attaquent Paris." *Paris Match*, no. 764 (30 November 1963), pp. 110–15.

Gray, Francine du Plessix. "At the Calders.'" *House and Garden* 124, no. 6 (December 1963), pp. 154–59, 189. Photographs by Pedro Guerrero.

"Pour Calder, la vérité sans fard." *La Maison Française* (Winter 1963–64), pp. 36–38.

"Connecticut Colossi in Gargantualand." *Time Magazine* 83, no. 9 (28 February 1964), p. 72.

Jones, James. "Letter Home." *Esquire* 61, no. 3 (March 1964), pp. 28, 30, 34.

"Le case di Calder: come vive un artista in America e in Europa." *Panorama* (Milan) 2, no. 21 (June 1964), pp. 88–101.

Gray, Cleve. "Calder's Circus." *Art in America* 52, no. 5 (October 1964), pp. 22–48. Two Calder drawings, on the cover and on p. 20. Portfolio of sixteen reproductions of circus drawings made in 1931 and 1932; interview with Calder about his interest in the circus theme; letter from Miró describing a performance of the *Cirque Calder* at his home in Montroig, Spain.

Canaday, John. "The Man Who Made Sculpture Move." *New York Times Magazine* (1 November 1964), pp. 32–33.

"The Mobile Eye." *Newsweek* (16 November 1964), p. 98. Review of exhibition at Solomon R. Guggenheim Museum, New York.

"Toys for All Ages." *Time Magazine* 84, no. 21 (20 November 1964), pp. 96–99.

Coates, Robert M. "Alexander Calder." *New Yorker* (21 November 1964), pp. 165–66, 168–69. Review of exhibition at Solomon R. Guggenheim Museum, New York.

Guppy, Nicholas. "Alexander Calder." *Atlantic Monthly* 214, no. 6 (December 1964), pp. 53–60.

Ragon, Michel. "Mobiles et stabiles de Calder." *Jardin des Arts*, no. 121 (December 1964), pp. 50–55.

Lyon, Ninette. "Alexander Calder, a Second Fame: Good Food." *Vogue* (January 1965), pp. 153–54.

Olson, Clarence E. "Calder's Cluttered Studio." *Pictures* (St. Louis Post-Dispatch), (21 February 1965), pp. 2–5. Review of exhibtion at Solomon R. Guggenheim Museum, New York.

Lemon, Richard. "Mobiles: The Soaring Art of Alexander Calder." *Saturday Evening Post*, no. 4 (27 February 1965), pp. 30–35.

Anderson, Wayne V. "Calder at the Guggenheim." *Artforum* 3, no. 6 (March 1965), pp. 37–41.

Howard, Jane. "Close up-Mobile Maker's Giddy Whirl." *Life* 58, no. 9 (5 March 1965), pp. 47–48, 50, 52.

Getlein, Frank. "Calder the Pioneer." *The New Republic* 152, no. 13 (27 March 1965), pp. 31–32. Review of exhibition at Solomon R. Guggenheim Museum, New York.

Rose, Barbara. "Joy, Excitement Keynote Calder's Work." *Canadian Art* 22, no. 3 (May–June 1965), pp. 30–33. Review of exhibition at Solomon R. Guggenheim Museum, New York.

"Alexander Calder." *Prometheus*, no. 11 (June 1965), pp. 1, 4.

Hyuga, Akiko. "Alexander Calder." *Mizue*, no. 724 (June 1965), pp. 13–21.

"Calder Drawings and Paintings." *Prometheus*, no. 11 (June 1965), p. 1.

Schneider, Pierre. "Calder, rossignol et éléphant." *L'Express* (26 July 1965), pp. 34–35. Review of exhibition at Musée d'Art Moderne, Paris.

Ragon, Michel. "Quatre jours avec Calder." *Arts*, special issue (August 1965), pp. 22–23.

Ragon, Michel. "L'exposition du Musée d'Art Moderne: de l'humeur à la féerie." *Arts*, special issue (August 1965).

p. 23. Review of exhibition at Musée d'Art Moderne, Paris.

Restany, Pierre. "La Grande Mostra di Calder a Parigi." *Domus*, no. 431 (October 1965), p. 28.

Rotzler, Willy. "Alexander Calder." *Du-Atlantis* (Zurich), (December 1965), pp. 969–83.

Plumb, Barbara. "Stamped with Personality." *New York Times Magazine* (6 February 1966), pp. 64–65.

Coates, Robert. "The Light Touch." *New Yorker* (19 February 1966), p. 140–42. Review of exhibition at Perls Galleries, New York.

Brooks, Peter. "A Calder Stabile." *Harvard Art Review* 1, no. 1 (Spring 1966), pp. 23–27.

"Boiler-Plate Beauty." *Time Magazine* (13 May 1966), pp. 78–79. Article about the dedication of *The Big Sail* at Massachusetts Institute of Technology.

Russell, John. "Alexander Calder in Saché." *Vogue* (July 1967), pp. 110–15, 119, 121, 130. Photographs by Lord Snowdon.

Nemser, Cindy. "Alexander Calder." *Arts Magazine* (December 1967–January 1968). Review of exhibition at Perls Galleries, New York.

"Calder On-stage." *Newsweek* 71, no. 13 (25 March 1968), p. 100. Account of Calder's *Work in Progress* at Rome Opera House.

"Alexander Calder." *Mizue*, no. 761 (June 1968), pp. 48–61.

"Calder: l'air comme un environnement." *L'Art Vivant* (November 1968), p. 16. Review of exhibitions at Perls Galleries in New York and Galerie Maeght in Paris, and of *La grande vitesse*.

Peter, John. "In Calder's kitchen: homemade tools, homegrown food." *Look* 32, no. 1 (9 January 1969), pp. 62–63.

"Calder à la Fondation Maeght." *Chroniques de l'art vivant*, no. 2 (May 1969), pp. 2–3. Review of exhibition at Fondation Maeght, Saint-Paul-de-Vence.

Arnoldi, Per. "Alexander Calder." *Mobilia*, no. 166 (May 1969), pp. 1–10.

Vinson, Robert-Jean. "Calder en plein air." *Connaissance des Arts*, no. 210 (August 1969), pp. 64–69.

Henry, Michael. "Moving Mobiles into the Garden." *Réalités*, no. 227 (October 1969), pp. 84–91, 93–94, 98.

Helwig, Werner. "Old Calders Werkstattmühle." *Die Waage* no. 3 (1970), pp. 103–08.

"MoMA Salutes Calder." *Pictures on Exhibit* 33, no. 4 (January 1970), pp. 8–9. Review of exhibition at Museum of Modern Art, New York.

Russoli, Franco. "'Mobiles' e 'Stabiles.'" *Pirelli* 23, no. 9–10 (September–October 1970), pp. 110–17.

Guppy, Shusha. "The House that Calder Built." *Vogue* 128, no. 5 (April 1971), pp. 130–34, 153.

Borgeaud, Georges. "Alexander Calder." *Les Nouvelles Littéraires*, no. 2288 (30 July 1971), p. 3.

Lévêque, Jean-Jacques. "Calder chez Toulouse-Lautrec." *Les Nouvelles Littéraires*, no. 2288 (30 July 1971), pp. 14–15.

Bruzeau, Maurice. "Alexander Calder, forgeron dans la cité." *Revue Française des Télécommunications*, no. 3 (April 1972), pp. 55–59.

Cate, Curtis. "Calder Made Easy." *Horizon Magazine* 9, no. 1 (Winter 1972), pp. 46–57.

Mitgang, Herbert. "Alexander Calder at 75: Adventures of a Free Man." *Art News* 72, no. 6 (Summer 1973), pp. 54–58.

Morgan, Ted. "A Visit to Calder Kingdom." *New York Times Magazine* (8 July 1973), pp. 10–11, 29, 32, 34, 37–38, 40.

Bruzeau, M. "Avec Calder." *Arts PTT*, no. 67 (March 1974). Photographs by J. Berteau.

Carandente, Giovanni. "L'arte è 'mobile' qual piuma al vento." *Bolaffiarte* 5, no. 40 (May 1974), pp. 28–35.

Parinaud, André. "Calder ou le génie du mouvement." *Galerie Jardin des Arts*, no. 145 (March 1975), pp. 61–65.

Hecht, Axel. "Calder: Poesie aus Draht und Eisen." *Stern*, no. 22 (May 1975), pp. 32–40.

Könnecke, Karl-Richard. "Der Mann, Den Wir Mr. Mobile Nennen." *Schöner Wohnen*, no. 11 (November 1975), pp. 258–66.

Marter, Joan M. "Alexander Calder: Ambitious Young Sculptor of the 1930's." *Journal of the Archives of American Art* 16, no. 1 (1976), pp. 2–8.

Quintavalle, Arturo Carlo. "Calder Auto/mobiles." *Studio Marconi*, no. 3–4 (5 February 1976), pp. 1, 6–11.

Pedrosa, Mario. "Un tournant chez Calder." *Studio Marconi*, no. 3–4 (5 February 1976), pp. 12–14.

Pedrosa, Mario. "Calder: una svolta." *Studio Marconi*, no. 3–4 (5 February 1976), pp. 15–17.

Camus, Marie-Hélène. "'Sandy' Calder: Homo Sapiens/Homo Faber." *Humanité*, no. 25 (21–27 July 1976), pp. 26–30.

Kramer, Hilton. "Toys, Trivets and Serving Trays." *New York Times Magazine* (17 October 1976), pp. 70–71, 73–76. Review of exhibiton at Whitney Museum, New York.

Hughes, Robert. "Calder's Universe." *Time Magazine* (25 October 1976), p. 76. Review of exhibition at Whitney Museum, New York.

Hellman, Geoffrey T. "Calder Revisited." *New Yorker* (1 November 1976), p. 36–37. A reunion with Alexander Calder before the opening of exhibitions at Perls Galleries and the Whitney Museum.

Stevens, Mark. "Calder: Artist of the Air." *Newsweek* (22 November 1976), p. 79.

Halasz, Piri. "America's Own Version of Matisse and/or Picasso-'Sandy' Calder." *Smithsonian* 7, no. 9 (December 1976), pp. 74–81.

Updike, John. "Calder's Hands." *New Yorker* (6 December 1976).

Schulze, Franz. "A Refrain for Alexander Calder (1898–1976)." *Art News* (January 1977), p. 48.

Goeritz, Mathías. "Recordando a Calder." *Obras* 4, no. 50 (February 1977), pp. 24–28. Calder on the cover.

Fujieda, Teruo. "Alexander Calder: Moving Sculpture and the Art of 'Movement.'" *Bijutsu Techo* (Japan) 29, no. 417 (February 1977), pp. 9–124. Authors contributing to this special issue on Calder: Tatsuo Knodon, Yusuko Nahahara, and Masakazu Horiuchi. Article includes comments on *Calder's Universe* at the Whitney Museum.

Goldin, Amy. "Alexander Calder, 1898–1976." *Art in America* 65, no. 2 (March–April 1977), pp. 70–73.

Franqui, Carlos. "Calder dans une de ses 'constellations.'" *XXᵉ siècle (new series)* 39, no. 48 (June 1977), pp. 140–141.

Sert, Josep Lluis. "Alexander Calder: 1898–1976." *Proceedings of the American Academy of Arts and Letters*, 2nd series, vol. 28 (1978). The tribute to Calder

was read at a meeting on 2 December 1977, and was published in the proceedings.

Marter, Joan M. "Alexander Calder at the Art Students League." *American Art Review* 4, no. 5 (May 1978), pp. 54–61, 117–18.

Marter, Joan M. "Alexander Calder: Cosmic Imagery and the Use of Scientific Instruments." *Arts Magazine* 53, no. 2 (October 1978), pp. 108-13.

Marter, Joan M. "Alexander Calder's Stabiles: Monumental Public Sculpture in America." *American Art Journal*, no. 11 (July 1979). pp. 75–85.

Review. *Bijutsu Techo* (Japan) 31, no. 456 (November 1979), pp. 150–65. Review of exhibition at Seibu Museum of Art, Tokyo.

Lelong, Daniel. "Calder: Comment piéger le mouvement?" *Beaux-Arts Magazine*, no. 4 (July–August 1983). pp. 48–55, 96. Review of exhibition at Palazzo a Vela, Turin.

Mattick, Paul Jr. "The Intimate World of Alexander Calder." *American Craft* 50, no. 2 (April/May 1990), pp. 52–59. Review of exhibition at Cooper-Hewitt National Design Museum, Smithsonian Institution, New York.

Pierre, Arnauld. "Mouvement et réalité dans l'oeuvre de Calder: une interprétation." *Les Cahiers du Musée National d'Art Moderne*, no. 47 (Spring 1994). pp. 57–75.

Calder. Special issue of *Connaissance des Arts*, 90 (July 1996). Published on occasion of Calder's solo exhibition at Musée d'Art Moderne de la Ville de Paris. Essays by Michael Gibson, Harry Bellet, and René Viau.

Charpin, Catherine. "Le Cirque Calder." *Arts de la Piste*, no. 4 (November 1996), pp. 10–11.

"Alexander Calder: Un Artista Juguetón." *Saber ver*, no. 6 (February–March 1997), pp. 1–33.

Maselllo, "The Amazing Calder." *Art & Antiques* 21, no. 5 (May 1998) pp. 73–77. Review of exhibition at National Gallery of Art, Washington, D.C.

Hughes, Robert. "The Merry Modernist." *Time Magazine* 151, no. 17 (4 May 1998). Review of exhibition at National Gallery of Art, Washington, D.C.

Marter, Joan. "The Legacy of Alexander Calder." *Sculpture* 17, no. 6 (July/August 1998), pp. 30–35.

Flescher, Sharon. "Calder's Artistic Development and Authenticity: An IFAR Evening with Sandy Rower." *IFAR Journal* 3, no. 2 (Spring 2000), pp. 18–22.

Tuchman, Phyllis. "Calder's Playful Genius." *Smithsonian Magazine* 32, no. 2 (May 2001), pp. 82–92.

Schjeldahl, Peter "Calder in Bloom." *New Yorker* (18 & 25 June 2001), pp. 166–68.

Group Exhibition Catalogues

New York Society of Independent Artists, Waldorf-Astoria, New York. *The Ninth Annual Exhibition of the Society of Independent Artists*. 6–29 March 1925.

New York Society of Independent Artists, Waldorf-Astoria, New York. *Tenth Annual Exhibition of the Society of Independent Artists*. 5–28 March 1926.

Anderson Galleries, Whitney Studio Club, New York. *The Whitney Studio Club Eleventh Annual Exhibition of Paintings and Sculpture by Members of the Whitney Studio Club*. 8–20 March 1926.

Salon de la Société des Artistes Indépendants. Paris. 20 January–29 February 1928.

New York Society of Independent Artists, Waldorf-Astoria, New York. *Twelfth Annual Exhibition of the Society of Independent Artists*. 9 March–1 April 1928.

Galleries of Jacques Seligmann, Ancien Hôtel de Sagan, Paris. *The Salon of American Artists*. 2–13 July 1928.

Salon de la Société des Artistes Indépendants. Grand Palais, Paris. *40ème Exposition Annuelle*. 18–28 January 1929.

Harvard Society of Contemporary Art, Cambridge, Massachusetts. *An Exhibition of Painting and Sculpture by the School of New York*. 17 October–1 November 1929.

Galerie G. L. Manuel Frères, Paris. *XIe Salon de l'Araignée*. (January–February 1930).

Salon de la Société des Artistes Indépendants, Paris. 17 January–2 March 1930.

Parc des Expositions, Porte de Versailles, Paris. *Association Artistique les Surindépendants*. 25 October–24 November 1930.

Museum of Modern Art, New York. *Painting and Sculpture by Living Americans*. 2 December 1930–20 January 1931.

Parc des Expositions, Porte de Versailles, Paris. *Association Artistique les Surindépendants*. 23 October–22 November 1931.

Muzeum Sztuki w Lodzi / Museum of New Art, Lodz, Poland. *Miedzynarodowa Kolekcja Sztuki Nowoczesnej / Collection Internationale d'Art Nouveau*. 1932.

Parc des Expositions, Porte de Versailles, Paris. 1940. 15 January–1 February 1932.

Galerie Vignon, Paris. *Exposition de dessins*. 15–28 January 1932.

Galerie Pierre, Paris. *Arp, Calder, Hélion, Miró, Pevsner, and Seligmann*. 9–24 June 1933. 47 pp. Text by Anatole Jakovski.

Berkshire Museum, Pittsfield, Massachusetts. *Modern Painting and Sculpture: Alexander Calder, George L. K. Morris, Calvert Coggeshall, Alma de Gersdorff Morgan*. 12–25 August 1933 (extended to 27 August). 8 pp. Statement by Alexander Calder (pp. 2–3).

Renaissance Society of the University of Chicago, Chicago. *A Selection of Works by Twentieth Century Artists*. 20 June–20 August 1934. 32 pp.

Museum of Modern Art, New York. *Modern Works of Art: Fifth Anniversary Exhibition*. 20 November 1934–20 January 1935. 152 pp.

Wadsworth Atheneum, Hartford, Connecticut. *American Painting and Sculpture of the 18th, 19th & 20th Centuries*. 29 January–19 February 1935.

Kunstmuseum, Luzern, Switzerland. *Thèse, antithèse, synthèse*. 24 February–31 March 1935.

Art Institute of Chicago, Chicago. *The Fourteenth International Exhibition of Water Colors, Pastels, Drawings and Monotypes*. 21 March–2 June 1935.

Albright Art Gallery, Buffalo Fine Arts Academy, Buffalo, New York. *Art of Today*. 3–31 January 1936.

Museum of Modern Art, New York. *Cubism and Abstract Art*. 2 March–19 April 1936. 250 pp.

Gallery of Living Art at the Paul Reinhardt Galleries, New York. *Five Contemporary American Concretionists: Biederman, Calder, Ferren, Morris, Shaw*. 9–31 March 1936. 11 pp. Text by A. E. Gallatin.

Museum of Modern Art, New York. *Modern Painters and Sculptors as Illustrators*. 27 April–12 September 1936.

Charles Ratton Gallery, Paris. *Exposition surréaliste d'objets.* 22–29 May 1936. 8 pp. Text by André Breton.

Museum of Modern Art, New York. *Fantastic Art, Dada and Surrealism.* 7 December 1936–17 January 1937. 250 pp. Preface by Alfred H. Barr, Jr.

Kunsthalle, Basel, Switzerland. *Konstruktivisten.* 16 January–14 February 1937.

Artek Gallery, Helsinki. *Fernand Léger/Alexander Calder.* 29 November–12 December 1937.

Stedelijk Museum, Amsterdam. *Tentoonstelling Abstracte Kunst.* 2–24 April 1938.

Musée du Jeu de Paume, Paris. *Trois siècles d'art aux États-Unis.* 24 May–31 July 1938. 200 pp. Exhibition in collaboration with Museum of Modern Art, New York. Preface by Jean Zay; foreword by A. Conger Goodyear; texts by Alfred H. Barr, Jr., John McAndrew, Beaumont Newhall, Iris Barry.

São Paulo, Brazil. 3rd *Salão de Maio.* 1939. 142 pp.

Division of Decorative Arts, Department of Fine Arts, San Francisco. *Golden Gate International Exposition, Decorative Arts.* 18 February–30 October 1939.

Division of Contemporary Painting and Sculpture, Department of Fine Arts, San Francisco. *Golden Gate International Exposition, Contemporary Art.* 18 February–30 October 1939.

Arts and Crafts Club of New Orleans, New Orleans, Louisiana. *Alexander Calder: Mobiles/Jewelry and Fernand Léger: Gouaches/Drawings.* 28 March–11 April 1941. 4 pp.

Arts Club of Chicago, Chicago. *Nine American Artists.* 3–28 February 1942. 4 pp.

Helena Rubinstein Building, New York. *Masters of Abstract Art.* 1 April–15 May 1942.

Cincinnati Art Museum, Cincinnati, Ohio. *Paintings by Paul Klee and Mobiles and Stabiles by Alexander Calder.* 7 April–3 May 1942. 16 pp.

Reid-Whitelaw Mansion, New York. *First Papers of Surrealism.* 14 October–7 November 1942.

Whitney Museum of American Art, New York. *Annual Exhibition of Contemporary Art.* 24 November 1942–6 January 1943.

Metropolitan Museum of Art, New York. *Artists for Victory: An Exhibition of Contemporary American Art.* 7 December 1942–22 February 1943.

Whitney Museum of American Art, New York. *Annual Exhibition of Contemporary American Art.* 23 November 1943–4 January 1944.

Renaissance Society, University of Chicago, Chicago. *Drawings by Contemporary Artists.* 20 May–19 June 1944. 4 pp.

Museum of Modern Art, New York. *Art in Progress, The Fifteenth Anniversary of the Museum of Modern Art.* 23 May–7 October 1944. 256 pp. Texts by James Thrall Soby, Alfred H. Barr, Jr., Nancy Newhall, George Amberg, Iris Barry, Elizabeth Mock, Serge Chermayeff and René D'Harnoncourt, Monroe Wheeler, Elodie Courter, Victor D'Amico.

San Francisco Museum of Art, San Francisco. *Abstract and Surrealist Art in the United States.* 6–24 September 1944.

Whitney Museum of American Art, New York. *Annual Exhibition of Contemporary American Sculpture, Watercolors, and Drawings.* 3 January–8 February 1945.

Buchholz Gallery / Curt Valentin, New York. *Recent Work by American Sculptors.* 6–24 February 1945.

Detroit Institute of Arts, Detroit, Michigan. *Origins of Modern Sculpture.* 22 January–3 March 1946. 11 pp.

St. Louis Art Museum, St. Louis, Missouri. *Origins of Modern Sculpture.* 30 March–1 May 1946 (extended to 15 May). 33 pp.

Cincinnati Modern Art Society, Cincinnati, Ohio. *4 Modern Sculptors: Brancusi, Calder, Lipchitz, Moore.* 1 October–15 November 1946. 16 pp.

Kunsthalle, Bern, Switzerland. *Calder, Léger, Bodmer, Leuppi.* 4–26 May 1947. 16 pp.

Palais des Papes, Avignon. *Exposition de peintures et sculptures contemporaines.* 27 June–30 September 1947. 92 pp. Texts by Ferand Léger, Christian Zervos.

Stedelijk Museum, Amsterdam. *Alexander Calder / Fernand Léger.* 19 July–24 August 1947. 16 pp.

Galerie Maeght, Paris. *Le Surréalisme en 1947.* (7 July 1947).

Venice. 24th *Biennale di Venezia.* 6 June–30 September 1948.

Museu de Arte Moderna, São Paulo, Brazil. *Do Figurativismo ao Abstracionismo.* 8–31 March 1949. 135 pp. Introduction by Sergio Milliet; text by Léon Dégand.

Stedelijk Museum, Amsterdam. *Surréalisme + Abstraction.* 19 January–26 February 1951. 72 pp.

Museum of Modern Art, New York. *Abstract Painting and Sculpture in America.* 23 January–25 March 1951. 160 pp. Text by Andrew Carnduff Ritchie.

Contemporary Arts Museum of Houston, Houston, Texas. *Calder-Miró.* 14 October–4 November 1951. 20 pp. Text by Mary Gershinowitz.

Museo de Arte Moderna, São Paulo, Brazil. 1st *Bienal do Museu de Arte Moderna de Sao Paulo.* 20 October–December 1951.

Venice. 26th *Biennale di Venezia.* 14 June–19 October 1952. Introduction by Rodolfo Pallucchini; text by James Johnson Sweeney (excerpt from MoMA 1943).

Moderne Galerie Otto Stangl, Munich, Germany. *Alexander Calder/Joan Miró.* 18 July–28 August 1952.

Hanna Bekker vom Rath/Frankfurter Kunstkabinett, Frankfurt am Main, Germany. *Alexander Calder, Paul Fontaine, Louise Rösler.* 22 February–22 March 1953.

Musée National d'Art Moderne, Paris. *12 Peintres et Sculpteurs Américains Contemporains.* 24 April–7 June 1953. 54 pp.

Wadsworth Atheneum, Hartford, Connecticut. *Alexander Calder: Mobiles / Naum Gabo: Kinetic Constructions and Constructions in Space.* 16 October–28 November 1953. 27 pp. Text by Charles E. Buckley.

Galerie Denise René, Paris. *Le Mouvement.* 6 April–15 May 1955.

Museum Fridericianum, Kassel, Germany. *Documenta: Internationale Ausstellung.* 15 July–18 September 1955. 128 pp.

World House Galleries, New York. *4 Masters Exhibition: Rodin, Brancusi, Gauguin, Calder.* 28 March–20 April 1957. 14 pp. Statement by Alexander Calder.

Brussels World's Fair, Brussels. *American Art: Four Exhibitions.* 17 April–18 October 1958. 92 pp.

Carnegie Institute, Department of Fine Arts, Pittsburgh, Pennsylvania. *The 1958 Pittsburgh Bicentennial International Exhibition of Contemporary Painting and Sculpture.* 5 December 1958–8 February 1959. 150 pp.

Museum Fridericianum, Orangerie, Bellvueschlos, Kassel, Germany. *Documenta 2. Kunst nach 1945: Malerei,*

Skulptur, Druckgrafik internationale Ausstellung. 11 July–11 October 1959. 71 pp.

Perls Galleries, New York. *Alexander Calder/Joan Miró.* 21 February–1 April 1961. 12 pp. Texts by Joan Miró and Alexander Calder.

Stedelijk Museum, Amsterdam. *Bewogen-Beweging.* 10 March–17 April 1961. 45 pp.

Galerie d'Art Moderne, Basel, Switzerland. *Arp / Calder / Marini.* 11 May–30 September 1963. 32 pp.

Alte Galerie, Museum Fridericianum, and Orangerie, Kassel, Germany. *Documenta/3: Malerei und Skulptur.* 27 June–5 October 1964. 417 pp.

Grosvenor Gallery, London. *Miró: Graphics, Calder: Mobiles, Ch'i Pai-shih: Paintings.* 28 October–20 November 1964.

Brook Street Gallery, London. *Vasarely / Calder.* July–September 1965. 18 pp.

Chateau de Ratilly, Nièvre, France. *Calder / Bazaine.* 19 June–10 September 1970. 32 pp. Text by Jean-Paul Sartre (reprint from Carré 1946).

Society of the Four Arts, Palm Beach, Florida. *Alexander Calder / Louise Nevelson / David Smith.* 6 March–5 April 1971. 26 pp. Text by John Gordon.

American Academy of Arts and Letters, and National Institute of Arts and Letters, New York. *Exhibition of Work by Newly Elected Members and Recipients of Honors and Awards.* 27 May–20 June 1971.

Fuji Television Gallery Co., Ltd., Tokyo. *Calder/Miró.* 15–30 November 1972.

Galerie Beyeler, Basel, Switzerland. *Miró/Calder.* December 1972–January 1973. 80 pp. Statements by Calder and Joan Miró.

Galleria Medea, Milan. *Calder e Mathieu.* 1-20 April 1975.

Galerie Artek, Helsinki. *Calder: Mobiles, Bijoux, Lithographies / Léger: Huiles, Gouaches, Lithographies.* 15 October–2 November 1975. 8 pp.

Rutgers University Art Gallery, New Brunswick, New Jersey. *Vanguard American Sculpture 1913–1939.* 16 September–4 November 1979. Texts by Joan Marter, Roberta K. Tarbell, and Jeffrey Wechsler.

M. Knoedler & Co., Inc., New York. *Alexander Calder — Fernand Léger.* 4–27 October 1979. 24 pp. Preface by Lawrence Rubin.

New Jersey State Museum, Trenton, New Jersey. *Beyond the Plane: American Constructions 1930–1965.* 29 October–31 December 1983. 111 pp. Text by Joan Marter.

Solomon R. Guggenheim Museum, New York. *From Degas to Calder: Sculpture and Works on Paper from the Guggenheim Museum Collection.* 30 July–8 September 1984. 26 pp. Introduction by Thomas M. Messer; text by Vivian Endicott Barnett (excerpts from Barnett 1980 and Barnett 1984).

Galería Theo, Madrid, Spain. *Doce esculturas Calder / Miró diez pinturas.* 5 December 1985–January 1986. 30 pp.

Galerie Louis Carré & Cie, Paris. *Alexander Calder — Mobiles; Fernand Léger — Peintures.* 13 October–26 November 1988. 69 pp. Texts by André Parinaud, Alexander Calder and Fernand Léger.

Solomon R. Guggenheim Museum, New York. *Picasso and the Age of Iron.* 19 March–16 May 1993. 331 pp. Preface by Thomas Krens; introduction by Carmen Giménez; texts by Dore Ashton and Francisco Calvo Serraller; chronology by M. Dolores Jiménez-Blanco.

Haus der Kunst, Munich. *Elan Vital oder das Auge der Eros: Kandinsky: Klee, Arp, Miró, Calder.* 20 May–14 August 1994. 567 pp. Texts by Christoph Vitali, Gert Mattenklott, Hubertus Gafner, Vivian Endicott Barnett, Wolfgang Kersten, Denis Hollier, and Klaus Kiefer.

American Academy in Rome. *American Art in Italian Private Collections.* 27 May–30 June 1994. Introduction by Caroline Bruzelius; texts by Martha Boyden, Maurizio Calvesi, Giovanni Carandente, and Gabriella Drudi.

Grosvenor Gallery, London. *Henry Moore O.M. 1898–1986; Alexander Calder 1898–1976.* 15 March–13 April 1995. 20 pp.

Phillips Collection, Washington, D.C. *Americans in Paris (1921–1931): Man Ray; Gerald Murphy; Stuart Davis, Alexander Calder.* 27 April–18 August 1996. 171 pp. Essays by Elizabeth Hutton Turner, Elizabeth Garrity Ellis, and Guy Davenport; chronology by Leigh Bullard Weisblat.

Nassau County Museum of Art, Roslyn Harbor, New York. *Calder and Miró.* 7 June–13 September 1998. 80 pp. Essay by Constance Schwartz.

Galería Elvira González, Madrid. *Alexander Calder / Yves Tanguy.* 21 Jaunuary–27 February 1999. 40 pp.

Montreal Museum of Fine Arts, Canada. *Cosmos.* 17 June–17 October 1999.

PaceWildenstein, New York. *Earthly Forms: The Biomorphic Sculpture of Arp, Calder, Noguchi.* 18 February–20 March 2000. 66 pp. Essay by Marc Glimcher.

Wadsworth Atheneum, Hartford, Connecticut. *Images from the World Between: The Circus in 20th Century American Art.* 19 October 2001–6 January 2002. 184 pp. Essays by Donna Gustafson, Ellen Handy, Karal Ann Marling, Eugene R. Gaddis, and Lee Siegal.

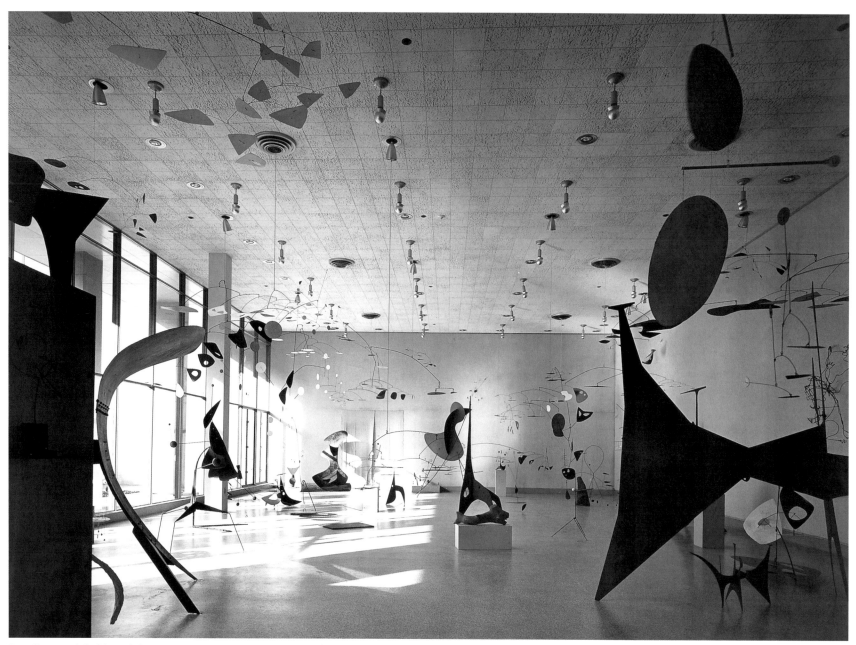

Installation of *Calder* exhibition at Massachusetts Institute of Technology, Cambridge, 1950 / Photo: Ezra Stoller

EXHIBITION HISTORY

Alexander S. C. Rower

Solo Exhibitions

1927

Galleries of Jacques Seligmann, Paris. [*Calder*].
August 1927.

1928

Weyhe Gallery, New York. *Wire Sculpture by Alexander
Calder*. 20 February–3 March 1928.

1929

Galerie Billiet–Pierre Vorms, Paris. *Sculptures bois et fil de
fer de Alexander Calder*. 25 January–7 February 1929.
Catalogue.

Weyhe Gallery, New York. *Wood Carvings by Alexander
Calder*. 4–23 February 1929.

Galerie Neumann-Nierendorf, Berlin, Germany.
Alexander Calder: Skulpturen aus Holz und aus Draht.
1–15 April 1929. Catalogue.

Fifty-Sixth Street Galleries, New York. *Alexander Calder:
Paintings, Wood Sculpures, Toys, Wire Sculptures,
Jewelry, Textiles*. 2–14 December 1929. Catalogue.

1930

Harvard Society for Contemporary Art, Harvard
Cooperative Building, Room 207, Cambridge,
Massachusetts. *Wire Sculpture by Alexander Calder*.
27 January–4 February 1930. Calder performed the
Cirque Calder on 31 January 1930.

1931

Galerie Percier, Paris. *Alexander Calder: Volumes –
Vecteurs – Densités / Dessins – Portraits*. 27 April–9 May
1931. Catalogue.

1932

Galerie Vignon, Paris. *Calder: ses mobiles*.
12–20 February 1932.

Julien Levy Gallery, New York. *Calder: Mobiles / Abstract
Sculptures*. 12 May–11 June 1932.

1933

Amics de l'Art Nou, Galeries Syra, Barcelona, Spain.
[*Calder*]. February 1933.

Sociedad de Cursos y Conferencias, Residencia de
Estudiantes, Madrid, Spain. [*Calder*]. February 1933.

Galerie Pierre Colle, Paris. *Présentation des oeuvres
récentes de Calder*. 16–18 May 1933.

1934

Pierre Matisse Gallery, New York. *Mobiles by Alexander
Calder*. 6–28 April 1934.

1935

The Renaissance Society of the University of Chicago.
Mobiles by Alexander Calder. 14–31 January 1935.
Curated by James Johnson Sweeney. Calder performed
the *Cirque Calder* on 16, 17, 20, and 24 January.

Arts Club of Chicago. *Mobiles by Alexander Calder*.
1–26 February 1935. Curated by James Johnson Sweeney.

1936

Pierre Matisse Gallery, New York. *Mobiles and Objects by
Alexander Calder*. 10–29 February 1936.

Avery Memorial, Hartford, Connecticut. *Calder Mobiles*.
April 1936.

Vassar College, Poughkeepsie, New York. *Sculpture by
Alexander Calder*. 5 May–8 June 1936.

1937

Pierre Matisse Gallery, New York. *Stabiles and Mobiles*.
23 February–13 March 1937.

Mayor Gallery, London. *Calder: Mobiles and Stabiles*.
1–24 December 1937.

Antheil Gallery, Hollywood, California. [*Calder*]. [1937].

1938

George Walter Vincent Smith Gallery, Springfield,
Massachusetts. *Calder Mobiles*. 8–27 November 1938.
Catalogue.

Artek Gallery, Helsinki. *Alexander Calder: Jewelry*.
December 1938.

1939

Pierre Matisse Gallery, New York. *Calder Mobiles —
Stabiles*. 9–27 May 1939. Catalogue.

1940

Pierre Matisse Gallery, New York. *Calder*. 14 May–1 June 1940.

Home of Mr. & Ms. Wallace K. Harrison, Huntington,
Long Island. [*Sculptures*]. 11–14 October 1940.

Willard Gallery, New York. *Calder Jewelry*.
3–25 December 1940.

1941

Pierre Matisse Gallery, New York. *Alexander Calder:
Recent Works*. 27 May–14 June 1941. Catalogue.

San Francisco Museum of Art. *Mobiles by Alexander
Calder, Stabiles and Jewelry*. 4–19 November 1941.

Willard Gallery, New York. *Calder Jewelry*.
8–25 December 1941.

Harnden Gallery, Hollywood, California. [*Calder*]. [1941].

1942

Pierre Matisse Gallery, New York. *Calder: Recent Work*.
19 May–6 June 1942 (extended to 12 June).

France Forever (The Fighting French Committee in the
United States), Washington, D.C. *Calder*. 14 October
1942.

Arts Club of Chicago. *Calder Drawings*.
6–27 November 1942.

Willard Gallery, New York. *Calder Drawings*.
1–24 December 1942. Originated from Arts Club of
Chicago, 6–27 November 1942.

1943

Pierre Matisse Gallery, New York. *Calder: Constellationes*.
15 May–15 June 1943.

Addison Gallery of American Art, Andover, Massachusetts.
17 Mobiles by Alexander Calder. 28 May–6 July 1943.
Catalogue. Concurrent with an exhibition of work by
Maud and Patrick Morgan.

Museum of Modern Art, New York. *Alexander Calder*.
29 September–28 November 1943 (extended to
16 January 1944). Curated by James Johnson Sweeney
in collaboration with Marcel Duchamp. Catalogue.

Arts Club of Chicago. *Jewelry by Alexander Calder*.
3–27 December 1943.

1944

France Forever (The Fighting French Committee in the
United States) Washington, D.C. *Calder: Paintings,
Mobiles, Stabiles and Jewelry*. 27 March–9 April 1944.
Calder performed the *Cirque Calder* on 25–26 March.

Buchholz Gallery/Curt Valentin, New York. *Recent Works
by Alexander Calder*. 28 November–23 December 1944.
Catalogue.

San Francisco Museum of Art. *Alexander Calder:
Watercolors*. 28 December, 1944–16 January 1945.

1945

Samuel M. Kootz Gallery, New York. *Calder Gouaches*.
September–6 October 1945.

Buchholz Gallery/Curt Valentin, New York. *Alexander
Calder*. 13 November–1 December 1945. Catalogue.

1946

Galerie Louis Carré, Paris. *Alexander Calder: Mobiles,
Stabiles, Constellations*. 25 October–16 November 1946.
Catalogue.

1947

Portland Art Museum, Oregon. [*Alexander Calder
Mobiles*]. 7–29 January 1947.

San Francisco Museum of Art. [*Alexander Calder*].
17 February–16 March 1947.

Mattatuck Historical Society, Waterbury, Connecticut.
Alexander Calder. 10–28 March 1947. Catalogue.

The Stable, New Haven, Connecticut. *Alexander Calder*.
26 May 1947.

Buchholz Gallery/Curt Valentin, New York. *Alexander
Calder*. 9–27 December 1947. Catalogue.

Chicago, Boyd-Britton Associates. [*Calder*]. [1947].

1948

Museu de Arte Moderna do Rio de Janeiro, Ministerio da
Educaçao e Saude, Rio de Janeiro. *Alexander Calder*.
September 1948. Catalogue.

Museo de Arte Moderna, São Paulo, Brazil. *Alexander
Calder*. October–November 1948.

Institute of Contemporary Arts, Washington, D.C.
[*Calder*]. [1948].

Buchholz Gallery/Curt Valentin, New York. *Alexander Calder
Recent Mobiles, 1948*. 11 December 1948–3 January 1949.

1949

Margaret Brown Gallery, Boston. *Calder*. 25 October–
12 November 1949.

Buchholz Gallery/Curt Valentin, New York. *Calder*.
30 November–17 December 1949. Catalogue.

1950

Galerie Maeght, Paris. Calder: *Mobiles and Stabiles*.
30 June–27 July 1950. Catalogue. Traveled to Stedelijk
Museum, Amsterdam; Galerie Blanche, Stockholm; The
Lefevre Gallery, London; Neue Galerie, Vienna.

Stedelijk Museum, Amsterdam. *Alexander Calder*.
6 October–15 November 1950. Catalogue. Originated
from Galerie Maeght, Paris, 30 June–27 July 1950.

Galerie Blanche, Stockholm. *Alexander Calder: Mobiles
and Stabiles*. December 1950. Catalogue. Originated
from Galerie Maeght, Paris, 30 June–27 July 1950.

New Gallery, Charles Hayden Memorial Library,
Massachusetts Institute of Technology, Cambridge.
Calder. 5 December 1950–14 January 1951. Curated by
James Johnson Sweeney.

Institute of Contemporary Arts, Washington, D.C.
[*Calder*]. [1950].

1951

Lefevre Gallery, London. *Mobiles and Stabiles by
Alexander Calder*. January 1951. Catalogue. Originated
from Galerie Maeght, Paris, 30 June–27 July 1950.

Institute of Contemporary Arts, Washington, D.C.
Sculptures by Alexander Calder. 17 April–2 June 1951.

Neue Galerie, Vienna. *Alexander Calder*. 10 May–15 June
1951. Catalogue. Originated from Galerie Maeght, Paris,
30 June–27 July 1950.

1952

Allen Memorial Art Museum, Oberlin, Ohio. *Calder
Mobiles*. 15 January–5 February 1952.

Curt Valentin Gallery, New York. *Alexander Calder:
Gongs and Towers*. 15 January–10 February 1952.
Catalogue.

Margaret Brown Gallery, Boston. *Alexander Calder: Gongs
and Towers*. 10–29 March 1952.

Galerie Maeght, Paris. *Alexander Calder: Mobiles*.
6–10 May 1952.

Galerie Parnass, Wuppertal, Germany. *Calder Mobile*.
5–20 June 1952. Catalogue. Traveled to Galerie Rudolf

Hoffmann, Hamburg, Germany; Moderne Galerie Otto Stangl, Munich, Germany; Overbeckgesellschaft, Lübeck, Germany; Württembergischer Kunstverein und der Staatsgalerie, Stuttgart, Germany; Galerie der Spiegel, Cologne, Germany; Galerie Springer, Berlin; Galerie Otto Ralfs in cooperation with the Städtisches Museum, Braunschweig, Germany; Hanna Bekker vom Rath/Frankfurter Kunstkabinett, Frankfurt am Main, Germany; Karl-Ernst-Osthaus-Museum, Hagen, Germany; Galerie Hella Nebelung, Düsseldorf, Germany; Museum am Ostwall, Dortmund, Germany; Studio für zeitgenössische Kunst, Kaiser Wilhelm Museum, Krefeld, Germany.

Galerie Rudolf Hoffmann, Hamburg, Germany. *Alexander Calder: Mobiles — Stabiles.* 28 June–15 July 1952. Originated from Galerie Parnass, Wuppertal, Germany, 5–20 June 1952.

Moderne Galerie Otto Stargl, Munich, Germany, 18 July–28 August, 1952. Originated from Galerie Parnass, Wuppertal, Germany, 5–20 June 1952.

Overbeckgesellschaft, Lübeck, Germany. [*Alexander Calder*]. 30 August–14 September 1952. Originated from Galerie Parnass, Wuppertal, Germany, 5–20 June 1952.

Württembergischer Kunstverein und der Staatsgalerie, Stuttgart, Germany. *Mobiles.* 25 September–15 October 1952. Originated from Galerie Parnass, Wuppertal, Germany, 5–20 June 1952.

Galerie der Spiegel, Cologne, Germany. *Alexander Calder — Mobile.* 16 October–29 November 1952. Originated from Galerie Parnass, Wuppertal, Germany, 5–20 June 1952.

Galerie Springer, Berlin, Germany. *Alexander Calder: Mobile.* 1 December, 1952–6 January 1953. Originated from Galerie Parnass, Wuppertal, Germany, 5–20 June 1952.

1953

Galerie Otto Ralfs in cooperation with the Städtisches Museum, Braunschweig, Germany. *Alexander Calder USA: Mobile.* 22 January–18 February 1953. Originated from Galerie Parnass, Wuppertal, Germany, 5–20 June 1952.

Hanna Bekker vom Rath/Frankfurter Kunstkabinett, Frankfurt am Main, Germany. 22 February–22 March 1953.

Originated from Galerie Parnass, Wuppertal, Germany, 5–20 June 1952.

Karl-Ernst-Osthaus-Museum, Hagen, Germany. *Alexander Calder Mobile.* 22 March–19 April 1953. Originated from Galerie Parnass, Wuppertal, Germany, 5–20 June 1952.

Walker Art Center, Minneapolis, Minnesota. *Alexander Calder Mobiles.* 22 March–19 April 1953. Traveled to Frank Perls Gallery, Beverly Hills, San Francisco Museum of Art.

Galerie Hella Nebelung, Düsseldorf, Germany. *Alexander Calder (USA) Mobile.* 3–28 May 1953. Originated from Galerie Parnass, Wuppertal, Germany, 5–20 June 1952.

Frank Perls Gallery, Beverly Hills. *Alexander Calder Mobiles.* 11 May–13 June 1953. Originated from Walker Art Center, Minneapolis, Minnesota, 22 March–19 April 1953.

Museum am Ostwall, Dortmund, Germany. [*Alexander Calder*]. 6–30 June, 1953. Originated from Galerie Parnass, Wuppertal, Germany, 5–20 June 1952.

Studio für zeitgenössische Kunst, Kaiser Wilhelm Museum, Krefeld, Germany. *Alexander Calder: Mobiles. Drahtplastiken als Mobiles. Blechplättchenspiel der Mobiles.* 5–26 July, 1953. Originated from Galerie Parnass, Wuppertal, Germany, 5–20 June 1952.

San Francisco Museum of Art. *Mobiles by Alexander Calder.* 4–27 September 1953. Originated from Walker Art Center, Minneapolis, Minnesota, 22 March–19 April 1953.

1954

American University, Beirut. *Alexander Calder.* February 1954.

Kestner Gesellschaft, Hannover, Germany. *Alexander Calder: Stabiles, Mobiles, Gouachen.* 18 March–2 May 1954. Catalogue.

Galerie des Cahiers d'Art, Paris. *Gouaches récentes de Calder.* 5–29 May 1954.

Galerie Rudolf Hoffmann, Hamburg, Germany. *Calder.* 12–30 June 1954. Catalogue.

Galerie Maeght, Paris. *Aix. Saché. Roxbury. 1953–54.* 13 November–15 December 1954. Catalogue.

1955

The Lefevre Gallery, London. *Mobiles by Calder.* January 1955. Catalogue.

Jehangir Art Gallery, Bombay. 25 March 1955.

Robinson Hall, Graduate School of Design, Harvard University, Cambridge, Massachusetts. *Calder.* 25 April–25 May 1955.

Curt Valentin Gallery, New York. *Alexander Calder.* 17 May–4 June 1955. Catalogue.

Museo de Bellas Artes, Caracas, Venezuela. *Exposiciòn Calder.* 11–25 September 1955. Catalogue.

Milwaukee Art Institute, Wisconsin. *Calder Mobiles and Stabiles.* 9 December 1955–19 January 1956. Traveled to Memorial Union Gallery, University of Wisconsin, Madison; Sioux City Art Center, Iowa; Beloit College, Wisconsin; University of Michigan Museum of Art, Alumni Memorial Hall, Ann Arbor; Northern Illinois State College, Department of Fine Arts, DeKalb; South Bend Art Association, Indiana; Museum of Art, University of Kansas, Lawrence; Fort Wayne Art School and Museum, Indiana.

1956

Perls Galleries, New York. *Calder.* 6 February–10 March 1956.

Memorial Union Gallery, University of Wisconsin, Madison. *Calder Mobiles and Stabiles.* 16 February–5 March 1956. Organized by Wisconsin Union Gallery Committee. Originated from Milwaukee Art Institute, Wisconsin, 9 December 1955–19 January 1956.

Galleria dell'Obelisco, Rome. *Calder.* 14–31 March 1956.

Sioux City Art Center, Iowa. *Calder Mobiles and Stabiles.* 26 March–13 April 1956. Originated from Milwaukee Art Institute, Wisconsin, 9 December 1955–19 January 1956.

Galleria d'Arte del Naviglio, Milan. *Calder.* 7–17 April 1956.

Galerie Lucie Weill, Paris. *Calder.* 3–26 May 1956.

Beloit College, Wisconsin. *Calder Mobiles and Stabiles.* 8 May–10 June 1956. Originated from Milwaukee Art Institute, Wisconsin, 9 December 1955–19 January 1956.

Circolo della Cultura e delle Arti, Trieste, Italy. *Calder.* 23 June–7 July 1956.

Davison Art Center, Wesleyan University, Middletown, Connecticut. [*Calder*]. 28 June–31 August 1956.

Musée Picasso, Château Grimaldi, Antibes. *Gouaches — Dessins — Mobiles de Calder.* 1 August–1 October 1956.

University of Michigan Museum of Art, Alumni Memorial Hall, Ann Arbor. *Calder Mobiles and Stabiles.* 16 September–14 October 1956. Originated from Milwaukee Art Institute, Wisconsin, 9 December 1955–19 January 1956.

Institute of Contemporary Art, Boston. *Jewelry and Drawings by Alexander Calder.* 18 October–21 November 1956.

Northern Illinois State College, Department of Fine Arts, DeKalb. *Calder Mobiles and Stabiles.* 29 October–19 November 1956. Originated from Milwaukee Art Institute, Wisconsin, 9 December 1955–19 January 1956.

South Bend Art Association, Indiana. *Calder Mobiles and Stabiles.* 30 November–25 December 1956. Originated from Milwaukee Art Institute, Wisconsin, 9 December 1955–19 January 1956.

1957

Museum of Art, University of Kansas, Lawrence. *Calder Mobiles and Stabiles.* 10–30 January 1957. Originated from Milwaukee Art Institute, Wisconsin, 9 December 1955–19 January 1956.

Fort Wayne Art School and Museum, Indiana. *Calder Mobiles and Stabiles.* 10 February–3 March 1957. Originated from Milwaukee Art Institute, Wisconsin, 9 December 1955–19 January 1956.

Frank Perls Gallery, Beverly Hills, California. *Alexander Calder.* 18 February–16 March 1957.

Kunsthalle Basel, Switzerland. *Alexander Calder.* 22 May–23 June 1957. Curated by Arnold Rüdlinger. Catalogue. Traveled to Städelsches Kunstinstitut, Frankfurt, Germany.

Städelsches Kunstinstitut, Frankfurt, Germany. *Alexander Calder.* 17 July–25 August 1957. Catalogue. Originated from Kunsthalle Basel, Switzerland, 22 May–23 June 1957.

1958

Corcoran Gallery, Washington, D.C. *Contemporary American Artists Series #27: Alexander Calder.* 25 January–2 March 1958.

Galerie Artek, Helsinki. *Alexander Calder: Exposition.* 29 January–2 June 1958. Catalogue.

Perls Galleries, New York. *Calder, Recent Works.* 10 February–8 March 1958.

Galerie Blanche, Stockholm. *Alexander Calder: Mobiles and Stabiles.* 1958.

1959

Galerie Maeght, Paris. *Calder: Stabiles.* 6 March–13 April 1959. Catalogue.

Stedelijk Museum, Amsterdam. *Alexander Calder, Stabilen, Mobilen.* 15 May–22 June 1959. Catalogue. Traveled to Kunsthalle Hamburg, Germany; Museum Haus Lange, Krefeld, Germany; Kunsthalle Mannheim, Germany; Haus der Jugend, Wuppertal-Barmen, Germany; Palais des Beaux-Arts, Brussels; Kunstgewerbemuseum, Zürich.

Kunsthalle Hamburg, Germany. *Calder: Stabiles 1957–59, Mobiles 1956–58.* 18 July–30 August 1959. Catalogue. Originated from Stedelijk Museum, Amsterdam, 15 May–22 June 1959.

Museum Haus Lange, Krefeld, Germany. *Alexander Calder, Stabilen, Mobilen.* 13 September–25 October 1959. Catalogue. Originated from Stedelijk Museum, Amsterdam, 15 May–22 June 1959.

Museu de Arte Moderna do Rio de Janeiro. *Alexander Calder: Escultura, Guache.* 23 September–25 October 1959. Catalogue.

Kunsthalle Mannheim, Germany. *Alexander Calder, Stabilen, Mobilen.* 7 November–13 December 1959. Catalogue. Originated from Stedelijk Museum, Amsterdam, 15 May–22 June 1959.

1960

Haus der Jugend, Wuppertal-Barmen, Germany. *Alexander Calder, Stabilen, Mobilen.* 10 January–21 February 1960. Catalogue. Originated from Stedelijk Museum, Amsterdam, 15 May–22 June 1959.

Perls Galleries, New York. *Alexander Calder "1960".* 15 March–9 April 1960. Catalogue.

Palais des Beaux-Arts, Brussels. *Alexander Calder.* 3 April–1 May 1960. Catalogue. Originated from Stedelijk Museum, Amsterdam, 15 May–22 June 1959.

Kunstgewerbemuseum, Zürich. *Kinetische Kunst: Alexander Calder, Mobiles und Stabiles aus den letzten Jahren.* 21 May–26 June 1960. Catalogue. Originated from Stedelijk Museum, Amsterdam, 15 May–22 June 1959.

1961

Katonah Gallery, New York. *Alexander Calder.* 15 October–14 November 1961.

Lincoln Gallery, London. *Alexander Calder: Gouaches.* November 1961. Curated by Nicholas Guppy. Catalogue.

Joan Peterson Gallery, Boston. *Calder.* 29 November–30 December 1961.

1962

Arkansas Arts Center, Little Rock. *The Works of Alexander Calder.* 1 March–1 April 1962.

Perls Galleries, New York. *Alexander Calder: 1962.* 20 March–21 April 1962.

Galerie Blanche, Stockholm. *Mobiles.* May–June 1962.

Galleria dell'Ariete, Milan. *Calder.* May–June 1962.

Martha Van Rensselaer Art Gallery, Cornell University of New York, Ithaca, New York. *Works of Alexander Calder.* 7 May–1 June 1962. Catalogue.

Galerie la Hune, Paris. *Michel Butor, "Cycle" sur neuf gouaches d'Alexandre Calder.* June 1962. Catalogue.

Brook Street Gallery, London. *Alexander Calder: Gouaches 1948–1962.* July 1962. Catalogue.

Arts Council of Great Britain, Tate Gallery, London. *Alexander Calder: Sculpture – Mobiles.* 4 July–12 August 1962. Curated by James Johnson Sweeney. Catalogue.

Galerie Bonnier, Lausanne. *Alexander Calder: Mobiles.* 25 October 1962.

Musée de Rennes, France. *Alexander Calder: Mobiles, Gouaches, Tapisseries.* 4 December, 1962–20 January 1963. Catalogue.

1963

Frank Perls Gallery, Beverly Hills. *Calder: Mobiles, Stabiles and Gouaches.* 13 March–12 April 1963.

Perls Galleries, New York. *Alexander Calder: 1963.* 19 March–27 April 1963. Catalogue.

Galerie Alex Vömel, Düsseldorf, Germany. *Gouachen von Calder.* May–June 1963. Catalogue.

Galerie Françoise Mayer, Brussels. [*Alexander Calder*].
18 November 1963.

Galerie Maeght, Paris. *Alexander Calder: Stabiles*.
22 November 1963. Catalogue.

1964

Galleria del Naviglio, Milan. *Alexander Calder: Gouaches
1963–1964*. 25 May–5 June 1964. Traveled to Galleria
Cavallino, Venice, 13–31 July 1964.

Galleria Cavallino, Venice. *Alexander Calder: Gouaches
1963–64*. 13–31 July 1964. Originated from Galleria del
Naviglio, Milan, 25 May–5 June 1964.

Perls Galleries, New York. *Calder: Circus, Ink Drawings
1931–1932*. 13 October–14 November 1964.

Solomon R. Guggenheim Museum, New York. *Alexander
Calder: A Retrospective Exhibition*. 6 November 1964–
31 January 1965. Catalogue. This exhibition was divided
into two parts. Part 1 traveled to Washington University
Art Gallery, St. Louis, Missouri; The Art Gallery of
Toronto. Part 2 traveled to Milwaukee Art Center,
Wisconsin; Des Moines Art Center, Iowa. Another
version of this exhibition traveled to Musée National
d'Art Moderne, Paris.

Museum of Fine Arts, Houston. *Alexander Calder: Circus
Drawings, Wire Sculpture and Toys*. 24 November–
13 December 1964. Curated by James Johnson Sweeney.
Catalogue.

1965

Makler Gallery, Philadelphia. [*Calder*]. January 1965.

Washington University Art Gallery, St. Louis, Missouri.
Alexander Calder: A Retrospective Exhibition.
21 February–26 March 1965. Catalogue. Originated from
The Solomon R. Guggenheim Museum, New York,
6 November 1964–31 January 1965.

Milwaukee Art Center, Wisconsin. *Alexander Calder:
A Retrospective Exhibition*. 25 February–28 March 1965.
Catalogue. Originated from Solomon R. Guggenheim
Museum, New York, 6 November 1964–31 January 1965.

Des Moines Art Center, Iowa. *Alexander Calder:
A Retrospective Exhibition*. 28 April–30 May 1965.
Originated from Solomon R. Guggenheim Museum,
New York, 6 November 1964–31 January 1965.

Art Gallery of Toronto. *Mobiles and Stabiles by Calder,
the Man Who Made Sculpture Move*. 1–30 May 1965.
Catalogue. Originated from Solomon R. Guggenheim
Museum, New York, 6 November 1964–31 January
1965.

Musée National d'Art Moderne, Paris. *Calder*. 8 July–
15 October 1965. Catalogue. Originated from Solomon R.
Guggenheim Museum, New York, 6 November 1964–
31 January 1965.

Laing Galleries, Toronto. *12 Calder Gouaches*.
25 September–16 October 1965.

1966

Perls Galleries, New York. [*Calder — New Works /
Mobiles, Stabiles, Gouaches*]. 12 February–12 March
1966.

Galerie Maeght, Paris. *Calder: Gouaches et Totems*.
18 February 1966. Catalogue.

Hayden Library, Massachusetts Institute of Technology,
Cambridge. [*Calder*]. April 1966.

Richard Gray Gallery, Chicago. *Alexander Calder*.
29 April–29 May 1966. Catalogue.

Lobby 7, Massachusetts Institute of Technology,
Cambridge. [*Calder*]. May 1966. Part of the dedication
ceremony for *La Grande Voile*.

Galerie Jan Krugier & Cie, Geneva. *Alexander Calder*.
9 June–30 July 1966. Catalogue.

Berkshire Museum, Pittsfield, Massachusetts. *Mobiles by
Alexander Calder*. 2–31 July 1966. Catalogue.

Institute of Contemporary Arts, London. *Calder,
The Painter*. 29 September–29 October 1966. Catalogue.

James Goodman Gallery, Buffalo, New York. *Calder*.
8–29 October 1966. Traveled to Donald Morris Gallery,
Detroit.

Centre Culturel Municipal de Toulouse. *Calder (Le Mois
USA)*. 26 October–28 November 1966. Catalogue.

Donald Morris Gallery, Detroit. *Alexander Calder*.
13 November–10 December 1966. Originated from James
Goodman Gallery, Buffalo, New York, 8–29 October
1966.

Perls Galleries, New York. *Calder: Jewelry*. 15 November–
17 December 1966.

Galerie Françoise Mayer, Brussels. *Totems, mobiles et
gouaches récentes*. 19 November–17 December 1966.
Catalogue.

1967

Obelisk Gallery, Boston. *Alexander Calder: Gouaches,
Mobiles*. 17 January–4 February 1967.

Museum of Modern Art, New York. *Calder: 19 Gifts from
the Artist*. 1 February–5 April 1967. Curated by Dorothy
C. Miller.

Openluchtmuseum voor beeldhouwkunst Middelheim,
Antwerp. *Totems et Gouaches*. 10 February–5 March
1967. Catalogue.

Phillips Collection, Washington, D.C. *Recent Stabiles by
Alexander Calder*. 8 April–30 May 1967. Catalogue.

Arco d'Alibert, Studio d'Arte, Rome. *Calder*. 21 April–
28 May 1967. Catalogue.

Akademie der Künste, Berlin. *Alexander Calder*. 21 May–
16 July 1967. Curated by Dr. Herta Elisabeth Killy.
Catalogue.

Heath Gallery, Atlanta, Georgia. *Alexander Calder:
Gouaches, Mobiles, Stabiles*. 8 June 1967.

Edgardo Acosta Gallery, Beverly Hills. *Twenty Gouaches
by Calder: Dating from 1950 through June, 1967,
in Honor of his Sixty Ninth Birthday*. 15 August–
7 September 1967.

Perls Galleries, New York. *Calder: Early Work—
Rediscovered*. 14 November–23 December 1967.
Catalogue.

1968

Maison de la Culture, Bourges, France. *Calder: Mobiles,
Stabiles, Sculptures, Gouaches*. 9 March–13 May 1968.
Traveled to Musée des Augustins, Toulouse.

Dayton's Gallery 12, Minneapolis, Minnesota. *Calder*.
17 April–11 May 1968. Catalogue. In collaboration with
Perls Galleries, New York.

Musée des Augustins, Toulouse, France. *Calder: Mobiles,
Stabiles, Sculptures, Gouaches*. September 1968.
Originated from Maison de la Culture, Bourges, France,
9 March–13 May 1968.

Galerie Maeght, Paris. *Flèches*. 10 October–November 1968.
Catalogue.

Perls Galleries, New York. *Calder/Space: Drawings 1930–1932; Gouaches 1967–1968.* 15 October–9 November 1968. Catalogue.

Kiko Galleries, Houston, Texas. *Calder.* [Fall 1968.] Catalogue.

1969

Donald Morris Gallery, Detroit. *Calder Gouaches.* 14 January–1 February 1969.

Gimpel Fils, London. *Alexander Calder: Standing Mobiles, 1968.* 18 February–15 March 1969. Catalogue.

Fondation Maeght, Saint-Paul-de-Vence, France. *Calder.* 2 April–31 May 1969. Catalogue. Traveled to Louisiana Museum of Modern Art, Humlebæk, Denmark; Stedelijk Museum, Amsterdam.

Manitou Gallery, Grand Valley State College, Allendale, Michigan. *Calder.* 4 May–15 June 1969. Catalogue.

Grand Rapids Art Museum, Michigan. *Alexander Calder: Mobiles and Stabiles.* 18 May–24 August 1969. Catalogue.

Louisiana Museum of Modern Art, Humlebæk, Denmark. *Calder.* 29 June–7 September 1969. Catalogue. Originated from Fondation Maeght, Saint-Paul-de-Vence, France, 2 April–31 May 1969.

Fundación Eugenio Mendoza, Caracas, Venezuela. *Calder en Venezuela.* 6 July–3 August 1969. Catalogue.

Stedelijk Museum, Amsterdam. *Calder.* 4 October–16 November 1969. Catalogue. Originated from Fondation Maeght, Saint-Paul-de-Vence, France, 2 April–31 May 1969.

Perls Galleries, New York. *Alexander Calder: Bronze Sculptures of 1944.* 7 October–8 November 1969. Catalogue.

Museum of Modern Art, New York. *A Salute to Alexander Calder.* 22 December, 1969–15 February 1970. Curated by Bernice Rose. Catalogue. Traveled to Museo de Arte Moderno, Bogotá, Colombia; Museo Nacional de Artes Plásticas, Montevideo, Uruguay; Museo Nacional de Bellas Artes, Buenos Aires, Argentina; Museo Nacional de Bellas Artes, Santiago, Chile; Museo Universitario de Ciencias y Arte, Mexico City; Columbus Gallery of Fine Arts, Columbus, Ohio; Tyler Museum of Art, Tyler, Texas; Joslyn Art Museum, Omaha, Nebraska; Oakland Museum, California.

1970

Long Beach Museum of Art, California. *Calder Gouaches: The Art of Alexander Calder.* 11 January–8 February 1970. Catalogue. Traveled to Fine Arts Gallery of San Diego, California; Phoenix Art Museum, Arizona.

Hokin Gallery, Palm Beach, Florida. [*Calder*]. 15 January–7 February 1970.

Kovler Gallery, Chicago. *Calder.* 22 January–21 March 1970.

Galerie Gunzenhauser, Munich, Germany. *Calder.* [24 September 1970]. Catalogue.

Fine Arts Gallery of San Diego, California. *Calder Gouaches: The Art of Alexander Calder.* 27 February–29 March 1970. Catalogue. Originated from Long Beach Museum of Art, California, 11 January–8 February 1970.

Museo Nacional de Artes Plásticas, Montevideo, Uruguay. *Alexander Calder: escultura, acuarelas y dibujos, grabados, libros ilustrados y joyas de la colección del Museum of Modern Art de Nueva York.* 1–29 April 1971. Catalogue. Originated from Museum of Modern Art, New York, 22 December, 1969–15 February 1970.

Phoenix Art Museum, Arizona. *Calder Gouaches: The Art of Alexander Calder.* 1–31 May 1970. Catalogue. Originated from Long Beach Museum of Art, California, 11 January–8 February 1970.

Museo Nacional de Bellas Artes, Buenos Aires, Argentina. *Escultura, acuarelas y dibujos, grabados, libros ilustrados y joyas de la colección del Museum of Modern Art de Nueva York.* 6 May–6 June 1971. Catalogue. Originated from Museum of Modern Art, New York, 22 December, 1969–15 February 1970.

Galerie Vömel, Düsseldorf, Germany. *Calder.* 1 July–31 August 1970. Catalogue.

Museo Nacional de Bellas Artes, Santiago, Chile. *A Salute to Alexander Calder.* 12 August–12 September 1971. Originated from Museum of Modern Art, New York, 22 December, 1969–15 February 1970.

Galerie Semiha Huber, Zürich. *A. Calder: Mobile, Bilder, Graphik, Teppiche.* October 1970.

Perls Galleries, New York. *Alexander Calder: Recent Gouaches—Early Mobiles.* 20 October–28 November 1970. Catalogue.

Museo Universitario de Ciencias y Arte, Mexico City. *Alexander Calder, esculturas, acuarelas, dibujos,* *grabados, libros ilustrados, joyería.* 28 October–28 November 1971. Catalogue. Originated from Museum of Modern Art, New York, 22 December, 1969–15 February 1970.

Museo de Arte Moderno, Bogotá, Colombia. [*A Salute to Alexander Calder.*] 29 October–13 December 1970. Originated from Museum of Modern Art, New York, 22 December, 1969–15 February 1970.

Galerie Blanche, Stockholm. *Alexander Calder: Mobiler, Stabile-Mobiler, Gouacher 1961–1970.* [1970]. Catalogue.

1971

Katonah Gallery, Katonah, New York. *Alexander Calder.* 9 February–24 March 1971.

Galerie Maeght, Paris. *Calder: Stabiles, Animobiles.* 12 February 1971. Catalogue.

Brook Street Gallery, London. [*Calder*]. April–May 1971.

Studio Marconi, Milan. *Calder.* April–May 1971. Catalogue.

Galerie d'Art Moderne Marie-Suzanne Feigel, Basel, Switzerland. *Alexander Calder: Mobiles, Mobiles/Stabiles, Bronzes, Gouaches et Lithographies.* 3 April–5 June 1971. Catalogue.

Gimpel Fils, London. *Alexander Calder: Sculptures and Gouaches.* 15 April–15 May 1971. Catalogue.

Galleria Il Milione, Milan. *Calder: Grafica e Libri Recenti.* 27 April–25 May 1971.

John Berggruen Gallery, San Francisco. *Alexander Calder.* 13 May–14 June 1971. Catalogue.

Galerie Artek, Helsinki. *Calder: 6 Tapisseries d'Aubusson 1970–1971.* 25 May–10 June 1971.

L'Obelisco, Rome. *Calder.* June 1971. Catalogue.

Musée Toulouse-Lautrec, Albi, France. *Calder.* 23 June–15 September 1971. Catalogue. Preface by Jean Devoisins. Traveled to Maison des Arts et Loisirs, Sochaux, France.

Badischer Kunstverein, Karlsruhe, Germany. *Alexander Calder: Mobiles, Stabiles, Bilder, Teppiche.* 29 August–3 October 1971. Catalogue.

Maison des Arts et Loisirs, Sochaux, France. *Calder.* 25 September–9 November 1971. Originated from Musée Toulouse-Lautrec, Albi, France, 23 June–15 September 1971.

Perls Galleries, New York. *Calder: Animobiles—Recent Gouaches.* 5 October–6 November 1971. Catalogue.

Whitney Museum of American Art, New York. *Alexander Calder: Tapestries.* 5 October–14 November 1971. Catalogue. Traveled to Corcoran Gallery, Washington, D.C.; Parker Street 470 Gallery, Boston.

Pace Gallery, Columbus, Ohio. *Calder.* 10 October–13 November 1971.

Galerie Moos, Inc., Montreal. *Alexander Calder: Original Gouaches.* 15 November–6 December 1971.

Corcoran Gallery, Washington, D.C. *Alexander Calder Tapestries.* 3 December 1971–2 January 1972. Originated from Whitney Museum of American Art, New York, 5 October–14 November 1971.

Taft Museum, Cincinnati, Ohio. *Alexander Calder. Early Works ca. 1927–1944.* 12 December, 1971–31 January 1972. Catalogue.

Galerie Blanche, Stockholm. [*Calder*]. (1971).

1972

Columbus Gallery of Fine Arts, Ohio. *A Salute to Alexander Calder.* 13 January–27 February 1972. Originated from Museum of Modern Art, New York, 22 December, 1969–15 February 1970.

Galerie Verrière, Paris. *Calder: Tapisseries.* 23 February–19 March 1972.

Parker Street 470 Gallery, Boston. *Alexander Calder Tapestries.* 19 March–8 April 1972. Originated from Whitney Museum of American Art, New York, 5 October–14 November 1971.

Tyler Museum of Art, Texas. *A Salute to Alexander Calder.* 20 March–30 April 1972. Originated from Museum of Modern Art, New York, 22 December, 1969–15 February 1970.

Leonard Hutton Galleries, New York. *Calder: Aubusson Tapestries.* 14 April–31 May 1972. Catalogue. Originated from Whitney Museum of American Art, New York, 5 October–14 November 1971.

Whitney Museum of American Art, New York. *Calder's Circus.* 20 April–11 June 1972. Catalogue.

DuBose Gallery, Houston. *Aubusson Tapestries by Calder.* 1–22 May 1972.

Gallerias Mer-Kup, Mexico City. *Aubusson Tapestries by Calder.* June 1972.

Sala Pelaires, Palma de Mallorca, Spain. *Calder.* September–October 1972. Catalogue.

Joslyn Art Museum, Omaha, Nebraska. *A Salute to Alexander Calder.* 7 September–22 October 1972. Originated from Museum of Modern Art, New York, 22 December, 1969–15 February 1970.

High Museum of Art, Atlanta, Georgia. *Calder in Atlanta.* 1–29 October 1972.

David Ash Gallery, Seattle, Washington. *Alexander Calder: Recent Lithographs.* 6–29 October 1972.

Perls Galleries, New York. *Alexander Calder: Oil Paintings.* 10 October–11 November 1972. Catalogue.

Hokin Gallery, Chicago. *Calder Paintings / Sculpture / Graphics.* 15 October–16 November 1972.

Delta International Art Center, Rome. *Alexander Calder.* 27 October–22 November 1972. Catalogue.

Oakland Museum, California. *A Salute to Alexander Calder.* 14 November 1972–1 January 1973. Originated from Museum of Modern Art, New York, 22 December, 1969–15 February 1970.

Arts Club of Chicago. *Aubusson Tapestries by Alexander Calder.* 15 November–30 December 1972. In cooperation with Art Vivant, New Rochelle, N.Y. Catalogue.

Galerie Bollack, Strasbourg. [*Calder*]. [1972].

1973

Galerie Der Spiegel, Cologne, Germany. *Calder, 22 Teppiche aus den Ateliers Pinton Aubusson.* [1973]. Catalogue. Traveled to Kunsthalle Bielefeld, Germany; Kubus, Hannover, Germany.

Galerie Maeght, Paris. *Calder: Recent Mobiles.* 24 January–24 February 1973. Catalogue.

Kunsthalle Bielefeld, Germany. *Calder: 22 Teppiche aus den Ateliers Pinton Aubusson.* 8 February–8 March 1973. Originated from Galerie Der Spiegel, Cologne, Germany. [January 1973].

Paine Art Center & Arboretum, Oshkosh, Wisconsin. *Tapestries by Calder.* 11 February–4 March 1973. Cooperation with Art Vivant, New Rochelle, N.Y. Catalogue.

Galerie T. Roussel, Perpignan. France. [*Calder*]. February–March 1973.

Kubus, Hannover, Germany. *Calder, 22 Teppiche aus den Ateliers Pinton Aubusson.* [15] March–15 April, 1973. Originated from Galerie Der Spiegel, Cologne, Germany. [January 1973].

Art Institute of Chicago. *Alexander Calder.* 23 April 1973. Calder presented his maquette for *Flamingo* in a one-night exhibition.

Palais des Beaux-Arts, Charleroi, Belgium. *Calder: Sculptures en plein air (Plaine des Manœuvres), Gouaches et petits mobiles (Bibliothèque communale).* 13 May–15 July 1973. Catalogue.

Galerie Maeght, Zürich. *Alexander Calder: Retrospektive.* 24 May–July 1973. Catalogue.

Solomon R. Guggenheim Museum, New York. *Calder Airplanes.* 9 August–7 October 1973. Traveled to Wharton Graduate School, Vance Hall, University of Pennsylvania, Philadelphia.

Sala Gaspar, Barcelona. *Calder: Escultures; Exposicio Calder Pintures.* September 1973. Catalogue.

Villa Montalvo, Saratoga. California. *Alexander Calder: Mobiles.* October 1973.

Perls Galleries, New York. *Calder at 75—Works in Progress.* 3 October–3 November 1973.

Joseloff Gallery, Hartford Art School, University of Hartford, West Hartford, Connecticut. *Alexander Calder.* 8–12 October 1973.

Detroit Institute of the Arts, Michigan. *Alexander Calder: Prints, Drawings, and Illustrated Books.* 18 October–18 November 1973.

Galleria d'Arte "La Bussola," Turin, Italy. *Calder.* 26 October 1973. Catalogue.

Gallery 36 (Foote, Cone & Belding), New York. *Flying Colors.* December 1973.

Wharton Graduate School, Vance Hall, University of Pennsylvania, Philadelphia. *Flying Colors.* 4–20 December 1973. Originated from Solomon R. Guggenheim Museum, New York, 9 August–7 October 1973.

1974

Centre National d'Art Contemporain, Paris. *Calder: Mobile et Lithographies.* 9 February–24 March 1974. Catalogue.

Harcus Krakow Rosen Sonnabend Gallery, Boston. *Alexander Calder/Tapestries.* 9 February–9 March 1974.

Katonah Gallery, Katonah, New York. *Alexander Calder.* 9 February–24 March 1974.

Studio d'Arte Condotti, Rome. *Calder.* 4 March 1974.

Centre Culturel de Saint-Pierre des Corps, Saint-Pierre des Corps, France. *Calder.* April 1974.

Rolly-Michaux Galleries, New York. *Alexander Calder: Selected Lithographs.* 30 April–18 May 1974. Traveled to Rolly-Michaux Galleries, Boston.

Leonard Hutton Galleries, New York. *Aubusson Tapestries by Calder.* April–June 1974. Catalogue.

Rolly-Michaux Galleries, Boston. *Alexander Calder: Selected Lithographs.* 21 May–8 June 1974. Originated from Rolly-Michaux Galleries, New York. 30 April–18 May 1974.

Galerie Jeanne Abeille, Toulouse, France. *Calder: Tapisseries d'Aubusson et Lithographs.* 29 May–10 July 1974.

Galleria Angolare, Milan. *Gouaches di Calder.* June 1974. Catalogue.

Musée Municipal, Limoges, France. *Calder: Mobiles, Gouaches, Tapisseries, Assiettes, Lithographies.* June 1974.

Salle des Ecuries de Saint-Hugues et Musée Ochier, Cluny, France. *Calder.* 21 June–8 September 1974.

Perls Galleries, New York. *Alexander Calder: Crags and Critters of 1974.* 15 October–16 November 1974. Catalogue.

Denise René/Hans Meyer, Düsseldorf, Germany. *Alexander Calder: Mobiles, Stabiles, Gouachen.* 17 October–22 November 1974. Catalogue.

Source Gallery, San Francisco. *Alexander Calder: Gouaches, Lithographs.* 18 October–14 November 1974.

Deson-Zaks Gallery, Chicago. *Calder.* 25 October–23 November 1974.

Museum of Contemporary Art, Chicago. *Alexander Calder: A Retrospective Exhibition, Work from 1925–1974.* 26 October–8 December 1974. Catalogue.

Galerie Court Saint-Pierre, Geneva. [*Calder*]. November 1974–January 1975.

1975

Galerie Maeght, Paris. *Calder: Crags and Critters.* 22 January–23 February 1975. Catalogue.

Bhirasi Institute of Modern Art, Bangkok, Thailand. *Calder's Circus.* 29 January–16 February 1975. Organized by National Collection of Fine Arts, Smithsonian Institute, Washington, D.C. and Whitney Museum of American Art, New York.

Center for the Arts Gallery, Wesleyan University, Middletown, Connecticut. *Alexander Calder: Tapestries.* 31 January–1 March 1975. Catalogue.

Galleria Morone 6, Milan. *Opere di Alexander Calder.* February 1975. Catalogue.

Mitchell Sewall Gallery, New York. [*Calder—Hammocks and floor mats*]. March–April 1975.

Portland School of Art, Outdoor Sculpture Exhibition Series, Maine. *Alexander Calder.* March–July 1975.

Haus der Kunst, Munich. *Calder.* 10 May–13 July 1975. Catalogue. Traveled to Kunsthaus, Zürich.

Kunsthaus, Zürich. *Calder.* 23 August–2 November 1975. Catalogue. Originated from Haus der Kunst, Munich, 10 May–13 July 1975.

Galerie Maeght, Zürich. *Calder: Crags and Critters.* September–October 1975. Catalogue.

Renaissance du Vieux Bordeaux, France. *Calder: Tapisseries-Mobiles.* 3–26 October 1975. Catalogue.

Galerie Parallèle, Geneva. *Les Mobiles tissés.* October 1975.

Perls Galleries, New York. *Alexander Calder: Recent Mobiles and Circus Gouaches.* 14 October–15 November 1975. Catalogue.

1976

High Museum of Art, Atlanta, Georgia. *Calder's Universe.* 5 March–1 May 1977. Catalogue. Originated from Whitney Museum of American Art, New York, 14 October 1976–6 February 1977.

Galeria Bonino, Rio de Janeiro. *Alexander Calder. Redes-Tapecarias.* 23 March–17 June 1976. Catalogue.

Artcurial, Paris. *Calder: Tapisseries Choisies.* 7–30 April 1976. Catalogue.

Gallery Wien, Jerusalem. *Calder.* 10 April–10 May 1976.

Galleria Rondanini, Rome. *Dai Mobiles ai Critters.* 12 April 1976. Catalogue.

Circle Gallery, Ltd., Chicago. [*Calder*]. April 1976.

Galleria Marlborough, Rome. *Alexander Calder: Arazzi e amache.* April 1976. Catalogue.

Walker Art Center, Minneapolis, Minnesota. *Calder's Universe.* 5 June–14 August 1977. Catalogue. Originated from Whitney Museum of American Art, New York, 14 October 1976–6 February 1977.

Fort Wayne Museum of Art and L.S. Ayres & Co., Indiana. *A Calder Occasion.* 20–25 September 1976.

May–D&F Stores, Denver, Colorado. *Alexander Calder: Lithographs, Gouaches, and Sculpture.* 21 September–2 October 1976. The exhibition was part of the salute to the American Scene.

The Greater Philadelphia Cultural Alliance, Pennsylvania. *Alexander Calder Festival.* 1–10 October 1976. Festival included dedication of *White Cascade* at the Federal Reserve Bank and the premiere of *Under the Sun*, a dance tribute to Calder performed by the Pennsylvania Ballet.

Indianapolis Children's Museum. *Flying Colors: Six Models.* 2 October–21 November 1976.

Strawbridge & Clothier Store, Philadelphia. *The Art of Alexander Calder.* 4–8 October 1976.

Makler Gallery, Philadelphia, Pennsylvania. *Alexander Calder.* 4–30 October 1976.

Pennsylvania Academy of Fine Arts, Philadelphia. [*Calder*]. October 1976.

Perls Galleries, New York. *Alexander Calder: Works on Paper 1925–1976.* 12 October–13 November 1976.

Brewster Gallery, New York. *Calder: Aubusson Tapestries and Selected Lithographs.* 13 October–13 November 1976.

Rolly–Michaux Gallery, New York. *Gouaches and Important Lithographs.* 14 October–13 November 1976. Traveled to Rolly–Michaux Gallery, Boston.

Whitney Museum of American Art, New York. *Calder's Universe.* 14 October 1976–6 February 1977. Curated by Jean Lipman and Richard Marshall. Catalogue. Traveled to High Museum of Art, Atlanta, Georgia; Walker Art Center, Minneapolis, Minnesota; Dallas Museum of Fine Arts, Texas. A reduced version of this exhibition traveled to San Jose Museum of Art, California; Portland Art Museum, Oregon; Phoenix Art Museum, Arizona; Joslyn Art Museum, Omaha, Nebraska; Loch Haven Art Center, Orlando, Florida; Hirshhorn Museum and Sculpture Garden, Smithsonian Institution, Washington, D.C.; Currier Gallery of Art, Manchester,

New Hampshire. Another version of Traveled to Seibu Museum of Art, Tokyo; Kita-kyushu Municipal Museum of Art, Japan; Prefectural Museum of Modern Art, Hyogo, Kobe, Japan; Yokohama City Gallery, Japan.

Rolly-Michaux Gallery, Boston. *Gouaches and Important Lithographs.* 11 November–24 December 1976. Originated from Rolly-Michaux Gallery, New York, 14 October–13 November 1976.

Bonino/Soho, New York. *Woven Mobility Designed by Alexander Calder.* 30 November 1976–5 January 1977.

Galerie Maeght, Paris. *Calder: Mobiles and Stabiles.* (23 November opening postponed) 1 December 1976– 8 January 1977. Catalogue.

1977

Albright-Knox Gallery, Buffalo, New York. *Graphics by Calder.* 4 January–27 February 1977.

Artists' Market/Warehouse Gallery, London. [*Alexander Calder*]. 15 March–14 April 1977.

Hess's Fine Arts Gallery, Allentown, Pennsylvania. *Calder Festival.* 16–30 April 1977.

Center for the Arts, Muhlenberg College, Allentown, Pennsylvania. *Calder Festival.* 19 April–5 May 1977. Catalogue.

Galeria Maeght, Barcelona. *Calder: Exposicio Antologica* [*1932-1976*]. April–May 1977. Catalogue.

Irving Galleries, Milwaukee. [*Calder*]. [*May*] 1977.

Galerie Saint-Martin, Paris. *Hommage à Calder, Tapisseries d'Aubusson.* 13 May–5 June 1977.

Dayton's, Minneapolis, Minnesota. [*Calder Tapestries*]. 7–21 June 1977.

Billy Rose Pavillion, Israel Museum, Jerusalem. *Homage to Calder.* 5 September 1977–7 January 1978.

Hooks-Epstein Galleries, Houston, Texas. *Alexander Calder.* 10 September–20 October 1977.

Dallas Museum of Fine Arts, Texas. *Calder's Universe.* 14 September–30 October 1977. Catalogue. Originated from Whitney Museum of American Art, New York, 14 October 1976–6 February 1977.

Junior Galerie, Goslar, Germany. *Alexander Calder: Plastiken, Gouachen, Grafiken, Gobelins.* 16–26 October 1977.

Missal Gallery, Scottsdale, Arizona. *Alexander Calder Lithographs: A Memorial Tribute.* 6–20 November 1977. Catalogue.

Brewster Gallery, New York. *Homage to Calder.* 12 November–3 December 1977.

American Academy and Institute of Arts and Letters, New York. *Alexander Calder Memorial.* 15 November– 30 December 1977. Catalogue.

Lakeview Center, Peoria, Illinois. [*Calder*]. 16–20 November 1976.

1978

ACA Gallery, Atlanta, Georgia. *Calder.* 20 January– 3 February 1978. Benefit for the Atlanta College of Art.

Galerie Artek, Helsinki. *Calder: Lithographies.* 27 January– 15 February 1978.

Musée National d'Art Moderne, Centre Georges Pompidou, Paris. *Images de Calder.* 17 February–27 March 1978.

San Jose Museum of Art, California. *Calder's Universe.* 2 April–21 May 1978. Originated from Whitney Museum of American Art, New York, 14 October 1976– 6 February 1977.

Galeria del Centro Colombo-Americano, Bogotá, Colombia. *Alexander Calder.* 27 April–31 May 1978.

Portland Art Museum, Oregon. *Calder's Universe.* 14 June–30 July 1978. Originated from Whitney Museum of American Art, New York, 14 October 1976– 6 February 1977.

Phoenix Art Museum, Arizona. *Calder's Universe.* 27 August–8 October 1978. Originated from Whitney Museum of American Art, New York, 14 October 1976– 6 February 1977.

Galerie Tokoro, Tokyo. *Alexander Calder: Mobiles and Gouaches.* 4 September–7 October 1978. Catalogue.

Sun-City Phoenix Art Museum, Arizona. *Works by Calder from the Collection of Mr. and Mrs. Orme Lewis.* 11 September–10 October 1978.

M. Knoedler & Co.,Inc., New York. *Alexander Calder: Sculpture of the 1970's.* 4 October–2 November 1978. Catalogue.

Joslyn Art Museum, Omaha, Nebraska. *Calder's Universe.* 4 November–17 December 1978. Originated from

Whitney Museum of American Art, New York, 14 October 1976–6 February 1977.

1979

Loch Haven Art Center, Orlando, Florida. *Calder's Universe.* 7 January–25 February 1979. Originated from Whitney Museum of American Art, New York, 14 October 1976–6 February 1977.

Garelick's Gallery, Scottsdale, Arizona. *Calder: Recent Graphics.* 19–31 January 1979.

Théâtre Maxime Gorki, Petit Quevilly, France. *Calder: lithographies, mobiles, stabiles.* 2 March–10 April 1979. Catalogue.

Hirshhorn Museum and Sculpture Garden, Smithsonian Institution, Washington, D.C. *Calder's Universe.* 15 March–13 May 1979. Originated from Whitney Museum of American Art, New York, 14 October 1976– 6 February 1977.

Competition & Sports Cars, Ltd. (BMW), Greenwich, Connecticut. *Calder — Lithographs.* April 6–21 1979.

Rolly-Michaux Gallery, Boston. *Alexander Calder — The Man and His Work.* 29 April–16 June 1979. Catalogue.

The Currier Gallery of Art, Manchester, New Hampshire. *Calder's Universe.* 2 June–29 July 1979. Originated from Whitney Museum of American Art, New York, 14 October 1976–6 February 1977.

Seibu Museum of Art, Tokyo. *Calder's Universe.* 23 September–29 October 1979. Catalogue. Originated from Whitney Museum of American Art, New York, 14 October 1976–6 February 1977.

Marisa del Re Gallery, New York. *Calder.* 2–20 October 1979.

Rolly-Michaux Gallery, New York. *Alexander Calder.* 10 October–10 November 1979.

Galleria Pieter Coray, Lugano, Switzerland. *Calder.* 26 October–24 November 1979. Catalogue.

Kita-kyushu Municipal Museum of Art, Japan. *Calder's Universe.* 3–25 November 1979. Catalogue. Originated from Whitney Museum of American Art, New York, 14 October 1976–6 February 1977.

The Prefectural Museum of Modern Art, Hyogo, Kobe, Japan. *Calder's Universe.* 22 December 1979–3 February

1980. Catalogue. Originated from Whitney Museum of American Art, New York, 14 October 1976–6 February 1977.

1980

Nahan Galleries, New Orleans, Louisiana. *Alexander Calder.* 2–25 February 1980.

Yokohama City Gallery, Japan. *Calder's Universe.* 10 February–9 March 1980. Catalogue. Originated from Whitney Museum of American Art, New York. 14 October 1976–6 February 1977.

Theo Waddington, Ltd., Toronto. *Sculpture and Gouache by Alexander Calder.* April 1980.

Chapelle de la Charité, Arles, France. *Calder.* 29 June–21 September 1980.

Kettle's Yard, Cambridge, England. *Calder.* 12 July–10 August 1980. Catalogue.

Marisa del Re Gallery, New York. *Calder.* October 1980.

M. Knoedler & Co., Inc., New York. *Alexander Calder: Standing Mobiles.* 4 December 1980–2 January 1981. Catalogue.

Galerie Brusberg, Hannover, Germany. *Alexander Calder: Mobiles, Stabiles, Grafik, und Critters.* 6 December 1980– 1 March 1981.

Galeria Jean Boghici, Rio de Janeiro. *Alexander Calder: Mobiles, Pintura, Guaches.* 18 December 1980–18 January 1981. Catalogue.

1981

Whitney Museum of American Art, New York. *Alexander Calder: A Concentration of Works from the Permanent Collection at the Whitney Museum of American Art.* 17 February–3 May 1981. Curated by Patterson Sims. Catalogue.

The Mayor Gallery and Waddington Galleries, London. *Calder.* 1–25 April 1981. Catalogue.

Galerie Maeght, Paris. *Calder.* October 1981. Catalogue.

Marisa del Re Gallery, New York. *Calder: Mobiles, Stabiles, Gouaches.* 22 December 1981–23 January 1982.

1982

Galerie Maeght, Zürich. *Calder.* 16 April–June 1982. Catalogue.

M. Knoedler & Co., Inc., New York. *Alexander Calder: Small Scale Works and Gouaches.* 15 May–3 June 1982. Catalogue.

Museo de Arte Moderno, Mexico City. *Tapices de Alexander Calder.* 20 July–29 August 1982. Catalogue.

Eduard Nakhamkin Fine Arts, New York. *Calder Tapestry Collection.* 17–27 October 1982.

University Art Museum, Berkeley, California. *Alexander Calder.* 3 November, 1982–16 January 1983. Catalogue.

1983

Flint Institute of Arts, Michigan. *Alexander Calder: Mobiles, Stabiles, Gouaches, Drawings from the Michigan Collections.* 20 February–27 March 1983. Catalogue.

M. Knoedler & Co., Inc., New York. *Alexander Calder: Stabiles.* 14 May–2 June 1983. Catalogue.

Palazzo a Vela, Turin, Italy. *Calder: Mostra retrospettiva.* 2 July–25 September 1983. Curated by Giovanni Carandente. Catalogue.

Greenberg Gallery and Missouri Botanical Garden, St. Louis, Missouri. *Calder in Retrospect.* 1 September–2 October 1983.

Musée National d'Art Moderne, Centre Georges Pompidou, Paris. *Des Stabiles et des Mobiles de Calder.* 26 October 1983–2 January 1984.

M. Knoedler Zürich AG, Zürich. *Alexander Calder: Sculptures, Works on Paper.* 3 December 1983–21 January 1984.

1984

Whitney Museum of American Art, Fairfield County, Stamford, Connecticut. *Calder: Selections from the Permanent Collection of the Whitney Museum of American Art.* 20 January–21 March 1984. Catalogue. Traveled to Whitney Museum of American Art at Philip Morris, New York.

Rachel Adler Gallery, New York. *Alexander Calder.* 12 May–16 June 1984.

Whitney Museum of American Art at Philip Morris, New York. *Calder: Selections from the Permanent Collection of the Whitney Museum of Modern Art.* 17 May–11 July 1984. Originated from Whitney Museum of American Art, Fairfield County, Stamford, Connecticut, 20 January–21 March 1984.

Museo de Bellas Artes, Caracas, Venezuela. [*Calder*]. May–June 1984.

Grand Rapids Art Museum, Michigan. *Calder in Grand Rapids.* 1–17 June 1984. Celebrating the fifteenth anniversary of the installation of Calder's *La grande vitesse.* Included a program at the Vandenberg Center, 1–3 June, with the premier performances of *A Festival Piece for Alexander Calder* by Jack Fortner and *Inaugural Fanfare* by Aaron Copland.

Herbert Palmer Gallery, Los Angeles. *Calder Gouaches and Mobiles.* 16 June–18 August 1984.

1985

Pace Gallery, New York. *Calder's Calders.* 3 May–8 June 1985. Catalogue.

Galerie Maeght Lelong, Paris. *Calder.* 14 May–8 June 1985.

Barbara Krakow Gallery, Boston. *Alexander Calder.* 18 May–13 June 1985.

Fort Worth Art Museum, Texas. *Calder Animals: Made at the Zoo and Elsewhere Too.* 2 June–1 September 1985.

Hudson River Museum in cooperation with the Whitney Museum of American Art, Yonkers, New York. *Calder Creatures Great and Small.* 21 July–15 September 1985. The book *Calder Creatures Great and Small*, by Jean Lipman with Margi Conrads, accompanied the exhibition. Traveled to Delaware Art Museum, Wilmington, Delaware; Montclair Art Museum, Montclair, New Jersey.

Delaware Art Museum, Wilmington, Delaware. *Calder Creatures Great and Small.* 27 September–10 November 1985. Originated from Hudson River Museum, Yonkers, New York, 21 July–15 September 1985.

1986

Bakalar Sculpture Gallery, List Visual Arts Center, Massachusetts Institute of Technology, Cambridge. *Alexander Calder: Artist As Engineer.* 31 January–13 April 1986. Catalogue.

Montclair Art Museum, New Jersey. *Calder Creatures Great and Small.* 11 May–29 June 1986. Originated from Hudson River Museum, Yonkers, New York, 21 July–15 September 1985.

Le Château Biron, Dordogne, France. *Calder*. June–30 September 1986. Catalogue.

Ancienne Ècole, bourg de Plouguiel, Côtes–du–Nord, France. *Calder a La Roche–Jaune: Mobiles, Gouaches, Bijoux*. 14 July–15 August 1986. Catalogue.

Sheldon Memorial Art Gallery, University of Nebraska, Lincoln, Nebraska. *Alexander Calder: An American Invention*. 13 September–16 November 1986. Catalogue.

Artcurial, Munich, Germany. *Calder: Mobiles, Gouachen, Lithographien*. 15 October–20 December 1986.

1987

Pace Gallery, New York. *Alexander Calder Bronzes*. 20 March–14 April 1987.

Equitable Gallery, Miami, Florida. *Calder Park: An Exhibition of Maquettes by Alexander Calder*. 22 April–May 1987.

Galerie Adrien Maeght, Paris. *Calder*. 18 June–10 August 1987. Catalogue.

Whitney Museum of American Art, New York. *Alexander Calder: Sculptures of the Nineteen Thirties*. 14 November 1987–17 January 1988. Catalogue. Curated by Richard Marshall.

Linssen Gallery, Cologne, Germany. *Calder Retrospective: 1898–1976*. 25 November 1987–January 1988. Catalogue.

1988

State Street Gallery, Westport, Connecticut. *Calder: Comprehensive Exhibition of over Fifty Works of Art*. 2 April–28 May 1988. Includes works by Sandra Calder Davidson.

Nohra Haime Gallery, New York. *Alexander Calder–Gouaches*. 14 September–15 October 1988.

Barbara Mathes Gallery, New York. *Calder: Drawings, Mobiles, and Stabiles*. 16 September–22 October 1988.

Gallerie Seno, Milan. *Alexander Calder: Standing and Hanging Mobiles 1945–1976*. 6 October–16 November 1988. Catalogue. Traveled to Edward Totah Gallery, London.

Edward Totah Gallery, London. *Alexander Calder: Standing and Hanging Mobiles 1945–1976*. December 1988. Catalogue. Originated from Gallerie Seno, Milan. 6 October–16 November 1988.

Arnold Herstand and Co., New York. *Alexander Calder: Selected Works*. 1 December 1988–11 February 1989.

1989

Galeria Maeght, Barcelona. *Calder*. February–March 1989. Catalogue.

Musée des Arts Décoratifs, Paris. *Calder Intime*. 15 February–21 May 1989. Curated by Daniel Marchesseau. Catalogue. Traveled to Centro Cultural/Arte Contemporáneo, Mexico City; Cooper–Hewitt National Design Museum, Smithsonian Institution, New York; Minneapolis Institute of Arts, Minnesota; Seibu Museum of Art, Tokyo.

Greenberg Gallery, St. Louis, Missouri. *Alexander Calder*. 10 March–22 April 1989.

Galería Theo, Madrid. *Calder*. 16–31 March 1989. Catalogue.

Knoxville Museum of Art at the Candy Factory, Tennessee. *The Mindlin–Gazaway Alexander Calder Collection*. 10 April–10 May 1987.

Gallery International 57, New York. *Alexander Calder Woven Mobility*. 11 April–6 May 1989.

Pace Gallery, New York. *Calder: Stabiles*. 5 May–17 June 1989. Catalogue.

Centro Cultural/Arte Contemporáneo, Mexico City. *Calder: obra íntima*. 1 June–15 August 1989. Originated from Musée des Arts Décoratifs, Paris, 15 February–21 May 1989.

Cooper–Hewitt National Design Museum, Smithsonian Institution, New York. *The Intimate World of Alexander Calder*. 17 October 1989–11 March 1990. Originated from Musée des Arts Décoratifs, Paris, 15 February–21 May 1989.

1990

The Minneapolis Institute of Arts, Minnesota. *The Intimate World of Alexander Calder*. 6 May–15 July 1990. Originated from Musée des Arts Décoratifs, Paris, 15 February–21 May 1989.

Seibu Museum of Art, Tokyo. *The Intimate World of Alexander Calder*. 3–28 August 1990. Originated from Musée des Arts Décoratifs, Paris, 15 February–21 May 1989.

Galerie Bonnier, Geneva. *Calder: Dix Gouaches 1970–1973*. 6 November 1990–15 January 1991. Catalogue.

Antique Poster Gallery, Ridgefield, Connecticut. [*Calder gouaches, etchings, lithographs*]. 13 November–22 December 1990.

Jack Rutberg Fine Arts Inc., Los Angeles. *Alexander Calder: Sculptures, Paintings and Gouaches*. 8 December 1990– 31 January 1991.

1991

Whitney Museum of American Art, New York. *Celebrating Calder*. 13 November 1991–2 January 1992. Curated by Jennifer Russell. Traveled to Royal Academy of Arts, London; IVAM, Centre Julio González, Valencia, Spain; Sonje Museum of Contemporary Art, Kyongju, Korea; Musée du Québec; Baltimore Museum of Art.

Galerie Maurice Keitelman, Brussels. *Calder Mobiles*. 29 November 1991–1 February 1992. Catalogue.

1992

Crane Gallery, London. *Calder: Oils, Gouaches, Mobiles and Tapestries*. 5 March–1 May 1992. Catalogue.

Royal Academy of Arts, London. *Alexander Calder*. 13 March–7 June 1992. Catalogue. Originated from Whitney Museum of American Art, New York, 13 November 1991–2 January 1992.

Galerie Municipale Prague. *Alexander Calder*. 23 June–30 August 1992. Catalogue.

IVAM, Centre Julio González, Valencia, Spain. *El Universo de Calder*. 12 September–8 November 1992. Originated from Whitney Museum of American Art, New York, 13 November 1991–2 January 1992.

La Défense, Parvis de La Défense et Galerie Art 4, Paris. *Les Monuments de Calder*. 7 October 1992–3 January 1993. Catalogue. Traveled to Kunst–und Ausstellungshalle, Bonn, 2 April–30 September 1993.

Museum of Contemporary Art, Chicago. *Alexander Calder from the Collection of the Ruth and Leonard J. Horwich Family*. 21 November 1992–31 January 1993. Catalogue.

1993

Hirshhorn Museum and Sculpture Garden, Smithsonian Institution, Washington, D.C. *Calder Gallery Installation*. January 1993–May 1994.

Kunst–und Ausstellungshalle, Bonn. *Alexander Calder: Die Grossen Skulpturen*. 2 April–30 September 1993. Catalogue. Originated from La Défense, Parvis de La Défense et Galerie Art 4, Paris. 7 October 1992– 3 January 1993.

Kunst–und Ausstellungshalle, Bonn. *Der Andere Calder*. 30 April–30 September 1993. Curated by Daniel Abadie and Pontus Hulten. Catalogue.

O'Hara Gallery, New York. *Alexander Calder: Sculpture, Paintings, Works on Paper*. 1 May–30 May 1993.

Sonje Museum of Contemporary Art, Kyongju, Korea. *Celebrating Calder*. 21 June–19 September 1993. Originated from Whitney Museum of American Art, New York, 13 November 1991–2 January 1992.

Musée Picasso, Château Grimaldi, Antibes, France. *Calder: Mobiles, stabiles, gouaches, bijoux*. 2 July– 27 September 1993. Catalogue.

Gagosian Gallery, New York. *Monumental Sculpture*. 18 September–30 October 1993. Catalogue.

1994

Galerie Maeght, Paris. *Calder: œuvres sur papier*. 3 March 1994.

Bibliothèque Municipale and Abbaye Saint–Germain, Auxerre, France. *Calder*. 27 May 1994.

William Beadleston, Inc., New York, in association with Susanna Allen Fine Art, London. *Alexander Calder: Mobiles / Stabiles*. 7 June–1 July 1994.

Ho Gallery, Hong Kong. *Calder*. 9 September–29 October 1994.

Musée du Québec. *Alexander Calder: L'imaginaire et l'équilibre*. 29 September 1994–15 January 1995. Catalogue. Originated from Whitney Museum of American Art, New York, 13 November 1991–2 January 1992.

Musée du Quebec. *L'Homme de Calder*. 29 September 1994– 15 January 1995. Curated by Daniel Drouin. Catalogue.

O'Hara Gallery, New York. *Alexander Calder: Selected Works 1932–1972*. 18 October–3 December 1994. Catalogue.

1995

Galerie des Cahiers d'Art, Paris. *Sculptures de Calder vues par Marc Vaux, Hugo Herdeg and Herbert Matter*. 15 March–6 April 1995.

A/D Gallery, New York. *Calder Jewelry*. 20 May–30 June 1995 (extended to 28 July).

Galerie Maeght, Paris. *Alexander Calder, "Bestiaire", Ouvrage en Lithographie*. 20 May–29 July 1995.

Bruce Museum, Greenwich, Connecticut. *The Mobile, the Stabile, the Animal; Wit in the Art of Alexander Calder*. 14 September–31 December 1995. Catalogue.

Baltimore Museum of Art. *Celebrating Calder*. 4 October 1995–7 January 1996. Originated from Whitney Museum of American Art, New York, 13 November 1991– 2 January 1992.

Louisiana Museum of Modern Art, Humlebæk, Denmark. *Alexander Calder: Retrospective*. 6 October 1995– 21 January 1996. Curated by Lars Grambye. Catalogue. Traveled to Moderna Museet, Stockholm; Musée d'Art Moderne de la Ville de Paris.

PaceWildenstein, Beverly Hills, California. *Alexander Calder: The 50's*. 9 November–29 December 1995. Catalogue. Traveled to PaceWildenstein, New York.

1996

PaceWildenstein, New York. *Alexander Calder: The 50's*. 19 January–17 February 1996. Catalogue. Originated from PaceWildenstein, Beverly Hills, California. 9 November–29 December 1995.

Galerie Proarta, Zürich. *Calder 1898–1976, Mobiles Bilder Lithographien*. 2 March–1 May 1996.

Moderna Museet, Stockholm. *Alexander Calder [1898–1976]*. 30 March–27 May 1996. Catalogue. Originated from Louisiana Museum of Modern Art, Humlebæk, Denmark, 6 October, 1995–21 January 1996.

Indianapolis Children's Museum. *Calder's Art: A Circus of Creativity*. 18 May 1996–5 January 1997.

Donjon de Vez, France. *Calder au Donjon de Vez*. 26 May– 29 September 1996. Catalogue.

590 Madison, New York. *Alexander Calder*. 3 June 1996– 14 February 1997. Organized by PaceWildenstein, New York.

Musée d'Art Moderne de la Ville de Paris. *Alexander Calder: 1898–1976*. 10 July–6 October 1996. Catalogue. Originated from Louisiana Museum of

Modern Art, Humlebæk, Denmark, 6 October, 1995– 21 January 1996.

Galería Estiarte, Madrid, Spain. *Calder: Obra Gráfica*. September–October 1996.

Indianapolis Art Center. *Indiana Collects Calder*. 13 September–1 December 1996. Curated by Julia Mooney Moore. Catalogue.

Indiana University Art Museum, Bloomington. *Calder at Indiana University*. 9 October 1996–2 February 1997.

1997

Galerie du Golf–Hôtel in Les Hauts de Gstaad – Saanenmöser, Gstaad, Switzerland. *Tel est Calder*. 8 February–18 March 1997.

National Gallery of Art, Washington, D.C. *Alexander Calder: The Collection of Mr. and Ms. Klaus Perls*. 9 March–26 May 1997 (extended to 6 July). Curated by Marla Prather. Catalogue.

Simon Capstick–Dale Fine Art Ltd., London. *Alexander Calder: Sculpture, Drawings and Gouaches*. 11 April– 16 May 1997.

Galería Senda, Barcelona. *Alexander Calder*. 16 April– 17 May 1997. Traveled to Salas de Exposiciones de la Sociedad Económica de Amigos del País, Obra Socio Cultural de Unicaja, Málaga, Spain.

Salas de Exposiciones de la Sociedad Económica de Amigos del País, Obra Socio Cultural de Unicaja, Málaga, Spain. *Alexander Calder*. 23 May–19 June 1997. Catalogue. Originated from Galería Senda, Barcelona, 16 April– 17 May 1997.

Palais Bénédictine, Fécamp (Seine Maritime), France. *Exposition Calder*. 20 June–21 September 1997. Organized by Galerie Maeght, Paris.

San Jose Museum of Art, California. *Flying Colors: The Innovation and Artistry of Alexander Calder*. 16 November 1997–1 February 1998.

Fundació Joan Miró, Barcelona. *Calder*. 20 November 1997–15 February 1998. Catalogue.

1998

Fundação Arpad Szenes–Vieira da Silva, Lisbon, Portugal. *Calder*. 19 March–24 May 1998. Catalogue.

National Gallery of Art, Washington, D.C. *Alexander Calder: 1898–1976.* 29 March–12 July 1998. Curated by Marla Prather and Alexander S. C. Rower. Catalogue. Traveled to San Francisco Museum of Modern Art.

National Science Olympiad, Grand Valley State University, Allendale, Michigan. *Classical, Casual and Calder.* 21 July 1998.

San Francisco Museum of Modern Art. *Alexander Calder: 1898–1976.* 4 September–1 December 1998. Originated from National Gallery of Art, Washington, D.C., 29 March–12 July 1998.

Scottsdale Museum of Contemporary Art, Arizona. *Alexander Calder: Le Grand Cirque.* 19 December 1998–21 March 1999. Catalogue.

1999

Susan Sheehan Gallery, New York. *Calder: Works on Paper.* 20 January–6 March 1999.

The Phillips Collection, Washington, D.C. *An Adventurous Spirit: Calder at The Phillips Collection.* 23 January–8 June 1999 (extended to 18 July). Curated by Elizabeth Hutton Turner. Catalogue.

Lever House, New York. *Alexander Calder Sculpture.* 27 January–31 May 1999. Curated by Richard Marshall.

O'Hara Gallery, New York. *Motion–Emotion: The Art of Alexander Calder.* 21 October–4 December 1999. Catalogue.

San Francisco Museum of Modern Art. *Focus on Calder: Selected Works from the 30's & 40's.* 1999.

2000

Gordon Jewish Community Center, Nashville, Tennessee. *Double Tribute.* 16 April–10 May 2000.

Wadsworth Atheneum, Hartford, Connecticut. *Calder in Connecticut.* 27 April–6 August 2000. Curated by Eric Zafran.

Darga & Lansberg Galerie, Paris. *Calder.* 26 May–30 July 2000.

Galerie Maeght, Paris. *Calder.* 9 June–29 July 2000.

Sala Pelaires, Palma de Mallorca, Spain. *Calder.* October 2000. Catalogue.

Iwaki City Art Museum, Japan. *Alexander Calder: Motion and Color.* 3 November–17 December 2000. Organized

by JACA (Japan Art & Culture Association). Curated by Richard Marshall and Alexander S. C. Rower. Catalogue. Traveled to Museum of Modern Art, Toyama, Japan; Hokkaido Obihiro Museum of Art, Obihiro, Japan; Museum of Art, Kochi, Japan; Hiroshima Prefectural Art Museum, Hiroshima, Japan; Kawamura Memorial Museum of Art, Chiba, Japan; Kumamoto Prefectural Museum of Art, Kumamoto, Japan; Nagoya City Art Museum, Japan.

2001

Museum of Modern Art, Toyama, Japan. *Alexander Calder: Motion and Color.* 6 April–13 May 2001. Originated from Iwaki City Art Museum, Japan.

Storm King Art Center, Mountainville, New York. *Grand Intuitions: Calder's Monumental Sculpture.* 21 May 2001–15 November 2003.

Hokkaido Obihiro Museum of Art, Obihiro, Japan. *Alexander Calder: Motion and Color.* 22 May–17 June 2001. Originated from Iwaki City Art Museum, Japan.

Museum of Art, Kochi, Japan. *Alexander Calder: Motion and Color.* 26 June–26 August 2001. Originated from Iwaki City Art Museum, Japan.

Hiroshima Prefectural Art Museum, Hiroshima–City, Japan. *Alexander Calder: Motion and Color.* 2 September–14 October 2001. Originated from Iwaki City Art Museum, Japan.

Kawamura Memorial Museum of Art, Chiba, Japan. *Alexander Calder: Motion and Color.* 20 October–16 December 2001. Originated from Iwaki City Art Museum, Japan.

Museum of Contemporary Art, Chicago. *Alexander Calder in Focus.* 13 December 2000–19 August 2001.

Kumamoto Prefectural Museum of Art, Kumamoto, Japan. *Alexander Calder: Motion and Color.* 22 December 2001–11 February 2002. Originated from Iwaki City Art Museum, Japan.

2002

Bellagio Gallery of Fine Art, Las Vegas. *Alexander Calder: The Art of Invention.* 25 January–24 July 2002. Curated by Alexander S. C. Rower and Marc Glimcher. Catalogue.

PaceWildenstein, New York. *Calder '76: The Cutouts.* 14 February–16 March 2002. Catalogue.

Nagoya City Art Museum, Japan. *Alexander Calder: Motion and Color.* 20 February–7 April 2002. Originated from Iwaki City Art Museum, Japan.

Ameringer & Yohe Fine Art, New York. *Calder: Four Maquettes, Two Stabiles, & a Little Bird Too.* 19 September–12 October 2002. Catalogue.

2003

PaceWildenstein at the Art Dealers' Association of America Art Fair, New York. *Calder in Miniature.* 19–24 February 2003. Catalogue.

Van de Weghe Fine Art, New York. *A Modern Definition of Space: Calder Sculpture.* 21 February–23 May 2003. Catalogue.

Group Exhibitions

1925

New York Society of Independent Artists, Waldorf–Astoria, New York. *Ninth Annual Exhibition of the Society of Independent Artists.* 6–29 March 1925. Catalogue.

1926

Artists Gallery, New York. January 1926.

New York Society of Independent Artists, Waldorf–Astoria, New York. *Tenth Annual Exhibition of the Society of Independent Artists.* 5–28 March 1926. Catalogue.

Anderson Galleries, Whitney Studio Club, New York. *The Whitney Studio Club Eleventh Annual Exhibition of Paintings and Sculpture by Members of the Whitney Studio Club.* 8–20 March 1926. Catalogue.

Anderson Galleries, New York. (Exhibition on the subject of the horse.) May 1926. Curated by Karl Freund.

1927

Galerie La Boétie, Paris. *Salon des Humoristes.* 6 March–1 May 1927.

1928

Salon de la Société des Artistes Indépendants, Paris. 20 January–29 February 1928. Catalogue.

New York Society of Independent Artists, Waldorf–Astoria, New York. *Twelfth Annual Exhibition of the Society of Independent Artists.* 9 March–1 April 1928. Catalogue.

Galleries of Jacques Seligmann. Ancien Hôtel de Sagan, Paris. *The Salon of American Artists.* 2–13 July 1928. Catalogue.

1929

Salon de la Société des Artistes Indépendants, Grand Palais, Paris. *40ème Exposition Annuelle.* 18–28 January 1929. Catalogue.

Salon des Tuileries, Paris. May 1929. Catalogue.

Harvard Society of Contemporary Art, Cambridge, Massachusetts. *An Exhibition of Painting and Sculpture by the School of New York.* 17 October–1 November 1929. Catalogue.

1930

Galerie G. L. Manuel Frères, Paris. 16th *Salon de l'Araignée.* [January–February 1930]. Catalogue.

Salon de la Société des Artistes Indépendants, Paris. 17 January–2 March 1930. Catalogue.

Parc des Expositions, Porte de Versailles, Paris. *Association Artistique les Surindépendants.* 25 October–24 November 1930. Catalogue.

Museum of Modern Art, New York. *Painting and Sculpture by Living Americans — Ninth Loan Exhibition.* 2 December 1930–20 January 1931. Catalogue.

1931

Künstlerhaus, Berlin. July 1931.

Parc des Expositions, Porte de Versailles, Paris. *Association Artistique les Surindépendants.* 23 October–22 November 1931. Catalogue. Calder performed the *Cirque Calder.*

1932

Parc des Expositions, Porte de Versailles, Paris. *"1940."* 15 January–1 February 1932. Catalogue.

Galerie Vignon, Paris. *Exposition de dessins.* 15–28 January 1932. Catalogue.

The Renaissance Society of the University of Chicago. *The Fifth Annual Exhibition of Modern French Painting.* 7–21 February 1932.

Berliner Sommerschau, Berlin. July 1932.

Muzeum Sztuki w Lodzi/Museum of New Art, Lodz, Poland. *Miedzynarodowa Kolekcja Sztuki Nowoczesnej / Collection Internationale d'Art Nouveau.* [1932]. Catalogue.

1933

L'Association Artistique Abstraction–Création, Paris. *Première série.* 19–31 January 1933.

Galerie Pierre, Paris. *Arp, Calder, Miró, Persner, Hélion, and Seligmann.* 9–24 June 1933. Catalogue.

Berkshire Museum, Pittsfield, Massachusetts. *Modern Painting and Sculpture: Alexander Calder, George L. K. Morris, Calvert Coggeshall, Alma de Gersdorff Morgan.* 12–25 August 1933 (extended to 27 August). Catalogue.

1934

Radio City (Rockefeller Center), New York. *The First Municipal Art Exhibition.* March 1934.

Renaissance Society of the University of Chicago. *A Selection of Works by Twentieth Century Artists.* 20 June–20 August 1934. Curated by James Johnson Sweeney. Catalogue.

Museum of Modern Art, New York. *Modern Works of Art: Fifth Anniversary Exhibition.* 20 November 1934–20 January 1935. Catalogue.

1935

Wadsworth Atheneum, Hartford, Connecticut. *American Painting and Sculpture of the 18th, 19th & 20th Centuries.* 29 January–19 February 1935. Catalogue.

Kunstmuseum, Luzern, Switzerland. *Thèse, antithèse, synthèse.* 24 February–31 March 1935. Catalogue.

Art Institute of Chicago. *The Fourteenth International Exhibition of Water Colors, Pastels, Drawings and Monotypes.* 21 March–2 June 1935. Catalogue.

Wadsworth Atheneum, Hartford, Connecticut. *Abstract Art.* 22 October–17 November 1935. Catalogue.

1936

Albright Art Gallery, Buffalo Fine Arts Academy, New York. *Art of Today.* 3–31 January 1936. Catalogue.

Gallery 41, Oxford, England. *Abstract and Concrete: an Exhibition of Abstract Painting and Sculpture Today.* 15–22 February 1936. Curated by Nicolette Gray. Traveled to University of Liverpool, School of

Architecture. 2–14 March 1936; Alex Reid & Lefevre, Ltd., London, April 1936; Gordon Fraser Gallery, Cambridge, 28 May–13 June 1936.

Museum of Modern Art, New York. *Cubism and Abstract Art.* 2 March–19 April 1936. Catalogue. Traveled to San Francisco Museum of Art, 27 July–27 August 1936; Cincinnati Art Museum, 10 October–15 November 1936; Minneapolis Institute of Arts, 29 November–27 December 1936; Cleveland Museum of Art, 7 January–7 February 1937; Baltimore Museum of Art, 17 February–17 March 1937; Rhode Island School of Design, Museum of Art, Providence, 24 March–24 April 1937; Grand Rapids Art Gallery, Michigan, 29 April–26 May 1937.

Gallery of Living Art at the Paul Reinhardt Galleries, New York. *Five Contemporary American Concretionists: Biederman, Calder, Ferren, Morris, Shaw.* 9–31 March 1936. Catalogue.

Museum of Modern Art, New York. *Modern Painters and Sculptors as Illustrators.* 27 April–12 September 1936. Catalogue.

Worcester Art Museum, Massachusetts. *Art of the Machine Age.* 15 May–18 October 1936. Catalogue.

Charles Ratton Gallery, Paris. *Exposition surréaliste d'objets.* 22–29 May 1936. Catalogue.

Museum of Modern Art, New York. *Fantastic Art, Dada and Surrealism.* 7 December 1936–17 January 1937. Catalogue. Traveled to Pennsylvania Museum of Art, Philadelphia, 30 January–1 March 1937; Institute of Modern Art, Boston, 6 March–3 April 1937; Museum of Fine Arts, Springfield, Massachusetts, 14 April–10 May 1937; Milwaukee Art Institute, Wisconsin, 19 May–16 June 1937; University Gallery, University of Minnesota, Minneapolis, 26 June–24 July 1937; San Francisco Museum of Art, 6 August–3 September 1937.

1937

Kunsthalle, Basel, Switzerland. *Konstruktivisten.* 16 January–14 February 1937. Catalogue.

Pavillon de la République Espagnole, Paris. *L'Exposition Internationale.* 24 May–26 November 1937.

Honolulu Academy of Arts, Hawaii. *Fantastic Art: Miró and Calder.* 1–15 June 1937.

London Gallery, London. *Constructive Art.* July 1937.

Artek Gallery, Helsinki. *Fernand Léger / Alexander Calder.* 29 November–12 December 1937. Catalogue.

1938

Stedelijk Museum, Amsterdam. *Tentoonstelling Abstracte Kunst.* 2–24 April 1938. Catalogue.

Katherine Kuh Gallery, Chicago. [*Moderns*]. May 1938.

Musée du Jeu de Paume, Paris. *Trois siècles d'art aux États-Unis.* 24 May–31 July 1938. Organized in cooperation with Museum of Modern Art, New York. Catalogue.

1939

São Paulo, Brazil. 3rd *Salão de Maio.* (1939). Catalogue.

Division of Decorative Arts, Department of Fine Arts, San Francisco. *Golden Gate International Exposition, Decorative Arts.* 18 February–30 October 1939. Catalogue.

Division of Contemporary Painting and Sculpture, Department of Fine Arts, San Francisco. *Golden Gate International Exposition, Contemporary Art.* 18 February–30 October 1939. Catalogue.

Rohm and Haas, Hall of Industrial Science, *New York World's Fair, New York.* 30 April–26 October 1939.

Galerie Guggenheim Jeune, London. *Contemporary Sculpture: Brancusi, Laurens, Pevsner, Henry Moore, Duchamp–Villon, Hans Arp, Calder, Taeuber–Arp.* [Summer 1939].

1940

Philadelphia Museum of Art in collaboration with the Fairmount Park Art Association. *Second International Exhibition of Sculpture.* 18 May–1 October 1940.

1941

Springfield Museum of Fine Arts, Massachusetts. *American Plastics.* 20 January–20 February 1941.

Arts and Crafts Club of New Orleans, Louisiana. *Alexander Calder: Mobiles / Jewelry and Fernand Léger: Gouaches / Drawings.* 28 March–11 April 1941. Catalogue.

Design Project, Los Angeles. *Alexander Calder, Mobiles, Stabiles, Jewelry: A Few Paintings by Paul Klee.* 27 September–27 October 1941.

1942

Arts Club of Chicago. *Nine American Artists.* 3–28 February 1942. Catalogue.

Vassar College, Poughkeepsie, New York. [*Joan Miró — Alexander Calder*]. 7–28 March 1942.

Museum of Modern Art, New York. *A Children's Festival of Modern Art.* 11 March–10 May 1942.

Helena Rubinstein Building, New York. *Masters of Abstract Art.* 1 April–15 May 1942. Catalogue.

Cincinnati Art Museum, Ohio. *Paintings by Paul Klee and Mobiles and Stabiles by Alexander Calder.* 7 April–3 May 1942. Catalogue.

Solomon R. Guggenheim Museum, New York. *Fifth Anniversary Exhibition.* October 1942.

Montclair Art Museum, New Jersey. *Twentieth Century Sculpture and Constructions.* 2–26 October 1941. Organized by Museum of Modern Art, New York. Traveled to Honolulu Academy of Arts, Hawaii, 2–14 December 1941; Vassar College, Poughkeepsie, New York, 20 May–15 June 1942; Museum of Modern Art, New York, 2–26 October 1942; University Art Gallery, University of Minnesota, Minneapolis, 3–24 November 1942; Cincinnati Modern Art Society, Ohio, 10–31 December 1942; Skidmore College, Saratoga Springs, New York, 31 January–21 February 1943.

Coordinating Council of French Relief Societies, Whitelaw Reid Mansion, New York. *First Papers of Surrealism.* 14 October–7 November 1942. Organized by André Breton and Marcel Duchamp. Catalogue.

Whitney Museum of American Art, New York. *Annual Exhibition of Contemporary Art.* 24 November 1942–6 January 1943. Catalogue.

Metropolitan Museum of Art, New York. *Artists for Victory: An Exhibition of Contemporary American Art.* 7 December 1942–22 February 1943. Catalogue.

1943

Museum of Modern Art, New York. *Arts in Therapy.* 2 February–7 March 1943.

Whitney Museum of American Art, New York. *Annual Exhibition of Contemporary American Art.* 23 November 1943–4 January 1944. Catalogue.

1944

Renaissance Society of the University of Chicago. *Drawings by Contemporary Artists.* 20 May–19 June 1944. Catalogue.

Museum of Modern Art, New York. *Art in Progress: The Fifteenth Anniversary of the Museum of Modern Art.* 23 May–7 October 1944. Catalogue.

San Francisco Museum of Art. *Abstract and Surrealist Art in the United States.* 6–24 September 1944. Catalogue.

Julien Levy Gallery, New York. *Imagery of Chess.* 12 December 1944–31 January 1945.

1945

Whitney Museum of American Art, New York. *Annual Exhibition of Contemporary American Sculpture, Watercolors, and Drawings.* 3 January–8 February 1945. Catalogue.

Buchholz Gallery/Curt Valentin, New York. *Recent Work by American Sculptors.* 6–24 February 1945. Catalogue.

Museum of Modern Art, New York. *First Exhibition of the Museum Collection of Painting and Sculpture.* 19 June–4 November 1945.

Santa Barbara Museum of Art, California. *Contemporary Sculpture.* August 1945. Exhibition, assembled and loaned by Curt Valentin (Buchholz Gallery, New York).

1946

Detroit Institute of Arts. *Origins of Modern Sculpture.* 22 January–3 March 1946. Catalogue. Traveled to St. Louis Art Museum, 30 March–15 May 1946. Catalogue.

Clay Club Gallery, New York. *Benefit: Exhibition and Sale of Sculpture to help raise funds for the Sculpture Center.* 15 April–[Spring] 1946.

Cincinnati Modern Art Society, Ohio. *4 Modern Sculptors: Brancusi, Calder, Lipchitz, Moore.* 1 October–15 November 1946. Catalogue.

1947

Kunsthalle, Bern, Switzerland. *Calder, Léger, Bodmer, Leuppi.* 4–26 May 1947. Catalogue.

Palais des Papes, Avignon. *Exposition de peintures et sculptures contemporaines.* 27 June–30 September 1947. Catalogue.

Stedelijk Museum, Amsterdam. *Alexander Calder / Fernand Léger.* 19 July–24 August 1947. Catalogue.

Galerie Maeght, Paris. *Le Surréalisme en 1947.* [7 July 1947]. Catalogue.

1948

Venice. 24th *Biennale di Venezia.* 6 June–30 September 1948. Catalogue.

Galerie d'Art Moderne, Basel, Switzerland. *Calder, Picasso, Steinwender.* December 1948–January 1949.

1949

Museu de Arte Moderna, São Paulo, Brazil. *Do Figurativismo ao Abstracionismo.* 8–31 March 1949. Catalogue.

Philadelphia Museum of Art in collaboration with the Fairmount Park Art Assocation. *Third International Exhibition of Sculpture.* 15 May–11 September 1949.

Virginia Museum of Fine Arts, Richmond, Virginia. *Calder and Sculpture Today.* 28 October–11 December 1949. Traveled to Mary Baldwin College, Staunton, Virginia, 13–21 December 1949; University of Virginia, Charlottesville, Virginia, 1–15 January 1950.

1951

Stedelijk Museum, Amsterdam. *Surréalisme + Abstraction.* 19 January–26 February 1951. Catalogue. Traveled to Palais des Beaux-Arts, Brussels, March 1951.

Museum of Modern Art, New York. *Abstract Painting and Sculpture in America.* 23 January–25 March 1951. Catalogue. Traveled to Dallas Museum of Fine Arts, 1–22 October 1951; St. Paul Gallery and School of Art, Minnesota, 5–26 November 1951; Winnipeg Art Gallery, Canada, 10–31 December 1951; Toledo Museum of Art, 14–28 January 1952; J.B. Speed Art Museum, Louisville, Kentucky, 18 February–10 March 1952; Southern Illinois University, Carbondale, 24 March–14 April 1952.

Contemporary Arts Museum of Houston, Texas. *Calder — Miró.* 14 October–4 November 1951. Catalogue.

Museo de Arte Moderna, São Paulo, Brazil. 1st *Bienal do Museu de Arte Moderna de São Paulo.* 20 October–December 1951. Catalogue.

Charlottenborg Palace, Copenhagen. *Klar Form.* 8–26 December 1951. Traveled to Konsthallen, Helsinki, 10–31 January 1952; Liljewalchs Konsthall, Stockholm, 10–27 March 1952; Kunstnernes Hus, Oslo, May 1952.

1952

Venice. 26th *Biennale di Venezia.* 14 June–19 October 1952. Catalogue.

Moderne Galerie Otto Stangl, Munich, Germany. *Alexander Calder/Joan Miró.* 18 July–28 August 1952. Catalogue. The Calder part of this exhibition originated from the solo exhibition at Galerie Parnass, Wuppertal, Germany, 5–20 June 1952.

Galerie la Hune, Paris. *Permanence du Cirque.* 18 November–9 December 1952.

1953

Hanna Bekker vom Rath/Frankfurter Kunstkabinett, Frankfurt am Main, Germany. *Alexander Calder, Paul Fontaine, Louise Rösler.* 22 February–22 March 1953. Catalogue. The Calder part of this exhibition originated from the solo exhibition at Galerie Parnass, Wuppertal, Germany, 5–20 June 1952.

Musée National d'Art Moderne, Paris. *12 Peintres et Sculpteurs Américains Contemporains.* 24 April–7 June 1953. Catalogue. Traveled to Kunsthaus, Zürich, 25 July–30 August 1953; Kunstsammlungen der Stadt Düsseldorf, 20 September–25 October 1953; Liljevalchs Konsthall, Stockholm, 24 November–20 December 1953; Taidehalli–Konsthallen, Helsinki, 8–24 January 1954; Kunstnernes Hus, Oslo, 18 February–7 March 1954.

Wadsworth Atheneum, Hartford, Connecticut. *Alexander Calder: Mobiles / Naum Gabo: Kinetic Constructions and Constructions in Space.* 16 October–28 November 1953. Catalogue.

Museu de Arte Moderna, São Paulo, Brazil. *Second Bienal do Museu de Arte Moderna de São Paulo.* 15 December 1953–28 February 1954. Catalogue. The United States was represented by three shows organized by Museum

of Modern Art: 45 works by Alexander Calder; paintings, drawings, and prints by 16 artists, including Baziotes, de Kooning; Ben Shahn; and Alton Pickens; and *Built in U.S.A.*

1955

Musée National d'Art Moderne, Paris. *Modern Art in the United States.* 30 March–15 May 1955. Organized by Museum of Modern Art. Curated by James Johnson Sweeney. This exhibition was divided into six sections and Traveled to Kunsthaus, Zürich, 16 July–28 August 1955; Palacio de la Virreina, Barcelona, and Museo de Arte Moderno, Barcelona, 24 September–24 October 1955; Haus des Deutschen Kunsthandwerks, Frankfurt, 13 November–11 December 1955; Tate Gallery, London, 5 January–12 February 1956; Gementemuseum, The Hague, 2 March–15 April 1956; Galerie Secession, Vienna, 5 May–2 June 1956; Kalemegdan Pavilion, Belgrade, Gallery Udurezenje Likovnih Umetnike Srbije, Belgrade, and Muzej Freska, Belgrade, 6 July–6 August 1956.

Galerie Denise René, Paris. *Le Mouvement.* 6 April–15 May 1955. Catalogue.

Museum Fridericianum, Kassel, Germany. *Documenta: Kunst des XX. jahrhunderts: Internationale Ausstellung.* 15 July–18 September 1955. Catalogue.

1957

World House Galleries, New York. *4 Masters Exhibition: Rodin, Brancusi, Gauguin, Calder.* 28 March–20 April 1957. Catalogue.

Uffici Palazzo dell'arte al Parco, Milan. *Undicesima Triennale di Milano.* 27 July–4 November 1957.

1958

Brussels Universal and International Exhibition. *American Art: Four Exhibitions.* 17 April–18 October 1958. Catalogue.

Carnegie Institute, Department of Fine Arts, Pittsburgh, Pennsylvania. *The 1958 Pittsburgh Bicentennial International Exhibition of Contemporary Painting and Sculpture.* 5 December 1958–8 February 1959. Catalogue.

1959

Museum Fridericianum, Orangerie, Bellvueschlos, Kassel. Germany. *Documenta 2. Kunst nach 1945: Malerei, Skulptur, Druckgrafik internationale Ausstellung.* 11 July–11 October 1959. Catalogue.

1961

Wilmington Society of Fine Arts, Delaware Art Center, Wilmington. *Calder/Alexander Milne, Alexander Stirling, Alexander.* 7 January–19 February 1961. Catalogue.

Perls Galleries, New York. *Alexander Calder / Joan Miró.* 21 February–1 April 1961. Catalogue.

Stedelijk Museum, Amsterdam. *Bewogen–Beweging.* 10 March–17 April 1961. Catalogue. Traveled to Moderna Museet, Stockholm, 17 May–3 September 1961; Louisiana Museum of Modern Art, Humlebæk, Denmark, September–October 1961.

1962

Fifth Festival of Two Worlds, Festival Foundation, Spoleto, Italy. *Sculptures in the City.* 21 June–22 July 1962. Curated by Giovanni Carandente.

1963

Galerie d'Art Moderne Marie–Suzanne Feigel, Basel, Switzerland. *Arp / Calder / Marini.* 11 May–30 September 1963. Catalogue.

1964

Alte Galerie, Museum Fridericianum, Orangerie, Kassel, Germany. *Documenta 3: Malerei und Skulptur.* 27 June–5 October 1964. Catalogue.

Grosvenor Gallery, London. *Miró: Graphics, Calder: Mobiles, Ch'i Pai-shih: Paintings.* 28 October–20 November 1964. Catalogue.

1965

Brook Street Gallery. London. *Vasarely/Calder.* July–September 1965. Catalogue.

1967

New York Cultural Showcase Festival, New York. *Sculpture in Environment.* 1–31 October 1967. Catalogue.

1970

Chateau de Ratilly, Nièvre, France. *Calder / Bazaine.* 19 June–10 September 1970. Catalogue.

1971

Society of the Four Arts, Palm Beach, Florida. *Alexander Calder / Louise Nevelson / David Smith.* 6 March–5 April 1971. Catalogue.

American Academy of Arts and Letters, and National Institute of Arts and Letters, New York. *Exhibition of Work by Newly Elected Members and Recipients of Honors and Awards.* 27 May–20 June 1971. Catalogue. Calder was awarded the Gold Medal for Sculpture.

1972

Museum of Fine Arts, Houston. *A Child's Summer with Calder and Miró.* 14 June–20 August 1972.

Fuji Television Gallery Co., Ltd., Tokyo. *Calder / Miró.* 15–30 November 1972. Catalogue.

Galerie Beyeler, Basel, Switzerland. *Miró / Calder.* December 1972–January 1973. Catalogue.

1973

Downtown Branch, Whitney Museum of American Art, New York. *3 Sculptors: Calder, Nevelson, David Smith.* 5 December 1973–3 January 1974.

1975

Hooks-Epstein Galleries. Houston. Texas. *Calder and Miró: Works on Paper 1957–1974.* 7 January–15 February 1975.

Pace Gallery, New York. *5 Americans: Calder, Cornell, Nevelson, Noguchi, David Smith: Masters of Twentieth Century Sculpture.* 11 January–22 February 1975.

Galleria Medea, Milan. *Calder e Mathieu.* 1–20 April 1975. Catalogue.

Moderne Galerie Otto Stangl, Munich, Germany. *Calder / Hartung.* [May 1975].

Galerie Artek, Helsinki. *Calder: Mobiles, Bijoux, Lithographies / Léger: Huiles, Gouaches, Lithographies.* 15 October–2 November 1975. Catalogue.

1979

Rutgers University Art Gallery, New Brunswick, New Jersey. *Vanguard American Sculpture 1913–1939.*

16 September–4 November 1979. Curated by Joan Marter, Roberta K. Tarbell, and Jeffrey Wechsler. Catalogue. Traveled to William Hayes Ackland Art Center, University of North Carolina, Chapel Hill, 4 December 1979–20 January 1980; Joslyn Art Museum, Omaha, Nebraska. 16 February–30 March 1980; The Oakland Museum. California, 15 April–25 May 1980.

M. Knoedler & Co., Inc., New York. *Alexander Calder — Fernand Léger.* 4–27 October 1979. Catalogue.

1983

New Jersey State Museum, Trenton. *Beyond the Plane: American Constructions 1930–1965.* 29 October–31 December 1983. Catalogue. Traveled to University of Maryland, Art Gallery, College Park, Maryland. 26 January–18 March 1984.

1984

Solomon R. Guggenheim Museum, New York. *From Degas to Calder: Sculpture and Works on Paper from the Guggenheim Museum Collection.* 30 July–8 September 1984. Catalogue.

1985

Galería Theo, Madrid, Spain. *Doce esculturas Calder / Miró diez pinturas.* 5 December 1985–January 1986. Catalogue.

1988

Galerie Louis Carré & Cie, Paris. *Alexander Calder — Mobiles; Fernand Léger — Peintures.* 13 October–26 November 1988. Catalogue.

1989

Gallery Urban, New York. *Miró: Major Works and Calder: Mobiles and Gouaches.* 1 April–31 May 1989. Traveled to Gallery Urban, Paris, 26 September–10 November 1989.

1993

Solomon R. Guggenheim Museum, New York. *Picasso and the Age of Iron.* 19 March–16 May 1993. Curated by Carmen Giménez. Catalogue. Traveled to Modern Art Museum of Fort Worth. Texas, 1 August–17 October 1993.

1994

Haus der Kunst, Munich. *Elan vital oder Das Auge Der Eros: Kandinsky, Klee, Arp, Miró, Calder.* 20 May–14 August 1994. Curated by Christoph Vitali. Catalogue.

American Academy in Rome. *American Art in Italian Private Collections.* 27 May–30 June 1994. Catalogue.

1995

Grosvenor Gallery, London. *Henry Moore O.M. 1898–1986; Alexander Calder 1898–1976.* 15 March–13 April 1995. Catalogue.

1996

Phillips Collection, Washington, D.C. *Americans in Paris [1921–1931]: Man Ray, Gerald Murphy, Stuart Davis, Alexander Calder.* 27 April–18 August 1996. Curated by Elizabeth Hutton Turner. Catalogue.

1998

Nassau County Museum of Art, Roslyn Harbor, New York. *Calder and Miró.* 7 June–13 September 1998. Curated by Constance Schwartz and Franklin Hill Perrell. Catalogue.

1999

Galería Elvira González, Madrid. *Alexander Calder / Yves Tanguy.* 21 Jaunuary–27 February 1999. Catalogue.

Montreal Museum of Fine Arts, Canada. *Cosmos.* 17 June–17 October 1999. Catalogue.

Arizona State University, Tempe. *Eye of the Collector: Works from the Lipman Collection of American Art.* 20 November 1999–13 February 2000. Curated by Marilyn A. Zeitlin. Catalogue.

2000

PaceWildenstein, New York. *Earthly Forms: The Biomorphic Sculpture of Arp, Calder and Noguchi.* 18 February–20 March 2000.

2001

Galerie Thomas, Munich. *Calder and Miró.* 25 June–11 August 2001.

Wadsworth Atheneum, Hartford, Connecticut. *Images from the World Between: The Circus in 20th Century American Art.* 19 October 2001–6 January 2002. Curated by Donna Gustafson; organized by the American Federation of Arts. Catalogue. Traveled to John and Mable Ringling Museum of Art, Sarasota, Florida, 1 February–12 May 2002; Austin Museum of Fine Art, Texas, 7 June–19 August 2002.

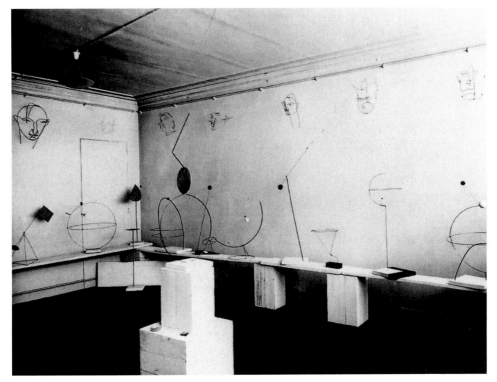

Calder exhibition at Galerie Percier, Paris, 1931. Courtesy Calder Foundation

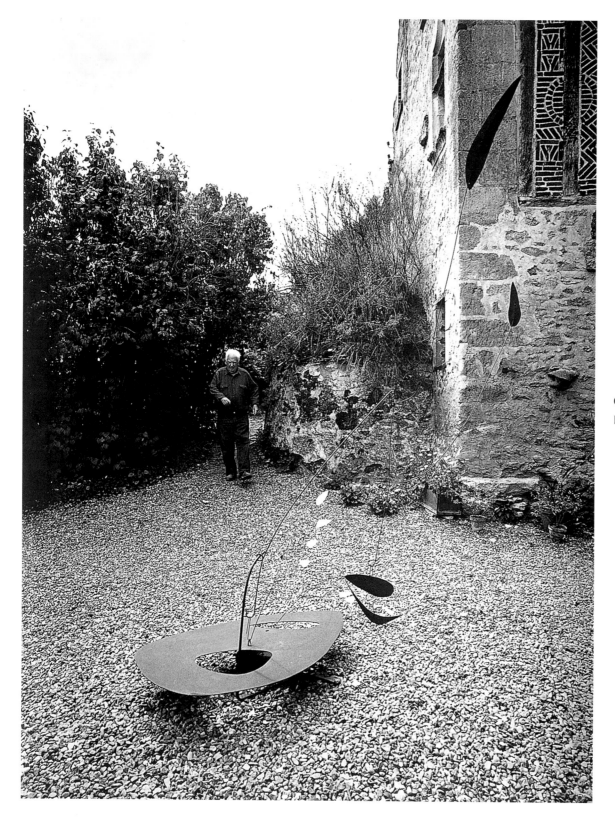

Calder walking toward *Lily of Force* at his house
François Premier, ca. 1969 / Photo: Ugo Mulas

Note:
Every effort has been made to ensure that credits
accurately comply with information supplied.

Addison Gallery of American Art, Phillips Academy,
 Andover, Massachusetts: cat. 16

Art Resource, New York: cat. 1, cat. 3, cat. 4, cat. 5, cat. 6,
 cat. 7, cat. 9, cat. 12, cat. 15, cat. 17, cat. 18, cat. 19,
 cat. 22, cat. 23, cat. 30, cat. 32, cat. 33, cat. 34, cat. 40,
 cat. 44, cat. 51, cat. 67, cat. 68

Courtesy Calder Foundation, New York, p. XII, p. 14, p. 15,
 p. 19, p. 21, p. 24, p. 31, p. 33, p. 63, p. 92, p. 104, p. 199,
 p. 206, p. 211, p. 255

 Gordon Christmas: cat. 29, cat. 31, cat. 63, cat. 65

 Hugo P. Herdeg: p. 10

 André Kertész: p. 17, p. 39

 Herbert Matter: p. 9, p. 46, p. 56, p. 101, p. 195, p. 197,
 p. 199

 Inge Morath: p. 209

 Gordon Parks: p. 36

 Ezra Stoller: p. 236

 Agnès Varda: p. 259

 Marc Vaux: p. 29

 De Witt Ward: p. 195

 Herb Weitman: p. 64, p. 206, p. 216

Pierre-Yves Dhinaut: cat. 20, cat. 37, cat. 48

Joan-Ramón Bonet-Verdaguer: cat. 41

Pedro E. Guerrero: p. 40, pp. 102–103, p. 185, p. 186, p. 207

Ugo Mulas: p. 4, p. 56, p. 62, p. 80, p. 81, p. 82, p. 93,
 p. 206, p. 215, p. 256

Man Ray: p. IV

City of Pittsburgh: cat. 59

CNAM / MNAM (Centre Pompidou-MNAM-CCI, Paris): cat. 47

RMN / Centre Georges Pompidou: cat. 45

Private collections: p. 22, p. 26, p. 28, cat. 24, cat. 27,
 cat. 28, cat. 36, cat. 52, cat. 64

Fundació Joan Miró, Barcelona. Donación Josep Lluís Sert:
 cat. 42

Fundación ICO: p. 11

Les Abattoirs, Toulouse / André Morin: cat. 47

Louisiana Museet / Poul Buchard: cat. 61

Musée d'art moderne Lille Métropol: cat. 69

Musée de Beaux-Arts, Nantes: p. 8

Musée du Louvre, Paris: p. 13

Musée Picasso, Paris: p. 6, p. 7

Museo Guggenheim Bilbao / Erika Barahona Ede: cat. 46

Museo Nacional Centro de Arte Reina Sofía: cat. 25

Museum of Fine Arts, Houston: p. 30

Museum Moderner Kunst Stiflung Ludwig, Vienna: cat. 53

Museum of Modern Art, New York: p. 25

National Gallery of Art, Washington, D.C. / Philip A.
 Charles: cat. 39

National Gallery of Canada, Otawa: cat. 35

O'Hara Gallery, New York: cat. 50, cat. 66

Pace Wildenstein / Paula Goldman: cat. 10

Pace Wildenstein / Ellen Page Wilson: cat. 55

Pushkin, Museum of Fine Arts, Moscow: p. 12

Rheinisches Bildarchiv, Museum Ludwig, Cologne: cat. 57

Solomon R. Guggenheim Foundation, New York / David
 Heald: p. 3, cat. 11, cat. 14, cat. 21, cat. 26, cat. 54

Solomon R. Guggenheim Foundation, New York / Ellen
 Labenski: cat. 8

Stedelijk Museum, Amsterdam: cat. 49

Menil Collection, Houston / Hickey-Robertson: cat. 62

JPMorgan Chase Art Collection: p. 35, cat. 60

Whitney Museum of American Art, New York / Sheldan C.
 Collings: cat. 56

Whitney Museum of American Art, New York / Jerry L.
 Thompson: cat. 2, cat. 13, cat. 38, cat. 43, cat. 58

PHOTOGRAPHIC CREDITS

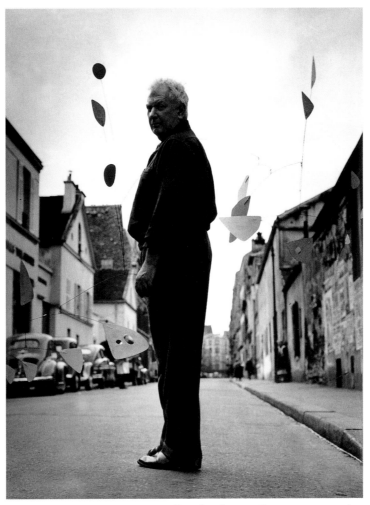

Calder carrying his mobile *21 Feuilles Blanches* in a Paris street, 1954 /
Photo: Agnès Varda